]

Renaissance Now!

THE VALUE OF THE RENAISSANCE PAST IN CONTEMPORARY CULTURE

edited by

Brendan Dooley

PETER LANG

Oxford· Bern · Berlin · Bruxelles · Frankfurt am Main · New York · Wien

Bibliographic information published by Die Deutsche Nationalbibliothek
Die Deutsche Nationalbibliothek lists this publication in the Deutsche
Nationalbibliografie; detailed bibliographic data is available on the
Internet at http://dnb.d-nb.de.

A catalogue record for this book is available from the British Library.

Library of Congress Control Number: 2014930497

Cover image © Erica Guilane-Nachez - Fotolia.com

ISBN 978-3-0343-0790-1

© Peter Lang AG, International Academic Publishers, Bern 2014
Hochfeldstrasse 32, CH-3012 Bern, Switzerland
info@peterlang.com, www.peterlang.com, www.peterlang.net

This publication has been peer reviewed.

Printed in Germany

Contents

Preface

'This lonely provincialism, this admission that we are just the historical moment that we are'[1] – who among the seekers along the pathways of the past has not experienced Richard Rorty's sense of isolation? Stepping out of the rather narrower focus suggested by our title, this book is concerned largely with subjects and their objects. It queries the relations between researchers and their studies; it investigates to what degree a certain reflexivity affects the seeker as well as the thing being sought; it wonders where the world of yesterday fits into the world of today, and vice versa. However hard we try, we will never fully succeed in bringing 'in here' what is 'out there'. Is that a boon or a bane? 'Objectivity is not neutrality', one expert (Thomas Haskell) has said.[2] Amen! We make a virtue of necessity and seize the chance to remind ourselves and others about the reasons that impelled us on our voyages of discovery and proffer our appraisal of what we found when we got there.

Ideas about doing an anthology on 'Renaissance Now!' coalesced when one of the contributors was asked to participate in an RTE radio broadcast about 'The Borgias' – not the historical family (one of whose descendants he claimed to have met once on a bus to Prato), but the television series. Midway into an on-the-air conversation touching the themes of anachronism, presentism, simplification, exaggeration and outright fabrication, he reflected that Jeremy Irons was brilliant as the patriarch of 'the world's first crime family' – whatever such a characterization might mean or not mean in respect to a still somewhat indistinct actual episode in recorded time. The conversation soon turned away from history to acting, representing, creating good television, audience expectations, mediation and remediation.

1 Richard Rorty, *Objectivity, Relativism, and Truth* (Cambridge: Cambridge University Press, 1991), p. 30.
2 Thomas L. Haskell, 'Objectivity Is Not Neutrality: Rhetoric vs. Practice In Peter Novick's *That Noble Dream*', *History and Theory* 29 (1990): 129–57.

The Renaissance, someone else on the programme noted, belongs to all of us, as each 'now' comes back to us from 'future' and fuses into 'past'. The project became the product of many hands; and those who generously gave time and energy to it shared a common interest in asking themselves and others how we like our Renaissance and how we want it to be remembered.

The road has been long, also, to the completion of this book. Some of the territory traversed is in evidence here only tangentially. The various offshoots of the original project have taken on lives of their own, and when they are not indicated in these pages the reader may hear about them one way or another from the personages who are. Christabel Scaife at Peter Lang expressed interest in the project at an early stage and helped us motivate the practical aspects of preparing a volume. We are deeply grateful. Those of us who did the editing are equally grateful to all our participants as much for their expertise as for their patience. We hope the final product meets their expectations as well as the expectations of our readers, whoever you are, lovers of things Renaissance, students in Renaissance courses, researchers completing bibliographies where the present work of knowledge collection meets the past we encounter through the lens of our scientific skills and our imaginations.

This is the place to thank all those who made the project possible, including many who are represented here only by reference but who played a part in the initial discussions, namely, James Hankins, John Henderson, Alessio Assonitis, Jeremy Lawrance, Flavio Boggi, Melanie L. Marshall, Stephen Boyd, Grace Neville, Arpad Szakolczai, Daragh O'Connell, Jason Harris. For logistical help we thank Esther Luettgen and Colin Duggan, in the Texts, Contexts and Cultures Programme at University College Cork, and for her expert proofreading Beatrix Faerber. Finally, our thanks to the Mellon Foundation, the Society for Italian Studies, and the College of Arts, Celtic Studies and Social Sciences at UCC and its Head, David Cox, as well as the Schools of History (Geoff Roberts) and English (James Knowles) and the Graduate School (David Ryan) and Vice Head of Research, Graham Allen.

Humanities research lives and thrives in a community that values knowledge, understanding and free inquiry; and the wider we look around, the less we feel inclined to take such things for granted. Maybe in some ways the voyage itself is constitutive of our convictions in this regard.

BRENDAN DOOLEY

Introduction

'Orlando slowly drew in his head, sat down at the table, and, with the half-
conscious air of one doing what they do every day of their lives at this hour,
took out a writing book labeled "Aethelbert: A Tragedy in Five Acts," and
dipped an old stained goose quill in the ink.' It was an age of extraordinary
accomplishment; this must surely be at least one of the meanings Virginia
Woolf was attempting to convey in these lines from her novel, set in the
Renaissance, where the principal character has just turned attention to
the objects in the room, and the associated tasks, after gazing out the open
window at the peacocks in the garden of his parents' country estate.[1] There
can be no doubt about the features that still impress. Take a more recent
novel, still on the newsstands. The dust jacket informs: 'In the simmering
hot summer of 1492, a monstrous evil is stirring within the Eternal City
of Rome. The brutal murder of an alchemist sets off a desperate race to
uncover the plot that threatens to extinguish the light of the Renaissance
and plunge Europe back into medieval darkness.' From 'a New York Times
bestselling author who is branching out' one would expect no less.[2] We are
put in mind of the monstrous evils that threaten to extinguish the lights
of the Western World – and maybe, that is the point.

Now step into the five-story atrium of the Grand Hyatt Hotel in
Washington, DC between 22 and 24 March 2012. The Renaissance Society
is meeting here, assisted by five restaurants, marble baths in the rooms,
'convenient in-lobby Metro Center access'. Over 1,100 sessions, ranging
from 'European Images of Death and Torture' to 'Diplomacy, Secrecy and

1 Virginia Woolf, *Orlando: A Biography* (London: L. and V. Woolf at the Hogarth
 Press, 1928), p. 16.
2 Sara Poole, *Poison: A Novel of the Renaissance* (New York: St Martin's Griffin, 2010).

Espionage', offer far more than any small team of assiduous bloggers could ever visit in three days. Forty-six sister societies are represented, based in Canada, the UK, France, Italy, Denmark, Taiwan, as if there was need of any more convincing demonstration about the global reach of the topic. This is not a world in crisis, except in comparison to the meeting in Venice two years ago, which beat all previous records both for attendance and for number of appointments. Venice after all has some distinct advantages as a site for discussions about Renaissance matters. Fewer than we might imagine, in this age of telepresence. As I sit by a babbling fake waterfall sipping a tasty Frappuccino and chatting with an expert on fifteenth-century French maps, I wonder, where, really, is the sense of place – where, in fact, is Renaissance studies?

The Renaissance has signified many things; and the many attempts to take stock of Renaissance studies as a field, in its many periods and contexts, appear to have developed into a mini-field in themselves. No wonder, considering the endless persistence of the term, and the fascination. Of the making of books on the Renaissance, apparently there is no end; and the same might be said of the making of Renaissances. This book is mainly concerned with the latter proliferation. And although the authors are aware of Renaissances come and gone, real or imagined, feared or hoped, and from time to time in their chapters they will evoke such refluxes and reflexes, they recognize the fundamental – indeed, the iconic – significance of what happened in Europe between 1350 and 1650. Our commitment here is to see what our contemporary infatuation with themes of renewal and rebirth can contribute to the field of Renaissance Studies, and vice versa. We wish to investigate what the Renaissance means to us, now.

The term has applied to more movements of renewal and rebirth over the centuries than we could possibly enumerate here. If we began by referring to the 'Carolingian Renaissance' that flourished in the eighth century around the court at Aachen, we will no doubt have slighted those for whom there is only the 'Twelfth-Century Renaissance', which saw a remarkable flowering of cultural productivity around Europe in many courts and in the new universities. Bypassing the endless strife between partisans of the twelfth century and those of the fourteenth, we hurry along to the post-Renaissance editions such as the 'Bulgarian Renaissance' of national identity

occurring between the eighteenth and nineteenth centuries. More recently, we would not want to omit the American Renaissance of Longfellow, Holmes and James Russell Lowell in the 1830s, the Chicago Renaissance of the early 1920s, involving Sherwood Anderson and Carl Sandburg, nor, surely, the Harlem Renaissance of the 1920s and 30s, featuring Langston Hughes and W.E.B. Du Bois. The Gaelic revival of the late nineteenth and early twentieth centuries has been called the 'Irish Literary Renaissance', proving that a single island can have more than one. Now there is the African Renaissance, since South African President Thabo Mbeki articulated this concept in the 1990s. Shall we omit Detroit's Renaissance Center, a glassified concretization of all that is new and vibrant in whatever happens to be at hand? All draw in one way or another from the canonization of this peculiar French term, first applied to European history by Jules Michelet in reference to the post-Middle Ages.

A current writer in a much-discussed book has predicted a future World Renaissance, in contrast to what he sees to be a kind of neo-medievalism characterized by the multi-polar or non-polar scattering of megacities we see now, where everything goes and all deals are good. 'We have more islands of governance than we have effective governments', says Parag Khanna, 'and just as in the Middle Ages, these islands are not states but cities.'[3] What needs to happen, in his view, is a return to sanity, reason and statecraft guided by an elite of brilliant minds with earth's best interests at heart. Never mind that such claims have been branded as jejune – among others, by Stephanie Giry in the *New York Times*.[4] What is important is that the claims have been made, and someone has listened (or, so it seems, read). Let the Renaissance now be evoked (as in this book) by those who actually study it.

The European Renaissance shows no signs of losing its appeal both as a cultural construct and as a periodical category. Prominent publishers are still soliciting new textbooks; and more general works on Western or

3 Parag Khanna, *Charting a Course to the Next Renaissance* (New York: Random House: 2011), p. 14.
4 Stéphanie Giry, 'Mosh Pit Diplomacy', *The New York Times*, 25 February 2011.

World Civilization or World History confirm that the period has managed to hold its own against encroaching 'Early Modern', also because of the visual appeal, while a few of the most recent developments in the field gradually trickle down to the level of the best undergraduate education.[5] On the other hand, Paul Grendler has announced that the *Encyclopedia of the Renaissance* of which he is the general editor has sold more than 6,000 copies: a record for academic publishing.[6] Powerful vested interests keep the scholarship alive: the establishment of centres, chairs and degree programmes of Renaissance Studies ensures continuity, while the rising costs of buying and authenticating artifacts ensures speculative interest.

The relation between the field and its context has always been a dynamic one. The word itself was first retailed in the French post-revolutionary period, amid efforts to explain the roots of the Enlightenment (and therefore, of the Revolution). Jacob Burckhardt evoked the concept, which he related to the emergence of 'the state as a work of art' and 'the development of the individual', at a time of reflection about the birth of two new nations in Europe: Italy and Germany.[7] The history of each key succeeding moment in Renaissance studies reminds us of just how much work the concept has done not only for our studies but for our societies. Max Weber returned to it at the height of the German empire, offsetting, in one work, the exuberance of the Renaissance age against the austerity of the Puritan one that later engulfed the German soul, and in another, saluting the artistic accomplishments won by Renaissance rationalism, in the course of a methodological exposé on the problem of objectivity and the admissibility of value-judgments in historical analysis.[8]

This book is concerned with the current interaction between Renaissance content and contemporary context. The evidence is all around us. There can be no doubt that the extraordinary concentration of works on

5 Mark Kishlansky et al., *Civilization in the West* (NY: Pearson, 2008), chap. 11.
6 *Encyclopedia of the Renaissance*, 6 vols (NY: Scribners, 1999).
7 Jacob Burckhardt, *The Civilization of the Renaissance, an Essay* (Oxford: Oxford University Press, 1945), Part 1.
8 Max Weber, *The Methodology of the Social Sciences*, translated and edited by Edward A. Shils and Henry A. Finch (Glencoe, IL: Free Press, 1949), pp. 30–1.

Renaissance worldly goods occurred at the height of the boom economy in the mid-1990s – so noted Lauro Martines, uselessly deploring the inevitable: the works, he said, 'bear witness to the fact that historical writing may bend too readily to the ideals and stresses of its own world'. The root cause: 'current campaigns for market economies and private enterprise, as mounted during the Reagan-Thatcher years, are here accommodated'.[9] So far, his call for intellectual purity in a polluted world has gone unheeded, and material culture studies are flourishing as never before. And how far historiography may, to use his analogy, 'bend' without 'breaking', is worth discussing. On the other hand, ubiquitous visual culture and advertising (says Randolph Starn) have demoted artists from lonely creators of beauty to paid image-makers.[10] Perhaps the current economic catastrophe will privilege studies on hard times and the investment in culture – and come to think of it, this too is a recurrent theme.[11]

Globalization and its aftermath have left a footprint: not only on the concepts but on the analyses. Fernand Braudel shied away from the term Renaissance but he studied intensely its economic foundations. In his later work he also moved out of the Mediterranean into the problematics of the modern world system, which became the signature concept of his disciple Immanuel Wallerstein. Faruk Tabak suggests that the Mediterranean 'waned' almost as long as it 'rose', consolidating and reconsolidating different

9 Lauro Martines, 'The Renaissance and the Birth of Consumer Society', *Renaissance Quarterly* 51 (1999): 193.

10 [David B. Rice], 'A Historian Revisits the Archives: Randolph Starn on Authenticity', *News of the National Humanities Center*, Autumn 2004, pp. 1, 10.

11 Robert S. Lopez, 'Hard Times and Investment in Culture', in *The Renaissance: A Symposium* (New York: Metropolitan Museum of Art, 1953), pp. 19–32; reprinted in Karl H. Dannenfeldt (ed.), *The Renaissance: Medieval or Modern?* (Boston: D.C. Heath and Company, 1959), pp. 50–63, and in Wallace K. Ferguson et al., *The Renaissance: Six Essays* (New York: Harper Torchbooks, 1962), pp. 29–54. See also Robert S. Lopez and Harry A. Miskimin, 'The Economic Depression of the Renaissance', *Economic History Review* 14 (1962): 408–26; the criticism by Carlo M. Cipolla, 'Economic Depression of the Renaissance?', *Economic History Review* 16 (1963): 519–24; and the responses of Lopez and Miskimin, *Ibid.*, pp. 525–9.

positions within its global context.[12] The current 'spatial turn', coming on the heels of the 'cultural turn', draws inspiration from a reflection about cultural and geographical interaction at the level of the everyday. Davide Scruzzi claims to have conceived his analysis of 'the perception of space and globalization in Venice from 1490 to around 1600' during the first signs of impending financial doom in 2005, and to have completed it in 2007, when, according to him, the globalizing process was at an end.[13]

The globalization controversy has also raised the question of, to put it in the words of Jerry Brotton, in a study of the Silk Road, 'Whose Renaissance is it, anyway?' Rather than exclusively on Europe, he notes, historians should be focusing on 'an amorphous Europe and the societies to its east'. After all, he goes on, Europe defined itself in terms of its eastern neighbours.[14] Jack Goody, considering 'Renaissances', focuses on the dilemma of 'the one or the many'. He cautions against attributing too much innovation to the European version, in view of the Arab role in transmitting the heritage of Classical Antiquity, and the Chinese role in technological advancement.[15] Viewing the problem in the broadest perspective, he suggests, all cultures where writing exists may evidence rebirth-like symptoms from time to time, simply because the preservation of the past permits certain kinds of reflexivity and reflectivity not possible in illiterate cultures.

European enlargement, including the various steps in this advance, has added new concerns about a European identity, and formulations of the problem in relation to Renaissance studies have been carried out on a vast scale. One, funded by the European Science Foundation with the title 'hidden unities shaping a common European past', asks whether

12 Faruk Tabak, *The Waning of the Mediterranean, 1550–1870: A Geohistorical Approach* (Baltimore: Johns Hopkins University Press, 2010).

13 Davide Scruzzi, *Eine Stadt denkt sich die Welt: Wahrnehmung geographischer Raüme und Globalisierung in Venedig von 1490 bis um 1600* (Berlin: Akademie Verlag GmbH, 2010), p. ix.

14 Jerry Brotton, *The Renaissance Bazaar: from the Silk Road to Michelangelo* (Oxford: Oxford University Press, 2002), p. 33.

15 Jack Goody, *Renaissances: the One or the Many?* (Cambridge: Cambridge University Press, 2010), pp. 7–42.

'European culture from 1400 to 1700 contained expressions of hidden cohesion against a background of intense conflict'. The answer, as one might expect, is, 'yes'.[16] The problem of collective identity in a regime of expansion and consolidation has attracted work focusing on the cultural contexts of the world's first globalization, viewed as having taken place in the Renaissance. Hence the interest in, for instance, the portrayal of the constructed 'other' in travel writing, drama, and so forth.[17] The various contributions to the project investigate religion as a medium of cultural exchange (István György Tóth and Heinz Schilling and others), cities as places of cultural exchange (Donatella Calabi and Stephen Turk Christensen and others), and the emergence of structures of communication as a factor in cultural exchange (Florike Egmond and Francisco Bethencourt, et al.).[18]

If we can hardly set aside our political aspirations when viewing the age that invented politics, we are not alone. The field has always been particularly influenced by the current climate in politics and society at large. To the cases of Michelet and Burckhardt, and their respective milieux, might be added Hans Baron, inspired, in drawing attention to the advent of civic humanism, by the democratic dreams of the Weimar period in Germany. The promise of democratic government has been a running theme, and was especially so in American contributions during the Cold War. The Venetian

16 Comment by Eric Dursteler in his review in *Renaissance Quarterly* 61 (2008): 947–50.
17 Emily C. Bartels, *Speaking of the Moor: from Alcazar to Othello* (Philadelphia: University of Pennsylvania Press, 2008); but see the comments on the genre by Ayanna Thompson in *Renaissance Quarterly* 62 (2009): 312–13; I am also thinking of Helen Ostovich, Mary V. Silcox, and Graham Roebuck, eds, *The Mysterious and the Foreign in Early Modern England* (Newark: University of Delaware Press, 2008).
18 The series 'Cultural Exchange in Early Modern Europe' is edited by Robert Muchembled and William Monter, and includes: István György Tóth and Heinz Schilling, eds, *Religion and Cultural Exchange in Europe, 1400–1700* (Cambridge: Cambridge University Press, 2006); Donatella Calabi and Stephen Turk Christensen, eds, *Cities and Cultural Exchange in Europe, 1400–1700* (Cambridge: Cambridge University Press, 2007); Florike Egmond and Francisco Bethencourt, eds, *Correspondence and Cultural Exchange in Europe, 1400–1700* (Cambridge: Cambridge University Press, 2007); Herman Roodenburg, ed., *Forging European Identities, 1400–1700* (Cambridge: Cambridge University Press, 2007).

or Florentine republics have been viewed inevitably with current political stereotypes in mind, occasionally with some resistance, so John Pocock's 1970s synthesis of the prevailing view regarding the Florentine roots of American culture was branded by the Italian scholar Cesare Vasoli as a 'grand ideological synthesis'.[19] In Italy, by contrast, especially during the 'Iron Years' of strife, sometimes violent, from the extremist left and right, Renaissance oligarchy was occasionally seen against the backdrop of what was conceived as the proto-collectivism of the Medieval communes. The post-Soviet age has added several new dimensions to Renaissance studies. We now have perspectives on Shakespeare in Russia after the lifting of the ban in 1954.[20] Meanwhile, a veritable outpouring of work has come from Polish universities, and off Polish presses, adding yet another obligatory language to the polyglot tool bag of the Renaissance expert.[21]

Ireland offers a highly interesting case of the Renaissance significance of political emancipation. Independence encouraged one scholarly trend suggesting Irish aloofness from such Renaissance developments as might smack too much of colonialism. Daniel Corkery, writing in 1930, noted, 'whatever of the Renaissance came to Ireland met a culture so ancient, widely based and well-articulated that it was received only on sufferance ...'.[22] In other words, Ireland achieved a Renaissance without the Renaissance.

19 Cesare Vasoli, 'The Machiavellian Moment: A Grand Ideological Synthesis', *The Journal of Modern History* 49 (1977): 661–70.

20 Zdenek Stříbrný, *Shakespeare and Eastern Europe*, Oxford Shakespeare Topics (Oxford: Oxford University Press, 2000).

21 Róża Ciesielska-Musameh, Anna Trębska-Kerntopf, *Odrodzenie: podręcznik do nauki historii literatury polskiej dla Polonii i cudzoziemców* (Lublin: Wydawnictwo Uniwersytetu Marii Curie-Skłodowskiej, 2000); Tadeusz Ulewicz, *Iter Romano-Italicum Polonorum, czyli, O związkach umysłowo-kulturalnych Polski z Włochami w wiekach średnich i renesansie* (Kraków: Universitas, 1999). This is not to disparage in any way the growing literature on Poland in other languages, such as Hans-Jürgen Bömelburg, *Frühneuzeitliche Nationen im östlichen Europa: das polnische Geschichtsdenken und die Reichweite einer humanistischen Nationalgeschichte (1500–1700)* (Wiesbaden: Harrassowitz, 2006).

22 Daniel Corkery, *The Hidden Ireland: A Study of Gaelic Munster in the Eighteenth Century* (Dublin: M.H. Gill 1924), p. 149.

His conclusions have inspired waves of local historiography and possibly even dramatic productions by Brian Friel and others, although they have not met with universal consensus among scholars. More recently, the various stages in EU membership encouraged a broad questioning of prevailing categories. After the 1970s came a shift to cosmopolitan models of cultural development and the focus began to move more toward investigations placing emphasis on tradition and innovation.[23] A new trend seeks out Irish contributions to arts and letters in a time, between the sixteenth and early seventeenth centuries, when English hegemony was still in doubt.

Women's emancipation in particular has taken on a Renaissance aspect, but this did not happen all at once. To Joan Kelly's famous question, 'Did Women Have a Renaissance?', as the summer of 1970s feminism heated up, the answer was for a long time a resolute no. 'There was no Renaissance for women', she stated, because, by definition, 'events that further the historical development of men, liberating them from natural, social, or ideological constraints, have quite different, even opposite, effects upon women'.[24] Subsequent work has agreed that 'one of the tasks of women's history is to call into question accepted schemes of periodization'. However, women's studies departments appear to have found 'Renaissance' to be a useful category of historical analysis; and to Joan Kelly's question, the answer 'maybe' prevails, at least at the level of studies on high culture: women poets, dramatists, polemicists, and their audiences, have been rediscovered inside and outside the court and convent, with easily accessible editions of their works, and a new field has emerged.[25]

23 *The Celts and the Renaissance: Tradition and Innovation: Proceedings of the Eighth International Congress of Celtic Studies 1987 held at Swansea, 19–24 July 1987* (Cardiff: University of Wales Press, 1990); Steven G. Ellis, 'Historiographical Debate: Representations of the Past in Ireland: Whose Past and Whose Present', *Irish Historical Studies* 27 (1991): 289–308; for the recent trend see especially Thomas Herron, intro. to *Ireland in the Renaissance*, ed. Thomas Herron and Michael Potterton (Dublin: Four Courts Press, 2007), pp. 19–42.

24 *Becoming Visible: Women in European History*, edited by Renate Bridenthal and Claudia Koonz (Boston: Houghton Mifflin Co, 1977), p. 137.

25 Especially Elissa B. Weaver, *Scenes from Italian Convent Life: an Anthology of Convent Theatrical Texts and Contexts* (Ravenna: Longo, 2009); Eadem, *Convent Theatre in*

The Harvard chair of gay and lesbian studies, endowed in 2009 to foster 'progress toward a more inclusive society', was titled to the early twentieth-century scholar F.O. Matthiessen, whose work was instrumental in creating the category of 'American Renaissance', although he did not work on the early modern period; and at time of writing, no chair holder of any chronological orientation has yet been named.[26] Meanwhile, 'Queer Renaissance' studies more than compensate for Michel Foucault's curious omission of the period in his study of sexuality. The mission mainstreams the 1970s cultural revolution's scholarly as well as social programme of placing the development of particular sexualities at the centre of larger histories. To be sure, some contributions dispense with history altogether, in favour of a less discipline-centred, indeed, less disciplined, outlook. 'We want to combat the restrictions of a historicist approach in our engagement with Renaissance materials', says Stephen Guy-Bray; 'restrictions that show up in the by-now ritualized statements that "of course there was no homosexuality back then" and "it is wrong to speak of sexual identity back then."'[27] On the other hand, Will Fisher suggests that Renaissance studies, when first consolidated in the nineteenth century, were 'imagined as a queer terrain'.[28]

An account of external pressures on the content of Renaissance scholarship could scarcely omit the digital revolution; and now there is such widespread interest in the 'Digital Renaissance' that an entire day at the Montreal meeting of the Renaissance Society in 2011 was dedicated to this theme. The use of machine-readable data goes back as far as the 1960s, and

Early Modern Italy: Spiritual Fun and Learning for Women (Cambridge: Cambridge University Press, 2002).

26 In the words of Harvard Overseer Mitchell L. Adams, in *Harvard Gazette*, 4 June 2009. In addition, Tracy Jan, 'Harvard to Endow Professorship in Gay Studies', *Boston Globe*, 3 June 2009.

27 Vincent Joseph Nardizzi, Stephen Guy-Bray, Will Stockton, in the title essay of the volume edited by them, *Queer Renaissance Historiography: Backward Gaze* (Farnham, Surrey: Ashgate Publishing, Ltd., 2009), p. 1.

28 Will Fisher, 'A Hundred Years of Queering the Renaissance', in *Queer Renaissance Historiography*, p. 15.

projects such as David Herlihy and Christiane Klapisch-Zuber's study of the Florentine Catasto of 1427, and Anthony Molho and Julius Kirshner's study of the Florentine Dowry fund of 1425.[29] Price series, wage comparisons and the like have been the staple of economic historians since the advent of humanities computing: see Richard Goldthwaite. In the late 1980s Sam Cohn did statistical analyses of Tuscan wills drawn up between 1250 and 1800, according to economic, social and geographical criteria. The closed-silo approach to data management has given way, in many quarters, to open access and open data, and Evelyn Welch and Michelle O'Malley and their team elaborated the method and made the database 'The Material Renaissance: Cost and Consumption in Italy, 1300–1640' available to any interested researcher.[30] The Medici Archive Project has taken the next step, to crowd-sourcing information regarding digitized images they are adding to their corpus of Medici Archive documents.[31]

The digital revolution has emancipated Renaissance studies in more ways than one. Already in the 1960s, the wide availability of microfilm copies of documents changed demographics in the archives: researchers were no longer sons and daughters of local families or else returning ex-servicemen who had been in the country twenty years before. They were anybody who could afford to spend a few weeks dealing with archivists and photographers. Now the number of those able to consult the vast amounts of material being thrown into the public viewing space is potentially defined only by the availability of a computer and a lifetime of study in the relevant ancient and modern languages.

29 David Herlihy and Christiane Klapisch-Zuber, *Les Toscans et leurs familles: une étude du 'catasto' florentin de 1427* (Paris: Fondation nationale des sciences politiques: École des hautes études en sciences sociales, 1978), trimmed and translated by Lydia Cochrane as *Tuscans and their Families: a Study of the Florentine Catasto of 1427* (New Haven: Yale University Press, 1985); and note also Julius Kirshner and Anthony Molho, 'The Dowry Fund and the Marriage Market in Early Quattrocento Florence', *The Journal of Modern History* 50 (1978): 404–38.

30 Research outputs include: Michelle O'Malley and Evelyn Welch, eds, *The Material Renaissance* (Manchester: Manchester University Press, 2007).

31 See <http://www.medici.org>.

How much Renaissance Studies has given back to the contexts, economic, social, cultural, upon which it has drawn, is impossible to say with any accuracy. To our contemporary world, it has given back insights about the conditions of artistic and intellectual creativity, the psychology of power, the conditions for advancement, the consequences of prejudice and oppression, the capabilities of the state, the human capacity for achievement, the need for resiliency in the face of threat, the capacities of Europe and the roots of Europe's common destiny, the relative dimensions of Church and State, as well as the hazards of European disunity, the hazards of prejudice and hatreds, the potentialities of mutual incomprehension, and much else. This book intends to deepen these perspectives on the role of Renaissance studies and add still more.

William H. McNeill, a historian with a penchant for the paradoxical, once defined the historian's job as 'the care and repair of public myth'. The quote deserves to be framed within the original 1982 article in *Foreign Affairs*, where he goes on, 'Myth lies at the basis of human society: that is because myths are general statements about the world and its parts, and in particular, about nations and other human in-groups that are believed to be true and then acted on whenever circumstances suggest or require common response.'[32] In other words, when the going gets rough, the myths get going: myths about who 'we' are as a culture, where we came from, where we want to be. To put the matter somewhat differently, McNeill thinks that the past provides us with the perspective guiding our vision of things, and when these visions are broken historians can help fix them. The Renaissance period has surely provided a rich store of myths from time to time. If the period we are now traversing seems sorely in need of new visions, new perspectives, new myths, can the Renaissance come to the rescue?

But it is time to turn the figurative podium over to our contributors, including those to whom reference has already been made.

32 William H. McNeill, 'The Care and Repair of Public Myth', *Foreign Affairs* 62 (1982): 1; the essay is reprinted in *Mythistory and Other Essays* (Chicago: University of Chicago Press, 1986), pp. 23–42.

Sheila Barker leads off, by returning to Burckhardt's concept of the state as a work of art among other works of art. The great Renaissance productions continue to inspire: but what, after all, are we looking at? The duelling frescoes in the Council Room of the Palazzo Vecchio in Florence, on the one side Leonardo's *Battle of Anghiari*, on the other, Michelangelo's *Battle of Cascina*, have long been regarded as one of the defining stylistic moments of Renaissance public artwork, even though one was later painted over and the other was never finished. In a brilliant exercise of historical detective work, Barker shows the Michelangelo was not about its supposed theme at all. Rather than a moment of inactivity during the battle of Cascina, an eventually victorious fourteenth-century conflict of Florence against Pisa, it actually represents a moment in the much less battle of Garigliano of 1503, between France and Spain, where Piero de' Medici, on the side of France, confirmed the shortcomings as a leader that had previously led to his exile from Florence in 1494, and drowned ignominiously in the Garigliano river during a chaotic retreat. The work is thus a snide allusion to the defeat of Medici tyranny, and by extension, a confirmation of the Florentine republic's anti-Medici legitimacy. Pointing darkly to Piero's watery end by way of a faceless figure being sucked under the current, the painting was not a commemoration but a defamation, designed to efface the memory of its target. And yet, over time, the shredded cartoon of the proposed fresco was itself effaced, so that traces remain only in the copies by Aristotile de Sangallo and others who saw it, and in the minds of contemporaries who set down their views.

Nicola Gardini ponders the theme of creativity amid thoughts of death that seems to run through Renaissance culture – not surprisingly, considering that the period is situated (he suggests) between the reformulation and deconstruction of Classical antiquity, and the recomposition and destruction of the Renaissance states in the Italian wars. Themes of unity and dismemberment occur here and there throughout the literature, sometimes influenced by Platonic philosophy, which found true dialectic in the oscillation between oneness and multiplicity. The myth of Osiris, the Egyptian river god dismembered by a rival and reassembled by Isis the devoted wife, reintroduced into Renaissance culture by the 1472 translation

of Plutarch's account, provided a powerful metaphor for controlling fears of disintegration.

Heinrich Lang points to elite consumption of objects for visual display as a key feature of Renaissance economics that left an enduring impact on global culture. This visuality, driven by, and in its turn driving, the development of new trade patterns, rather than any particular style, was the leading feature of the emerging economic structure of the Renaissance. In good times and in bad, the finest silks and other luxury products always found a market. The pattern, he suggests, is recurring in recent times, when a visually-oriented digitally-enhanced economy of consumption has fuelled an important growth spike, with an important difference. New technology allows consumers to be producers and democratizes the consumption of luxuries. He wonders how this particular pattern may change as growth reverses and economic barriers return, with the 'produsage' economy, as it is now being called, once again becoming an elite phenomenon.

Maximilian Schuh carefully traces the introduction of humanistic texts into the curriculum at the University of Ingolstadt in the fifteenth century, in the light of new evidence regarding the social and economic contexts involving students. In contrast to previous often ideologically-oriented studies, he finds curricular change to have been largely motivated and inspired by efforts to accommodate the supply of instruction to a changing demand. As career opportunities opened up in the growing bureaucracies, the most sought-after courses tended to be those which emphasized rhetorical and writing skills. Then as now, change was met with complaints about decline and insinuations about succumbing to the Zeitgeist; but curriculum change permitted the university to continue its dynamic role not only in the realm of ideas but also in the society at large.

Thomas F. Earle shows how Luis de Camões' *Os Lusiadas*, the epic of Vasco da Gama's voyage to India published in 1572, has furnished material to critics belonging to opposite ends of the political spectrum. He prefers a reading that takes full account of the strategic juxtapositions: human versus mythological, physical versus spiritual love, glory and disaster, as well as the parallel but contrasting stories united by a single element, such as the death of the 'dama delicada' Inês de Castro and the deaths of the Moorish invaders of Portugal, all killed by king Alfonso IV. In the major portion of

the poem, dedicated to da Gama, a key speech by Adamastor, the giant of the South, da Gama's nemesis, later transformed into the Cape of Good Hope, delivers contrasting themes: amazement at the explorers' daring as well as outrage at their destructiveness. Whether pride in national identity or the evils of colonialism, or whatever particular interpretation a given critical line, current or obsolete, might suggest, are more in evidence here, is beside the point, as the poet's method is to leave contradictory meanings latent in a poem that attempts to mirror the complexity of life.

Tom Conley takes us deep into Montaigne's Book III, third *Essay*, ostensibly concerned with the author's three associations – with friends, women and books – but actually exposing layer upon layer of self-reflection shedding valuable light on Montaigne's interaction with the external world as well as with the internal one. The essay is filled out in the Bordeaux text with long handwritten additions, later incorporated into the 1599 posthumous edition of the work, referring to Montaigne's tower and his study within it. The physical place and space of writing thus remind the writer and the reader about the ways in which experience is mediated by point of view, an element of self-reflection about the writer's art that challenges our effort to create distance between Renaissance and modernity, while at the same time reopening the question of where Montaigne stands in relation to the 'age classique' theorized by Foucault.

David Edwards addresses another form of ego document in his contribution concerning the English viceroys of Ireland: namely, the elaboration of official service journals with an eye to displaying the qualities of good rulership. As the ethos of Elizabethan officialdom began to shift emphasis to a notion of authority as a duty rather than merely as a right, office holders sought new ways of accounting for activities abroad. Long periods of actual indolence and distraction had to be obfuscated by a focus on plausible bursts of activity. The military aspect, of course, would predominate: 'victorious' campaigns of 'subjugation' and 'reduction to allegiance' sounded well among the courtiers likely to read the reports. Nor was there much need, in those busy rebellious times, to invent actions – only to embellish them; which the writers did, utilizing all the rhetorical flourishes that a smattering of Classical readings, not excluding Caesar's Gallic Wars, might offer to their creative muse.

José Montero Reguera reminds us that Miguel de Cervantes, whose reputation as a stylistic and intellectual innovator continues to benefit, within the wider world of criticism, from being featured in this sense by Michel Foucault, was pre-eminently a Renaissance figure. Although in some ways a herald of modernity, Montero argues, he fits more comfortably in the environment of Charles V than in that of Philip II, bordering on the Counter Reformation. Indeed, a deeper understanding of Cervantes within his context encourages a new appreciation of the sheer inventiveness possible within Renaissance culture.

Chris Barrett takes the cue from recent insights regarding space cognition to re-examine John Milton's 'poetics of navigation' in *Paradise Lost*. The poem, she notes, reminds us that advances in maps are often connected to advancing a pedagogical as well as a geographical agenda. Satan, the bad navigator, the angel with a directional deficiency, inevitably fails. Adam succeeds, as soon as he begins to understand how to 'read' the map of the world – not simply as an observer, but as an ethical person engaged in acting virtuously. Cartographic literacy is a metaphor for intelligent literary readership, but also a reminder of the darker side of maps: rooted in technological developments that have as often been enlisted for disciplining and doing violence as for doing good.

Brendan Dooley addresses the twin themes of freedom and restraint in the distribution of knowledge. The mechanical reproduction of books imposed a significant challenge in respect to practices matching certain kinds of cognition to certain levels of society. In Florence, demonic magic was particularly sensitive, not only because of the ecclesiastical prohibitions but because of the powers supposedly conferred. Occasional exemplary punishments reinforced the boundaries between what was allowed to whom, and on what grounds. The chapter focuses on the contrasting experiences of Don Giovanni, a Medici prince whose involvement in magical investigations and activities was overlooked, and Benedetto Blanis, his librarian and sorcerer, who suffered after losing Don Giovanni's patronage. Then as now, the benefits of controlling the distribution of knowledge, from the standpoint of those able to operate such controls, could outweigh the benefits of open availability. In a way, Dooley's other contribution, regarding the

'Digital Renaissance', pushes the communications theme into yet another, technology-enabled dimension.

Federico Barbierato, rather than evoking our estrangement from the time of the Renaissance, seeks out familiarity, at least in the realm of religious thought and feeling. Contrary to earlier readings by Lucien Febvre, Jean Delumeau and others, he suggests that rational atheism was not only possible but widespread at the popular level. Focusing on seventeenth-century Venice, he suggests that people knew what they believed and what they did not believe, and many of them did not believe Christianity. Interrogating early modern people about their beliefs, thoughts and feelings, whether serious, whimsical or deliberately obfuscating, still remains as problematical as Roland Barthes found it, when characterizing a voyage into the sixteenth-century psyche. Caution is clearly in order before taking at face value the testimonies of those questioned by the Inquisition and other official bodies (or the 'patients' as some were called in the quaint terminology applied to persons under torture). Perhaps a careful handling of evidence will determine that such an approach succeeds in dissolving 'the cumbersome categories of the history of ideas and philosophy, demonstrating their limited use in grasping the transience, agility, rapidity and violence of the positions embodied in real people'. In the meantime, Barbierato adds numerous cases of unorthodoxy to the celebrated ones already illuminated by Carlo Ginzburg.

Paul R. Wright, on the other hand, explores Jacob Burckhardt's deep suspicions about historicism's presentist bias, i.e., its tendency to seek the laws of history in contemporary experience. At the same time, Burckhardt himself could not prevent elements of his own deep uneasiness about the post-1848 world of media-saturated populism from colouring his alternative vision, in the *Civilization of the Renaissance*, of elite individual action leading to modernity. He ends with a reflection on Graham Greene's post-WWII novel and screenplay *The Third Man*, with the famous Renaissance remark reputedly improvised during screening by Orson Welles, emphasizing the vision of progress amid violence, to show how the Renaissance has been 'a powerful touchstone for processing European crisis' and is likely to be so again.

Was there a Renaissance of science? Herbert Butterfield didn't think so.[33] But subsequent work, taken into account and extended here by Joseph S. Freedman, has pointed to the Renaissance roots of the so-called 'scientific method'. Already a half-century before Descartes and decades before Francis Bacon, Jacopo Zabarella attempted to formulate rules for a hypothetico-deductive model of great future significance, and such a model was elaborated in the first self-proclaimed *methodus scientifica* by Joannes Bellarinus in 1606. The notion that the hypothetico-deductive model applied mostly to natural knowledge Freedman identifies as a nineteenth-century development, defied, he adds, in current elementary school teaching, which attends to applications across the disciplines. In the latter context, children, whether they know it or not, engage in an authentic practice of Renaissance Now!

The accounts of these contributions have been far too schematic; better to let our contributors speak for themselves. And if the object of our study seems to defy simple characterizations, to resist gross generalizations, to thwart methodological agreement, such is the consequence of engaging a wide and diverse scholarly community devoted to elucidating, utilizing, even exploiting concept and content. And perhaps the wealth of meanings we have drawn from an increasing volume of materials is at least one reason for our object's enduring allure.

33 Herbert Butterfield, *The Origins of Modern Science* (London: Bell, 1949), p. viii.

SHEILA BARKER

1 The Drowning Man in Michelangelo's *Battle of Cascina*

Though Jacob Burckhardt may not have intended it this way, his famous comparison between Renaissance Italian statecraft and a work of art ('Der Staat als Kunstwerk') reflects the way states exploit visual imagery to articulate, popularize and enforce their political agendas. A striking example of this phenomenon is offered by a government at the focus of Burckhardt's study, the Florentine Republic, and a lost artwork now known only though copies (Figure 1), Michelangelo's cartoon for the *Battle of Cascina*.[1] This cartoon was the monumental preparatory chalk drawing, over 116 square metres in size, for a mural, never undertaken, in the Hall of the Great Council in the Palazzo della Signoria, commissioned in 1504 at the direction of Piero Soderini, *gonfaloniere*-for-life of the Florentine Republic.[2] Its arresting imagery as well as its genesis and destruction are all implicated by the volatile politics of an imperilled Renaissance state.

1 The copy universally considered to be closest to Michelangelo's cartoon is the Holkam Hall painting attributed to Aristotile da Sangallo. Michelangelo's original studies for the cartoon survive, including the compositional drawing at the Gabinetto degli Stampi e Disegni in Florence catalogued as Uffizi 613E (black, partly over stylus, 23.5 × 35.6 cm), and the sheet with Studies for the Battle of Cascina and the Bruges Madonna at the British Museum in London (black chalk and pen and ink over lead-point, 31.5 × 27.8 cm). On these and other related drawings, see Michael Hirst, *Michelangelo and His Drawings* (New Haven and London: Yale University Press, 1988), 42–5.

2 On the size of the cartoon, see Carmen Bambach, 'The Purchases of Cartoon Paper for Leonardo's *Battle of Anghiari* and Michelangelo's *Battle of Cascina*', *I Tatti Studies: Essays in the Renaissance* 8 (1999), 126 and app. I, doc. VI.

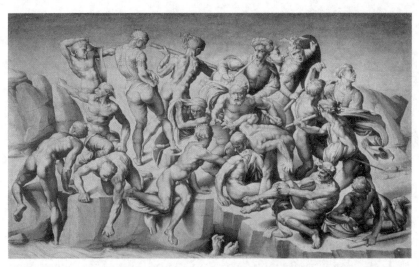

Figure 1: attr. Aristotele da Sangallo, ca. 1542, copy after Michelangelo's lost *Battle of Cascina* (1504–1505), oil on panel, 77 × 130 cm, Holkham Hall, Collection of the Earl of Leicester.

Previous studies have shown that the decision to have Michelangelo represent the Battle of Cascina – a clash that took place in 1378 between Pisa's mercenary army and the Florentine militia – was determined by Soderini's goal of mustering support among members of the Great Council for the current military campaign against Pisa.[3] This war to regain Pisa, now mostly fired by financial speculation, had been instigated years earlier

3 The theory was first advanced in Johannes Wilde, 'The Hall of the Great Council of Florence', *Journal of the Warburg and Courtauld Institutes* 8 (1944): 65–81, esp. 80. It has been echoed in some way by nearly every successive art historian (for exceptions, see n. 12 below). The most intense pursuit of this theory so far is Alessandro Cecchi, 'Niccolò Machiavelli o Marcello Virgilio Adriani? Sul programma e l'assetto compositivo delle "Battaglie" di Leonardo e Michelangelo per la Sala del Maggior Concilio in palazzo Vecchio', *Prospettiva* 83–84 (July–October 1996): 102–15. Advancing the theory that all the artworks in the room refer to the Florentine Guelf party history and identity, Cecchi, *ibid.*, 109, makes much of the fact that Soderini had been a Guelph captain since 1491.

by a Grand Council then under the sway of Savonarolan Piagnoni and their religious propaganda in favour of an imperialist holy war.[4] In recent times, though, the Pisan offensive had been relegated to a low priority so that the eastern Florentine territories could be defended from the attacks being launched by Piero de' Medici's and Cesare Borgia's armies.[5] This latter threat disintegrated following the death of the Borgia pope in August of 1503. Soon afterwards, in the autumn of 1503, Soderini began earnestly pushing for a reprisal of the Pisan war.[6]

Coinciding closely with this new aggression in the west, Soderini commissioned the first battle mural, *The Battle of Anghiari*, from Leonardo da Vinci in October of 1503.[7] Michelangelo was commissioned to make a pendant battle mural shortly before 22 September 1504.[8] As suggested

4 See Lorenzo Polizzotto, *The Elect Nation. The Savonarolan Movement in Florence 1494–1545* (Oxford: Clarendon Press, 1994) 23, 226–7 and *passim*; and Humfrey Butters, *Governors and Government in Early Sixteenth-Century Florence, 1502–1509* (Oxford: Clarendon Press, 1985), 83–114. Both the Soderini family and the Capponi family had strong financial stakes in the current Pisan war; see John Spike, *The Young Michelangelo: The Path to the Sistine. A Biography* (London: Duckworth, 2011), 160.

5 Polizzotto, *Elect Nation*, 226.

6 Robert Carlucci, 'The Visual Arts in the Government of Piero Soderini during the Florentine Republic' (PhD dissertation, Columbia University, 1994), 446.

7 Wilde, 'Hall of the Great Council', 79; Carlucci, 'The Visual Arts', 364; Nicolai Rubinstein, *Palazzo Vecchio, 1298–1532: Government, Architecture, and Imagery in the Civic Palace of the Florentine Republic* (Oxford: Clarendon Press, 1995), 4; and James Carlton Hughes, 'Politics, Religion, and the Lost Michelangelo' (Chapel Hill, NC, Univ. of North Carolina, Diss., 2004), 33.

8 On the chronology of the commission, see the fundamental historical source, Giorgio Vasari, *Le vite de' più eccellenti architetti, pittori, et scultori italiani, da Cimabue, insino a' tempi nostri. Nel edizione per i tipi di Lorenzo Torrentino, Firenze 1550*, ed. Luciano Bellosi and Aldo Rossi, intro. Giovanni Previtali, 2 vols (Turin: Einaudi, 1986), 2:888. More generally, Alfredo Lensi, *Palazzo Vecchio* (Milan: Bestetti e Tumminelli, 1929), 99–104; and Wilde, 'Hall of the Great Council', 78–9. With reference to new documentation, Luisa Morozzi, '*La Battaglia di Cascina* di Michelangelo: Nuova ipotesi sulla data di commissione', *Prospettiva* 53–56 (1988–89); 320–4; and Bambach, 'The Purchases', 105–33. Most recently: Michael Hirst, *Michelangelo: the Achievement of Fame*, 1475–1534 (New Haven and London: Yale University Press, 2011), 58–61; and Spike, *The Young Michelangelo*, 159–63.

by Johannes Wilde, Soderini probably chose the 1440 Battle of Anghiari and the 1364 Battle of Cascina because of their loose geographic resonance with his own military campaigns, respectively his defence of the Casentino against Piero de' Medici, and the ongoing war against Pisa.[9]

Despite its relevance to Soderini's contemporary warmongering, *The Battle of Cascina* does not depict the violent contest between Pisans and Florentines that is indicated by its title, for there is no fighting to be seen here, not even an apparent enemy.[10] Addressing this incongruity between imagery and title, Vasari explained in his 1550 *Lives of the Artists* that the cartoon represents the Florentine army dressing after having been roused by a false alarm as they were bathing in the Arno.[11] Vasari's synthesis loosely fol-

The choice of Michelangelo to make this mural is not perhaps as obvious as it might seem at first. He had had no fresco commissions to date, and he had even possibly been working for Piero de' Medici when the latter was exiled; on the probable cover-up of Piero's commission of the early *Hercules* from him, see Maria Ruvoldt, 'Michelangelo's Slaves and the Gift of Liberty', *Renaissance Quarterly* 65 (2012), 1037. Perhaps by hiring Michelangelo, Soderini was making a statement about the 'repentance' of former Mediceans to the cause of the Republic. After all, Leonardo had also been lured away from the enemy, in this case Cesare Borgia, in order to execute a mural for the Hall.

9 Wilde, 'Hall of the Great Council', 80. Cf. Frederick Hartt, 'Leonardo and the Second Florentine Republic', *Journal of the Walters Art Gallery* 44 (1986), 109; Carlucci, 'The Visual Arts', 391–2, 446; Rubinstein, *Palazzo Vecchio* 74; Nicolai Rubinstein, 'Machiavelli and the Mural Decoration of the Hall of the great Council in Florence', in *Musagetes: Festschrift für Wolfram Prinz* (Berlin: Mann, 1991): 275–85); and Cecchi, 'Niccolò Macchiavelli', 103–4. The battle standards of Anghiari were kept at the office of the *gonfaloniere* since 1442, and thus the battle also was associated with Soderini's office (Rubinstein, 'Machiavelli', 282 n.41; and Cecchi 'Niccolò Machiavelli', 104).

10 A related drawing in the British Museum, London, shows soldiers mounted on horseback, but according to most scholars this is an apocryphal addition that did not appear on Michelangelo's original cartoon. Various theories about the reason these cavalry were added to the London drawing can be found in Michael Hirst, 'I disegni di Michelangelo per la Battaglia di Cascina (ca. 1504)' in *Tecnica e stile: Esempi di pittura murale del Rinascimento italiano*, ed. Eve Borsook and Fiorella Superbi Gioffredi (Milan: Silvana, 1986), 43–58; cf. Hirst, *Michelangelo*, 59–60.

11 Vasari, *Le vite [...] 1550*, 2: 888: '[...] quivi cominciò un grandissimo cartone [...] E lo empié di ignudi che bagnandosi per lo caldo nel fiume d' Arno, in quello stante

lows the Villani family account and the more detailed account in Leonardo Bruni's 1442 *History of the Florentine People*, where it is recounted that the Pisans repeatedly startled the Florentines with false alarms to weary them and dull their reactivity before launching a real attack on their camp.[12]

While Vasari's solution is generally plausible with regard to the imagery in Michelangelo's cartoon, it solution raises thorny problems about the suitability of such a subject. First there is the issue of behavioural decorum: Why did Soderini countenance Michelangelo's scene of half-naked loitering soldiers for the Florentine Republic's sacrosanct assembly room? Then, there is the question of artistic decorum: How is Michelangelo's non-conflictual theme a fitting pendant to the mural that Soderini had commissioned for the Hall the previous year, Leonardo da Vinci's *Battle of Anghiari*, a hair-raising image of savage hand-to-hand combat?

Previous studies have largely skirted these puzzling questions, and the inappropriateness of Michelangelo's imagery has been explained away by invoking an artist's licence to pursue personal aesthetic whims, without

si dava a l'arme nel campo fingengendo che li inimici li assalissero; e mentre che fuor dell'acque uscivano per vestirsi i soldati, si vedeva dalle divine mani di Michele Agnolo disegnato chi tirava su uno, e chi calzandosi affrettava lo armarsi per dare aiuto a' compagni; altri affibiarsi la corazza, e molti mettersi altre armi indosso, et infiniti, combattendo a cavallo, cominciare la zuffa.' It is unclear from the remaining copies and autograph sketches precisely how 'infinite [soldiers], fighting on horseback, starting the battle' noted by Vasari would have related to the main scene of bathers; if both were to have been in the same composition, the scene of fighting was probably much smaller and meant to be understood in the distance and taking place in a future moment with respect to the soldiers dressing on the riverbank. For considerations of this problem based on historical drawings, see n. 10 above.

12 Cecchi, 'Niccolò Machiavelli'. The original sources are Giovanni Villani, Matteo Villani, and Filippo Villani, *Cronache storiche di Giovanni, Matteo e Filippo Villani: A miglior lezione ridotte coll' aiuto dei testi a penna*, ed. Ignazio Moutier and Francesco Gherardi Dragomanni, 7 vols (Milan: Borroni e Scotti, 1848) 6: 493–7 (bk. 11, par. 97); and Leonardo Bruni, *Historiarum Fiorentinarum libri xii* [1442] (Strassburg: Lazarus Zetzner, 1610), 176 (bk. 8). Vasari and Michelangelo may have consulted the 1473 Italian translation of Bruni's work by Donato Acciaiuoli, a copy of which was kept by Soderini at the Palazzo della Signoria (see e.g., *Istoria fiorentina*, tr. Donato Acciaiuoli (Florence: Felice Le Monnier, 1861), 438.

regard to the patron or the work's purpose.[13] By contrast, it will be argued here that Michelangelo's perplexingly ignoble subject was contrived to hide in plain view an entirely different battle than that to which the title refers, and that this tacit allusion was meant – just like the other artworks commissioned for the Hall and the display there of Medici *spolia* – to demonstrate the demise of Medici tyranny.

An important clue to the 'hidden' subject of *The Battle of Cascina* is found in the striking but unstudied foreground detail of a drowning man. Contemporaries would have seen in this otherwise inexplicable detail an arresting allusion to the recent drowning of Piero de' Medici in the Garigliano River in the winter of 1503, a momentous tragedy which brought to pass Savonarola's famous prophecy that Piero would never again rule Florence or return to the city.[14]

The Dominican preacher had foreseen Piero's misfortune nearly a decade earlier, after the Florentine *Signoria* had condemned him to exile on 9 November 1494, for having rendered Pisa, Livorno, and a half-dozen

13 Writing in the midst of the heyday of Formalism, Cecil Gould, *Michelangelo. Battle of Cascina* (Newcastle-upon-Tyne: University of Newcastle-upon-Tyne, 1966), 3, 19, n. 5, argued that Michelangelo depicted the incident of the alarm because it was an opportunity to depict the male nude. Along similar lines, Gould also argued that Leonardo chose the Battle of Anghiari because a cavalry battle allowed him to display his artistic forte, drawing horses. See also Michael Wallace, *Michelangelo, the Artist, the Man, and his Times* (Cambridge: Cambridge University Press, 2010), 63, who agrees that 'Michelangelo's peculiar subject gave him unprecedented scope to exercise his artistic specialty: the male nude in action.' Recently the theory of Michelangelo's aesthetic dictates has been revived and expounded by Joost Keizer, 'Michelangelo, Drawing, and the Subject of Art', *Art Bulletin* 93, n. 3 (Sept. 2011): 304–24, who argues that the young artist 'did away with traditional content and took instead the making of art as [his] subject', an aim which Keizer argues was intended to advance the social struggles of artists. Explanations of Michelangelo's imagery in terms of his personal artistic aims, rather than the patron's requirements and the work's intended function, presume the twenty-nine-year-old artist to have improbably wielded influence over Soderini.

14 On Savonarola's prophecy of Piero de' Medici's death, see Benedetto Luschino, *Vulnera diligentis*, ed. Stefano Dall'Aglio (Florence: Sismel, 2002), 161 (bk. 2, ch. 19, f. 85r), and 367 n. 199.

Florentine fortresses to Charles VIII of France. After two fruitless attempts to re-enter Florence with mercenary armies, Piero launched attacks on the Republic's eastern Casentino territories. He first assailed the Casentino in 1498 at the flank of Guidobaldo da Montefeltro, and returned here in 1502 in league with Cesare Borgia, the son of Pope Alexander VI.[15] The failure of both campaigns followed by Alexander VI's death in August 1503 left Piero exposed and isolated. For protection, he turned to Louis XII of France, joining the doomed French campaign to wrest the Kingdom of Naples from Ferdinand II of Aragon in the autumn of 1503.

The French had entered into this conflict with a twofold advantage over the Spanish: greater numbers and superior heavy artillery.[16] They were entirely unprepared, however, for an unusually brutal autumn of storms, floods, and bitter cold, such that by late 1503, ravaged by hunger, exhaustion, and disease, they were forced to arrest their offensive. Having set up camp on the high, rocky banks of the Garigliano River, they waited for spring as defections and sickness steadily whittled their numbers.[17] It was in this prostrate condition that the French encampments were surprised on 28 December 1503, by a bold Spanish advance known as the Battle of Garigliano.

When advance word reached their camps of the imminent Spanish attack, the French made a rushed and chaotic retreat. Their anaemic cavalry set off immediately for the coastal town of Gaeta. Lagging behind them was the ragtag and shoeless infantry carrying the light artillery. Although the archers had been ordered to remain in the camp in order to cover the infantry's exit, they instead fled for their lives. The sick soldiers in the camp infirmary were abandoned to the mercy of the enemy, but efforts were made to salvage what they could of the heavy artillery: loaded on to nine boats, it was sent down the Garigliano River towards their ships in the harbour, where unbeknownst to the French army a monstrous tempest was brewing.

15 Gaetano Pieraccini, *La Stirpe de' Medici di Cafaggiolo: saggio di ricerche sulla trasmissione ereditaria dei caratteri biologici*, 3 vols (Florence: Nardini, 1986), 1:159–60; cf. Carlucci, 'The Visual Arts', 380.

16 Piero Pieri, *La Battaglia del Garigliano del 1503* (Rome: Luigi Proja, 1938), 69.

17 Pieri, *La Battaglia*, 46–8.

Piero de' Medici, despite his privileged rank, had not departed with the cavalry to safety; inexplicably, he had instead embarked on one of the boats headed to the harbour.[18] Within hours of setting off, he – along with 300 other men – drowned when all nine boats were capsized by storm waves near the mouth of the Garigliano River.[19]

An examination of Michelangelo's cartoon in light of the circumstances of Piero de' Medici's death reveals that numerous aspects of the image correspond more closely to the history of the French defeat at Garigliano than to the Florentine victory at Cascina. Most notably this is the case with the previously mentioned foreground detail of two outstretched hands belonging to a man who has sunk below the water's surface. Though his perilous situation has been recognized by two frantic companions on shore, they are impeded from helping him by obstacles in their paths, and so the viewer grasps the certainty of his watery death. No drowning incidents are mentioned in any of the histories of the battle of Cascina, so it would have been natural for members of the Council instead to associate this terrifying hieroglyph with the famous recent drowning of Florence's exiled former leader, Piero de' Medici.

Facilitating this interpretation is the striking nudity of the soldiers in Michelangelo's composition. Although art historians have tended to see this display of naked bathers as a gratuitous imposition that only served Michelangelo's formal interest in the nude, the unclothed bodies do in fact correspond to the wretched circumstances of the French army in the aftermath of the Battle of Garigliano.[20] Contemporary descriptions of the battle all emphasize that it took place amidst an unusually long spell of stormy and frigid weather for which the French troops were disastrously

18 D'Auton suggested that the men who went down the river with the heavy artillery – including Piero de' Medici – were all sick. Jean d'Auton, *Chroniques de Louis XII* (Paris: Librarie Renouard, 1889–1895), 3: 298–9.

19 Piero's body was recuperated a few days later and buried in the abbey church of Montecassino; see Pieraccini, *La Stirpe*, 161. Much later, in 1531, a wall tomb was commissioned by Clement VII de' Medici from Antonio da Sangallo; this tomb was destroyed in the 1944 airstrikes on the abbey.

20 See note 10 above.

unequipped. During their long encampment, they had been largely cut off from supply lines, and clothing shortages were further exacerbated by losses during flooding. Immediately following the battle, the Florentines received shocking reports of French soldiers wandering nude and hungry through the countryside, trying to reach Rome. The Florentine chronicler Luca Landucci wrote that 'in this cold weather, many French – those who were able – fled from the Kingdom [of Naples], all of them bereft of their possessions and naked.'[21] As reported by Landucci, those soldiers who reached the walls of Rome resorted to murdering the locals in order to steal their food, and in their desperation to stay warm at night, they burrowed into the large mounds of manure and excrement that were located in the extramural dumping grounds; in these infernal places, they often were found dead the next morning. Significantly, Landucci's description of the French fugitives reduced by starvation and nudity to a state of savagery follows almost immediately in his chronicle upon the notice that Piero de' Medici had drowned in the Garigliano – a juxtaposition that recalls the close association of naked soldiers and a drowning man in Michelangelo's mural design.[22]

Another aspect of Michelangelo's image that lends itself to an interpretation in terms of the recent French defeat is the evident straining of the men as they pull on their hose and fasten their buttons. Vasari had sought to explain this extraordinary exertion by proposing that in their great rush, the bathing men had not taken the time to dry themselves, and the dampness of their skin made it hard to put on their clothes.[23] Needless to say, no such details can be found in the histories of the Battle of Cascina, and we are faced with an implausibly banal theme for a monumental public commission: how could Soderini's bellicose agenda have possibly derived lustre from an image of the Florentine militia army challenged by a pair of knickers and unbalanced by a simple shirt? This acrobatic dressing seems

21 Luca Landucci, *Diario fiorentino dal 1450 al 1516*, ed. Iodoco Del Badia (Florence: G.C. Sansoni, 1883), 265: 'E in questi tempi freddi, s'era fuggiti del Reame molti Franciosi, chi aveva potuto, tutti svaligiati e ignudi.'

22 Landucci, *Diario fiorentino*, 265–6.

23 Vasari, *Le vite [...] 1550*, 888.

especially grotesque when compared to Leonardo's *Battle of Anghiari*. In a juxtaposition of the intended pendants, Michelangelo's scene of men struggling with clothing appears as a parody of the furious gyrations and exploding contortions of Leonardo's clashing knights, whose strenuous dynamism evinces the danger and difficulty of their heroic action.

This almost satirical effect produced by the image of soldiers straining as they dress – one which must have chafed some Council members' sense of decorum – disappears when the composition is interpreted as a scene of the French troops whom wintertime diseases had decimated long before the Spanish attacked their camp. Indeed, these diseases were regarded as the chief cause of the French defeat according to both eye-witness Jean d'Auton as well as Florentine statesman Niccolò Machiavelli.[24] The soldiers' difficulty in dressing and readying for battle reflects the feebleness and disease that led to the French army's downfall. Two details particularly lend themselves to this reading: First, a crumpled figure in the centre-right foreground, partly obscured by the men bustling around him, has been paralysed by a morbid lassitude that prevents him from dressing or even holding up his head. The infirmity afflicting the French encampment is perhaps symbolized by another figure, a bearded old man whose head is encircled by ivy. Though Vasari explained the ivy to be a kind of hat to provide shade (in defiance of all common sense), the detail of this widely used medical simple might also be intended to evoke battlefield medicine, that is, a makeshift cure for a sick soldier.[25]

24 D'Auton, *Chroniques*, 3: 298–9; Machiavelli, *I sette libri dell'arte della guerra*, in *Opere di Niccolò Machiavelli, cittadino e segretario fiorentino*, 8 vols ([Florence]: s.n., 1796–99) 4: 285 (bk. 6). For a concurring opinion, Pieri, *La Battaglia*, 69.

25 Vasari, *Le vite [...] 1550*, 888. Ivy was recommended by Pliny the Elder and Dioscorides for headaches and sinus inflammation when applied to the head as a poultice, and for dysentery when ingested. Renaissance-era endorsements include, e.g. *Hortus Sanitatis, vel tractatus de herbis et plantis, de animalibus omnibus et de lapidus* (Strassburg, 1497) bk. 1, chps. 162, 163; Pietro Andrea Mattioli, *Commentarii, in Libros sex Pedacii Dioscoridis Anazarbei, de Materia Medica*, 2: 660–3; Jean Ruel, trans., *Pedaci Dioscorides de Materia medica* (Lyon, 1550; first ed. 1516), 309–10; and Antonio Musa Brasavola, *Examen omnium simplicium medicamentorum quorum in officinis usus est* (Lyon, 1537), 143–4.

As indicated in the opening of this essay, the hidden subject of Michelangelo's cartoon was bound up with the factional politics of the Florentine Republic. To begin with, the cartoon's allusion to the drowning of the Medici despot reflects the Savonarolan theme that seems to underlie all the decorations for the Hall of the Grand Council: the Florentine Republic's victory over tyranny through divine providence.[26] Johannes Wilde had deduced this theme largely in consideration of the two inscription plaques that once hung in the Hall.[27] The Italian inscription on one plaque ('He who calls for a *parlamento* wants to take the government away from the hands of the people') condemned the Medicis' corruption of the popular assembly called the *parlamento*, which was promptly abolished upon Piero de Medici's exile in 1494.[28] The Latin inscription on the other plaque ('That Counsel was God's own and whosoever seeks to harm it will be punished') hailed the role of Divine Providence in the institution of Savonarola's Republic, and issued a stern warning to its opponents with the implication that they were also enemies of God.[29]

Although the plaques, particularly the Italian one, openly referred to current events and all but named the Medici, the first work of art that was commissioned for the Hall hid its political message behind thick veils. This work, an altarpiece commissioned from Filippino Lippi in 1498, presumably had the same theme as its later replacement, Fra Bartolomeo's *St Anne Altarpiece*, which commemorated the 1343 expulsion of Walter of Brienne

26 Wilde, 'The Hall of the Great Council', 78–81; Ronald Martin Steinberg, *Fra Girolamo Savonarola, Florentine Art, and Renaissance Historiography* (Athens, Oh.: Ohio University Press, 1977), 100–5; and Polizzotto, *Elect Nation*, 219, n. 204.

27 Landucci, *Diario fiorentino*, 126; Lensi, *Palazzo Vecchio*, 81; and Wilde, 'The Hall of the Great Council', 74.

28 The long inscriptions were summarized by Landucci, 126, as 'Chi vuol fare parlamento vuol torre al popolo el reggimento', and 'Tal Consiglio era di Dio e chi la cerca guastare capiterà male.' Wilde, *ibid.*, notes that Benedetto Varchi also recorded the inscriptions.

29 See Polizzotto, *Elect Nation*, 23 n. 49, for references in Savonarola's sermons to the punishment of enemies of the state as heretical enemies of God.

on St Anne's feast day in a subtle and indirect denunciation of tyranny.[30] Four years later in 1502, when Soderini was elected *gonfaloniere*-for-life, Andrea Sansovino's marble sculpture of the Holy Saviour was commissioned for the wall above the *gonfaloniere*'s chair; at the time Soderini was intensely engaged in cultivating his alliance with the Savonarolan party known as the Piagnoni, whom he hoped to dissuade from reconciliation with the pro-Medici party of the Palleschi.[31] The subject of the Holy Saviour tied in with the overarching theme of the Hall's decoration – and with Soderini's politics – because the feast day of the Holy Saviour was the day Piero de' Medici had been driven from Florence; it also had, however, a particular resonance with the Piagnoni, since it was Savonarola who had exhorted the Florentines to observe this feast day as the anniversary of the Medici expulsion.[32] With this commission, Soderini had initiated a pattern of bold, mordant references to recent history and to the partisan rhetoric that reverberated in the Hall of the Great Council.

Pressing to vilify the Medici, Soderini chose as a subject for his next commission the Battle of Anghiari which, as mentioned above, bore a geographic resonance with his recent expulsion of the armies of Piero de' Medici and Cesare Borgia from the Casentino.[33] Leonardo's subject bore yet another, deeper connection with Soderini's political strategies: With this battle, the Florentines defeated *condottiere* Niccolò Piccinino, who had been abetted by a disloyal exile from the Florentine Republic, Rinaldo

30 Lippi's commission was cancelled upon the artist's death in 1504; much later, in 1510, it was reassigned to Fra Bartolomeo. On its link to the Hall's anti-tyrannical theme, see Wilde, 'The Hall of the Great Council', 77, and more generally, Roger J. Crum and David G. Wilkins, 'In Defense of Florentine Republicanism: Saint Anne and Florentine Art, 1343–1575', in K. Ashley and P. Sheinborn, eds, *Interpreting Cultural Symbols: Saint Anne in Late Medieval Society* (Athens, Ga.: University of Georgia Press, 1990), 152–3.

31 In 1505, Sansovino left for Rome and abandoned the work begun in 1502. Savonarolism was being rekindled in these very years by the Frate's stalwart adherents. Dall'Aglio, 76–81. On the *Piagnoni* party's conciliatory policies towards the pro-Medici *Palleschi* beginning around 1500, see Lorenzo Polizzotto, *Elect Nation*, 17, 23–4 and *passim*.

32 Wilde, 'The Hall of the Great Council', 78.

33 For Soderini's organization of the defence, see Carlucci, 'The Visual Arts', 390–1.

degli Albizzi. Seen in light of contemporary events, Albizzi's betrayal of the Republic would have evoked close parallels with Piero de' Medici's traitorous pact with Cesare Borgia.[34] Thus, even before Michelangelo had begun his cartoon, Soderini was developing a visual programme that associated Piero de' Medici with the Republic's most perfidious enemies.

With Piero de' Medici at the centre of Florence's internecine conflicts, reactions to his death were sharply divided. His demise was hailed above all in Soderini's quarters, but the *gonfaloniere*'s detractors, especially those among the so-called *grandi*, saw in Piero de' Medici's death a serious blow to their hopes of deposing Soderini and re-installing the Medici.[35] These dangerous opponents among the *grandi* may indeed have been Soderini's target audience when he (and Michelangelo too, presumably) conceived of a monumental image showing a drowning man and an army conquered by the forces of nature, as if to give Florentines a frightening proof of the plaque's admonishing inscription, 'That Counsel was God's own and whosoever seeks to harm it will be punished.' Soderini would also have carefully calculated the impact of such an image on the Piagnoni in the Great Council. Surely he hoped to buttress his alliance with the Piagnoni by paying homage in this image to both Savonarola's prophecy regarding Piero de' Medici's doom, and Savonarola's promise that divine providence would lead the Elect Nation to prevail over its enemies (whom Soderini identified

34 Rubinstein, *Palazzo Vecchio*, 74; and Cecchi, 'The Visual Arts', 103–4.

35 On the rejoicing in Florence at Piero de' Medici's death, see the annotation of Iodoco Del Badia in Landucci, *Diario fiorentino*, 265 n. 1. On disappointment among Soderini's enemies, see Cerretani's *Dialogo delle cose di Firenze*, a summary of which describes their reaction to Piero's drowning: '[...] molti della nobiltà gli [referring to Soderini] diventorno inimici, et cominciornno a pensare in che modo gli fussino con la Città potuti uscire di sotto, et non viddono il più commodo modo, che segretamente favorire la Casa de' Medici, et sua amici, et perchè Piero de' Medici era affogato di già nel Garigliano si guidorno per altra via, et questo era col benificare, sovvenire, et aiutare in tutti quei modi che potevano qualunque Fiorentino fussi a Roma, ò altrove capitato, il che ogni giorno gli faceva più grati.' 'Sommario et ristretto cavato dalla Historia di Bartolomeo Cerretani, scritta da lui in Dialogo delle cose di Firenze dall'Anno 1494 al 1519 (è copiata da una copia lacera et male scritta)', Archivio di Stato, Firenze (ASF), Carte Strozziane, Prima Serie, 138, 2r.

as the Medici).[36] As Lorenzo Polizzotto has argued, for the Piagnoni, the veracity of Savonarola's prophecies represented the foundation of the validity of their beliefs, and these beliefs determined their political actions.[37]

If the figure of the drowning man was meant to be recognized by the Great Council members as the fallen Medici rebel, one might ask why there are no attributes to clarify his identity, not even a face. One possible explanation is that while it was critical that his contemporaries understood the allusion to Piero de' Medici, Soderini did not wish for the allusion to function as a commemoration. In fact, the visual solution that Michelangelo arrived at very nearly approaches a *damnatio memoriae*. Notably, this ancient Roman practice of effacing a public enemy's portraits and cancelling his written name to obliterate him from public memory was still occasionally used, *mutatis mutandis*, to punish traitors in fifteenth-century Florence.[38]

Yet Michelangelo's darkly clever solution doesn't merely submerge Piero's identity, it also holds Piero's effigy out for view, exposing his folly and perpetuating his horrible death. In this way, the anonymity of the *damnatio memoriae* has been combined with the public humiliation of a *pittura infamante*. *Pitture infamanti*, literally defamatory images, depicted both effigied and actual executions of those charged with crimes like bankruptcy, treason, and fraud in order to shame the criminals and their families,

36 Soderini's eventual success in convincing the Piagnoni of his Savonarolism is confirmed in Polizzotto, *Elect Nation*, 219–21.

37 Polizzotto, *Elect Nation*, 226. Also Donald Weinstein, 'The Myth of Florence', in Nicolai Rubinstein, ed., *Florentine Studies: Politics and Society in Renaissance Florence* (London: Faber and Faber, 1968), 15–44. For this element in Savonarolan piety outside of Florence, see Stefano Dall'Aglio, *Savonarola and Savonarolism*, tr. John Gagné (Toronto: Center for Renaissance and Reformation Studies, 2010), 20, 40–1, 78–9, 108–9.

38 A recent Florentine example of an adapted form of *damnatio memoriae* was the decree following the Pazzi Conspiracy that ordered the removal of the coat of arms and name of the Pazzi from their confiscated property, and which prevented Florentines from marrying into their family, as noted in Agnolo Poliziano, *Congiura de' Pazzi*, tr. Anicio Bonucci (Florence: Felice Le Monnier, 1856), 83.

and to extend punishment beyond the grave.[39] When they held the reins of government, the Medici were particularly devious in their use of *pitture infamanti*, charging talented artists capable of striking realism to carry out the public desecration of their enemies. At the behest of Cosimo de' Medici in the first half of the fifteenth century, Andrea del Castagno painted life-size images of hanged men on the facade of the Palazzo del Podestà.[40] These images depicted members of the Albizzi, Peruzzi and Strozzi families; all had been exiled in 1434 for plotting against the pro-Medici government and several of them were also hanged, following the Battle of Anghiari. In more recent times, Lorenzo de' Medici had covered the facade of the Palazzo della Signoria with Botticelli's portrayals of eight life-size hanged

39 The following discussion of *pitture infamanti* is based closely on Gino Masi, *La pittura infamante nella legislazione e nella vita del comune fiorentino secc. XIII–XVI* (Rome: Società editoriale del Foro italiano, 1931), 6–18. Masi's study was fundamental for later investigations, e.g. Gherardo Ortalli, *La pittura infamante nei secoli XIII–XVI* (Rome: Jouvence, 1979); and Samuel Y. Edgerton, *Pictures and Punishment: Art and Criminal Prosecution during the Florentine Renaissance* (Ithaca, NY: Cornell University Press, 1985). For other cultural practices surrounding capital punishment in Florence, see Nicholas Terpstra, ed., *The Art of Executing Well: the Rituals of Execution in Renaissance Italy* (Kirksville, Mo.: Truman Sate University Press, 2008).

Florentine *pitture infamanti* have not survived except for those that are incorporated into larger, normative artworks, such as the portrayal of the Duke of Athens as the man giving vinegar to the Crucified Christ in the *Crucifixion* by Andrea di Buonaiuto in the Spanish Chapel at Santa Maria Novella (which may have inspired Michelangelo's portrayal of Biagio da Cesena as Minos in Hell in the Sistine Chapel *Last Judgement*). The dreadfulness of *pitture infamanti* incited criminals and their families to make reparations (usually by paying fines or debts) in order to petition for the removal of the offending image. Whitewashing resulted in a 'tabula rasa' denoting the expiation of the crime and the reconciliation of the household with the community.

40 Marita Horster, *Andrea del Castagno: Complete Edition with a Critical Catalogue* (Oxford: Phaidon, 1980), 12, gives sources for Castagno's fresco, and proposes that Castagno, henceforth known as 'Andreino degli Impicchati', was obliged to depart Florence as a result of this 'party-political commission.' The precise date and details of Castagno's picture are debatable, as the historical sources are vague and somewhat conflicting.

corpses in the aftermath of the 1478 Pazzi Conspiracy.[41] Written below each effigy of the men accused of participating in the conspiracy were taunting verses (or 'epitaphs', as one contemporary called them) composed by Lorenzo de' Medici himself.

For fifteen years, Botticelli's depiction of Lorenzo de' Medici's dead enemies loomed over Florence, shaming and tormenting the families of the accused.[42] Then, the same month that Piero de' Medici was sent into exile, the Florentine *Signoria* called back anti-Medici exiles and ordered the removal of both Botticelli's and Castagno's *pitture infamanti*.[43] As one of the first acts of the reborn Florentine Republic, the destruction of the *pitture infamanti* that had symbolized Medici oppression signalled the eclipse of that family's autocratic rule.

On occasion, the victims of *pitture infamanti* retaliated in kind. In one case, an outlaw who had been the target of a *pittura infamante* painted on the Palazzo della Signoria turned the tables by commissioning a fresco to

41 This fresco was commissioned in 1478 by the Otto di Guardi e Balìa through the intervention of Lorenzo de' Medici. See Ronald Lightbown, *Sandro Botticelli. Life and Works* (London: Elek, 1978), 48–9, and the documents published in Ronald Lightbown, *Sandro Botticelli. Complete Catalogue* (London: Elek, 1978), 48. See also Irene Cotta, 'Potere e giustizia politica: la congiura dei Pazzi e la pittura infamante' in Domenico A. Conci, Vittorio Dini and Francesco Magnelli, eds, *L'arte al potere: universi simbolici e reali nelle terre di Firenze al tempo di Lorenzo il Magnifico* (Bologna: Editore Compositori, 1992), 121–3. The payment document from the Otto to Botticelli was first published by Herbert Horne in 1908; see Herbert P. Horne, *Botticelli, Painter of Florence*, intro. John Pope-Hennessy (Princeton, N.J.: Princeton University Press, 1980), 350 (doc. xviii).

42 The disturbing impact of this image is emphasized by Lauro Martines, *April Blood. Florence and the Plot against the Medici* (London: Pimlico, 2004), 135. Pope Sixtus IV della Rovere, despite all that was at stake during his peace negotiations with Medici-controlled Florence in 1479, did not omit to press for such an apparently minor matter as the removal from Botticelli's fresco of the effigy of Archbishop Salviati Riario, the pope's close ally and distant relative (Lightbown, *Life and Works*, 49).

43 On the destruction of Botticelli's fresco, see Lensi, *Palazzo Vecchio*, 76; Lightbown, *Life and Works*, 49; and Lightbown, *Complete Catalogue*, 215 (cat. no. G2), citing Giovanni Cambi, *Istorie fiorentine* (also the source of the notice of the destruction of Castagno's frescoes), and Jacopo Nardi, *Istoria della città di Firenze*.

be painted in his own hamlet that showed the Palazzo della Signoria itself hanged upside down.[44] The phenomenon of such 'image battles' involving *pitture infamanti* provides insight into the Republic's destruction in 1494 of Botticelli's and Andrea dal Castagno's gruesome frescoes, and its commissioning from Michelangelo of a retaliatory image that cast infamy on the House of Medici.

Unfortunately for Soderini, the *Piagnoni* could not completely disavow their ties to Medici faction, and the delicate balance he had achieved in 1504 rapidly disintegrated. To make matters worse, all of his artists soon abandoned their commissions and left the city.[45] In August of 1512, while Michelangelo was atop sixty-five feet of scaffolding frescoing the Sistine Ceiling, Soderini's Republic suffered a total collapse as a consequence of Cardinal Giovanni de' Medici's merciless sack of Prato. On 1 September 1512, the Medici definitively returned to power. Taking revenge on their Florentine enemies, they ransacked and desecrated the Hall of the Great Council, and, needless to say, the commissions for the Hall's artworks were cancelled. Under these circumstances, Michelangelo's cartoon fell into the hands of the family it was designed to defame.[46]

44 Masi, *La pittura infamante*, 26.
45 In the spring of 1505 Michelangelo left for Rome and there is no clear evidence that he returned to the cartoon, although he does seem to have alighted here briefly in the spring of 1506. See Michael Hirst, 'Michelangelo in 1505', *Burlington Magazine* 132 (1991), 762; and Hirst, *Michelangelo*, 60.
46 Vasari and Vincenzo Borghini, both apologists for Medici rule, similarly claim Michelangelo's cartoon was first displayed to the public in Santa Maria Novella's Sala del Papa, where Leonardo's cartoon was also kept. In 1510 the cartoon was in the Hall of the Great Council in Palazzo Vecchio, according to a reference in Francesco Albertini's *Memoriale*, for which see Hughes, 'Politics, Religion, and the Lost Michelangelo', 5; and Hirst, *Achievement of Fame*, 60. Hirst, *Achievement of Fame*, 60 and 289 n. 70, argues that by 1508 the cartoon was in the Sala del Gran Consiglio, and does not give any credence to notices of the work's display in the Sala del Papa of Santa Maria Novella. Vasari, *Le vite [...] 1550*, 889, said it was next moved to the palace of the Medici on via Larga and kept in the 'sala grande di sopra', a point which no one has contested.

The beginning of the cartoon's physical degradation coincides with the restoration of Medici rule in Florence in 1512. Obfuscating the real history of the violent attack on the image, the Medici loyalist Giorgio Vasari claimed in his 'Life of Michelangelo Buonarroti' in both editions of the *Lives of the Artists* that the cartoon had been 'torn, and separated into many pieces' by the zealous artists ('nelle mani degli artefici') who copied it during Giuliano de' Medici's rule; the latter was carefully excused from charges of acquiescence or indifference by Vasari's claim that he had been sick in this period.[47]

There is good reason to suspect that Giuliano's true attitude towards the anti-Medicean artwork was not passive indifference so much as meditated malevolence. Giuliano was Piero's younger brother and had initially been sent into exile with him; a disrespectful allusion to his brother's wretched death in a large-scale work of art would have been unbearable, even if it was wrought by the hand of the 'divine' Michelangelo. Moreover, the exculpating sickness Vasari cited actually occurred in 1515–16, three years following the apparently well-known destruction of the cartoon in 1512 during the midst of the Medici's vindictive sabotage of the Hall of the Great Council at the hands of Giuliano's sculptor, Baccio Bandinelli.[48] Perhaps pressured by criticisms of his red-herring account in the first edition, Vasari added to his second addition a few of the actual circumstances of the cartoon's destruction, noting in the 'Life of Baccio Bandinelli' that 'during the tumult at that time in the palazzo [della Signoria] because of the renovation of the [Medici] government, Baccio all by himself secretly cut the cartoon into many pieces'.[49] Vasari stressed that Baccio acted alone, offering hypothetical explanations for Bandinelli's barbarism that deflected blame from his

47 Vasari, *Le vite [...] 1550*, 889; Giorgio Vasari, *Le vite dei più eccellenti pittori, scultori e architetti* [Giunti 1568 ed.], intro. Maurizio Marini (Rome: Grandi Tascabili Economici Newton, 2002), 1211.

48 On Giuliano's sickness, see Luciano Bellosi and Aldo Rossi's commentary in Vasari, *Le vite [...] 1550*, 889 n.41.

49 Vasari, *Le vite* [Giunti 1568 ed.], 962: 'Nel tumulto addunque del palazzo per la rinnovazione dello stato, Baccio da sè solo segretamente stracciò il cartone a suo modo.'

Medici patron by focusing on the sculptor's personal rivalries. Nevertheless, it seems more probable that Giuliano not only condoned the iconoclasm but even requested it of his sculptor, in the very period when his soldiers had converted the Hall of the Great Council into a den of vice, complete with a tavern, gambling tables, and a brothel, all to punish the Piagnoni.[50] It is tempting to imagine that, at his master's urging, Bandinelli's first cut in the cartoon excised the offending motif of the drowning man, thus cancelling the *pittura infamante* that had incited Florentines to gloat over his brother's death.

Little is known about the final history of the injured and dismembered image, except that by 1550, its remnants were in the hands of Uberto Strozzi of Mantua. Ascanio Condivi would write in his 1553 biography of Michelangelo that the remaining vestiges of the cartoon were being taken care of by Uberto Strozzi 'with great diligence, as if they were sacred objects'.[51] The Strozzi sold these 'sacred objects' to the Savoy court sometime before 1621, the year that an accidental fire in the Paradise Room of the Ducal Palace in Turin laid waste to the remaining shards of Michelangelo's cartoon.[52] Thus, Michelangelo's extraordinary drawing, famous for its artistry as well as its role in anti-Medicean politics, came to its own wretched end, first targeted by the weapons of merciless enemies, then exiled, and ultimately the victim of a tragic natural disaster, much like Piero de' Medici himself. Both the man and the artwork that portrayed his death had paid the price for their signal roles in the maelstrom of Florentine politics.

50 On the desecration of the hall by the Medici, see Polizzotto, *Elect Nation*, 241, following the account in Cerretani's 'Storia in dialogo'.

51 Vasari, *Le vite [...] 1550*, 889. Ascanio Condivi, *Vita di Michelangelo Buonarroti*, ed. Giovanni Nencioni (Florence: S.P.E.S., 1998), 28: '[...] con grandissima diligenza e come cosa sacra'.

52 Lensi, *Palazzo Vecchio*, 103.

2 Osiris and the End of the Renaissance

Metaphors of palingenesis, restoration, and unification are recurrent in Italian Renaissance literature and art. The ancient story of Hippolytus provides a paradigmatic account of the characteristically Renaissance dialectic between fragmentation and recomposition. As recorded in the epics of Vergil and Ovid, Hippolytus' body was torn apart by Poseidon's horses (in Vergil's phrasing, 'distractus equis', *Aen.* VII, 767), but Aesculapius, the god of medicine himself, restored his members back to unity and life.[1] This myth appears in the writings of numerous Renaissance literati with heavily charged cultural significance.[2] Poliziano refers to it at the beginning of his *Centuria secunda* as a metaphor of his daring philological enterprise; Raphael mentions it in his famous letter to Pope Leo X in reference to the physical ruin of Rome; and Castiglione – who must have been the actual author of that same letter – equates Raphael's planned restoration of the ancient city with Aesculapius' miraculous reassembling of Hippolytus.

However, we should not forget that the Italian Renaissance explores the concept of rebirth or restoration as much as it focuses on that of impending death (a second much-feared death!). Representations of both are part of a single self-mythologizing courtly ideology, which is – in Italy at least – what I believe we should ultimately mean by the term 'Renaissance' (as I argue in my book *Rinascimento*). While celebrating itself as the return of light and unity after the centuries-long darkness and dispersal of the middle ages, the Renaissance also thematizes its own inevitable relapsing

1 *Aeneid* VII, 761–82 and *Metamorphoses* XV, 492–546.
2 See my *Rinascimento* (Torino: Einaudi, 2010) 17, 85, 99, 106, 110. See also A. Bartlett Giamatti, *Exile and Change in Renaissance Literature* (New Haven and London: Yale University Press, 1984), 12–32.

into obscurity and disunion. Renaissance literature seethes with references to the disappearance of the newly retrieved historical integrity. While the beginning is described as the restoration of what lay disjoined for too long, the end is evoked in terms of physical disintegration. It is this idea of physical disintegration – i.e. one of the pivotal metaphors through which the Renaissance historicizes itself – that I would like to present today.

We can state without exaggeration that the symbolic boundaries of the Renaissance are two specular visions of 'de-struction': on the one side, the shipwreck of ancient literature (I take this metaphor from Flavio Biondo);[3] on the other, the dissolution of all regained historical plenitude as a consequence of foreign invasions and political ruin. Both sides are strewn with spoils and fragments, ancient and modern: mangled books here and dispersed limbs there. Even such a comical – but only in appearance – episode in Ariosto's *Orlando Furioso* as the passage in which Orlando scatters his arms around the plain stages Renaissance obsession with dismemberment:[4]

> Il quarto dì, da gran furor commosso,
> e maglie e piastre si stracciò di dosso.
>
> Qui riman l'elmo, e là riman lo scudo,
> lontan gli arnesi, e più lontan l'usbergo:
> l'arme sue tutte, insomma vi concludo,
> avean pel bosco differente albergo. (*OF* XXIII, 132, 7–8 and 133, 1–4)

[On the fourth day, worked into a great frenzy, he stripped off his armour and chain-mail.

The helmet landed here, a shield there, a piece of armour further off, the breastplate further still: arms and armour all found their resting-place here and there about the wood.]

3 See my *Rinascimento*, p. 93.
4 I comment on the tragic aspect of Orlando's folly in my *Per una biblioteca indis-
 pensabile* (Turin: Einaudi, 2011), 194–7. The edition of *Orlando furioso* used here is
 edited by Marcello Turchi and Edoardo Sanguineti (Milan: Garzanti, 1974).

In the Renaissance frame of mind, all sorts of imperfection or deterioration tend to be represented in terms of physical crumbling or mangling (what the Greek designates as *sparagmós*). For example, Pico – to whom I will return shortly – writes:

> Sedabit naturalis philosophia opinionis lites et dissidia, quae inquietam hinc inde animam vexant, *distrahunt* [my emphasis] et lacerant.[5]

> [Natural philosophy will resolve all disagreements of clashing opinions, which unsettle, tear apart and lacerate the soul from all sides.]

Curiously, Pico resorts to the very same verb 'distraho' which Vergil uses in the passage on Hippolytus' death quoted above.

One of the most outstanding depictions of physical disintegration is to be found in Girolamo Fracastoro's beautiful Latin poem *Syphilis*, which describes the devastating effects of the newly discovered pox:

> Quinetiam erodens alte, et se funditus abdens
> Corpora pascebat misere: nam saepius ipsi
> Carne sua exutos artus, squallentiaque ossa
> Vidimus, et foedo rosa ora dehiscere hiatu ... (I, 355–58)

> [Moreover the disease gnawed deep and burrowed into the inmost parts, feeding on its victims' bodies with pitiable results: for on quite frequent occasions we ourselves have seen limbs stripped of their flesh and the bones rough with scales, and mouths eaten away yawn open in a hideous gape ...][6]

Further down, in a most graphic close-up, the poet dwells on the repulsive decomposition of a beautifully shaped young Lombard man ('corpore pulchro', l. 387; 'juvenile gravi corpus durare palaestra', l. 390):

> Nam nimium fidentem animis, nec tanta timentem
> Invasit miserum labes, *qua saevior usquam*
> *Nulla fuit,* [my emphasis] nulla unquam aliis spectabitur annis.

5 Giovanni Pico della Mirandola, *Discorso sulla dignità dell'uomo*, ed. Francesco Bausi, Fondazione Pietro Bembo (Milan: Guanda, 2003), p. 40.
6 *Fracastoro's Syphilis*, ed. Geoffrey Eatough (Liverpool: Francis Cairns, 1984), 55–7.

Paulatim ver id nitidum, flos ille juventae
Disperiit, vis illa animi: tum squallida tabes
Artus (horrendum) miseros obduxit, et alte
Grandia turgebant foedis abscessibus ossa.
Ulcera (proh divum pietatem) informia pulchros
Pascebant oculos, et diae lucis amorem,
Pascebantque acri corrosas vulnere nares.
Quo tandem infoelix fato, post tempore parvo
Aetheris invisas auras, lucemque reliquit. (I, 397–408)

[For the poor youth, too self-assured, unaware of these great dangers, was seized by this plague, more savage than there has been anywhere or than will ever be seen at any future time. Gradually that glistening springtime, that flower of his youth perished utterly, that vigour of mind: then the wasting sickness with its filthy scabs (sheer horror) covered his sorry limbs, and, deep within, his bones began to swell large with hideous abscesses. Ugly sores (ye gods have pity) began to devour his lovely eyes and his love of the holy light and to devour his nose, which was gnawed away, leaving a pierceful wound. A brief interval, then finally the unlucky youth departed heaven's hateful breath and the light.][7]

What we have just read is an event that symbolizes in paradigmatic terms the historical fall from zenith to nadir. In the final section of book I, the poet makes the poor chap's repellent death into an obvious symbol of Italy's ruin. For Fracastoro, the decay of flesh is at one with military invasions, political discords, and bloodshed.[8] The last section of book I (ll. 421ff) is a most passionate lament on Italy's recent misfortunes, condemning the French-Spanish contest for the political control of the peninsula: 'Ausonia infoelix, en quo discordia priscam / Virtutem, et mundi imperium perduxit avitum!' (ll. 437–8) [Unhappy Italy, behold the end to which discord has brought your ancient virtue and your world-wide empire, an

7 *Ibid.*, 57–9.

8 The political connotation of a disease such as syphilis is evident from the very fact that it was named after the enemy ('morbus gallicus'). The ducal heir, Alfonso I, suffered from such a stigmatizing disease: see Jon Arrizabalaga, John Henderson and Roger French, *The Great Pox. The French Disease in Renaissance Europe* (New Haven and London: Yale University Press, 1997), 50.

ancestral inheritance].[9] The military symbolism of the disease is also apparent from the intertextuality of Fracastoro's lines. Indeed, the phrase 'qua saevior usquam / Nulla fuit' in the above-mentioned passage echoes 'nec saevior ulla / pestis' in the *Aeneid* (III, 214–15), where the Harpies assault and mire every dish of the Trojan exiles. Interestingly enough, Ariosto also identifies the Harpies with the invading foreign armies in the *Furioso* (34, 1–2). More intertextual resonances are to be found in the following lines of Fracastoro's book I:

> Ergo hanc per miseras terras Saturnus agebat
> *Pestem* [my emphasis] atrox, nec saeva minus crudelis et ipse
> Miscebat Mavors, coniunctaque fata ferebat.
> Quippe lue hac nascente putem simul omnia diras
> Eumenidas cecinisse fera et crudelia nobis.
> Tartareos etiam Barathro (dira omina) ab imo
> Excivisse lacus, *Stygiaque ab sede* [my emphasis] laborem,
> Pestemque, horribilemque famem, bellumque, necemque. (I, 413–20)

[Morose Saturn drove this plague over the wretched earth: Mars too no less cruel contributed his savagery, and set in motion the effects of their fatal conjunction. For I should think that coincident with the birth of this pestilence the dread Furies had prophesied for us every act of savagery and cruelty: that they had summoned the lake Tartarus (dire omens) from the bottom of the Pit, and from their Stygian abode toil, plague, horrible famine, war, death.][10]

From the Harpies episode in the *Aeneid* Fracastoro also derives the word 'pestis'. Here, Vergil's 'pestis' is used with a double meaning: both literal and metaphorical; namely, it simultaneously indicates the actual contagion of syphilis and the scourge of war. Besides, Fracastoro alludes to the rest of line 215 in *Aeneid* III, 'ira deum Stygiis sese extulit undis', that is the infernal depths from which the Harpies rose (and into which Astolfo, in *OF* XXXIII, will push them back).[11]

9 *Fracastoro's Syphilis*, 58–61.
10 *Fracastoro's Syphilis*, 58–9.
11 For a political interpretation of the Harpies in the *Orlando Furioso*, see my *Rinascimento*, 155–6.

Fracastoro definitely composed his beautiful poem out of love for poetry and medicine, but, as is apparent from such quotations, he could not help making a metaphorical connection between the disease and the rotting state of Italy's political body (the equation between political and physical malady already being asserted by Machiavelli in his *Principe*). Indeed, the poem appeared in 1530, that is three years after the traumatic sack of Rome, which all humanists perceived as the collapse of the Renaissance.

Before Fracastoro, Poliziano provided a similar conflation of the pathological and the political in his *Sylva in scabiem*, a poem in hexameters drawing on the same classical sources as Fracastoro's *Syphilis* (mainly Vergil and Lucretius). Poliziano's bold virtuosity in the representation of the most repulsive putrefaction still disconcerts interpreters. Attilio Bettinzoli, to name but one representative instance of recent critical bafflement, explains away the *Sylva* as a gratuitous exercise in baroque, nothing but nonsensical exaggeration.[12] I could not disagree more. I believe this poem springs from, and refers to, the sad time in Poliziano's life, around 1480, when the poet lost Lorenzo's favour and found himself alone and desperate away from Florence.[13] The *Sylva* represents Poliziano's exile from the Medici house and does so in terms of the most excruciating physical torment. Scabies does not signify allegorically the symptoms of anger, as has been claimed, but the consequences of the poet's exclusion from Lorenzo's household.[14] Poliziano is not referring to any specific form of disease, despite all those who still strive to give this disease a name. The hyperbolic gangrene or leprosy in the *Sylva* symbolizes the disintegration that the individual's bodily and mental unity must suffer when he ceases to be part of a political

12 See Attilio Bettinzoli, *Daedaleum iter. Studi sulla poesia e la poetica di Angelo Poliziano* (Florence: Leo S. Olschki, 1995), 59–61.

13 On the chronology see Orvieto, in Angelo Poliziano, *Sylva in scambiem*, ed. Paolo Orvieto (Roma: Salerno, 1989) 44.

14 Orvieto emphasizes the psychological component of the malady in his introduction to the *Sylva*. However, he himself suggests elsewhere that the poem was composed after the break-up with Lorenzo and produces a letter by Poliziano, written after he left Florence, which mentions 'una piaga, un tumore difficilmente sanabile'. Orvieto, *Poliziano* (Roma: Salerno, 2009) 214.

and cultural whole. Indeed, the *Sylva*'s conclusion clearly states that only Lorenzo can cure the ailing body and restore it to health, equating him – a most forceful metaphor – with the ruler of the universe, namely a supreme symbol of *unifying concord* ('omnipotens et numine *cuncta gubernans* / plena suo', ll. 353–4).

This interpretation of the *Sylva* also helps us to understand the ultimate meaning of Poliziano's *Orfeo*. Far from being a merely philological fantasy on the patron of all poets, classical and modern, or some enigmatic disguising of autobiographical concerns (in particular, homosexuality) or a critique of *furor*, the *fabula* appears to be engaged with a similar preoccupation to that which represents the thematic core of the *Sylva*. Once again, the poet's fall from grace is expressed through physical disintegration, indeed an archetypal instance of *sparagmós*, harking all the way back to the narratives of Vergil and Ovid.

In Renaissance imagination, there is an interesting similarity between politics and philology. The two share a medical metaphor. Just like the philologist repairs the decaying and disfigured limbs of ancient literature (let's think of Bracciolini's description of his discovery of Quintilian), so does the ruler give back energy and vigour to the suffering body of his subjects. Poliziano's *Sylva* is centred around a metaphor which most aptly expresses the interrelatedness of literature and power. Once demoted from his official rank, the poet falls ill and dies. His past merits – interestingly enough, Poliziano concludes the *Sylva* with an allusion to his greatest achievements, his translations from Homer and his *Stanze* – are no longer enough to grant him energy and health. In a very similar way, the disease of the beautiful Lombard in Fracastoro's poem symbolizes the demotion of a whole political system.

There is another interesting example I should like to mention. I take it from the *incipit* of what is likely to constitute the most programmatic text of the Renaissance, the *Libro del cortegiano*. In the very beginning, the author inserts a eulogy of Guidubaldo, the ruler of Urbino. Ritually enough, Guidubaldo is depicted as a wonderful, extremely gifted man. However, Castiglione also tells us that his outstanding qualities are undercut by malady:

la fortuna invidiosa di tanta virtù, con ogni sua forza s'oppose a così glorioso princi-
pio, talmente che, non essendo ancora il duca Guido giunto alli venti anni, s'infermò
di podagre, le quali con atrocissimi dolori procedendo, in poco spazio di tempo
talmente tutti i membri gli impedirono, che *né stare in piedi né moversi potea*; e così
restò un dei più belli e disposti corpi del mondo deformato e *guasto* nella sua verde
età [my emphasis]. (I, 3)

[Fortune, envious of so great a worth, set herself against this glorious beginning with
all her might, so that, before Duke Guido had reached the age of twenty, he fell sick
of the gout, which grew upon him with grievous pain, and in a short time so crip-
pled all his members that *he could not stand upon his feet or move*. Thus, one of the
fairest and ablest persons in the world was deformed and marred at a tender age.][15]

This introductory allusion to the weakness of the ruler's body not only
casts a melancholic shadow over the entire dialogue, but it clearly identi-
fies the specific case of Guidubaldo's disease with the impending political
disaster of Italy as a whole. The subtle allusions to the 'veglio di Creta' (the
ailing feet and the adjective 'guasto'), who allegorizes the decline of human
history in Dante's *Inferno* XIV, enhance the representation of Guidubaldo's
suffering body as a symbol of historical decadence.

* * *

In the Renaissance, the horror of disintegration – both in retrospect and
in view of what is still to come – is counterbalanced by an obdurate quest
for restorative remedies: philology (textual repair), medicine (physical
recovery), political theory (concord), or philosophy (Pico's syncretism).
The opposition of the one pole to the other, that is of disintegration to
integration, does not simply represent the way in which the Renaissance
establishes its boundaries via-à-vis the disappointing past or the menacing
future, as I have so far appeared to imply, but it is a constitutive feature of
the Renaissance imagination as such. Let's call it a sort of inherent model-
ling oscillation between oneness and multiplicity. I have already quoted
the myth of Hippolytus, which encapsulates such oscillation very well.

15 Baldesar Castiglione, *The Book of the Courtier*, tr. Charles S. Singleton (Garden City
NY: Anchor Books, 1959), 14.

Starting from the mid-Quattrocento, this myth also becomes known in its Egyptian variant, the story of Osiris, as told by two newly rediscovered Greek sources, Plutarch's *De Iside et Osiride* and Diodorus' historical writings. It is on the early Renaissance fortune of Osiris that I should like to focus in the second half of this paper.

Of course, Osiris was known to other ancient authors, like Herodotus, Apuleius, Macrobius, and Ammianus. However, it is only in Diodorus and in Plutarch that humanists were able to find a full account of the dismemberment of Osiris. Inevitably, their version of the story was to have a remarkable impact on the imagination of some of them – which shows how promptly the Renaissance expanded the territories of its symbolism by incorporating compatible elements or grafting its images onto alternative paradigms. (Incidentally, one may note that the fortune of Osiris in the second half of the Quattrocento demonstrates that Renaissance Egyptology did not start as pure fascination with the hieroglyphs, but rather that humanism was induced to approach the culture of ancient Egypt by an instinctive impetus of assimilation.)[16]

The fortune of the Osirian myth was greatly promoted by Poggio's translation of Diodorus' initial books in 1451. This translation was published in 1472. Plutarch's *De Iside et Osiride* starts circulating later. In the early 80s, it is known by Poliziano.[17] Ermolao Barbaro translated the Greek text into Latin, but his translation was not published. Another translation was produced by Celio Calcagnini in the sixteenth century with the title *De rebus aegyptiacis* (Celio speaks of this translation as something just completed in a letter to his nephew dating from 1518).[18]

One of the earliest readers of Plutarch's *De Iside et Osiride* was Pico della Mirandola. A few allusions to this treatise surface in the *Oratio de dignitate*

16 On hieroglyphs the reference texts are still: Karl Giehlow, *Hieroglyphica*, eds Maurizio Ghelardi and Susanne Müller (Turin: Nino Aragno, 2004) (first German edition 1915) and *The Hieroglyphics of Horapollo*, translated by George Boas, with a new forward by Anthony Grafton, Bollingen Series XXIII (Princeton: Princeton University Press, 1993) (first American edition 1950).

17 Giehlow, *Hieroglyphica*, 147.

18 Calcagnini, *Opera aliquot* (Basileae: Froben, 1544), p. 12.

hominis, although Plutarch is never openly mentioned. Interestingly, one particular passage refers to the dismemberment of Osiris:

> Ac nec satis hoc [getting rid of one's sensual appetites] erit, si per Iacob scalam discursantibus angelis comites esse volumus, nisi et a gradu in gradum rite promoveri, et a scalarum tramite deorbitare nusquam, et reciprocos obire excursus bene apti prius instructique fuerimus. Quod cum per artem sermocinalem sive rationariam erimus consequuti, iam Cherubico spiritu animati, per scalarum idest naturae gradus philosophantes, a centro ad centrum omnia pervadentes, nunc unum quasi Osyrim in multitudinem vi Titanica discerpentes descendemus, nunc multitudinem quasi Osyridis membra in unum vi Phebea colligentes ascendemus, donec, in sinu Patris – qui super scalas est – tandem quiescentes, theologica foelicitate consumabimur. (*Oratio* 82, 34–6)

> [Even this, however, will not be enough, if we wish to be the companions of the angels who traverse the ladder of Jacob, unless we are first instructed and rendered able to advance on that ladder duly, step by step, at no point to stray from it and to complete the alternate ascensions and descents. When we shall have been so prepared by the art of discourse or of reason, then, inspired by the spirit of the Cherubim, exercising philosophy through all the rungs of the ladder – that is, of nature – we shall penetrate being from its centre to its surface and from its surface to its centre. At one time we shall descend, dismembering with titanic force the 'unity' of the 'many', like the members of Osiris; at another time, we shall ascend, recollecting those same members, by the power of Phoebus, into their original unity. Finally, in the bosom of the Father, who reigns above the ladder, we shall find perfection and peace in the felicity of theological knowledge.]

This is quite an extraordinary passage, both stylistically and conceptually. The reference to Osiris is rapid, but remarkably significant. On the one hand, it shows how readily Pico's memory appropriated newly discovered sources. On the other, it provides an appreciable instance of Pico's allegorical inclinations. The dismemberment of Osiris signifies the intellectual operation of the soul descending from unity to multiplicity and then ascending from multiplicity back to unity. Besides, this ascetic movement is associated with that of angels going up and down Jacob's ladder – a syncretistic conflation that makes the reference to Osiris all the more intriguing. In his *Commento sopra una canzona de amore composta da Girolamo Benivieni* (III, 10), which was written in 1486 (just before the

Oratio), Pico traces this double motion, at once spiritual and intellectual, to Plato's *Philebus*:

> L'ordine dell'universo è che dalle cose separate e intelligibile procedino le cose infe-riore, e queste quanto più possono alle sue cause convertendosi a loro ritornino; il che veggio nella presente canzona mirabilmente essere dal Poeta osservato il quale, d'amore e di bellezza avendo a trattare, prima dalla celeste bontà e dal celeste amore incominciò [...] Ora nel resto della canzona mostra a noi come dalla beltà sensibile si ascende per ordinati gradi alla beltà intelligibile, alla quale giunto termina l'autore l'opera sua, come in quella a cui pervenendo ogni amoroso desiderio terminare si debbe; né più sottile, né più ordinato, né più sufficiente modo può osservare, chi di qualunque cosa ha a trattare, quanto ha el Poeta nostro qui dottamente osservato; modo da pochi inteso e conosciuto, ed è quello che Platone nel *Filebo* chiama dedurre la unità in multitudine e la multitudine nella sua unità redurre, il che chi bene sa fare meritamente, come Platone scrive, *tamquam Deum eum sequi debemus*, uomo certamente divino e angelo terrestre, atto, per la scala di Iacob, in compagnia delli altri contemplativi angeli, *pro arbitrio* ad ascendere e descendere.

> [The order of the universe is such that from the separate intelligible things there proceed the inferior things, and these transforming themselves as much as they can, return back to their causes, and this we see marvellously observed by the Poet, who, having to speak of love and beauty, began with celestial goodness and celestial love ... Now in the rest of the poem he shows us how from sensible beauty we rise by orderly steps to intelligible beauty, and having reached this, the author terminates his work, as one who having attained every amorous desire must finish. Nor can anyone observe a more subtle or more orderly or more adequate way of observing, than that wisely observed by our Poet; a way only understood and known to a few, indeed, the way which Plato in his *Philebus* calls deducing unity from the many and reducing the many back to its unity, and the one truly able to do this, as Plato writes, 'we must follow as we do God', as he is certainly divine and an earthly angel, able by Jacob's ladder, in the company of the other contemplative angels, 'by freewill', to rise or fall.][19]

The relation between unity and multiplicity occupies the first section of Plato's dialogue. Pico must refer in particular to 15d–e, 16c–17a:

19 Pico della Mirandola, *De hominis dignitate, Heptaplus, De ente et uno e scritti vari*, ed. Eugenio Garin (Florence: Vallecchi, 1942), 566–7.

We say that one and many are identified by reason, and always, both now and in the past, circulate everywhere in every thought that is uttered. This is no new thing and will never cease; it is, in my opinion, a quality within us which will never die or grow old, and which belongs to reason itself as such. And any young man, when he first has an inkling of this, is delighted, thinking he has found a treasure of wisdom; his joy fills him with enthusiasm; he joyously sets every possible argument in motion some-times in one direction, rolling things up and kneading them into one, and sometimes again unrolling and dividing them ... and the ancients, who were better than we and lived nearer the gods, handed down the tradition that all the things which are ever said to exist are sprung from one and many and have inherent in them the finite and the infinite. This being the way in which these things are arranged, we must always assume that there is in every case one idea of everything and must look for it – for we shall find that it is there – and if we get a grasp of this, we must look next for two, if there be two, and if not, for three or some other number; and again we must treat each of those units in the same way, until we can see not only that the original unit is one and many and infinite, but just how many it is. And we must not apply the idea of infinite to plurality until we have a view of its whole number between infinity and one; then, and not before, we may let each unit of everything pass on unhindered into infinity. The gods, then, as I said, handed down to us this mode of investigating, learning, and teaching one another; but the wise men of the present day make the one and the many too quickly or too slowly, in haphazard fashion, and they put infinity immediately after unity; they disregard all that lies between them, and this it is which distinguishes between the dialectic and the disputatious methods of discussion.[20]

Unsurprisingly, in chapter XXV of his commentary on the *Philebus* (probably composed in 1469), Marsilio Ficino also underscores the impor-tance of the ability to move between unity and multiplicity:

> Statim vero ostendit facultatem eiusmodi non modo ad voluptatis et sapientiae sed ad cuiuscumque rei cognitionem esse admodum necessariam. Omnes enim ac semper et in omnibus quaecumque vel cogitamus vel dicimus dividere et unire cogimur, ex unoque in multa et contra ex multis in unum deducere [...] Eo vero quod per omnia currit, si recte utimur, de omnibus vere sentimus et loquimur; sin abutimur, falso. Ex quo concluditur ut ars illa quae circa unum et multa dividendo et uniendo versatur summopere sit cognitu necessaria.

20 Plato, *Philebus*, in Plato, *Statesman, Philebus, Ion*, transl. H.N. Fowler and W.R.M. Lamb, Loeb Classical Library (Cambridge MA: Harvard University Press), 1975.

[Socrates demonstrates immediately that such an ability is absolutely necessary in order to know not only about wisdom and pleasure, but about anything at all. For we are always forced to divide and unite in everything we think about or talk about, and to go from the one into the many and the reverse, from the many into the one. [...] But if we use dialectic properly (which traverses everything), we will feel and talk about everything correctly; but if we abuse it, incorrectly. You can conclude therefore that the art which deals with dividing and uniting the one and the many is absolutely vital to knowledge.][21]

In Pico's allegorical interpretation of the dismemberment of Osiris as man's intellectual ability to control multiplicity, the conflict between division and completeness which characterizes the Renaissance mind appears to come to some sort of philosophical equilibrium, indeed a real solution. The restored unity of Osiris represents the triumph of synthesis, which is the ideological aim of the *Oratio*. This text itself is an Osirian body, rising from multiplicity to oneness.

The Osirian paradigm – that is the dialectic division/totality – is active throughout the *Oratio* and may be detected even in passages which are admittedly indebted to other sources. Here's a telling example. Towards the conclusion, Pico asserts the originality of his thought and does so by resorting to the authority of Seneca (letter XXXIII).

Quid erat et aliorum quot erant tractasse opiniones, si, quasi ad sapientium symposium asymboli accedentes, nihil nos quod esset nostrum, nostro partum et elaboratum ingenio, afferebamus? Profecto ingenerosum est (ut ait Seneca) sapere solum ex commentario [Seneca writes: 'turpe est enim seni aut prospicienti senectutem ex commentario sapere'] et, quasi maiorum inventa nostrae industriae viam praecluserint, quasi in nobis effaeta sit vis naturae, nihil ex se parere quod veritatem, si non demonstret, saltem insinuat vel de longinquo. (196–7, pp. 92–4)

[And what would it have profited us if, having discussed the opinions of innumerable others, like *asymboli*, at the banquet of wise men, we should contribute nothing of our own, nothing conceived and elaborated in our own mind? Indeed, it is the characteristic of the impotent (as Seneca writes) to have their knowledge all written down in their note-books, as though the discoveries of those who preceded us had

21 Marsilio Ficino, *The Philebus Commentary*, a Critical Edition and Translation by Michael J.B. Allen (Berkeley: University of California Press, 1975) 230–3.

closed the path to our own efforts, as though the power of nature had become effete
in us and could bring forth nothing which, if it could not demonstrate the truth,
might at least point to it from afar.]

Seneca's beautiful letter not only informs us about the gnoseological
concerns of a late Stoic philosopher, but also provides interesting remarks
on the problematic relation between memory and knowledge, tradition and
innovation which is crucial in the Renaissance and in the whole of western
culture ('aliud autem est meminisse, aliud scire', in Seneca's words). How
much am I to learn from the books I have read and how much from my
own experience? Seneca's answer is quite straightforward: one can quote
others' works, but should above all produce personal ideas. Machiavelli
intends something similar in his famous phrase in the *incipit* of his *Principe*:
'la cognizione delle azioni delli uomini grandi, imparata da me con una
lunga *esperienza* delle cose moderne e una continua *lezione* delle antiche'
['Knowledge about the actions of great men, learned by me through *long
experience* of modern matters and a continuous *study* of ancient ones'] [my
emphasis]. Boccaccio himself would yoke together bookish and empirical
knowledge: 'sì per le parole de' savi uomini udite e sì per le cose da me molte
volte *e vedute e lette*' [by I heard from wise men as well as by things I *saw
and read*'] [my emphasis] (*Decameron*, introduction to the fourth day).
 In the same letter, Seneca suggests that the various elements of knowl-
edge should cohere in some harmony. One cannot stand without the others.
Therefore, if we want to become familiar with the thoughts of great minds,
we must study all of them and not selectively. Nobody can take just indi-
vidual sections without taking apart the rest, because all sections are con-
nected with one another and form a perfect whole (an idea surfacing also
in a significant letter by Calcagnini):[22]

> Quare depone istam spem posse te summatim degustare ingenia maximorum virorum:
> tota tibi inspicienda sunt, tota tractanda. Continuando res geritur et per lineamenta
> sua ingenii opus nectitur ex quo nihil subduci sine ruina potest.

22 *Opera aliquot* (Basel: Froben, 1544) 23. As far as I can see, Calcagnini alludes to
 Vitruvius (the *incipit* of *De architectura*) rather than to Seneca.

[So give up this hope of being able to get an idea of the genius of the greatest men by so cursory an approach. You have to examine and consider everything in its totality. There is a sequence about creation and a work of genius is a net of its individual features from which nothing can be subtracted without disaster.]

In the following lines Seneca makes a very interesting comparison between the wholeness of knowledge and that of the human body: no one, he argues, would think that a beautiful woman is she who is praised just for her legs or for her arms, beauty being a quality of one's entire physical appearance:

Nec recuso quominus singula membra, dummodo in ipso homine, consideres: non est formonsa cuius crus laudatur aut brachium, sed illa cuius universa facies admirationem partibus singulis abstulit.

[I have no objection to your inspecting the components individually provided you do so without detaching them from the person they actually belong to; a woman is not beautiful when her ankle or arms win praise, but when her total appearance diverts admiration from the individual parts of her body.]

That these lines should have a great impact on Pico's mind is easy to imagine. While he was quoting Seneca, he was still appealing to the Osirian paradigm.

Another relevant occurrence of the Osirian myth around those years is to be found in art. This is going to be my concluding example. In 1492, Pinturicchio starts decorating the apartment of Alexander VI, who has just become pope, with a cycle of frescoes representing the whole story of the Egyptian god. Experts claim that Pinturicchio was not influenced directly by Diodorus, but by the famous antiquarian Annius of Viterbo, who provided his own account of the Osirian myth in his *Antiquitates*.[23]

23 On Annius see Brian Curran, *The Egyptian Renaissance: The Afterlife of Ancient Egypt in Early Modern Italy* (Chicago: University of Chicago Press, 2007), 121–31 and Anthony Grafton, 'Invention of Traditions and Traditions of Invention in Renaissance Europe: The Strange Case of Annius of Viterbo', in Anthony Grafton and Ann Blair, eds, *The Transmission of Culture in Early Modern Europe* (Philadelphia: University of Pennsylvania Press, 1990), 8–38.

In any case, Annius himself followed Diodorus very closely, even *verbatim*.
As Brian Curran states, 'the sequence of events in Pinturicchio's frescoes
corresponds so closely to Diodorus' narrative that they can almost be said
to 'illustrate' his version of the story'.[24] Be that as it may, what is particularly
striking in Pinturicchio's frescoes is the representation of the dismember-
ment. One actually gets to see the scattered limbs – a rather horrific scene.
This is Annius' account:

> in sex ac viginti partes dissectum, cuilibet eorum qui secum tanti sceleris participes
> fuerant partem dedit, veluti tanti facinoris consciis, et ut simul ipsos defensores
> custodesque regni fidos haberet.[25]

Diodorus' text, as translated by Poggio, obviously served as the source
of this passage (and of many others):

> in sex ac viginti partes dissectum, cuilibet eorum, qui secum tanti sceleris participes
> fuerant, partem dedit, veluti eius facinoris consciis, et simul ut ipsos defensores
> custodesque haberet regni fidos.[26]

Fritz Saxl, one of the first interpreters of Pinturicchio's cycle, claims
that those frescoes are meant to celebrate the Borgia dynasty.[27] Osiris,
after his death, was worshipped in the form of the bull Apis. Since a bull
is the symbol of the Borgia family, the myth of Osiris allegedly provides
a mythical etiology of the symbol. This may well be. However, Saxl fails
to pay any attention whatsoever to the dismemberment. This is a rather

24 Curran, *Egyptian Renaissance*, 119. For other possible literary sources of the frescoes
 see Curran, 119–20.

25 *Antiquitates*, foll. 135v–136r, Paris, 1512.

26 I quote here from the Bologna edition of 1472.

27 On the meaning of the cycle see Fritz Saxl, 'L'appartamento Borgia', in *Lectures*, vol.
 I (London: Warburg Institute, University of London, 1957), 174–88; N. Randolph
 Parks, 'On the Meaning of Pinturicchio's Sala dei Santi', *Art History* 2 (1979), 291–317;
 Paola Mattiangeli, 'Annio da Viterbo ispiratore di cicli pittorici', in Giovanni Baffoni
 and Paola Mattiangeli, eds, *Annio da Viterbo: Documenti e ricerche* (Rome Consiglio
 nazionale delle ricerche: Multigrafica, 1981), vol. II, 257–303; Curran, *Egyptian
 Renaissance*, 107–31 (rich in bibliographical references).

surprising omission, although neglect of the dismemberment is recurrent in the critical tradition on Pinturicchio's cycle. Saxl simply appears to be keen to stress that Pinturicchio, through the Osirian myth, intended to trace the origins of the Borgia family to the most ancient civilization of the world, which even predated that of the Greeks. I believe we should also note that the Osirian myth was not simply etiological, but served as a propagandistic narrative of the Borgias' perpetuity. Nobody will destroy their political power. No division, no enemy will prevent that family from becoming eternal. Indeed, division can only increase their strength and lead to triumph. This is the ultimate meaning of the cycle. We can fully grasp it only if we keep in mind that the dismemberment, as I have shown in this chapter, is the most characteristic bugbear of the Renaissance mind. The paintings have got a propitiatory, apotropaic function. Through them, Alexander VI aims to exorcize his fear of political catastrophe, which is characteristically represented as dismemberment. We should also consider that, far from being purely symbolic, the physical laceration of the opponent was common practice in the Borgia family. Alexander VI's son, Cesare Borgia, the duke of Valentino, had his chief minister in the Romagna, Remirro de Orco, brutally mutilated and displayed on the public square, so that everyone could see. This is Machiavelli's account of the event in his diplomatic legations of 1502 (26 December):

> Messer Rimirro questa mattina è stato trovato *in dua pezi* in su la piaza dove è anchora; et tucto questo populo lo ha possuto vedere; non si sa bene la cagione della sua morte, se non che li è piaciuto così al Principe, el quale mostra di sapere *fare et disfare li huomini* [my italics] ad sua posta, secondo e' meriti loro.

> [Messer Rimirro this morning was found *in two pieces* in the piazza where he still is at the moment; and the whole populace was able to see him; the reason for his death is not known, except that such was the pleasure of the Prince, who shows that he knows how to *make and break men* as he wishes, according to their merits.]

Machiavelli provides a more succinct, but no less significant version of the same episode in the *Principe*:

[Il duca] lo fece, a Cesena, una mattina mettere *in dua pezzi* [my italics] in su la piazza, con uno pezzo di legne e uno coltello sanguinoso accanto: la ferocità del quale spettaculo fece quegli popoli in uno tempo rimanere satisfatti e stupidi. (VII, 28)

[One morning in Cesena [the duke] had him cut in *two pieces* in the piazza, with a piece of wood and a bloody dagger next to him; and the ferocity of this spectacle made that populace at once satisfied and stupid.]

In conclusion, in Pinturicchio's cycle, Osiris does embody the civilizing ruler, the inventor of agriculture and the resurrected bull, as art historians claim on the basis of what the frescoes literally depict, but he also and above all represents the triumph of dynastic ideology over political vulnerability; of unity over division, that is the most quintessentially Renaissance mythology, both in philology and in politics.

3 Renaissance Economies: Markets, Tastes, Representations[1]

Introduction

When in 1501 the merchant banker Alessandro Gondi ordered four Oriental rugs from his Florentine correspondent Niccolò Carsidoni, who was active in Pera, he not only referred to a well-established mercantile network, but he also had in his mind to fashion his domestic environment. In his letter to Carsidoni he explained:

> But I might ask you to send the said things to me via Ragusa and Ancona [...] one rug for a large bed. This rug shall be fine and beautiful as much as possible, but it should not be a top quality item. It shall be made of hair, 5 2/3 *braccia* long and refined in so far you would judge it to be due for a person like me (i.e. at the same status) and for a nice room.[2]

Gondi belonged to a Florentine elite family. He had clear ideas about the practices of display and, hence, he described the objects he wanted

1 This essay derives from my current work on a project funded by the German Research Foundation (*Deutsche Forschungsgemeinschaft: DFG*) 'Markets – Networks – Spaces' and is by no means an exhaustively elaborated article on the main subject. Here I am trying to give some insights based on some documentation collected from the archives I am working on.

2 Marco Spallanzani, *Oriental Rugs in Renaissance Florence* (Genova: 2007), doc. 115, 128: 'Ma vorrei che dette chose mi mandassi per via di Rauggia e d'Anchona [...] Uno tapetto per uno letuccio, che sia fine e bellissimo quanto può esere, non però chosa in superllativo grado. Che sia di pello, lungho braccia 5 2/3 e sie una opera bella, come giudichate vogli uno letuccio per uno mie pari e una bella chamera.'

to have for his own household in well-defined terms of quality. In this case he even tells Carsidoni to send the goods on the overland route from Constantinople to Ragusa, by ship to Ancona, and on mule back to Florence. Alessandro's uncle Giuliano, a wealthy silk merchant, had begun to build a fashionable Renaissance palace in 1490 and left the unfinished edifice to his children when he died some months before the cited letter was sent.[3] The prosperous Gondi family obviously had developed a keen sense of social distinction by ostentatiously elaborated façades and objects of domestic culture.[4]

The few lines quoted here introduce two perspectives on economies. Firstly, Gondi's order exemplifies a specific demand which promotes the creation of markets, in this case of markets for Oriental rugs as a particular item of domestic interior. This kind of demand shaped a specialized commercial segment, the Levantine trade. Secondly, it points to relations between markets, constituting the structures of distribution and supply. The cited letter addresses an agent in Pera and prescribes the overland trade route as the best transport option, geographically speaking.

These two aspects of Renaissance markets, viewed from the demand-side and from the supply-side, may lead to a more general question: what is the economic history of the Renaissance, now? (If there is any economic history of *the* Renaissance at all.) Was there a specific Renaissance economy

3 Andreas Tönnesmann, *Der Palazzo Gondi in Florenz*, Römische Studien der Bibliotheca Herziana 1 (Worms: 1983), 17–20, 26, 32. The exact situation of the construction works in 1501 is not clear. However, the architect, Giuliano da Sangallo, was one of Lorenzo de' Medici's favoured artists and probably was conveyed to Giuliano Gondi by Lorenzo himself.

4 Michael Lingohr, 'The Palace and Villa as Space of Patrician Self-Definition', in Roger J. Crum and John T. Paoletti (eds), *Renaissance Florence. A Social History* (Cambridge: 2006), 240–72, here 262. Roger J. Crum/John T. Paoletti, '"... Full of People of Every Sort": The Domestic Interior', in Roger J. Crum and John T. Paoletti (eds), *Renaissance Florence. A Social History* (Cambridge: 2006), here 288. James R. Lindow, *The Renaissance Palace in Florence: Magnificence and Splendour in Fifteenth-Century Italy* (Aldershot: 2007).

which, in the present case, requires a specific set of historical approaches and questions?[5]

The discussion on Renaissance economic history appears twofold. On the one hand it introduces a broader view about economic history and asks how historical economies might be analysed. On the other hand it concerns the specific character attributed to, and the perception of, the Renaissance.

In 1998 Lauro Martines published a review article on the books by Lisa Jardine *Worldly Goods* (1996) and by Richard Goldthwaite *Wealth and the Demand for Art in Italy* (1993) and subjected the two works to a harsh critique, arguing that they posit the anachronistic model of a 'consumer society' for the interpretation of Renaissance economy.[6] Two of Martines' points are very well taken. On the one hand he objects to the narrow concept of economy which is associated with a rather Italian elite perspective. Indeed, there is no doubt that a main characteristic of what we call the Renaissance was that it was an elite culture. And considering that the Renaissance was an elite phenomenon, economically speaking we are dealing mostly with the high end of markets. Economic history in general has shown that the period between 1300 to 1600, which is usually taken for the core phase of the Renaissance, is not entirely shaped by specific Renaissance phenomena. Instead, the economic situation takes momentum from various trends such as the evolution of literacy and accounting technology or the technological development in agriculture. A 'standard' discussion of the said period would refer to the Black Death and the economic downturn during these years.[7] More than 80 per cent of the rural economy is

5 Robert S. Lopez, 'Hard Times and Investment in Culture', in Karl H. Dannenfeldt (ed.), *The Renaissance – Medieval or Modern?* (Boston: 1959), 50–61. Carlo M. Cipolla, 'Economic Depression of the Renaissance?', in *Economic History Review* 16 (1964), 519–24.

6 Lauro Martines, 'The Renaissance and the Birth of Consumer Society', *Renaissance Quarterly* 51 (1998), 193–203.

7 Stephan R. Epstein, 'L'economia italiana nel quadro europeo', in Franco Franceschi, Richard A. Goldthwaite and Reinhold C. Mueller (eds), *Commercio e cultura mercantile*, Il Rinascimento italiano e l'Europa 4 (Treviso: 2007), 3–47, here 10–27. William Caferro, *Contesting the Renaissance* (Chichester 2011), 131–8. Cf. Lopez, 'Hard Times' and Cipolla, 'Economic Depression'.

basically not integrated into the concept of a Renaissance economy, nor is the everyday reality of most of the population, who were suffering from frequently recurring epidemic disease or the pressing rigours of warfare.[8]

On the other hand Martines suggests that there is no sense in speaking of 'the one' Renaissance.[9] We may agree. In any case, my hypotheses are that Renaissance cultures are distinguished from other styles of culture, or cultural behaviour, mainly by the characteristics of a visual culture fostered by a distinct 'habitus' of representation.[10] My use of the plural in 'economies' emphasizes that a discussion of the Renaissance economy faces us with a kaleidoscopic picture of various economies – Martines is correct to doubt the generality of the elite economy. Here, I am echoing the former debate and will concentrate on what Martines left out in exploring the early modern economies of 1300 to 1600: 'Renaissance now!'

The point I want to make here is that there were Renaissance economies with their specific markets, dealing with the context of typical Renaissance demand and thus requiring an analysis of the respective markets and supply.[11] I propose to use the term 'Renaissance' as Philip Sohm uses the term 'styles' in a broader, art historical context 'less [...] as concept than as a heuristic that enables us to perform analytic functions'.[12]

The search for Renaissance economies and Renaissance economic history will be carried out in three parts. The first describes some conditions of Renaissance economies, and, hence, focuses on consumption as

8 William Caferro, 'Warfare and Economy in Renaissance Italy, 1350–1450', *Journal of Interdisciplinary History* 39 (2008), 167–209.

9 This way of discussion has a long tradition: one of the most illuminating essays on this debate is by Johan Huizinga, 'Het Probleem der Reniassance', in Johan Huizinga, *Verzamelde werken* (Haarlem: 1949), IV, 231–75.

10 Michael Baxandall, *Painting and Experience in Fifteenth Century Italy. A Primer in the Social History of Pictoral Style* (Oxford: 1972), chapter 2. See Stephen Greenblatt, *Renaissance Self-Fashioning from More to Shakespeare* (Chicago: 1980).

11 So the rural economies, for example, form another history which only chronologically coincides with the Renaissance period.

12 Philip Sohm, *Style in the Art Theory of Early Modern Italy* (Cambridge: 2001), 9.

a configurative tendency of the demand end of the market model.[13] The second part turns to goods and distribution networks as key features of the organization of economies and markets. We will pay particular attention to two products, namely, silk thread and Oriental rugs. Referring to some documentation from Tuscan archives, we will highlight aspects of Renaissance economies that are of interest for economic history. The third part discusses the specifics of Renaissance economies.

1. Conditions and Consumption

Two factors are fundamental to economic development from the thirteenth to the sixteenth century. The first is the emergence of networks of trade.[14] The rise of long-distance trade during the period we usually call 'Commercial Revolution' was a result of the evolution in technology and logistics. Particularly the density of the communication system – here the role of literacy comes in – and the development of accounting methods are symptoms of technological advancement.[15] The web of trade routes and the invention of efficient means of transport show the gradually enhanced

13 Richard A. Goldthwaite, 'Economic Parameters of the Italian Art Market (15th to 17th Centuries)', in Marcello Fantoni, Louisa Matthew and Sara F. Matthews-Grieco (eds), *The Art Market in Italy (15th–17th Centuries) – Il mercato dell'arte in Italia (secc. XV–XVII)* (Ferrara: 2003), 423–44, here 425.

14 Lisa Jardine, *Worldly Goods. A New History of the Renaissance* (New York: 1996): Jardine makes two chapters from this observation: one on Levantine trade ('Conditions for change: Goods in Profusion'), the other on flourishing courts ('The Price of Magnificence'). She takes both from Richard Goldthwaite but without quoting. Cf. Richard A. Goldthwaite, *Wealth and the Demand for Art in Italy, 1300–1600* (Baltimore/London: 1993), 39–46.

15 The matrix of literacy and technological evolution like juridical instruments and contract law is held to be the most important indicator of this distinctive process: Franz-Josef Arlinghaus, *Zwischen Notiz und Bilanz: Zur Eigendynamik des Schriftgebrauchs in der kaufmännischen Buchführung am Beispiel der Datini/di*

performance of logistics. Levantine trade in particular became a major component of Italian and European economies from the later middle ages onwards.[16] Cultural skills, maritime technologies and a certain accumulated experience were needed for the import of raw silk, the production of silk cloth and the distribution of high quality silk goods. An essential challenge was the long time lapse from investment for acquisition of raw silk to the profit from sales of the expensive product. This explains why most of the merchants active in the silk business operated as international bankers at the same time.[17] The distribution of luxury goods like silk cloth required networks for contacting wealthy and aristocratic consumers.[18]

Secondly, the accumulation of wealth made possible the purchase of refined products and investment in socially relevant display. During the fifteenth century a unique accumulation of wealth in the hands of urban elites and courts took place.[19] Particularly Italian merchant bankers,

Berto-Handelsgesellschaft in Avignon (1367–1373), Gesellschaft, Kultur und Schrift. Mediävistische Beiträge 8 (Frankfurt am Main: 2000).

16 See Paola Lanaro, 'At the Centre of the Old World. Reinterpreting Venetian Economic History', in Paola Lanaro (ed.), *At the Centre of the Old World. Trade and Manufacturing in Venice and the Venetian Mainland, 1400–1800*, Centre for Reformation and Renaissance Studies. Essays and Studies 9 (Toronto: 2006), 19–69. See Heinrich Lang, 'Levantehandel', *Enzyklopädie der Neuzeit*, VII (Stuttgart: 2008), coll. 856–60.

17 Bruno Dini, 'Aspetti del commercio di esportazione di panni di lana e di drappi di seta fiorentini in Costantinopoli, negli anni 1522–1532', in Luigi De Rosa (ed.), *Studi in memoria di Federigo Melis* (Naples: 1978), IV, 1–52. The most up-to-date introduction to the Italian silk trade: Sergio Tognetti, 'I drappi di seta', in Franco Franceschi, Richard A. Goldthwaite and Reinhold C. Mueller (eds), *Commercio e cultura mercantile* (Il Rinascimento italiano e l'Europa 4 (Treviso: 2007), 143–70.

18 Richard A. Goldthwaite, *The Economy of Renaissance Florence* (Baltimore: 2009), 162–7.

19 We may note that there are two diametrically diverse views of the economic development during the late fourteenth and early sixteenth century: the Lopez-hypothesis refers to shrinking economic volumes. However Richard Goldthwaite is the protagonist of an optimistic view which I am referring to. It seems very likely that the elites cited by Goldthwaite were able to accumulate means in their hands and, hence, became decisive groups of consumers.

patricians and ennobled citizens, experienced a striking growth of financial and material means at their disposal. Lords like the Gonzaga of Mantua or the Montefeltro of Urbino profited from their mercenaries' wages.[20] French or Burgundian nobles and courts formed another distinguished and wealthy group of consumers.[21] Even if we reject the assumption of an economic dynamic after the crises of the fourteenth century being the result of 'creative destruction',[22] we can confidently situate a recovery of the economic situation at latest from the middle of the fifteenth century onwards. Economic growth can be observed in Flanders, South Germany and also France.[23] A socially broader consumption in Nuremberg around 1500 is a symptom of the same process of a prospering economic situation in so many towns all over Europe.[24]

20 Elisabeth Ward Swain, 'The wages of peace. The condotte of Lodovico Gonzaga, 1436–1478', *Renaissance Studies* 3 (1989), 443–52. Bernd Roeck, 'Krieg, Geld und Kunst. Federico da Montefeltro als Auftraggeber', in Wilfried Feldenkirchen, Frauke Schönert-Röhlk and Günther Schulz (eds), *Wirtschaft, Gesellschaft, Unternehmen. Festschrift für Hans Pohl zum 60. Geburtstag*, 2 (Stuttgart: 1995), 695–711. Bernd Roeck, 'Über den Zusammenhang zwischen Kunstgeschichte und Wirtschaftsgeschichte. Architektur und Ökonomie in der Frühen Neuzeit', in Hans-Peter Becht and Jörg Schadt (eds), *Wirtschaft – Gesellschaft – Städte. Festschrift für Bernhard Kirchgässner zum 75. Geburtstag* (Ubstadt-Weiher: 1998), 171–82. Heinrich Lang, 'Das Geschäft mit der Gewalt. Kriegsunternehmer am Beispiel der italienischen Condottieri zwischen 1350 und 1550', in Matthias Meinhardt and Markus Meumann (eds), *Die Kapitalisierung des Kriegs. Kriegsunternehmer in Spätmittelalter und Früher Neuzeit* (Berlin: LIT Verlag, forthcoming).
21 Salvatore Ciriacono: 'Per una storia di lusso in Francia', *Ricerche di storia sociale e religiosa* 1978, 181202.
22 Joseph Schumpeter, 'Die Krise des Steuerstaates', in Rudolf Hickel, Rudolf Goldscheid and Joseph Schumpeter (eds), *Die Finanzkrise des Steuerstaates. Beiträge zur politischen Ökonomie der Staatsfinanzen* (Frankfurt am Main: 1976) (1st edition 1918), 329–79.
23 Paolo Malanima, *Pre-modern European Economy. One Thousand Years (10th–19th Centuries)*, Global Economic History Series 5 (Leiden/Boston: 2009), 16 (indicator: demographic density), 246 (indicator: urbanization rates), 276–8 (indicator: general pre-industrial growth).
24 See Marco Spallanzani, 'Tessuti di seta fiorentini per il mercato di Norimberga intorno al 1520', in Renato Grispo (ed.), *Studi in memoria di Giovanni Cassandro*, Pubblicazioni degli Archivi di Stato, Saggi 18 (Rome: 1991), 995–1116. Jutta

The concept of consumption in general describes consumer behaviour as the agent of demand.[25] It explains the demand side of the traditional market model and is determined by needs and taste. The patrician's households and the princely courts, the urban and the noble palaces are emblematic sites of consumption.[26] In the simplest terms, a consumer's demand oscillates between the request for basic commodities of everyday life and the yearning for luxury goods for display-oriented events. However, specific Renaissance modes of consumption were generated by distinctive display. The core groups of the Renaissance elite – courtly and urban – seemed to define themselves by a particular 'habitus'. The self-fashioning of the Renaissance elite in their urban and courtly context involved a typical elitist eagerness to be distinctively represented on a social and a cultural level – the concept of 'habitus' as introduced by Pierre Bourdieu.[27] But this kind of 'conspicuous' consumption was not exclusively limited to the patrician elite in towns. We can observe similar tendencies among the economic (non-patrician) elite and among modestly wealthy artisans purchasing material goods for similar purposes. These tendencies were somewhat restricted by sumptuary legislation and cultural etiquette.[28]

The contexts of display were public ceremonies and publicly celebrated private rituals. Public ritual had considerable political significance for the self-representation of city states or princes' courts.[29] Rites of passage like

Zander-Seidel, 'Zeichen der Distinktion: Kleidung und Schmuck', in Daniel Hess and Dagmar Hirschfelder (eds), *Renaissance – Barock – Aufklärung. Kunst und Kultur vom 16. bis zum 18. Jahrhundert. Germanisches Nationalmuseum* (Nuremberg: 2010), 150–65.

25 Goldthwaite, 'Economic Parameters'.

26 Vivianna Zelizer, 'Culture and Consumption', in Neil Smelser and Richard Swedberg (eds), *The Handbook of Economic Sociology* (Second edition, Princeton/Oxford/New York: 2005), 331–54, here 337–9. Richard A. Goldthwaite, *The Building of Renaissance Florence. An Economical and Social History* (Baltimore: 1980).

27 See Pierre Bourdieu, *Distinction: A Social Critique of the Judgement of Taste*, trans. by Richard Nice (London: 1984).

28 Paula Hohti, '"Conspicuous" consumption and popular consumers: material culture and social status in sixteenth-century Siena', *Renaissance Studies* 24 (2010), 654–70.

29 Richard Trexler, *Public Ritual in Renaissance Florence*, 1982.

marriage ceremonies offered the opportunity for conspicuous consumption.[30] The end of Renaissance modes of consumption may be dated to a reduction of public ceremonies including entries and religious feasts on the one hand, and, on the other, a retreat of private ritual and private consumption behaviours to spaces out of the public realm and behind the walls of private dwellings.[31]

Particularly the world of paintings evidences a decisive step in the evolution of media. The turn towards the visual is the most significant aspect of the coming of the Renaissance. The transformation of elites into visually dominated cultures may be described by the 'habitus' of display. Visual representation of display in paintings was an elite phenomenon and illustrates the Renaissance style of consumption.[32]

If we take increasing consumption as an indicator of growing wealth and the progressively depicted self-representation of the urban and courtly elites by means of costly objects, Renaissance economies existed in a flourishing period of wealthy consumers and visually oriented demand.

30 Jacqueline M. Musacchio, *Art, Marriage and Family in the Florentine Renaissance Palace*, New Haven 2008. Sharon Strocchia, 'The Everyday Theatre', in Crum/John T. Paoletti (eds), *Renaissance Florence. A Social History* (Cambridge: 2006), 57.

31 It could mean the retreat to the villas as well. This is a hypothesis, for which the main literature on Renaissance Florence offers hints: Volker Breidecker, *Florenz. Oder: Die Rede, die zum Auge spricht. Kunst, Fest und Macht im Ambiente der Stadt* (2nd edition, Munich: 1992). Marvin Trachtenberg, *Dominion of the Eye. Urbanism, Art, and Power in Early Modern Florence* (Cambridge: 1997), 275–83. John Najemy, 'Florentine Politics and Urban Spaces', in Roger J. Crum and John T. Paoletti (eds), *Renaissance Florence. A Social History* (Cambridge: 2006), 19–54, here 48–54. Lingohr, 'The Palace', 270–2.

32 Paolo Malanima, *Pre-modern European Economy. One Thousand Years (10th–19th Centuries)*, Global Economic History Series 5 (Leiden/Boston: 2009), 318–19.

2. Goods and Distribution Networks

Conditions and consumption frame an economy's components including production. We thus now move our focus from the demand side of the traditional market model to the supply side. Again, we do not use the market model as a binding concept, but as a heuristic instrument helping us to get a view of what is going on. Since markets are central to economies, we are particularly interested in how markets are constituted and we shall pose questions about their structure and realities. Starting with Renaissance consumption and its conditions, we now look at particular products as operators in order to analyse and interpret markets and their existence, and hence, economies.[33]

The movement of goods in exchange, and the distribution networks connecting supply and demand – such is the economic arena we simply call markets – will be described by following the product lines of silk cloth and Oriental rugs.[34] Account books of Florentine merchant bankers, for instance, provide rich proxy data which allow us to reconstruct mercantile networks. In this context networks are understood as social and economic processes that overlap, support and complement simple business contacts in reference to markets. Consequently, our sketch of Renaissance economies focuses on the agents of supply, the places of supply, the methods of exchanging values, production, qualities of goods and the customers as agents of demand.[35]

33 Particularly on product lines as heuristic operators: Christof Jeggle, 'Economies of quality as a Concept of Research on Luxury', in Rengenier C. Rittersma, ed., *Luxury in the Low Countries. Miscellaneus Reflections on Netherlandish Material Culture, 1500 to the Present* (Brussels: 2010), 25–44.

34 On the product line as analytic instrument for 'reading' markets: Jeggle, 'Economies of quality', 32–4.

35 See Jens Beckert, Rainer Diaz-Bone and Heiner Ganßmann, 'Einleitung. Neue Perspektiven für die Marktsoziologie', in Jens Beckert, Rainer Diaz-Bone and Heiner Ganßmann, eds, *Märkte als soziale Strukturen* (Frankfurt am Main: 2007), 19–39.

In this case study what is known about the merchant bankers dealing with silk cloth and Oriental rugs depends upon documentation in the Tuscan archives.[36] Mainly Florentine, Lucchese and Venetian merchants and their agents in the upper layer of business partnerships supplied the Italian and transalpine markets with raw silk, silk cloth and Oriental rugs. Particularly the Venetians dominated the Levantine trade for some centuries and transferred bales of raw silk from East to West.[37] The Datini archives with their masses of bundles of letters exemplify the enormous significance of the silk cloth trade for Tuscan merchant bankers and shows the importation of rugs to Italy.[38]

The fairs held in Lyons were major distribution events in Europe, and the markets there were amongst the most prominent for each economic sector, such as commerce and banking in general. Since the 1460s when Italian merchant bankers were especially attracted by the privilege conceded by the French king Louis XI, the flourishing town on the banks of the Rhône had gained its favourable position in the European web of trade.[39] In his study on the economy of Renaissance Florence, Richard Goldthwaite persuasively proposes Lyons as the most important node in the Florentine business network abroad during the later fifteenth and throughout the sixteenth century.[40] The business affairs of the Salviati family, which I take as an example, clearly confirm these assumptions: Iacopo and his cousin Alamanno Salviati were able to take advantage of a well-established network

36 See Heinrich Lang, 'Teppiche', *Ezyklopädie der Neuzeit*, XIII, Stuttgart 2011, coll. 366–9.

37 The company run in Lyons in the name of Antonio Gondi during the early decades of the sixteenth century clearly exemplifies this general observation: Archivio di Stato di Firenze, Gondi, 7 (1517–1519: *Libro Grande Debitori e creditori segnato E*). We find references to these ledgers in Roberta Morelli, *La seta fiorentina nel Cinquecento*, Milan 1976. Dini, 'Aspetti del commercio', 1–52.

38 Federigo Melis, *Aspetti della vita economica medievale (studi nell'Archivio Datini di Prato)*, Siena 1962. Spallanzani, *Oriental Rugs*, 80–7.

39 Richard Gascon, *Grand commerce et vie urbaine au XVIe siècle. Lyon et ses marchands (environs de 1520 – environs de 1580)* (Paris: 1971), 57–9.

40 Goldthwaite, *The Economy of Renaissance Florence*, 162–7.

of business partners when they decided to set up a branch in Lyons.[41] A
close study of the Florentine merchant bankers Averardo and Piero Salviati
e compagni – the Salviati enterprise continued to exist bearing this name by
then – for the period from the Easter fair in 1534 to the Easter fair a year
later demonstrates the relative importance of silk for Italian merchants who
were involved in international commerce and banking.[42] Whereas trade in
Oriental rugs forms a negligible quantity, the goods of the silk sector alto-
gether amount to nearly 50 per cent of the whole volume of trading. While
about 25 per cent was in raw silk, the remaining share refers to various kinds
of silk cloth, most of it imported from Florence.[43] These findings could be
confirmed either by long term analysis of the Salviati account books or a
more general study on some other Florentine or Lucchese merchant bank-
ing enterprise.[44] If we compare a South German company like the Tucher
from Nuremberg to these data, we find similar tendencies. Throughout the
sixteenth century Lyons appears to be the most important point of refer-
ence for commerce, government finance and credit to such Nuremberg

41 See Valeria Pinchera, 'L'Archivio Salviati. La storia degli affari attraverso un Archivio
 familiare', *Società e storia* 13 (1990), 979–86. Agnes Martin-Pallini, 'L'installation
 d'une famille de marchands-banquiers florentins à Lyon au début du XVIᵉ siècle, les
 Salviati', in Jean-Louis Gaulin/Susanne Rau (eds), *Lyon vu/e d'ailleurs (1245–1800):
 échanges, compétitons et preceptions*, Collection d'histoire et d'archéologie médiévales
 22 (Lyon: 2009), 71–90.
42 Archivio Salviati, I, 522 (*Libro Debitori e creditori segnato M*). Heinrich Lang,
 'Herrscherfinanzen der französischen Krone unter Franz I. aus Sicht italienischer
 und oberdeutscher Bankiers. Die Rolle der Florentiner Salviati als Financiers der
 französischen Regierung', in Peter Rauscher, Thomas Winkelbauer (eds), *Das Blut
 des Staatskörpers. Forschungen und Perspektiven zur Finanzgeschichte der Frühen
 Neuzeit* (Vienna: forthcoming).
43 Archivio Salviati, I, 522 (*Libro Debitori e creditori segnato M*). Heinrich Lang,
 'Seide aus Florenz. Eine Luxusindustrie am Beispiel der der Florentiner Salviati im
 16. Jahrhundert', in Mark Häberlein, Markwart Herzog, Christof Jeggle, Martin
 Przybilski, Andreas Tacke (eds), *Luxusgegenstände und Kunstwerke vom Mittelalter
 bis zur Gegenwart: Produktion – Handel – Formen der Aneignung* (Konstanz:
 forthcoming).
44 Gascon, *Grand commerce*.

merchants as the Imhoff, the Baumgartner or the Tucher.[45] They came to Lyons particularly to buy silk cloth sold there. The secret account book that Andreas Imhoff kept during his sojourn on the banks of the Rhône in 1520/21 is a good example showing the acquisition of silk cloth either for distribution or for personal use.[46]

However, in contrast to the traditionally accepted view of the Lyons fairs, the markets there in fact were markets of brokers and distributors. Raw silk and Oriental rugs imported by the Salviati company were mostly sold on commission and were not passed on directly to consumers. The most widespread distribution model was business-to-business. French merchant bankers bought nearly all bales of raw silk shipped to the Rhône gateway and provided production facilities in France. The Spanish raw silk which was further processed by Tuscan spinners and weavers arrived at the port in Pisa and was handed over to the bankers' own business partners.[47] According to the Salviati sources the distribution of Oriental rugs was about the same. They were brought to Lyons in bundles and sold to partners, for example, the thirteen rugs which were purchased by the Florentine merchant Neri Ventura in early 1533/34.[48]

Raw silk was mainly produced in Spain and Southern Italy. The company of Francesco Davanzati and Averardo Salviati which belonged to the Salviati business partnership agglomerate operating in Naples, purchasing raw silk which would be sent to Florence. Its agents travelled to Calabria where they bought the expensive material and organized the transfer to Florence via Livorno or Pisa.[49]

45　Michael Diefenbacher, '*Je lenger, je unfleysiger*. Sebald X. Tucher und die Niederlassungen der Tucherschen Handelsgesellschaft in Genf und Lyon in der ersten Hälfte des 16. Jahrhunderts', in Axel Gotthard, Andreas Jakob and Thomas Nicklas (eds), *Thomas Studien zur politischen Kultur Alteuropas. Festschrift für Helmut Neuhaus zum 65. Geburtstag*, Historische Forschungen 91 (Berlin: 2009), 359–402.

46　Germanisches Nationalmuseum Nürnberg, Adelsarchiv Imhoff, Rep. 1, Fasc. 46, No. 1 (*Geheimbuch des Andreas Imhoff, Nürnberg*), 1519ff.

47　Lang, 'Seide aus Florenz'.

48　Archivio Salviati, I, 522, fol. 135.

49　Lang, 'Seide aus Florenz'.

The case of the transfer of raw silk from Almeria to Lyons provides a rough impression of the organization of distribution and the typical structures. In 1534 the exporter Marchiot Carrión from Seville chooses a syndicate which he joins in order to sell four bales of raw silk. Together with the heirs of Francisco de Salamanca and Alvaro de Sandoval and company from Burgos he sells his wares to the Salviati on 3 November, from whom he receives 4,739 *Livres* for the physical goods and services.[50] While the proportion of raw silk imported to Europe from the Levant was constantly shrinking at the beginning of the sixteenth century, prestigious silk cloth was still an important commodity in the exchange between East and West.[51] The trade ships travelling back and forth were loaded with various kinds of cloth to a large degree – woollen cloth to the East, silk fabrics like *cambellotti*[52] [camlets] to the West. Those from the Levant supplying the markets in Lyons carried raw silk (particularly yellow raw silk) to the monetary value of two fifths of their cargo. Evidence for this comes from lists of items transported on the *Restina*, a ship sailing on the Salviati's behalf in 1539/40.[53]

The acquisition of seventeen Oriental rugs in 1542 by the Salviati company in Lyons exemplifies the spatial and business organization of the import of goods from the Levant. Iacopo Capponi is the exporter resident in Pera who buys rugs from Turkish dealers and sends them westward. An agent and colleague, Amiel Albertas from Marseilles, is employed by the Salviati company of Lyons. Albertas puts them into contact with the ship owner and arranges the dispatch of the Levantine goods. In Lyons, the director of the Salviati company, Lionardo Spina, is commissioned to sell the items.[54]

50 Archivio Salviati, I, 522, fol. 131.

51 Dini, 'Aspetti', 1–52.

52 Antonia Licatese, *Stoff- und Seidenbezeichnungen im mittelalterlichen Italien* (Saarbrücken: 1989), 158–60, here 212–17.

53 Archivio Salviati, I, 537 (*Libro Debitori e creditori segnato O*), fol. 182, fol. 182r, fol. 320, fol. 320r.

54 Archivio Salviati, I, 544 (*Libro Debitori e creditori segnato Q*), fol. 318 (*Tappeti di Turchia di n(ost)ro conto*).

If we retrace Oriental rugs to their provenance, we end up concluding that the silk rugs of the mid-sixteenth century originated in Persia. There an experienced labour force was locally organized and rugs were woven by hand. Italian agents in Pera, Beirut and Alexandria had no direct contact with workshops. They bought and ordered rugs from intermediaries or distributors.[55]

Oriental rugs like other goods from the Levant travelled on two main trade routes to Lyons: One was the overseas route from Alexandria, Beirut or Constantinople (to mention the three most important Oriental gateways) directly to Livorno or Pisa, and to Marseilles where they were shipped along the Rhône. The alternative was overland from Constantinople to Ragusa by caravan, where cargo then went by ship to Ancona, crossed the Italian peninsula, and went again by ship from Pisa to Marseilles. At the ports of Livorno, Pisa and Marseilles loads were usually unpacked, sorted according to trading marks and orders, and tied again.[56]

A famous centre for the production of silk cloth was Florence. During the fifteenth and sixteenth centuries the processes of manufacturing and refining silk cloth took place within the city walls. Spinning and dyeing were low-qualified jobs and mostly women worked as spinners. Weaving, by contrast, was very specialized work carried out by expert weavers. Particularly the design of patterns required artistic intervention and a skilled working force. The most expensive part of production was the gold embroidery which was connected with the *battiloro* companies.[57]

Silk fabrics varied widely. Places of provenance signalled the quality of the producers and therefore dictated prices. The paintings of the fifteenth and sixteenth centuries show a growing diversity of types and patterns, and simultaneously an increasing attention paid to silk cloth and its elaboration. Because of the high expenditure on the materials needed, the complex

55 Lang, 'Teppiche'. Kurt Erdmann, *Der Orientalische Knüpfteppich. Versuch einer Darstellung seiner Geschichte*, Tübingen 1955. Spallanzani, *Oriental Rugs in Renaissance Florence*, 11–12, 18–24.
56 Spallanzani, *Oriental Rugs in Renaissance Florence*, 12–18.
57 Tognetti, 'I drappi di seta'.

processes of production and the long cycles from investing to vending, silk belonged to the high price segment.[58]

Oriental rugs were differentiated according to a few categories. Two indicators were the most significant issues. On the one hand the rug size, and on the other, the commission being asked. Most rugs were in the 2 to 2.5m and 2.5 to 3m size groups.[59] The rugs documented by the Salviati archives were not commissioned, but imported in dozens and not very expensive individually.[60]

At the demand end, consumers decided on the consequences of distribution and articulated the needs to which the supply attempted to respond in the marketplace. The tiny group of consumers who were able to spend on silk cloth and Oriental rugs was constituted by three main groups. Firstly, there were the urban elites such as patrician merchants from Lyons and from cities in Flanders, Italy and Southern Germany. Secondly, there were church dignitaries, clerics, and religious institutions. Thirdly, there were the nobility and courts.[61] However, domestic goods and rich cloth also formed part of considerable secondary or second-hand markets. Consumers among the wealthy urban artisans – belonging therefore to lower social layers – nevertheless might aim to purchase objects of 'conspicuous' consumption. If they were not able to afford brand-new goods, they looked to the supply available on second-hand markets.[62]

Urban elites comprised merchants who were distributors as well as consumers of luxury goods. This was the case with the patricians of Italian cities as well as those of French and Southern German ones. The Florentine

58 Lisa Monnas, *Merchants, Princes and Painters. Silk Fabrics in Italian and Northern Paintings 1300–1550*, New Haven/London 2008, 41–65, chapter 3 and 4.

59 Spallanzani, *Oriental Rugs in Renaissance Florence*, 41–8.

60 Many of the Oriental rugs were transferred by Ragusian intermediaries like Iacopo Dantichio who appears prominently on the Salviati's behalf during the 1530s: Archivio Salviati, I, 508 (*Libro Debitori e creditori L*), fol. 221–221r.

61 Spallanzani, *Oriental Rugs in Renaissance Florence*, 29–40. Lisa Jardine for some reason concentrates on the 'leisure class' only, the courts: Jardine, *Worldly Goods*, chapter 'Conspicuous Consumption'.

62 The secondary and second-hand markets played for all consumers a role which can hardly be overrated: Hohti, 'Material culture', 659–63.

merchants Torrigiani, Antinori and Olivieri expanded their silk export business to Nuremberg in the early years of the sixteenth century and were present there for some decades.[63] City states like Florence, Siena, Augsburg and Nuremberg had patrician burgher governments which at the same time were commissioners for silk cloth and Oriental rugs. The display of valuable objects had a serious political impact; the ceremonies of urban public life are to be read like comprehensive systems of signs that were animated by collective representation. Hence, sumptuous objects were needed to meet expectations. In consequence, city states' governments were an attractive consumer group to be supplied with silk fabrics and rugs – expensive hangings, decorative furnishings of public or government buildings and costumes for dignitaries.[64]

The church was an important consumer in every way. Its need for representation and possession of rich objects was immense. The performance of masses and processions by clergy required respectable robes and had to be framed by valuable and decorative visual programmes (for example altar hangings, floor cover, retables). Monasteries, churches and chapels had to be well equipped and furnished. Religious endowments invested in objects which were placed in church halls.[65]

Courts and nobles formed another key group of consumers for silk cloth and Oriental rugs. The many Italian lords needed rich silk vestments for representation.[66] Particularly the French aristocracy was a growing milieu of wealthy consumers supplied by Italian merchants who had moved to Lyons and Paris.[67] One of the few cases allowing us to follow the path of a particular rug from its entrance into the Italian merchant banker's orbit all the way to the consumer's hands may be distinctly seen through the lens of the account books: In May 1533 Lionardo Spina, the director of the Salviati company resident in Lyons from 1518 to 1561, negotiated with

63 Francesco Guidi Bruscoli, 'Drappi di seta e tele di lino tra Firenze e Norimberga nella prima metà del Cinquecento', *Archivio Storico Italiano* 159 (2001), 359–94.
64 Spallanzani, *Oriental Rugs in Renaissance Florence*, 29–36, 49–54. See Trexler.
65 Spallanzani, *Oriental Rugs in Renaissance Florence*, 38–40, 49–54. See Trexler.
66 Monnas, *Merchants, Princes and Painters*, chapter 1.
67 Goldthwaite, *The Economy of Renaissance Florence*, 162–7.

Philippe Chabot, Seigneur de Brion at d'Aspremont and Grand Admiral of King Francis I, about the price of an Oriental rug that probably had been ordered by Chabot.[68] Oriental rugs were not quite a speculative commodity. Profit margins were tiny. Lionardo Spina preferred to take *uno pezzo di domasco veneziano* [a piece of Venetian damask] valued at 75 lbs in exchange for the twenty-two Oriental rugs which he was trying to get rid of in late 1534 and early 1535.[69]

This last point brings us back to the question about agents involved in connecting production, supply, distributers, and consumers:[70] In Constantinople and Pera some Italian merchant bankers constituted a diaspora and functioned as agents for acquisition and orders, like the Niccolò Carsidoni mentioned above. They operated at the interface between the Christian and the Muslim world. A group particularly focusing on the Levantine trade were the Ragusian merchants.[71] When Oriental rugs were brought by the overland route passing Ragusa and were shipped to Ancona, Ragusians intervened as organizers of the shipment. The Salviati company maintained a good relationship with Iacopo Dantichio who was the intermediary for Oriental rugs transferred to Lyons in 1534.[72] In France Piero Spina, Lionardo's brother was *Hoffaktor* ['purveyor to the court'] and middleman for the sale of luxury goods and for the credit business. He stayed with the French court on the Salviati's behalf and gained the required trust for delicate financial deals the Salviati sought with the king. One of his tasks was the consignment of valuable items like silk fabrics to members of the French court.[73]

68 Archivio Salviati, I, 522, fol. 222: (*Ill. Signore Filippo de Cabot Ghrande amiraglio di Franc[i]a*).

69 Archivio Salviati, I, 522, fol. 137 (*Drappi di più sorte di nostro conto auti in baratto di tapetti*). Marco Spallanzani observes the same economic conditions considering his collection of documents: Spallanzani, *Oriental Rugs in Renaissance Florence*, 41–6.

70 See Jeggle, 'Economies of Quality', 32–4.

71 Spallanzani, *Oriental Rugs in Renaissance Florence*, 21–4.

72 Archivio Salviati, I, 522, fol. 7r: Iacopo Dantichio (Importer), Salviati (*a commissione*), sale to Filippo Strozzi e co: *4 tapetti/lib 27*.

73 Lang, 'Herrscherfinanzen'.

3. Renaissance Economies

The two previous sections refer to the demand and supply sides of the market model. Particularly the organization of supply has been discussed following two product lines and this has led to a reflection on the emergence of specialized markets and the agents working in them (in a very impressionistic manner). The question to ask now is about the link connecting consumption to markets on the one hand, and to economies in general on the other. What was the specific quality of *the* Renaissance which led to a typical Renaissance way of consumption and, thus, to specialized markets? And why is this specific style of economies to be distinguished from other economic developments which continued during the Renaissance?

The most significant change which characterizes the Renaissance style in contrast to whatever had been before is the appearance of decorative objects like silk cloth and Oriental rugs in visual representations – in addition to the more anthropocentric forms which are depicted. In this regard we may take iconographic changes in paintings as indicators of cultural change. Making the world visual is the main feature of representations which could be defined as particularly characteristic of the Renaissance.[74] The incentive for the elaborate and 'conspicuous' way of consumption is articulated by Giovanni Pontano in his treatise *De splendore* in 1498:

74 Peter Burke, *The Italian Renaissance. Culture and Society in Italy*, Princeton 1972, chapter 'Taste'. Peter Burke cites treatises on art and beauty which introduce the importance of representation of objects: Burke, *The Italian Renaissance*, 144–5. For the theory we may – still – refer to Erwin Panofsky, 'Iconography and Iconology. An Introduction to the study of Renaissance Art', in Erwin Panofsky, *Meaning in the Visual Arts*, Reprint (Chicago: 1982), 26–54. Francis Haskell, *History and its Images. Art and the Interpretation of the Past* (New Haven/London: 1993).

[...] the goods of the splendid man should therefore be both polished and abundant. Not only should they correspond to his wealth but also to the expectations of others and to his dignity. [...] To do this it is necessary to be ready to spend a great deal, for things that are rare and excellent come at a high price.[75]

This statement applies not only to the Neapolitan court context where Giovanni Pontano wrote his treatise. 'Splendour', a key feature of the Renaissance lifestyle and therefore a constitutive element of the Renaissance 'habitus' of consumption, was derived from Classical texts (such was the Renaissance pattern of reception and construction of a newly organized world).[76]

The turn towards the visual – as we may denominate the generative phenomenon of the Renaissance – indicates an essential change in the perceptional 'habitus', entailing also the discovery of social distinction by objects and thus making social distinctions visible. Objects like silk fabrics and Oriental rugs came into use as symbols of distinction.[77] At issue is not the mere appearance of Oriental rugs in visual representations, but the mode of perception and, thus, representation. From the fourteenth century onward we observe a change in patterns and styles of Oriental rug which evidentially came from different regions and were decorated differently. Increasing attention to the patterns on silk vestments or rugs clearly shows a growing consciousness of the representative power objects could have. Objects were charged with meaning and had to be read as symbolic texts.[78]

75 Evelyn Welch, 'Public Magnificence and Private Display: Giovanni Pontano's *De splendore* (1498) and the Domestic Arts', *Journal of Design History* 151 (2002), 223. For the context see: Hohti, '"Conspicuous" consumption', 654. Repetitions in translation reflect the original.

76 Guido Guerzoni, '*Liberalitas, Magnificentia*, Splendor: The Classic Origins of Italian Lifestyles', in Neil De Marchi and Craufurd D.W. Goodwin (eds), *Economic Engagements with Art*, Annual Supplement to *History of Political Economy* 31 (Durham/London: 1999), 332–78.

77 Rainer Diaz-Bone, *Kulturwelt, Diskurs und Lebensstil. Eine diskurstheoretische Erweiterung der Bourdieuschen Distinktionstheorie* (first edition: 2002; Wiesbaden: 2010).

78 Hohti, '"Conspicuous" consumption', 666–9. The 'different uses' ('didactic use', 'persuade') are already described in Burke, *The Italian Renaissance*, 124–2.

Visual representations explain uses of worldly goods. The famous San Marco Altarpiece of 1438–40 executed by Fra Angelico (Florence, Museo di San Marco) shows a kelim displaying geometrically arranged animals – like on the 'Annunciation' by Benozzo Gozzoli (Narni, Pinacoteca Communale).[79] These rugs serve as an elaborate stage on which the holy event is taking place.[80] They have an evident predecessor in the 'Annunciation' by Puccio di Simone, who was working in the mid-fourteenth century; there Mary is sitting on a pillow situated upon an animal patterned rug.[81] One of the most famous representations of an Oriental rug is by Hans Holbein the Younger (1497/98–1543) in 'The Ambassadors or Jean de Dinteville and Georges de Selve' dated 1533.[82] In this arrangement the meticulously depicted Oriental silk rug serves as a table cover and bears a pattern which is named after the painter: the Holbein pattern.[83] The context of the latter representation is diplomatic and noble; and both characters shown in the painting are dressed in beautifully depicted fur-trimmed silk fabrics. In the Ghirlandaio frescos in the Tornabuoni and Sassetti Chapels we are able to observe the reentrance of silk fabrics into the world of vestment representation – mainly as hats and caps.[84] At the beginning of the sixteenth century the noble class of the Medici duchy wears expensive and luxurious silk cloth to demonstrate their social and political rise.[85]

But these visual representations of worldly goods above all demonstrate a visually transformed perception, *habitus*, and a strategy of display aiming to meet the expectations of consumers – consumers who would buy the paintings and who wished to view themselves framed with their

79 Spallanzani, *Oriental Rugs in Renaissance Florence*, plate 11, 157.
80 Spallanzani, *Oriental Rugs in Renaissance Florence*, plate 10, 156.
81 Spallanzani, *Oriental Rugs in Renaissance Florence*, plate 2, 149.
82 See John North, *The Ambassadors' Secret. Holbein and the World of the Renaissance* (London/New York: 2002).
83 Spallanzani, *Oriental Rugs in Renaissance Florence*, 63–5.
84 Carole Collier Frick, *Dressing Renaissance Florence. Families, Fortunes, and Fine Clothing* (Baltimore/London: 2002), 152, 201–19.
85 Monnas, *Merchants, Princes and Painters*, chapter 6 and 7.

objects of consumption.[86] The gradual movement towards conspicuous consumption as a mode of representation is the essential development based on a visually attuned culture. The imperatives of social distinction, of course, involved the tiny top layer of society. However, this very tendency of exclusion by consumption is the essence of the turn towards the visual present in the Renaissance.[87]

In consequence, the worldly goods which were associated with the needs of visual representation could be defined as the items at the centre of Renaissance economies. The markets of textiles, decorative products, luxury goods, exotic objects and pieces of art were very specialized markets and supplied a comparably specialized demand by wealthy consumers. Hence, Renaissance economies characterize their own specific segment of late medieval and early modern European economies. Though the term 'Renaissance economies' points to a period in history which comprises the centuries between 1300 and 1600, it definitively does not subsume all economic sectors or all layers of society during that time span. Moreover, Renaissance economies describe a typical variation of markets and hint at the economic dimension of the European Renaissance. Of course, this raises the simple question: who owned the means to buy all these beautiful things, and who had to work hard to supply the sophisticated demand, who paid, how did these markets work, and so on.

Renaissance economic history views economic developments from the consumer's perspective – and, thus, is not limited to the 'birth of a consumer society'. It takes consumption as a reference point for viewing the economic processes leading to a visual turn within a nascent Renaissance society and for analysing the specific markets that supplied particular needs and that were shaped by changing tastes. Thus it is an elite perspective on economies, precisely because Renaissance society experienced an exclusionist tendency exercised by the cultural upper layer. Nevertheless, following the product line of any representative object, the whole range of the economic world unfolds. The agents in Renaissance markets could be described in

86 Baxandall, *Painting and Experience*, chapter 2: refers to 'the eyes of the contemporaries'.
87 Hohti, 'Material culture', 659–63.

the same way as the producers and the labour forces with their technical needs, or the shippers, the intermediaries and the go-betweens. The search for typical Renaissance economies and the perspective on the product lines are heuristic instruments which help to achieve a better understanding of economic history and of a cultural *époque* in history.

Conclusion: Renaissance Après Renaissance Now

Later portraits of the mid-sixteenth century like the Florentine school 'Portrait of Cardinal Marcello Cervini degli Spannocchi' (before 1555, Rome, Galleria Borghese)[88] or the portrait of Antonio Pucci executed by Pier Francesco Foschi (1540, Florence, Corsini Collection)[89] display combinations of elaborate silk clothing and robes with table coverings of Oriental rugs. These portraits show the prelates in a narrow environment, enclosed in their *studioli* behind the walls of their palazzos. Thus, these portraits illustrate the subtle process of consumer segregation. Elitist consumption retreated behind walls of gardens and palazzos. Public ritual was reduced to just princely entries and religious processions. The withdrawal of luxury and consumption into privatized areas and the iconographic programme of the Counter-Reformation put an end to the visual Renaissance 'habitus'.

The 'Later Renaissance' consumption of luxury goods like silk cloth and Oriental rugs on demand was a more exclusively aristocratic and courtly consumption. The role of merchant bankers as agents in markets slightly changed – they were not consumers at that level anymore – and the typical Renaissance specialized markets were transformed into markets of court supply.[90]

88 Spallanzani, *Oriental Rugs in Renaissance Florence*, plate 99, 235.
89 Spallanzani, *Oriental Rugs in Renaissance Florence*, plate 101, 237.
90 See John Najemy, *A History of Florence, 1200–1575*, Oxford 2006, 486–90.

We may observe a Renaissance of the Renaissance now. The post-modernist Renaissance is the 'new turn towards visual media' of the digital revolution. With its omnipresent icons, images and moving pictures it signals the reappearance of the Renaissance 'habitus' turned visual. In our day this means to be present in pictures: We do not realize this visual turn by representative objects or by representing characteristic worldly goods or symbols, but by representing ourselves in digital visuality.[91]

This iconographic development follows the logic of democracy and liberties of the twentieth century. It comprises a wider social range; in fact, the presence in the internet – the visual media in essence – is not subject to any restriction, apart from technical obstacles. It is worth revisiting the consumers' side of the market model. In the case of the new turn towards the visual, consumers are changing into 'produsers', consumption into 'pro-dusage', as Axel Bruns puts it. This means that worldly goods are changed into 'products' through the participation of consumers in the generating process.[92]

This new Renaissance will come to an end when economic mecha-nisms of exclusion begin to restrict self-representation and participation in the generating process to the few who can pay or who can bypass the technical obstacles. The visual culture of the postmodern Renaissance will be hidden away behind the virtual firewalls. And the future history of Renaissance economies will describe this characteristic economy as being the main feature of our day, now.

91 See Horst Bredekamp, 'Drehmomente – Merkmale und Ansprüche des *iconic turn*', in Christa Maar and Hubert Burda (eds), *Iconic Turn. Die Neue Macht der Bilder* (Cologne: 2004), 15–26.

92 Axel Bruns, *Blogs, Wikipedia, Second Life, and Beyond. From Production to Produsage*, Digital Formations 45 (New York: 2008), 359–405.

MAXIMILIAN SCHUH

4 Making Renaissance Humanism Popular in the Fifteenth-Century Empire: The *studia humanitatis* at the University of Ingolstadt*

The study of intellectual renewal in general and of Italian Renaissance humanism in particular usually focuses on the achievements of extraordinary protagonists – in this case, Petrarch, Coluccio Salutati, Marsilio Ficino, Leonardi Bruni, Poggio Bracciolini and others. Therefore it is no surprise that the diffusion or transfer of the *studia humanitatis* from Italy to other regions of Europe is commonly attributed to key charismatic figures. These intellectual role models with their interest in rhetoric, grammar, history, moral philosophy and poetics as well as with their enthusiasm for classical Greek and Latin language and literature allegedly inspired a large number of followers.[1] One of the most famous is Aeneas Sylvius Piccolomini, the later Pope Pius II, who brought the humanists' ideas north of the Alps to the German-speaking parts of the Holy Roman Empire.[2] In a second step some of his German followers became propagators and fervent advocates of the *studia*

* This essay presents central arguments from my doctoral thesis: Maximilian Schuh, *Aneignungen des Humanismus. Institutionelle und individuelle Praktiken an der Universität Ingolstadt im 15. Jahrhundert* (Education and Society in the Middle Ages and Renaissance 47) (Leiden: Brill, 2013).

1 Paul Oskar Kristeller, 'The European diffusion of Italian humanism', *Italica* 39 (1962), 1–20.

2 Johannes Helmrath, '*Vestigia Aeneae imitari*. Enea Silvio Piccolomini als "Apostel" des Humanismus. Formen und Wege seiner Diffusion', in Johannes Helmrath, Ulrich Muhlack, Gerrit Walther, eds, *Diffusion des Humanismus. Studien zur nationalen Geschichtsschreibung europäischer Humanisten* (Göttingen: Wallstein, 2002), 99–141.

humanitatis. Lewis Spitz, for example, identified among others Conrad Celtis as the arch-humanist, who fiercely fought for humanist renewal in Germany.[3]

At the universities in the Holy Roman Empire, however, those followers of the *studia humanitatis* were met by scholarly rejection, because academic teachers stubbornly defended the scholastic tradition. Nevertheless humanistic reason supposedly won over scholastic backwardness.[4] Since the nineteenth century, literary and historical scholarship painted this picture of events finally leading to fundamental humanistic university reforms in the sixteenth century.[5] But the concentration on the exceptional humanists' words and deeds and the uncritical assumption of their perspective on the late medieval universities caused rather prejudiced scholarly verdicts. In Gustav Bauch's book on humanism at the University of Ingolstadt published at the beginning of the twentieth century Celtis is without any question the hero of a 'humanistische Glanzperiode' [humanistic heyday].[6] That Bauch was working on an edition of Celtis's correspondence[7] may explain this concentration but does not help understand the adoption of new ideas in Ingolstadt. Students, masters and professors in Ingolstadt complained about the arch-humanist's regular absences, his drunkenness during lectures

3 Lewis W. Spitz, *Conrad Celtis. The German arch-humanist* (Cambridge, MA: Harvard University Press, 1957); Lewis W. Spitz, 'The Course of German Humanism', in Heiko A. Oberman, ed., *Itinerarium Italicum. The Profile of the Italian Renaissance in the Mirror of its European Transformations* (Studies in Medieval and Reformation Thought 14) (Leiden: Brill, 1975), 371–436.

4 For example, Gustav Bauch, *Geschichte des Leipziger Frühhumanismus. Mit besonderer Rücksicht auf die Streitigkeiten zwischen Konrad Wimpina und Martin Mellerstadt* (Leipzig: Harrassowitz, 1899); Gustav Bauch, *Die Rezeption des Humanismus in Wien. Eine literarische Studie zur deutschen Universitätsgeschichte* (Breslau: Marcus, 1903) (reprint Aalen: Scientia, 1986); Gustav Bauch, *Die Universität Erfurt im Zeitalter des Frühhumanismus* (Breslau: Marcus, 1904).

5 Ulrich Muhlack, 'Zum Verhältnis von Klassischer Philologie und Geschichtswissenschaft im 19. Jahrhundert', in Hellmut Flashar, Karlfried Gründer, Axel Horstmann, eds, *Zur Geschichte und Methodologie der Geschichtswissenschaften* (Göttingen: Vandenhoeck & Ruprecht, 1979), 225–39.

6 Gustav Bauch, *Die Anfänge des Humanismus in Ingolstadt. Eine litterarische Studie zur deutschen Universitätsgeschichte* (München/Leipzig: Oldenbourg, 1901).

7 *Ibid.*, vi.

and his aggressive style. His impact on regular university structures was therefore rather low. But the humanist's perspective remained the important perspective for scholarship. As late as 2003 Joachim Gruber's negative characterization of the pre-humanist university in Cologne in the fifteenth century – published in his preface to Celtis's *Panegyris ad duces Bavariae* – was not based on thorough historic evidence but on the picture sketched by humanists in the highly polemic *Epistolae obscurorum virorum*.[8]

That is not the only historiographical burden. Any study of the *studia humanitatis* at the University of Ingolstadt in the late fifteenth century must also deal with concepts of German university historiography that obstruct an unbiased analysis. Herbert Grundmann in the late 1950s sketched a romantic picture of the medieval academic world: *Amor sciendi*, the love of knowledge, he claimed, was the common interest that established close personal connections between all members of the medieval *universitas magistrorum et scolarium*. Precisely because of this *amor sciendi*, the university was an extraordinary pre-modern institution. Social status within its boundaries was determined by scientific achievement alone and not by birth, estate or something else. The medieval *studium generale* therefore appeared as a close-knit community of learning, which had freed itself from the hierarchy of medieval estates and rallied exclusively around scientific interest.[9] The West German professor, who presented his views in two papers delivered in Jena and Leipzig, argued against Marxist historiography in the German Democratic Republic, which characterized universities as educational institutions producing personnel needed to maintain the

8 *Conradi Celtis Protucii Panegyris ad duces Bavariae*. Edited, with an introduction, translation and commentary, by Joachim Gruber (Wiesbaden: Harrassowitz, 2003) (Gratia 41), XXIX; [...] Gerlinde Huber-Rebenich: Art. 'Epistolae obscurorum virorum', in *Deutscher Humanismus 1480–1520. Verfasserlexikon* 1 (Berlin: Walter de Gruyter, 2008), col. 646–58.

9 Herbert Grundmann, *Vom Ursprung der Universität im Mittelalter* (Berichte über die Verhandlungen der sächsischen Akademie der Wissenschaften zu Leipzig. Philologisch-historische Klasse 103,2) (Berlin: Akademie-Verlag, 1957). Later editions were published in West Germany in 1960, 1964 and 1976.

power of the ruling classes.[10] But Grundmann was no less ideological.[11] Even Western European reviewers of his publication heavily criticized the ideological background of his assumptions.[12] In 1964 Peter Classen carefully challenged Grundmann's stress on the *amor sciendi* and argued for a reassessment of the political, economic and social influences on the emerging universities.[13]

A more fundamental critique of Grundmann's notion arose in West Germany along with the increasing importance of social history since the 1960s. Based on research on the social history of the medieval *studia generalia* and the statistical analysis of matriculations at universities in the Holy Roman Empire during the fifteenth century, Peter Moraw, Rainer A. Müller, Rainer Christoph Schwinges and others took the opposite view to Grundmann's. Universities were not free of the hierarchies of medieval society. Rather, these very hierarchies were mirrored in their academic structure. Poor students were sometimes able to make some social progress by personal achievement but on the whole the course of studies was dictated by their status within medieval society. Law students came from wealthier social backgrounds than those studying theology or medicine, some were even noble or patrician, so that the faculty of law naturally claimed a high rank within the social structure of the university. More than half of the student body did not rise within the academic ranks at all because the costs of promotion and tuition fees were an effective instrument to limit access to academic degrees.[14]

10 For example Max Steinmetz, 'Zur Geschichte der deutschen Universitäten und Hochschulen', in *Studien- und Hochschulführer der Deutschen Demokratischen Republik 1954/55* (Berlin: Deutscher Verlag der Wissenschaften, 1954), 11–39.

11 Walther Rüegg, 'Themen, Probleme, Erkenntnisse', in Walter Rüegg, ed., *Geschichte der Universität in Europa*, vol. 1: *Mittelalter* (München: Beck, 1993), 24–48, 28–9.

12 See for example the review by Wolfram von den Steinen, *Historische Zeitschrift* 186 (1958), 116–18.

13 Peter Classen, 'Die Hohen Schulen und die Gesellschaft im 12. Jahrhundert', *Archiv für Kulturgeschichte* (1966), 155–80.

14 Peter Moraw, 'Zur Sozialgeschichte der deutschen Universitäten im späten Mittelalter', in *Gießener Universitätsblätter* 8,2 (1975), 44–60; Peter Moraw, 'Das spätmittelalterliche Universitätssystem in Europa – sozialgeschichtlich betrachtet',

Therefore I suggest an approach to the study of this field which combines aspects of intellectual historiography with the institutional conditions outlined by social historiography. Based on the sources of the *studium generale* in Ingolstadt, I will argue for the relative openness of the curriculum to adopt humanistic ideas. The demands of the non-academic work sphere greatly facilitated modifications of the curriculum at the arts faculty. Those were not initiated by high profile humanists but by the arguably scholastic masters themselves. As over 80 per cent of university attendees studied at the arts faculty, such changes had a far more profound impact than the incidental lectures and speeches delivered by an arch-humanist such as Conrad Celtis. In a first step I will outline the social, economic and institutional conditions of teaching and learning at the universities in the Empire. Furthermore different social types of students are presented. In a second step I will show which part of the university curriculum was essential for which type and explain how these findings tie in with the adoption of the *studia humanitatis* at the Ingolstadt arts faculty.

In the fifteenth century the university landscape in the Empire north of the Alps was completely restructured by several new princely and civic foundations. While in 1419 only eight universities existed, their number

in Horst Brunner and Norbert Richard Wolf, eds, *Wissensliteratur im Mittelalter und in der Frühen Neuzeit: Bedingungen, Typen, Publikum, Sprache* (Wissensliteratur im Mittelalter 13) (Wiesbaden: Reichert, 1993), 9–25; Rainer A. Müller, *Universität und Adel. Eine soziokulturelle Studie zur Geschichte der bayerischen Landesuniversität Ingolstadt 1472–1648* (Ludovico Maximilianea. Forschungen 7), (Berlin: Duncker & Humblot, 1974); Rainer C. Schwinges, *Deutsche Universitätsbesucher im 14. und 15. Jahrhundert. Studien zur Sozialgeschichte des Alten Reiches* (Veröffentlichungen des Instituts für Europäische Geschichte Mainz 123), (Stuttgart: Franz Steiner, 1986); Rainer C. Schwinges, 'Der Student in der Universität', in Walter Rüegg, ed., *Geschichte der Universität in Europa*, vol. 1: *Mittelalter* (München: Beck, 1993), 181–223; Rainer C. Schwinges, 'Resultate und Stand der Universitätsgeschichte des Mittelalters vornehmlich im deutschen Sprachraum – Einige gänzlich subjektive Bemerkungen', *Mensch – Wissenschaft – Magie. Mitteilungen der Österreichischen Gesellschaft für Wissenschaftsgeschichte* 20 (2000), 97–119.

increased to seventeen before the Reformation.[15] Those foundations were closely linked to an educational expansion. In the beginning of the century the average number of matriculations was about 400–600 and had increased to nearly 3,000 students per year by the end of it. Meanwhile the average population growth rate just slowly recovered from the setbacks of the Black Death.[16]

The growing student figures fundamentally challenged the medieval university system. Originally academic graduations were a form of co-optation to recruit a substantial teaching staff. Now an even smaller percentage of the university attendees was able to follow an academic career. Nearly half of them never took any degree at all. The overwhelming part tried to acquire some knowledge and skills by attending a few university courses. They could possibly enhance the chances to take up position as a parish priest, vicar, teacher, scribe or the like. A higher social prestige and the participation in important social networks were other benefits of some time spent at university.[17] To describe theses students from a modern per-

15 Jacques Verger, 'Grundlagen', in Walter Rüegg, ed., *Geschichte der Universität in Europa*, vol. 1: Mittelalter (München: Beck, 1993), 49–80, 65–8; Arno Seifert, 'Das höhere Schulwesen. Universitäten und Gymnasien', in Notker Hammerstein, ed., *Handbuch der deutschen Bildungsgeschichte*, Bd. 1: 15.–17. Jahrhundert. *Von der Renaissance und der Reformation bis zum Ende der Glaubenskämpfe* (München: Beck, 1996), 197–346, 198f.; Notker Hammerstein, *Bildung und Wissenschaft vom 15. bis zum 17. Jahrhundert* (Enzyklopädie Deutscher Geschichte 64) (München: Oldenbourg, 2003), 6.

16 Rainer C. Schwinges, 'Universitätsbesuch im Reich vom 14. zum 16. Jahrhundert. Wachstum und Konjunkturen', *Geschichte und Gesellschaft* 10 (1984), 5–30, 10–13, 18; Schwinges, *Deutsche Universitätsbesucher*, 23–37; Seifert, 'Das höhere Schulwesen', 198–9.

17 Vgl. Schwinges, 'Der Student in der Universität', 181–7; Götz-Rüdiger Tewes, 'Dynamische und sozialgeschichtliche Aspekte spätmittelalterlicher Artes-Lehrpläne', in Rainer C. Schwinges, ed., *Artisten und Philosophen. Wissenschafts- und Wirkungsgeschichte einer Fakultät vom 13. bis zum 19. Jahrhundert* (Veröffentlichungen der Gesellschaft für Universitäts- und Wissenschaftsgeschichte 1) (Basel: Schwabe, 1999), 105–28; Klaus Wriedt, 'Studium und Tätigkeitsfelder der Artisten im späten Mittelalter', in Rainer C. Schwinges, ed., *Artisten und Philosophen. Wissenschafts- und Wirkungsgeschichte einer Fakultät vom 13. bis zum 19. Jahrhundert* (Veröffentlichungen

spective as university dropouts is misleading as they never had planned to follow a course of studies that finished with a degree.[18]

The faculty of arts was the very centre of the universities in the Empire. The majority of students took some courses there, as formal requirements for entry were rather low. Only a very basic proficiency in Latin was necessary, so that sufficient funding for tuition fees and living costs were the main hindrance for prospective students.[19]

Based on these facts Rainer C. Schwinges described five types of students at late medieval universities in the Empire. Three of them are closely linked to the faculty of arts. The first type, the *scolaris simplex* aged between fourteen and sixteen, did not advance to any academic degree at all. He stayed for 1.8 years on average at the arts faculty and tried to get some skills and knowledge useful in a non-university work sphere.[20]

With his degree the sixteen- to nineteen-year-old bachelor student, the second type, received a formal certificate for his two- to three-year-long acquisition of knowledge and academic skill that was confirmed by

der Gesellschaft für Universitäts- und Wissenschaftsgeschichte 1) (Basel: Schwabe, 1999), 9–24, 12–14; Martin Kintzinger, 'A Profession but not a Career? Schoolmasters and the *Artes* in Late Medieval Europe', in William J. Courtenay and Jürgen Miethke, eds, *Universities and Schooling in Medieval Society* (Education and Society in the Middle Ages and Renaissance 10) (Leiden/Boston: Brill, 2000), 167–81; Martin Kintzinger, *Wissen wird Macht. Bildung im Mittelalter*, Ostfildern 2003, 142–57; David L. Sheffler, *Schools and Schooling in Late Medieval Germany. Regensburg, 1250–1500* (Education and Society in the Middle Ages and Renaissance 33) (Leiden: Brill, 2008) 161–4.

18 Jacques Verger, 'Die Universitätslehrer', in Walter Rüegg, ed., *Die Geschichte der Universität in Europa*, vol. 1: *Mittelalter* (München: Beck, 1993), 139–57, 139–42; Martin Kintzinger, '*Licentia*. Institutionalität "akademischer Grade" an der mittelalterlichen Universität', in Rainer C. Schwinges, ed., *Examen, Titel, Promotionen: Akademisches und staatliches Qualifikationswesen vom 13. bis zum 21. Jahrhundert* (Veröffentlichungen der Gesellschaft für Universitäts- und Wissenschaftsgeschichte 7) (Basel: Schwabe, 2007) 55–88.

19 Rainer C. Schwinges, 'Die Zulassung zur Universität', in Walter Rüegg, ed., *Die Geschichte der Universität in Europa*, vol. 1: *Mittelalter* (München: Beck, 1993), 161–80, 162–6.

20 Schwinges, 'Der Student in der Universität', 182.

a commission of masters. This certificate could be an advantage in the job market with the *scolares simplices* and therefore help to attain a minor post. The percentage of poor students (*paupers*) in this type is higher than in any other, which shows – at least in Schwinges's opinion – their distinct eagerness for social advancement.[21] It illustrates their willingness to get a formal certificate for their financial and academic investments.

The third student type is the master student, starting around the age of twenty. After his bachelor degree he continued the course of studies at the arts faculty. After graduation as a *magister artium* he instantly began to teach the arts curriculum for two years to obtain his degree.[22] In Ingolstadt he had to be able to teach the whole curriculum because the distribution of courses was cast by lots.[23] Therefore the *magistri* had a rather broad knowledge of grammar, logic, mathematics and Aristotelian philosophy. Some of them remained teachers and administrators at the arts faculty for the rest of their lives, but many continued to study theology, law or medicine. They were simultaneously students and professors, a dichotomy that characterized the medieval university.[24]

These three student types, closely linked to the faculty of arts, accounted for over 80 per cent of the student body at universities in the Empire north of the Alps.[25] Nevertheless university historiography focused and still focuses on noble students and on graduates from the higher faculties (type 4 and 5) because these seemed of higher political importance and left more evidence than the bulk of young men crowding German university towns in the fifteenth century.[26]

21 Schwinges, 'Der Student in der Universität', 182f.; Rainer C. Schwinges, '*pauperes* an deutschen Universitäten des 15. Jahrhunderts', *Zeitschrift für Historische Forschung* 3 (1981), 285–9.

22 Schwinges, 'Der Student in der Universität', 183.

23 Christoph Schöner, *Mathematik und Astronomie an der Universität Ingolstadt im 15. und 16. Jahrhundert* (Berlin: Duncker & Humblot, 1994) (Ludovico Maximilianea. Forschungen, 13), 126–8.

24 Schwinges, 'Der Student in der Universität', 183.

25 Schwinges, *Deutsche Universitätsbesucher*, 92.

26 Even the *Repertorium Academicum Germanicum*, an online database initiated by Rainer C. Schwinges that contains medieval and early modern scholars from the

Although the importance of this group of university attendees is repeatedly stressed in social history, little attention is paid to the influence of these circumstances on the arts curriculum. The question arises, if there is a connection between the socio-economic division of the student body and the academic knowledge pools in which the members of the respective groups were interested. In other words: Is it possible to identify separate sections of the arts curriculum which were more important for one group than the others? Moreover, did this have consequences for the reception of humanists' ideas in Ingolstadt?

In order to answer these questions the fifteenth century general arts curriculum has to be examined. It has been convincingly shown by Sönke Lorenz that in the fourteenth century the *septem artes liberales* [seven liberal arts] were marginalized by the increasing importance of Aristotle's works. Since 1366 Aristotelian logic, ethics and natural philosophy dominated the Parisian arts curriculum and the universities in the Empire widely followed this model during the fifteenth century.[27]

The Ingolstadt arts curriculum in the version of 1478 supports this argument. The council of the faculty approved a course timetable that indicates the dominant position of Aristotelian philosophy.[28] The lesson

Holy Roman Empire, neglects for pragmatic reasons students below the rank of *magister artium*. See Rainer C. Schwinges, 'Repertorium Academicum Germanicum. Ein Who's Who der graduierten Gelehrten des Alten Reiches (1250–1550)', in Peter Moraw, *Gesammelte Beiträge zur Deutschen und Europäischen Universitätsgeschichte. Strukturen – Personen – Entwicklungen* (Education and Society in the Middle Ages and Renaissance 31) (Leiden: Brill, 2008), 577–602 and the project description at: <http://www.rag-online.org> accessed 27 March 2012.

27 Sönke Lorenz, '*Libri ordinarie legendi*. Eine Skizze zum Lehrplan der mitteleuropäischen Artistenfakultät um die Wende vom 14. zum 15. Jahrhundert', in Wolfgang Hogrebe, ed., *Argumente und Zeugnisse* (Studia Philosophica et Historica 5) (Frankfurt am Main: Lang, 1985), 204–58; Jürgen Sarnowsky, 'Die *artes* im Lehrplan der Universitäten', in Ursula Schaefer, ed., *Artes im Mittelalter* (Berlin: Akademie Verlag, 1999), 69–82.

28 Dekanatsbuch der Artistenfakultät, München, Universitätsarchiv, O-I-2, fol. 3r, printed in Karl von Prantl, *Geschichte der Ludwig-Maximilians-Universität in Ingolstadt, Landshut, München. Zur Festfeier ihres vierhundertjährigen Bestehens*

plan is divided into a part for the *scolares* and a part for the *baccalarii* at eight o'clock during the summer semester and nine o'clock during the winter semester.[29] The *scolares* were supposed to attend lectures on the *Parva Logicalia*, a set of introductions to Aristotelian logic compiled in the Middle Ages.[30] The *Ars vetus* was the very foundation of Aristotelian logic, which explained relations, the ten categories and basic logical rules.[31] Aristotle's *Libri phisicorum* were covered in the third lecture in this time slot. The *scolares* had to attend each of these courses for one whole semester. So the curricular requirements for the admission to the bachelor exam could be fulfilled in three consecutive semesters. The tuition fees for the courses mentioned underline their importance within the curriculum. With one *florenus* tuition fee the *Parva logicalia* and the *Libri phisicorum* were among the most expensive classes taught.[32]

The second integral part of the curriculum for the *scolares* was the grammar lecture at eleven o'clock. In 1478 the Ingolstadt faculty council decided to abandon the popular medieval grammar – Alexander's of Villa Dei *Doctrinale* that was part of the original 1473/74 curriculum.[33] Together with its abundant commentary literature it had become more

im Auftrage des akademischen Senats verfaßt, 2 vols (München: Christian Kaiser, 1872; reprint Aalen: Scientia Verlag, 1968), vol. 2, 90–1.

29 Dekanatsbuch der Artistenfakultät, München, UA, O-I-2, fol. 3r, printed in Prantl, *Geschichte*, vol. 2, 90: '*Pro ordinariis lectionibus hore statute: Estate hora octava, hyeme nona: Pro scolaribus: 1 fl. [florens] Parva logicalia per mutationem. 3 ß [solidi] Vetus ars per mutationem. 1 fl Phisicorum per mutationem.* Pro waccalariis eadem hora: Estate: 12 den. [denarii] Metaphisicae xii libri per mutationem. Hieme: flor. Ethicorum x libri per mutationem'.

30 Seifert, 'Das höhere Schulwesen', 209.

31 Seifert, 'Das höhere Schulwesen', 209.

32 The exchange rate was 1fl. = 7 ß = 210 den. = 26.25 gr. (grossi); 8 den. = 1 gr. See Walter Ziegler, *Studien zum Staatshaushalt Bayerns in der zweiten Hälfte des 15. Jahrhunderts. Die regulären Kammereinkünfte des Herzogtums Niederbayern 1450–1500* (München: Beck, 1981), 58–62.

33 The original document is lost. Therefore a print from the eighteenth century is the most reliable source for the 1473/74 curriculum. Johann Nepomuk Mederer, *Annales Ingolstadiensis Academiae*, 4 vols, Ingolstadt 1782, vol. 4, 93–4: 'Volens promoveri ad baccalariatum debet audivisse lectiones et exercitia librorum, ut infra notatur: [...]

an introduction to a scholastic philosophy of language than a grammar textbook.[34] Instead the *Instititutiones grammaticae* written by Priscian of Caesarea around AD 500 were introduced.[35] This grammar provided a wide range of examples from classical Latin literature and made references to Greek grammar, as it was originally written for Greek native speakers.[36] The decision for this textbook might be considered as an expression of humanistic interest in classical Latin language and literature, which subsequently changed the institutional foundation of the grammar course. From another perspective it might be seen as a tribute to scholastic tradition, because Priscian had been an integral part of the Paris arts curriculum before 1366.[37] The convergence of these motives in Ingolstadt led to this rather early modification. At other universities in the Empire such as

10 [septimane] prime partis Alexandri 3 gr. 8 [septimane] secunde partis 3 gr. (hic aut alibi obaudivisse)'.

34 Reinhold F. Glei, 'Alexander de Villa Dei (ca. 1170–1250), Doctrinale', in Wolfram Ax, ed., *Lateinische Lehrer Europas. Fünfzehn Portraits von Varro bis Erasmus von Rotterdam* (Köln: Böhlau Verlag, 2005), 291–312; Philip Ford, 'Alexandre de Villedieu's *Doctrinale puerorum*. A medieval bestseller and its fortune in the Renaissance', in George Hugo Tucker, ed., *Forms of the 'Medieval' in the 'Renaissance'. A multidisciplinary exploration of a cultural continuum* (Charlottesville, VA: Rookwood Press, 2000), 155–71.

35 Dekanatsbuch der Artistenfakultät, München, Universitätsarchiv, O-I-2, fol. 3r, printed in Prantl, *Geschichte*, vol. 2, 89: 'Hora undecima, quae die ieiunii commutata est in terciam. Pro scolaribus: 14 hebd. Maius volumen Prisciani 40 den. [=] 5 gr. 10 hebd. Minus volumen Priscian. 3 gr. [=] xxiiii den.'

36 Marc Baratin, 'Priscian von Cäsarea', in Wolfram Ax, ed., *Lateinische Lehrer Europas. Fünfzehn Portraits von Varro bis Erasmus von Rotterdam* (Köln: Böhlau Verlag, 2005), 247–72.

37 Maarten J.F.M. Hoenen, 'Zurück zu Autorität und Tradition. Geistesgeschichtliche Hintergründe des Traditionalismus an den spätmittelalterlichen Universitäten', in Jan A. Aertsen and Martin Picavé, eds, *'Herbst des Mittelalters'? Fragen zur Bewertung des 14. und 15. Jahrhunderts* (Miscellanea Mediaevalia 31) (Berlin: Walter de Gruyter, 2004), 133–46.

Heidelberg, Vienna, Tübingen and Leipzig the *Doctrinale* was still used in the early sixteenth century.[38]

The third and final time slot at one o'clock in the afternoon featured material from a variety of textbooks, which were read for a limited time span from one to six weeks: Some covered Aristotelian books, but there also were lectures on arithmetical, geometrical and rhetorical works – remnants of the *septem artes liberales*.[39]

Who among the *scolares* was interested in which part of the curriculum? First we need to distinguish between *scolares* who planned to take the bachelor exam and those who just stayed for some time at university without taking any degree at all. The former had not only to fulfil the curricular requirements for admission to the examination, but also to acquire the knowledge needed to pass the exam. Therefore they surely concentrated on Aristotelian logics and grammar. These were the central subjects tested in the oral bachelor exam.[40] At least in the grammar course they were directly confronted with basic humanist ideas promulgated by the study of a textbook using classical literature. The other parts of the curriculum were of lower importance to them.

In comparison, the *scolares* who did not plan to take the bachelor exam were much freer in their decision which courses to attend. Their main aim presumably was to acquire knowledge useful in a non-university work environment. Not the *amor sciendi* but economic reasoning was their main impetus. Besides proficiency in Latin acquired in the grammar course, especially the lectures in the afternoon time slot were of interest.

38 Seifert, 'Das höhere Schulwesen', 236; Johannes Helmrath, '"Humanismus und Scholastik" und die deutschen Universitäten um 1500', in *Zeitschrift für Historische Forschung* 18 (1988), 187–203, 196.

39 Dekanatsbuch der Artistenfakultät, München, UA, O-I-2, fol. 3r, printed in Prantl, *Geschichte*, vol. 2, 90: 'Pro ordinariis lectionibus hore statute:. [...] Hora prima post prandium: Pro scolaribus: 3 gr. Elencorum 6 hebd. 3 gr. Priorum 6 hebd. 1 gr. Obligatoria 8 dies. 1 gr. Algorismus 8 dies. 1 gr. Prima Euclidis 8 dies. 3 gr. Spera materialis 6 hebd. 5 gr. Libellus epistolaris 3 hebd'. Seifert, 'Das höhere Schulwesen', 210.

40 Seifert, 'Das höhere Schulwesen', 210.

Among others, basic mathematical, rhetorical and epistolographic skills were taught in this time slot.

A codex composed in the late 1470s and early 1480s by the Ingolstadt student Johannes Gramug,[41] a member of the chivalric order of the Hospitallers, supports this thesis.[42] He collected almost exclusively rhetorical and mathematical texts.[43] This knowledge surely helped to enhance career opportunities as the continuing professionalization of administration in the fifteenth century created growing fields of work for people with this kind of skills. For the chivalric order the academic qualification was probably less important than the actual ability to apply the skills in daily administrative practice.

In the afternoon slot the rhetoric class seems to have been preeminent. Costing a five *grossi* tuition fee, this three week course was not only the most expensive at one o'clock. Comparing the average weekly price of every lecture, at 1.66 gr. it was the most expensive course in the whole arts curriculum. Even the main lectures in the morning amounted only to an average weekly price of 1.01 gr.[44] Apparently the rhetoric courses were popular with the students and high student demand made it possible to charge relatively high fees. In 1473/74 the price for the then one-week class had been one *grossus*. In 1490 the council of the arts faculty discussed a kind of language module for university beginners to increase course attendance

41 Berlin, Staatsbibliothek Preußischer Kulturbesitz, Ms. lat. qu. 382. For the manuscript description see Agostino Sottili, 'I codici del Petrarca nella Germania occidentale VII', *Italia medievale e umanistica* 18 (1975), 1–72, 35–41.

42 Götz von Pölnitz et. al., eds, *Die Matrikel der Ludwig-Maximilians-Universität. Ingolstadt – Landshut – München*, 9 vols (München: Lindauer, 1937–1984), vol. 1, col. 85, line 5 (11 October 1478): 'Johannes Gramück de Memingen ordinis Sancti Spiritus'.

43 Among various exemplary letters and a short rhetorical treatise, the codex contains for example the *Tractatus de algorismo* written by *Johannes de Sacrobosco* (fol. 299r–310v). See Sottili, *I codici*, 35–41; Schöner, *Mathematik und Astronomie*, 150–2.

44 For the average weekly price the tuition fee for the course is divided by the number of weeks of its duration. For the rhetoric class: 5 gr. divided by 3 weeks equals 1.66 gr. The main lectures took the whole semester, i.e. 24 weeks. The tuition fee of 1 fl. equals 26.25 gr. divided by 24 weeks equals 1.01 gr.

and improve academic achievement.[45] During the first semester they were to attend lectures on the *Parva logicalia* at 9 am, Priscian at 11 am and only the rhetoric class at 1 pm.[46] This modularization does not seem to have been implemented, but in 1492 a new curriculum for the arts faculty contained a three-week rhetoric course with a decreased fee of two *grossi*.[47] Demand and supply for academic courses were constantly changing.

The unspecific labeling of the rhetoric course in the official curriculum as *libellus rhetoricalis* and *libellus epistularis* opened it up for the integration of new educational ideas. The Ingolstadt master Martin Prenninger, educated at the university of Vienna, who had an interest in humanism, wrote a humanist textbook in the first half of the 1470s that explained letter writing drawing exclusively on Ciceronian examples.[48] As an *intimatio* posted at

45 Dekanatsbuch der Artistenfakultät, München, Universitätsarchiv, O-I-2, fol. 35r: 'Et ne scolares nostre facultatis dum saepius visitare collegium coguntur, minus in audiendo lectionibus et exercitiis diligentie ac fervoris exhibeant, ac quo minus a suo privato studio retardentur, placuit facultati, quod libri audiendi ordine infra notato audiantur distincte, ita quod nec liceat alicui pluribus audire horis quam tribus lectiones et exercitia, nisi ad hoc domini decani specialis accesserit consensus'.

46 Dekanatsbuch der Artistenfakultät, München, UA, O-I-2, fol. 35r: 'Audiantur suo ordine et horis: In prima mutatione: Textus Parvorum Logicalium, maioris voluminis Prisciani, minoris voluminis Prisciani, libelli rhetoricalis'.

47 Redaktion der artistischen Statuten 1492, München, Universitätsarchiv, B-II-5, fol. 5v–6r printed in Prantl, *Geschichte*, vol. 2, 109–10: 'Ordo et tempus librorum legendorum in collegio artistarum mutatione aestivali cum eorundem pastus designatione [...] Hora prima: [...] 2 gr. Libellus rethoricalis, a festo S. Mathei [21 September] usque ad festum S. Galli [16 October]. [...] Ordo librorum legendorum mutatione hiemali [...] Hora prima: [...] 2 gr. Libellus rethoricalis a festo Benedicti [21 March] usque Georgii [24 April]'.

48 Martin Prenninger, *Ars epistolandi*: Ansbach, Regierungsbibliothek, Ms. lat. 148, fol. 62r–88r; Erlangen, Universitätsbibliothek, Cod. 639, fol. 99r–114r; Mattsee, Stiftsbibliothek, cod. 24, fol. 200v–212v; München, Bayerische Staatsbibliothek, clm 14644, fol. 1r–21r; München, Bayerische Staatsbibliothek, clm 18801, fol. 111r–137r; Paris, Bibliothèque nationale de France, lat. 11347, fol. 131r–156v; Seitenstetten, Stiftsbibliothek, cod. 178, fol. 7r–27r; Wien, Österreichische Nationalbibliothek, cod. 3123, fol. 2r–17v. See 'Franz Josef Worstbrock', 'Prenninger, Martin', in *Die deutsche Literatur des Mittelalters. Verfasserlexikon* vol. 7 (Berlin 1989), col. 822–5;

the time to inform students strongly suggests, similar books were read by Prenninger during regular rhetoric classes at 1 pm taking place in lecture halls of the university.[49] Therefore the older notion that this humanistic textbook was only used in private courses not part of the official arts curriculum should be dismissed.[50] It is among the earliest evidence of the preoccupation with the *studia humanitatis* in regular courses at the university of Ingolstadt, almost twenty years before Conrad Celtis gave his first lecture in 1491. Prenninger was able to interest Oswald Wishaimer in the new educational ideas, who used his former teacher's textbook in his own regular rhetoric classes as another *intimatio* from Ingolstadt shows.[51] And Wishaimer passed that interest again to his student Leonhard Estermann,

Wolfgang Zeller, *Der Jurist und Humanist Martin Prenninger gen. Uranius (1450–1501)* (Contubernium 5), (Tübingen: Franz Steiner, 1973), 83–92.

49 Erlangen, Universitätsbibliothek, Cod. 639, fol. 204r, printed in Ludwig Bertalot, 'Humanistische Vorlesungsankündigungen in Deutschland im 15. Jahrhundert', *Zeitschrift für Geschichte der Erziehung und des Unterrichts* 5 (1915), 1–24, 15: 'Quisquis bonarum artium studiosus adolescens de regimine personalium verborum omnem plenam facilemque ac veram cognicionem assequi vult, is cras hora prima in Boecii auditorio sui presentiam exhibeat, eloquentissimi doctissimique viri Francisci Philelphi pulcherrimum de personalibus verbis opusculum ex Martino Brenningario minimo pretio et scripturus et auditurus'.

50 See for example Albrecht Liess, 'Die artistische Fakultät der Universität Ingolstadt 1472–1588', in Laetitia Boehm and Johannes Spörl, eds, *Die Ludwig-Maximilians-Universität in ihren Fakultäten* (Berlin: Duncker & Humblot, 1980), vol. 2, 9–35, 22–4; Schöner, *Mathematik und Astronomie*, 466–73.

51 München, Bayerische Staatsbibliothek, clm 18801, fol. 110r, printed in Bertalot, 'Humanistische Vorlesungsankündigungen', 16: 'Vix aliquid credas esse pulcherius, bone indolis adolescens, quam ea, que tibi sunt animo: Rite posse perscribere. Quomodo id in omni genere epistolarum fieri debeat, Osvaldus Wishamer de Grafing arcium liberalium magister pro viribus et ingenio suo cras hora prima ordinarie legere et docere incipiet. Quisquis ergo laudis fame et glorie es studiosus, lectorium Alberti Magni tum accedito auditurus in cursu lectionum, que tibi ad id conducent et que fortasse erunt non indecora'.

who became a monk at the Benedictine monastery of Tegernsee after graduating as *magister artium* in Ingolstadt.[52]

In 1487 the Ingolstadt master Paul Lescher printed a humanistic textbook in the Bavarian university town. His *Rhetorica pro conficiendis epistolis accommodata*[53] combined traditional medieval chancery knowledge with the demand for classical Latin style and Italian humanists' rhetorical teaching. Thus Lescher's *Rhetorica* represents a transitional stage in the process of adapting humanistic ideas to university courses.[54]

The last part of this short work contains a compilation of the *Elegantiolae* written by the Italian humanist Augustinus Datus. It was a very popular textbook in the Empire north of the Alps as it explained in a simple way stylistic features of classical Latin.[55] From the 1470s, nearly twenty manuscript copies of this book were created by Ingolstadt students in the fifteenth century. It seems to have been an integral text for Ingolstadt rhetoric classes and also Johannes Gramug wrote it down in 1479 in his above-mentioned collection.[56]

52 Maximilian Schuh, 'Ingolstadt oder Italien? Möglichkeiten und Grenzen akademischer Mobilität im Reich des 15. Jahrhunderts', in Tina Maurer and Christian Hesse, eds, *Von der Authentica habita zur Deklaration von Bologna – Akademische Mobilität in epochenübergreifender Perspektive* (Itinera 31), (Basel: Schwabe 2011), 23–45, 42.

53 Paul Lescher, *Rhetorica pro conficiendis epistolis accommodata* (Ingolstadt: Bartholomäus Golsch[?] [14]87) [GW (=Gesamtverzeichnis der Wiegendrucke) M18010].

54 See Maximilian Schuh, '*In dicendo et ornatus et copiosus*. Zur Diversität der Rhetorik an der Artistenfakultät der Universität Ingolstadt im 15. Jahrhundert', in Georg Strack and Julia Knödler, eds, *Rhetorik in Mittelalter und Renaissance. Konzepte – Praxis – Diversität* (Münchner Beiträge zur Geschichtswissenschaft 6) (München: Herbert Utz), 2011, 315–36.

55 Paolo Viti, 'Dati, Agostino', in *Dizionario Biografico degli Italiani*, vol. 33 (1987), 15–21.

56 Berlin, Staatsbibliothek Preußischer Kulturbesitz, Ms. lat. qu. 382, fol. 51r–95v, fol. 95v, printed in Sottili, 'I codici del Petrarca VII', 36: 'Libellus isagogicus Augustini Dati Senensis oratoriis [sic!] primarii ad Andream Christoferri filium missus explicit feoliciter [sic!] in alma universitate Ingolstatensi per me Johannem Gramugg fratrem ordinis Sancti Spiritus tunc temporis studens [sic!] 1479'.

Notations added to the text of *Elegantiolae* manuscripts by students show that Latin eloquence and Ciceronian style were not only taught but also eagerly learned in Ingolstadt. Glosses inserted between the lines of the text explain the meaning of single words and grammatical phenomena. They were probably dictated by the master and written down by the students during the lectures.[57] Johannes Gramug for example noted in his copy above *Therentius* the short information: *id est poeta*,[58] in the same way another student wrote in his codex above *Cicero* the clarification *ille poeta*.[59]

The glosses in the margin of the manuscript pages contain no grammatical or lexical explanations. Further Latin examples illustrate the stylistic rules in the main text. Very interesting are the glosses added to a rule of the *Elegantiolae*, which explains the correct use of the particles *multo* and *longe* with the superlative of adjectives and adverbs: *Comparativis vero vel multo vel longe preponi solet, ut: iusticia multo preclarior est ceteris virtutibus. Socrates longe sapientior est aliis philosophis.*[60] Johannes Gramug noted on the left margin of the page the similar example *Jacobus est multo fortior Philippo*.[61] The anonymous student glossator of a manuscript codex passed on by the monastery of St Emmeram in Regensburg wrote down similar examples: *Longe vel multo cum comparativo: [?]lnon eloquendo multo prestantior est Petro. Johannes longe fortior est Petro.*[62] Then the content of the glosses changes: *Vinum multo preclarius est cervisia. Studium Ingolstatense est multo vigorosius Lipsense.*[63] Even in a fifteenth-century university, alcoholic beverages and inter-university-rivalry examples from the students' and masters' daily life were used as a didactic concept in foreign language education. As the rhetoric class addressed university begin-

57 See for example Jürgen Leonhardt and Claudia Schindler, 'Neue Quellen zum Hochschulunterricht vor 500 Jahren. Ein Tübinger Forschungsprojekt zur Leipziger Universität', *Jahrbuch für Historische Bildungsforschung* 13 (2007), 31–56.

58 Berlin, Staatsbibliothek Preußischer Kulturbesitz, Ms. lat. qu. 382, fol. 58r.

59 München, Bayerische Staatsbibliothek, clm 18801, fol. 2r.

60 München, Bayerische Staatsbibliothek, clm 14644, fol. 64v.

61 Berlin, Staatsbibliothek Preußischer Kulturbesitz, Ms. lat. qu. 382, fol. 58r.

62 München, Bayerische Staatsbibliothek, clm 14644, fol. 64v.

63 München, Bayerische Staatsbibliothek, clm 14644, fol. 64v.

ners, basic teaching methods had to be applied. Above *multo* and *longe* the anonymous scribe noted the grammatical explanation *hoc adverbum* and the synonym *valde* between the margins, for Socrates the clarification *ille philosophus* was necessary.[64]

The same text passage was glossed by Johannes Stetmaister[65] in the codex he used in Ingolstadt rhetoric classes.[66] In his version of the *Elegantiolae* the main text differs. Socrates is substituted by Aristotle: *Aristoteles longe aliis philosophis sapientior.*[67] Probably this version made far more sense in an arts lecture as the philosopher dominated the faculty's curriculum. In the margin he noted two examples: *Rex Ungariae multo fidelior est christianitati aliis regibus. Johannes Stetmaister longe carior est puellis ceteris waccalareis.*[68] Humanism was literally made popular in Ingolstadt. The bachelor not only understood the stylistic rule formulated in the text, but he was also able to use it in a productive and witty way. The second example was probably Stetmaister's own thought, not dictated by a master. The promotion records of the faculty show his position within the university. He was the last of thirty-seven students noted down for the bachelor promotion in winter 1479.[69] The bachelors were not ranked by

64 München, Bayerische Staatsbibliothek, clm 14644, fol. 64v.

65 Matrikel Ingolstadt, vol. 1, col. 82, l. 24 (9 May 1478): *Johannes Stetmaister de Aussee.*

66 Augsburg, Staats- und Stadtbibliothek, 2° Cod 213, fol. 1r–74v. See Herrad Spilling, *Die Handschriften der Staats- und Stadtbibliothek Augsburg: 2° Cod 101–250* (Handschriftenkataloge der Staats- und Stadtbibliothek Augsburg 3) (Wiesbaden: Harrassowitz, 1984), 221–4.

67 Augsburg, Staats- und Stadtbibliothek, 2° Cod 213, fol. 7v: 'De comparativo. Comparativis vero vel multo vel longe preponi solet, ut: Justicia multo preclarior est ceteris virtutibus. Et: Aristoteles longe aliis philosophis sapientior'.

68 Augsburg, Staats- und Stadtbibliothek, 2° Cod 213, fol. 7v. See Spilling, *Handschriften Augsburg*, 222. Johannes Stetmaister was promoted to bachelor on 13 December 1479, giving a *terminus post quem* for the composition of this gloss.

69 Dekanatsbuch der Artistenfakultät, München, UA, O-I-2, fol. 70v: 'Promoti atque locati sub decanatu magistri Johannis Eysteter Ingolstatensis anno domini lxxix° mutatione hyemali in angaria Lucie [up to four days after 15 December] ante nativitatem domini nostri Jhesu Cristi [...] Johannes Stetmaister ex Ausse 37'.

their academic achievement during the exam but by their social status.[70] So Stetmaister was at the very bottom of the hierarchy within the university. With the knowledge and the skills acquired he had to make a living in a non-academic environment. After the bachelor promotion he does not appear in any university records. His example proves the attractiveness of the rhetoric class. Stetmaister took the course after his bachelor exam. The class was part of the curriculum of the *scolares*. So he did not have to fulfil any curricular requirements, but instead took the class because of the humanistic matters taught.

In 1493 the attractiveness of the humanistic course led the arts faculty's council to institutionalise the *Elegantiolae* as the official textbook for the rhetoric class. This shows the list of the distribution of textbooks to the individual masters teaching them. The *libellus rhetoricalis* from former years was substituted by Augustinus Datus.[71] The orientation towards the requirements of a non-academic work sphere urged the majority of masters to integrate the new knowledge into a curriculum that increasingly became state of the art. Only six of approximately fifty masters received a fixed salary from the university.[72] As the rest heavily relied on tuition fees to make a living, they had to acknowledge the specific interests of their students to ensure high levels of attendance in their courses. And the targeted student belonged to types 1 and 2 outlined above. The far smaller number of master students (type 3) pursued more traditional parts of the artistic curriculum such as Euclid and Aristotelian moral philosophy to fulfil the

70 Schwinges, *Deutsche Universitätsbesucher*, 355–60; William Clark, *Academic Charisma and the Origins of the Research University* (Chicago: University of Chicago Press, 2006), 105–9; Marian Füssel, *Gelehrtenkultur als symbolische Praxis. Rang, Ritual und Konflikt an der Universität der Frühen Neuzeit* (Darmstadt: Wissenschaftliche Buchgesellschaft, 2006), 166–75.

71 Dekanatsbuch der Artistenfakultät München, Universitätsarchiv, O-I-2, fol. 47r, printed in Schöner, *Mathematik und Astronomie*, 486–7.: [1493] 'Prima Septembris magistri sequentes obtinuerunt per eleccionem ordinarias lectiones principales quatuor, alias vero per sortem iuxta consuetudinem et decreta collegii artistarum. [...] Augustinum Datum magister N. Waldman'.

72 Arno Seifert, 'Das Ingolstädter *collegium vetus*. Die Geschichte eines frühen Lehrstuhltyps in der Artistenfakultät', *Historisches Jahrbuch* 89 (1969), 33–51.

requirements for the master's exam. These classes were consequently less open to humanistic innovation. But in 1485 the Ingolstadt master Nikolaus Bernauer used Leonardo Bruni's translation of Aristotle in his course on moral philosophy.[73] Even the master's students could not avoid contact with the new ideas anymore.[74]

The Ingolstadt examples impressively prove the arts faculty's openness to the adoption of humanist ideas. Admittedly no comprehensive educational programme was installed and Aristotle remained the main reference point in the curriculum. Nevertheless, the growing number of students faced the *studia humanitatis* in grammar and rhetoric classes, long before the German arch-humanist Conrad Celtis started to teach outside the compulsory course of studies in Ingolstadt. And even then he did not reach greater numbers of students but created a small elite circle that indulged in the contempt of the university's masters and students. A far broader impact was made by curriculum modifications in the arts faculty as the majority of the university attendees were affected. Scholarship therefore has to abandon the elite humanists' perspective on the universities in the Empire north of the Alps and begin an unbiased assessment of humanist tendencies in the *studia generalia*. The reasons for the acquisition of the new ideas within this institutional framework were not a romanticized *amor sciendi* but the desire for social and economic advantages. Therefore I argue for a closer connection between the changes in the intellectual realm in the fifteenth century and the social, economic and institutional conditions of teaching and learning.

73 München, Bayerische Staatsbibliothek, clm 14993a, fol. 5r–138v. Preface, fol. 1v: 'Oratio magistri Nicolai Bernawer Ratisponensis in laudem et preconium moralis philosophie specialiter in decem libros Ethicorum Aristotelis. [...] Facta sunt hec anno domini etc. octogesimo quinto. Dominus Bernawerius libros hos explicavit pro informatione baccalorum ob amorem et plenam diligentiam lectionarii haud sine magno labore compendinari anno etc. octogesimo sexto'.

74 München, Bayerische Staatsbibliothek, clm 14993a, fol. 2r: *Aristotelis Ethicorum libros latinos facere nuper institui, non quia prius traducti non essent, sed quia sic traducti erant, ut barbari magis quam latini effecti viderunt.* See James Hankins, *Humanism and Platonism in the Italian Renaissance*, vol. 1: *Humanism* (Storia e Letteratura 215) (Rome: Edizioni di storia e letteratura, 2003), 182–3.

So the study of late medieval universities may offer answers to today's problems. In contemporary discussions about higher education in Germany against the backdrop of the Bologna process, a stricter course of studies at the universities is clearly favoured. This comes hand in hand with the abandonment of traditional knowledge, as for example proficiency in Latin for History degrees. Instead Spanish and non-European languages become more important and trendy. This may be considered as cultural decay, but is really owing to the changing social and economic conditions in a global work-sphere. An autonomous *amor sciendi* imagined and cultivated by a few elitist scholars may be seen as the desirable reason for taking up higher education and an academic degree. But as in the fifteenth century also in the twenty-first century, teaching and learning at university level are highly influenced by economic and social circumstances. Keeping that in mind allows a better and unprejudiced evaluation of the arguments in political and scholarly discussions. In particular, the selfless pursuit of knowledge is a myth which discounts other reasons for academic activity. As long as educational opportunities are closely connected with social background – and this is the case in Germany – it is rather hypocritical to bring forward arguments which exclude specific social milieux from academia. In my opinion the comprehensive study of the University of Ingolstadt in the fifteenth century may help unmask such hypocrisies in historical scholarship and in current debates.

THOMAS F. EARLE

5 The Two Adamastores: Diversity and Complexity in Camões's *Lusiads*

The Lusiads (*Os Lusíadas*) was first published in 1572. Like everything else about this fascinatingly complex work, saying what it is about is not easy. A number of *cantos* are devoted to the history of mainland Portugal, but the main action of this epic poem is the first voyage of the Portuguese under their commander Vasco da Gama to India (1497–99). A crucial event in the voyage was the rounding of the Cape of Good Hope, which seemed to Europeans to be the end of the known world. In *The Lusiads* Gama, now arrived at the friendly port of Malindi, in east Africa, narrates the voyage to the sheikh of the port city. One of Camões's claims in his poem was that it contained only historical fact but, like many other statements in *The Lusiads*, that is far from being the whole truth. The Portuguese did indeed round the Cape in the course of their voyage, but Gama describes that event as an encounter with a giant, Adamastor, who appears overhead and prophecies disaster to those who enter his realm. In the fifty years or so which intervened before Camões wrote his poem the disasters duly occurred, yet the ambivalence which is so marked a feature of it is clearly apparent in the way that a purely mythological figure predicts historical events.[1]

The encounter with Adamastor is one of the best-known episodes of Camões's *Lusiads*, and it might seem presumptuous to try to add something to the critical literature about it. However, the attention of critics, whether in Portugal or elsewhere, is usually drawn to uncovering the broader

1 For a discussion of this point, see Frank Pierce, 'Camões' Adamastor', in *Hispanic Studies in Honour of Joseph Manson*, Dorothy M. Atkinson and Anthony H. Clarke, eds (Oxford: Dolphin, 1972), 207–15 (207).

political meaning of the episode as a whole, sometimes with surprisingly contrary results, as will appear later. Here an attempt will be made to read the episode largely by and for itself, using the techniques of close analysis of the text which ultimately derive from Anglo-American New Criticism. It is true that the concern of that school with ambiguity and paradox can sometimes overlook the political meaning which must inevitably be associated with the public and historical nature of epic poetry, particularly Camões's, which has national history as its theme. Nevertheless, a reading which concentrates on the aesthetic value of the passage will at least have the merit of setting it free from the orthodoxies, whether of the left or the right, which have for so long dominated the criticism of *The Lusiads*.

An attempt will also be made here to bring into focus criticism written in English and in Portuguese, something which again is not always done. The important essay by the American scholar David Quint about Adamastor, which will be discussed in detail below, is not mentioned in the recent *Dicionário de Luís de Camões*, an excellent encyclopaedia with many first-rate extended essays on Camões and his times, but one which, on past form, will be barely noticed in the English-speaking world.[2] Both critical camps, though, have a good deal to offer each other.

My title mentions the two Adamastors, not a critical observation of much originality. Many readers have noticed how he changes. He begins as the threatening prophet of shipwreck and disaster to all who sail past his cape, but then, after Gama's brief interrogation, tells his own story in quite a different tone. That story principally concerns his failed love for the nymph Thetis, 'das águas a princesa'.[3] The shift in personality and in language will be the main topic of this paper.

2 *Dicionário de Luís de Camões*, ed. Vítor Aguiar e Silva (Lisbon: Caminho, 2011). David
 Quint, 'The Epic Curse and Camões' Adamastor', in *Epic and Empire* (Princeton:
 Princeton University Press, 1992), 99–130. An honourable exception is Hélio Alves,
 Camões, Corte-Real e o sistema da epopeia quinhentista (Coimbra: Universidade de
 Coimbra, 2001), 419–20.
3 'The princess of the seas' (V.52). All translations are my own. It is customary to refer
 to the poem by *canto* and stanza number. Editions vary very little. My references are
 taken from Frank Pierce's edition for Oxford University Press (1972).

The shift certainly requires explanation, because otherwise the narrative appears contradictory, and accordingly many critics have addressed it. It is not my intention to give an exhaustive list here, but it may be helpful to compare the Brazilian Cleonice Berardinelli and the Portuguese Aníbal Pinto de Castro with the American David Quint, referred to above.

Both Berardinelli and Pinto de Castro note the contrast between the rage of Adamastor's opening assault on the Portuguese: 'Ó gente ousada, mais que quantas / no mundo cometeram grandes cousas,'[4] and the very different tone of the conclusion of his first speech, when he tells the tale of the shipwreck of Manuel de Sousa Sepúlveda and his wife, D. Leonor de Sá, on the coast of south-east Africa.[5] The tragic story is followed by Gama's interrogation and then Adamastor's autobiographical account of his own love affair, which must in some way be connected to what had preceded it.

In an article published in 1973 Berardinelli tries to come to terms with the giant's capacity to empathise with the lovers, even though their death forms part of the punishment of the Portuguese which he had predicted. She concludes that his feeling for them derives from his own capacity to love, even though that love was not returned. Pinto de Castro also discusses the same topic in an article reprinted in his *Páginas de um Honesto Estudo Camoniano* of 2007. The article in question, however, was first printed in 1972, about the same time as the Brazilian critic's work.[6]

Both these admirably sensitive and imaginative studies make it clear that there must be a link between the two love stories narrated by the giant. Nearly forty years later, it may be possible to go a little further, because the similarities, and differences, between the last days of Manuel de Sousa

4 'Oh bold race, bolder than all those who have done great things in the world' (V.41).
5 This event occurred in 1552, and an account of it was published shortly afterwards, with the title 'Relação da mui notável perda do galeão grande S. João'. For a modern edition, see *História Trágico-Marítima*, ed. Damião Peres, I (Oporto: Companhia Editora do Minho, 1942), 13–41.
6 Cleonice Berardinelli, 'Uma leitura do Adamastor', in *Estudos camonianos* (Rio de Janeiro: Ministério da Educação e Cultura, 1973), 33–40 (37). Aníbal Pinto de Castro, *Palavras de um Honesto Estudo Camoniano* (Coimbra: Centro Interuniversitário de Estudos Camonianos, 2007), 187–8.

Sepúlveda and the transformation of Adamastor from unhappy lover into the Cape of Good Hope form part of a system of oppositions which can be found in many parts of the poem.

The first thing to see is what the stories have in common, remembering that one immediately follows the other, which gives greater viability to the search for parallels. The two stories also have the same geographical location, southern Africa, and in both cases a former master of the seas comes to a sad end on dry land. Sousa Sepúlveda was the captain of the galleon *S. João*, while Adamastor, in mythology one of the companions of the giants who assailed Mount Olympus, had ruled the oceans (V. 51). But much more unites them than just this.

When Adamastor describes the sufferings which the lovers will have to endure he puts particular stress on the nakedness of Leonor, who is stripped by the Africans who surround the little band of wanderers. It is a historical detail, which Camões could have read in the printed version of the shipwreck, but it also has an important role in the poetic narrative. Adamastor stresses the beauty of the 'linda dama' and her 'cristalinos membros e perclaros',[7] but this is not an erotic description. Rather, the narrator wishes to draw attention to the pathetic situation of Leonor, who had seen her children die before her eyes.

According to the anonymous author of the shipwreck narrative Manuel de Sousa Sepúlveda outlived his wife though, like her, he ultimately perished in the African sands, but Adamastor has them die together, in verses which are some of the most deeply felt of the whole poem:

> Ali, despois que as pedras abrandarem
> Com lágrimas de dor, de mágoa pura,
> Abraçados, as almas soltarão
> Da fermosa e misérrima prisão.[8]

7 'Lovely lady', 'bright, fair limbs' (V. 47).
8 'There, after softening the stones with tears of suffering, of pure sadness, they will embrace and set their souls free from the beautiful and wretched prison [of the body]' (V. 48).

The poetic conceit whereby the tears of lovers could melt stones probably came to Camões from his reading of the first eclogue of Garcilaso de la Vega: 'Con mi llorar las piedras enternecen / Su natural dureza y la quebrantan,'[9] but what in the Spanish poet seems no more than rhetorical exaggeration has in *The Lusiads* an extremely important expressive function, as will appear shortly. For the moment it is important to recall that tears are salty, though the narrator does not say so explicitly. Immediately afterwards the lovers die together, a moment for which the poet finds a commonplace, that of the body as a prison from which the soul escapes on death to obtain the freedom of the life eternal. Camões also gives the well-worn notion added expressive force, which is only revealed, however, when the tragic history of the Sepúlveda family is read in parallel with the loves of Adamastor.

Right at the start of that narrative it becomes clear that that it is the nakedness of the nymph Thetis that attracts the giant:

> Um dia a vi, co as filhas de Nereu,
> Sair nua na praia, e logo presa
> A vontade senti de tal maneira,
> Que inda não sinto cousa quer mais queira.[10]

A little later he sees her again, still naked:

> Úa noite, de Dóris prometida
> Me aparece de longe o gesto lindo
> Da branca Tétis, única, despida.[11] (V. 55)

9 'As I weep the stones soften and break their natural hardness'. For the Spanish text, see *La poesía de Garcilaso de la Vega*, ed. María Rosso Gallo (Madrid: Real Academia Española, 1990), 310 (ll. 197–8).

10 'One day I saw her and the daughters of Nereus emerge naked on the beach, and I felt my will caught in such a way that since then I have never felt anything that I wanted more' (V. 52).

11 'One night, as Doris [her mother] had promised, the beautiful figure of Thetis appeared to me at a distance, white, unlike all others, naked' (V. 55).

For me the final line has a strong erotic charge, and it is certainly very different from the language used to describe Leonor. All the same, it is undeniable that neither lady is clothed.

Adamastor rushes to embrace her, but she vanishes, and he finds himself grasping the rough rocks and vegetation of the Cape, into which a few stanzas later he himself is transformed. So he becomes not all spirit, like the Sepúlvedas, but the 'terra dura' [hard earth] of the Cape, washed by the sea which separates him forever from Thetis.

There are many connections between the two stories, which are like the two sides of the same coin. The nakedness of the ladies involved, pathetic in one case, erotic in the other, has already been noted. The salt tears of the human couple soften the stones, but the giant, who has become the Cape, knows that he himself is an unbridgeable barrier which prevents him from entering the sea which is the home of his nymph. In addition, Manuel and Leonor embrace, but Adamastor tries in vain to kiss Tethis. The same Portuguese word, 'abraçado' is used of the successful relationship and the failed one (V. 48 and 56). Finally, the souls of the Portuguese couple leave the prison of their bodies, but Adamastor, the giant, has no soul: he calls Tethis, the 'vida deste corpo', and he remains forever imprisoned in the rocks of the Cape.[12]

At first sight, the series of contrasts might lead the reader to think that the protagonists of the two stories are entirely different, because the humans experience a tragic love, whose spiritual nature suggests that they are too good for this world, while the giant, transformed into earth, the lowest of the four elements, has an entirely physical passion for Thetis, proof that he lacks the higher feelings associated with the Sepúlvedas.

However, the relationship between the human and mythological worlds is more complex than that. In the first place, the two worlds must have something in common, because communication and mutual understanding between them are possible, even easy. Adamastor and Gama speak the same language, after all. Adamastor's purpose in narrating the story of the Sepúlvedas is to draw attention to the suffering which will be the fate

12 'Life of my body' (V. 55).

of many of those who round the Cape. But, in spite of himself, he draws attention to the beauty and pathos of their story. Yet there is no denying that Adamastor is a monster, hideous and grotesque, as he himself is forced to admit when he repeats Thetis's ironic comment, transmitted to him by her mother: '... Qual será o amor bastante / De ninfa, que sustente o dum Gigante?'[13] Nevertheless, as Pinto de Castro points out, Adamastor may have a giant's body, but he has a human heart, and it is easy to detect in his narrative of his failed erotic experience some of the bitterness so often expressed by Camões in his lyric poetry.[14]

So there is something human about Adamastor, despite his being a mythological creature, and if what is human is, above all, the capacity to feel strong sexual desire, it cannot be denied that such desires have an important place in Camões's lyric poetry. Nor is it the case that the tragic love of Manuel de Sousa Sepúlveda and his wife excludes a physical element, for they were the parents of children 'em tanto amor gerados e nascidos.'[15]

At the moment of death the souls of the two lovers are released from the beautiful and most wretched prison of the flesh. The image of the body as the prison of the soul is a common-place, as already pointed out, and the use of the word 'mísera' [wretched] in this context is also normal. But to call that same prison 'fermosa' [beautiful] is much more striking. However, Camões never condemns the physical aspect of sex in absolute terms. Even in a religious poem, like his extended paraphrase of Psalm 117, 'By the waters of Babylon', and in a passage of that poem where Camões is conscious of his own sinfulness, he cannot deny the pleasures of the flesh: 'E tu, ó carne que encantas, / Filha de Babel tão feia ...'[16] The word 'encantas', like the 'fermosa prisão' of *The Lusiads*, expresses Camões's belief that the desire for physical pleasure is inherent in human nature.

13 'What love of a nymph could satisfy a giant?' (V. 53).
14 Aníbal Pinto de Castro, *Palavras de um Honesto Estudo Camoniano*, 187–8.
15 'Conceived and born in such love' (V. 47).
16 'Oh flesh that enchants, daughter of Babylon the most foul'. For the Portuguese text, see Luís de Camões, *Lírica completa*, ed. Maria de Lurdes Saraiva, I (Lisbon: Imprensa Nacional, 1980), 283 (ll. 311–12).

It is possible to conclude from the textual analysis of the two stories told by Adamastor that there is a close connection between them, and that Berardinelli's and Pinto de Castro's impressionistic readings have a sound basis. The characters' experiences are closely parallel, but their moral worth is different, positive in the case of the human couple, negative in the case of the giant. Even the giant, the narrator in both cases, is aware of the pathos of the human story, and the grotesquerie of his. But the parallels remain. I have already suggested that the two narratives might be regarded as the two sides of the same coin. In that case, what they have in common would be love, which can involve monstrous passions, but also nobility, tragic suffering and a relationship which is spiritual as well as physical.

However, this is not the moment to attempt a reading of the Adamastor episode as a whole, but rather to draw attention to a compositional technique, much used by Camões, of creating parallel situations which allow the reader to see the differences and similarities between them. The contrasts are never absolute, because there is always some unifying factor.

The same technique can be found in some of the other episodes included in the poem, as for instance that of Inês de Castro, the lover of the heir to the throne of Portugal who was put to death on the orders of the king, Afonso IV. That episode follows immediately after the narrative of the Battle of Salado, in which a joint Portuguese and Castilian army defeated a Moorish invasion of the Peninsula. The link is not simply chronological, because there are parallels and contrasts between the two episodes which link them. One of those is the presence of the king. He wins the battle against the invaders in which, according to the narrator, more foes perished than on any previous occasion in history (III. 115). Immediately afterwards, without any break, Inês's tragic story begins, in which the same monarch is responsible for her death. In this way, Camões indicates how there is a factor which unites a glorious victory against the traditional enemy and the unjust killing of an innocent woman, which is war. The point is made explicitly:

> Que furor consentiu que a espada fina,
> Que pôde sustentar o grande peso
> Do furor mauro, fosse aleventada
> Contra uma fraca dama delicada?[17]

In this way two contrasting events – the death of thousands, and the death of an innocent woman – are seen to be alike because of the presence of a common element, war, whose moral value varies greatly according to circumstances.

The technique is not only narrative, but can be seen also at the level of language, as for example in the opening of Adamastor's tirade, in which he abuses the Portuguese for their outrageous behaviour:

> E disse: – Ó gente ousada, mais que quantas
> No mundo cometeram grandes cousas:
> Tu, que por guerras cruas, tais e tantas,
> E por trabalhos vãos nunca repousas,
> Pois os vedados términos quebrantas
> E navegar meus longos mares ousas,
> Que eu tanto tempo há já que guardo e tenho,
> Nunca arados de estranho ou próprio lenho ...[18] (V. 41)

It is clear that this is a tirade from the quantity of negative language used: 'ousada' and 'ousas' [dares] in the bad sense, the adjectives 'crua' and 'vãos' applied to war and toil and finally the statement that certain areas are forbidden to the Portuguese. Yet is equally obvious that Adamastor, knowingly or not, is also saying exactly the opposite: 'daring' has positive connotations, in

17 'What fury allowed the sharp blade, which could withstand the fury of the Moors, to be raised against a weak and delicate woman?' (III. 123). For further discussion, see Thomas F. Earle, 'Rhetoric and the construction of narrative in *Os Lusíadas*', in José Augusto Cardoso Bernardes, ed., *Luiz Vaz de Camões Revisitado* (Santa Barbara Portuguese Studies: Santa Barbara, 2003), 67–78 (73–7).

18 'He spoke: 'O daring people, more than any who have done great things in the world. You who in so many and so great cruel wars, and useless toils never rest – since you have broken the forbidden bounds and dare to sail my wide seas, never furrowed by foreign or native vessels, which for so long I have guarded and kept as my own ...' (V. 41).

English as in Portuguese, he admits the Portuguese have done 'great things', they never rest, and they have entered seas where no one had sailed before.

However, if we bear in mind the relationship between the two love stories told by Adamastor it is possible to see that there is no contradiction in simultaneously attacking and praising the Portuguese sailors. They are indeed daring, in both senses, and it is interesting to note that the word 'ousado', or a synonym, is used in each of the first four stanzas of Adamastor's speech, always in relation to the Portuguese. The giant naturally lays more stress on the negative aspect of the voyages of discovery, on disaster and on suffering, but the other, glorious side is there also because, in Camões's view, the tragic aspect of the Portuguese expansion is intimately linked to its greatness.

The same technique can be examined further. The Adamastor episode appears in the central *canto* of the poem, at the moment when the voyagers pass from the Atlantic to the Indian Ocean, from the known to the unknown. Consequently, the episode has parallels with other key moments of the epic, with the Isle of Love, in other words, with the end of *The Lusiads* – parallels already explored by many critics – and also with the beginning. These are less well known.

The first stanza of *The Lusiads* reads as follows:

> As armas e os barões assinalados
> Que da ocidental praia lusitana,
> Por mares nunca dantes navegados,
> Passaram ainda além da Taprobana,
> Emguerras e perigos esforçados
> Mais do que prometia a força humana,
> E entre gente remota edificaram
> Novo reino, que tanto sublimaram.[19]

19 'The arms and the famous men who, from the western Lusitanian shore, passed over seas never sailed before, further even than Taprobana, brave in dangers and in wars, more than human strength promises, and amongst remote people built a new kingdom, which they made sublime ...'.

Adamastor's tirade might be read as a rewriting of this stanza, and thereby a way of linking the opening of the epic with its middle section. In this way the seas 'nunca arados de estranho ou próprio lenho' are the seas 'nunca dantes navegados', the 'vedados términos' Taprobana, traditionally believed to be the end of the world, and the 'guerras cruas' and the 'trabalhos vãos' the reverse of the 'perigos e guerras esforçados' of the first stanza. And might not the Portuguese be 'barões assinalados' because they 'cometeram grandes cousas'?

Once again the positive and the negative are linked, this time by the events of the story narrated in the epic, which are capable of more than one interpretation. There is ambiguity even in some of the phrases of the opening stanza, especially in the 'perigos e guerras esforçados / mais do que prometia a força humana'. The words mean that there was an element of the superhuman in the feats of the Portuguese, but there is also another, concealed meaning, which is that the Portuguese went beyond what was humanly possible, and that divine assistance was necessary to guarantee the arrival of the fleet in India. But a full discussion of this topic would require a second article.

It is time to return to Adamastor. Camões's vision of him is, inevitably, complex, because to him every question has two sides, each dependent on the other. It therefore becomes very difficult to move from a detailed analysis of sections of text to a global interpretation of the whole episode, and it is not my intention to do so here. Instead, I will give a brief account of two already published accounts, each of them excellent, but taking opposed political positions. The aim is partly to bring together critical positions emanating from very different intellectual traditions, the North American and the Portuguese, and also to show how, in the balanced structure of the poem, distinct political views can coexist.

The chapter in David Quint's *Epic and Empire* (1992) about Adamastor is particularly interesting because of the way in which he contextualizes the giant's appearance in the narrative structure of the poem. Various incidents occur in the course of the voyage from Portugal to the Cape of Good Hope which is narrated by Gama to the Sheikh of Malindi in *Canto* V. One of these is the unexpected sight of a waterspout (stanzas 19–23) and another the encounter with a group of Africans in the Bay of St Helena

(stanzas 27–36). A number of critics have already pointed out how the waterspout, which looks like a cloud bursting with water, is a prefiguration of Adamastor, described as a 'uma nuvem que os ares escurece'.[20] It is a view repeated by Quint, but he, more unusually, also sees the relevance of the encounter with the Africans.

On landing in the Bay of St Helena, near the Cape, the Portuguese meet an African with whom they are unable to communicate. The next day, more Africans appear and one of the sailors, Veloso, described by the narrator as 'arrogante' (V. 31), accompanies the group into the interior. This rash move leads to an armed conflict in which Gama is wounded. The Portuguese fight back, and then sail on, Gama commenting on 'a malícia feia e rudo intento / da gente bestial, bruta e malvada'.[21]

The incident was recorded by the historians Barros and Castanheda, but Camões did not include it just because it happened in historical fact. It is also there because it is a truly epic event, with a close parallel in the encounter between Odysseus and the Cicones in Book IX of the *Odyssey*, and also, as Quint thinks, because it prepares the reader for the appearance of Adamastor.[22]

Quint notes the meaning of Adamastor's name, 'untamed', and the behaviour of the Africans is fierce and violent. Gama says of one of them that he was 'selvagem mais que o bruto Polifemo',[23] the giant of classical mythology who inspired Camões's creation, and he compares the black band of Africans to a dense cloud, like the famous 'nuvem que os ares escurece', already mentioned, which is the first indication of the Cape of Good Hope and of the monster who is its personification. These are the arguments put forward by Quint, to which one might add the fact that the Adamastor episode follows the encounter with the Africans without any transition. These moments, when one episode leads directly into another, are always significant in the epic, as in the examples already mentioned of

20 'A cloud which darkens the air' (V. 37).
21 'The crude malice and violent intentions of the bestial, brutish and wicked people' (V. 34).
22 Quint, 116–17. The adventure with the Cicones occurs in the *Odyssey*, IX, ll. 39–61.
23 'More savage than the brute Polyphemus' (V. 28).

the giant's love narrative, which follows immediately after the tragic death of the Sepúlvedas, or the way in which the story of Inês de Castro is joined seamlessly to the account of the bloody battle of Salado.

This is perhaps the moment to introduce a parenthesis. If the juxtapositions of episodes in *The Lusiads* are very often significant in themselves, then the old neo-Aristotelian belief in the distinction between main action and more or less relevant episodes is once again challenged. The structure of the poem is no longer the voyage of Vasco da Gama and the rest, because all the episodes have an equal literary value. However, it was under the influence of neo-Aristotelianism that Pinto de Castro passed over what he calls the 'historical anecdote' of the Bay of St Helena episode, which he considered to be a mere 'picaresque pause' in the 'ascending movement of the narrative'.[24]

For Quint, however, the episode is extremely important, because it shows how Adamastor personifies, not just the geographical reality of the Cape, which is the traditional view, but also the human inhabitants, both of them hostile to the coming of the white man. However, as we know, Adamastor's threats soon give way to the narrative of his emotional disappointments. According to Quint, the episode as a whole only increases the belief of the Portuguese in the greatness of their achievements and, in his words, the Africans 'are displaced and swallowed up in Camões's giant'. However, there is something disturbing about the whole incident, and Quint concludes: 'Camões's monster, born of the initial encounter of Portuguese imperialism and its native subjects, is the first in a line of specters haunting Europe'.[25] The last phrase is an evident reference to the opening of the *Manifesto of the Communist Party*.

Quint's left-wing view of the episode leads him to see in the giant's tirade one of the first protests against what would become, after Camões's time, European colonialism, even if the protest is stifled almost as soon as it is uttered. Yet the political stance does not diminish the scholarly

24 Pinto de Castro, 181.
25 Quint, 124–5.

importance of the article, which is particularly valuable for its rehabilitation of the Bay of St Helena episode.

In the twentieth century *The Lusiads* has more often been the property of the right than of the left, and this is the case of the article by Pinto de Castro included in his book, *Páginas de um honesto estudo camoniano*, which has already been mentioned. Like Quint's piece it is of considerable scholarly value. Its originality consists in the link established by Pinto de Castro between the epic and tragic aspects of the episode or, in other words, between the future glory of Portugal resulting from the first voyage to India and the disasters correctly prophesied by the giant.[26]

The point is essentially the same as that made in the present article, though here the opportunity has been taken to explore Pinto de Castro's *aperçu* in the context of *The Lusiads* more widely. The same association between triumph and disaster, between the positive and the negative, can be found too in Camões's lyric poetry. It occurs in the heroic *oitavas* dedicated to the viceroy Dom Constantino de Bragança, in which an epic tone prevails. There the viceroy's unpopularity with his subjects is taken as a proof of his moral greatness. Another, better-known example can be found in the final lines of the ode 'Pode um desejo imenso', in which the poet laments the failure of his fellow-countrymen to appreciate the beauty of his verses, and of his lady, and brings his poem to an epigrammatic close:

> Mas faça o que quiser o vil costume,
> Que o sol, que em vós está,
> Na escuridão dará mais claro lume.[27]

The conclusion, here as in the Adamastor episode, is that, in an imperfect world, the best and the worst are indissolubly linked.

26 Pinto de Castro, 183–4.

27 The ode takes its title from its first line, 'An immense desire is able ...'. It concludes: 'The vulgar can have the habits they choose, for the sun which shines within you will a give a brighter light in the darkness'. Both poems are printed in Maria de Lurdes Saraiva's complete edition, vol. III. The *oitavas* are at pp. 219–23 and the ode at pp. 86–8.

It was perhaps inevitable, in an article published for the first time in 1972, to commemorate the fourth centenary of the first edition of *The Lusiads*, that Pinto de Castro should have continued by speaking of the 'nacionalismo proselitista de Camões' and of the 'valor indómito dos Portugueses'.[28] Especially the words 'nacionalismo proselitista' seem to include Camões among the supporters of the right-wing regime of Marcelo Caetano, the successor of Salazar. Perhaps while that regime was in power it was difficult to express oneself any other way in Portugal, but it remains surprising that the same episode of the poem should provoke two such different political reactions.

This paper has sought to prove that in the Adamastor episode, and in many others in *The Lusiads*, Camões employs a literary technique which allows him to include and, up to a certain point, reconcile the contradictions which are inherent to the epic. In this way he is able to penetrate the mysteries of human love, at once physical and spiritual, and is aware of the connections between glory and disaster. The network of related oppositions extends within and outside the episode, not all of which have been discussed here. However, there are evident links between Adamastor and the Isle of Love of *Cantos* IX and X. Nor is the episode unique in its oppositions of positive and negative, and other episodes – like that of Inês de Castro, mentioned above – can be read in the same way. Camões's awareness that there are at least two aspects to every argument has stylistic as well as narrative consequences, and there are innumerable passages in the poem where there is one, obvious, sense and another, concealed but nonetheless there, which implies the opposite.

Such an approach to the poem certainly downplays its political aspect which has seemed so important to previous critics. If Quint is to be believed, even as the Portuguese penetrated the Indian Ocean for the first time, Camões did not forget the suffering of the peoples of Africa at the hands of Europeans. At the same time, if we follow Pinto de Castro, the poet used this triumphal moment to proclaim the glory of his nation. Is it necessary to believe either of them? It could be argued that the episode

28 'Camões's proselytizing nationalism' and 'unconquerable Portuguese valour'.

contains both these meanings, as well as various others. The poem need not, therefore, be read in the light of the critic's political convictions, but rather as a deeply felt meditation on events whose ultimate meaning remains mysterious.

TOM CONLEY

6 Renaissance *que voicy*: Torque in a Tower (Reading Montaigne, *Essais*, III, iii)

Renaissance Now!: the motto under which the papers of this volume are written suggests that the early modern age, at once both familiar and remote, ought to be displaced into the cultures in which we are living. The vertical dash of the exclamation point compels us to think of the Renaissance as something that in the same thrust is informative and alienating: the bedrock of the modern era, when seen from afar, the Renaissance can tell us how we are shaped as we are and, as psychoanalysts are wont to say, 'where we are coming from'. Yet we discover its mental structures to be so unlike what we know that its alterity prods us to rethink how we live our lives and reconsider what we believe we are. The title infers, too, that the task of the historian and the critic has political valence: in our various disciplines we 'work' on the Renaissance not to retreat into a fantasy of what it might have been but to bring it into our perspective in order to alter the condition of our world for the better. In a strong sense we find in it a sensorium – a way of living – that we would do well to recognize.

In this sense Michel Foucault's luminous pages of *Les Mots et les choses* (1966) on the passage of a mentality that marked the Renaissance to a classical age detail how a regime of similitude and analogy gave way to another of resemblance. A prevailing mode of inquiry in the Renaissance obtained knowledge through endless comparison of objects and their names. However strange they might seem when set in contiguity, close and patient inspection of words and things revealed traits that became points of reference, cairns or *jalons* on pathways of ever-varying itineraries of investigation. In the Renaissance, Foucault avowed, analogy made possible the juxtaposition of a sewing machine to an umbrella on an operating

table. In the classical age that followed, the very thought of the comparison that Lautréamont made famous at the turn of the twentieth century would have been impossible. Foucault appealed to the author of *Les Chants de Maldorer* to remark that in the Renaissance the names and attributes of two heteroclite objects could be compared along different axes so as to open productive inquiry into the nature of things. He implied that Lautréamont's similitude, a figment of the creative imagination of our time, is understood *now* by dint of the way it would have been appreciated in the Renaissance. Albeit in different ways and with different consequences, early modern modes of investigation belong to the ways we see and read cultural forms of our moment: Foucault added that the Renaissance underwent a long period of repression before one of gestation and emergence in the 'long' nineteenth century made possible an appreciation of literature of the kind that Lautréamont and his contemporaries emblazoned.

But with a difference. At the end of the second chapter (following a detailed reading of Velasquez's *Las Meniñas*), after designating the four similitudes that tied the sight, tact and sound of language to what it designated, he notes that in fact modern literature, what we can savour now – or at least in the modern age that begins in the nineteenth century – retrieves and redirects the forces of attraction that had been operative in Renaissance writing.[1] In the coda to the chapter on 'the prose of the world', he writes,

1 The four terms are *convenientia* ['a resemblance tied to space in the form of "step-by-step." It is of the order of conjunction and adjustment' (33)], *aemulatio* ['a kind of suitability, which would be free from the law of place, and, immobile, would be at play, in the distance (...), something of a reflection and of the mirror' (34)], *analogy* ['the marvelous confrontation of resemblances over space' that also addresses 'fittings, links and junctures' (36)], and *sympathies* or attractions [the 'principle of mobility' that 'instantly runs through vast spaces', and that 'transforms, alters, but in the direction of whatever is identical', such that its twin figure is 'antipathy' (38–9)]. The four figures 'tell us how the world must fold over and upon itself, double itself, be reflected or concatenated so that things can resemble one another' (41). Resemblances bear *signatures* that envelop the four principles into each other. To seek meaning is to find ways of revealing resemblances (44).

[o]n peut dire en un sens que la 'littérature', telle qu'elle s'est constituée et s'est désignée comme telle au seuil de l'âge moderne, manifeste la réapparition, là où l'on ne l'attendait pas, de l'être vif du langage. [...] Or, tout au long du XIXe siècle et jusqu'à nous encore – de Hölderlin à Mallarmé, à Antonin Artaud – , la littérature n'a existé dans son autonomie, elle ne s'est détachée de tout autre langage par une coupure profonde qu'en formant une sorte de 'contre-discours', et en remontant ainsi de la fonction représentative ou signifiante du langage à cet être brut oublié depuis le XVIe siècle. (58–9)

[in a way it can be said that 'literature', such as it is shaped and designated at the threshold of the modern age, makes clear reappearance, exactly where it was least expected, of the living being of language. [...] Thus only throughout the nineteenth century and even up to our time – from Hölderlin to Mallarmé, to Antonin Artaud, does literature exist in its autonomy: when it forms a type of 'counter-discourse', in thus moving from the representative or signifying function of language [back] to this brute being forgotten since the sixteenth century.]

A champion of the culture wars of the 1960s and early 1970s, Foucault is exhumed here less to give credence to Renaissance studies in a new iteration of the *Querelle des anciens et des modernes* in which theorists are pitted against historians than to deploy the concept of analogy to ask how what is *then* can become *now*. Now then? Contrary to the Renaissance, the classical age drew an indelible line of divide between *seeing* and *saying*. It refused to recognize that when spoken a name was scrutinized. Yet in the earlier age the form and shape of a name, part and parcel of living matter, suggested that it might have connection with the object to which it referred. It could be a living sign in consort with what it 'represented'. Inversely, the object itself could not be sensed apart from the fantasies that sound and shape of the name might inspire and, no less, bequeath to it. In various ways – some visible, others translucent and even opaque – signs and their referents were interrelated in a vast network of correspondences attesting to the beauty of God's handiwork.[2]

2 The legions of studies on the topic hardly need recall. Formative was François Jacob, *La Logique du vivant: Une histoire de l'hérédité* (Paris: Gallimard, 1970) that Foucault had known prior to its publication, as well as the same author's *La Sexualité des bactéries* (Paris: Institut Pasteur, 1959), co-written with Elie Wollman. With little

Montaigne made the point saliently and with varied inflection. In noting that he was afflicted with the malady of the kidney stone that caused his father's death (at the respectable age of seventy-eight years), the author of 'De la ressemblance des enfans aux peres' stated, '[i]l est à croire que je dois à mon pere ceste qualité pierreuse, car il mourut merveilleusement affligé d'une grosse pierre qu'il avoit en la vessie' [it seems that I owe to my father this stony quality because he died tremendously afflicted by a huge stone lodged in his bladder].[3] The symptom of the malady is found in his father's name: the memory of Pierre Eyquem indicates that the 'stony quality' that brings pain and disquiet might inhere in the gene-like characters of a common substantive that are coded in his Christian name. The resemblance of child to the father owes to the transmission of the genetic character contained in both blood and the six characters of his name. The reader of the essay is obliged to examine the correspondences at the foot of the letter, in the shape of the printed characters of *Pierre* in order to discern how the 'resemblance' of the child to the father operates through analogy. Elsewhere, in the *incipit* to 'De la gloire' that would seemingly call into

attention paid to its historical virtue *Les Mots et les choses* exerted influence on debates concerning the line of division between the arbitrary and motivated character of the linguistic sign that multifarious readings of Saussure's *Cours de linguistique générale* had prompted, especially Claude Lévi-Strauss in *Tristes Tropiques* (Paris: Plon, 1955). Included were Jacques Lacan, *Écrits* (Paris: Editions du Seuil, 1966); Roland Barthes, *Eléments de sémiologie* (Paris: Gonthier, 1968), Jacques Derrida, *Glas* (Paris: Galilée, 1974), Gérard Genette, *Mimilogiques: Voyages en Cratylie* (Paris: Editions du Seuil, 1976), and other titles. Contrary to Foucault and Jacob, few paid great heed to the way that the Renaissance tradition of analogy betrayed Saussure's insistence on the 'arbitrary' or conventional nature of the linguistic sign. One of the first was François Rigolot, in *Poésie et onomastique: L'exemple de la Renaissance* (Geneva: Doz, 1977) and in *Le Texte de la Renaissance: Des Rhétoriqueurs à Montaigne* (Geneva: Droz, 1982).

3 Michel de Montaigne, *Essais*, in *Essais*, ed. Pierre Villey (Paris: PUF/Quadrige, 1968) 763 [or <http://www.lib.uchicago.edu/efts/ARTFL/projects/montaigne> in the Montaigne Project online]. All reference to the *Essais* will be drawn from this edition and illustrations from the corresponding digital page images of the Bordeaux Copy included in the text of the Montaigne Project. Translations from the French are my own.

question the relation of the kidney stone, *la pierre*, to the father, *Pierre*, a relation of the word to the thing, like that of Lautréamont's sewing machine to the umbrella on an operating table, albeit attenuated, is nonetheless maintained. 'Il y a le nom et la chose; le nom, c'est une voix qui voix qui remerque et signifie la chose; le nom, ce n'est pas une partie de la chose ny de la substance, c'est une piece estrangere joincte à la chose, et hors d'elle' [There is the name and the thing; the name is a voice that remarks and signifies the thing; the name is not part of the thing nor of its substance, it's a foreign piece joined to the thing, and outside of it]. The articulation is built on the denial – hence an underhanded admission – of analogy. An object becomes what it is when a foreign voice, calling attention to it, seems to speak from within its being. The action of naming tends to affix the sight and sound of the name to the thing signified, and ultimately the range of associations in the signifying matter bear on its character. No matter what the relation of the name and thing may exactly be, analogy, initiated through comparison, inheres in its process.

The *Essais* are a laboratory in which the epistemic virtue of analogy, resemblance and signature are tested within the vital tissue of their style. Nowhere are comparisons of words and things more clearly set forward than in one of the most baffling of all – at once crisp, clear but also infinitely confusing – chapters of the third volume. 'De trois commerces' [Of three commerces, or what has been translated as 'three kinds of association'] mixes a discrete ordering or even 'busing' of information within itineraries of ever-forking paths of comparison. The essay portrays the author reflecting on how analogy allows him to 'manage' and to 'distribute' his affections. Its style, that makes keen use of the forces of attraction and repulsion with which Foucault equated the Renaissance with modern literature, enables its printed form to become an intermediate area between a discourse and a table or diagram.[4] Ostensibly treating of the pleasures the author obtains

4 'Form of content', an expression that in *Surveiller et punir: Naissance de la prison* (Paris: Gallimard, 1975) Foucault borrowed from Louis Hjelmslev's semiotic theory to describe the spatial plan of Jeremy Bentham's panopticon, applies to the plethora of information that early modern compilers aimed to organize and control by means of diagrammatic charts, a topic central to Ann M. Blair's *Too Much to Know: Managing*

from friends, women and books, respectively, the essay embeds Ramist modes of organization at once within its spatial disposition – the 'place' it occupies in the greater volume of the *Essais* – and its phrasing or manner of style. Before he addresses any of the three ostensive topics, a play of association and of forking itineraries is clearly drawn in the emblematic aspect of the number of the chapter, its title, and its *incipit*:

> Chapitre iii *De trois commerces*
> (b) Il ne faut pas se clouër si fort à ses humeurs & complexions. Nostre principalle suffisance, c'est sçavoir s'appliquer à divers usages. C'est estre, mais ce n'est pas vivre, que se tenir attaché & obligé par necessité à un seul train. Les plus belles ames sont celles qui ont plus de varieté et de souplesse. (818)

> [Chapter iii *Of Three Commerces*
> We must not be nailed so strongly to our humors and complexions. Our principal satisfaction is to know how to apply ourselves to different uses [usages]. It is being but not living when by necessity we are attached and obliged to hold to a single line. The most handsome souls are those that have the most variety and suppleness.]

Book three, chapter three, three 'commerces': Would each be, as Randle Cotgrave noted in 1611, some kind of 'intercourse of traffike; familiaritie, or acquaintance gotten; correspondencie, or intelligence continued, between people, in dealing, or trading together'?[5] Or, in Montaigne's idiolect of his own creation, would they belong, as much as to friends, women and book, to an amphibious order, moving between Latin and French, word and thing, or sign and referent in which in merchandise or commodities, said to be bought and sold, have no place outside of the 'market' of the

Scholarly Information Before the Modern Age (New Haven: Yale University Press, 2010). Based on Marxian theory of labour, Jacques Rancière's studies of the shifts in 'distributions' of sensation, in *Aisthesis: Scènes du régime esthétique de l'art* (Paris: Galilée, 2011), are applicable where Montaigne arranges and even 'furnishes' the space of his pleasures.

5 *A Dictionarie of the French and English Tongues*, compiled by Randle Cotgrave (London: Adam Islip, 1611); online as <http://www.pbm.com/~lindahl/cotgrave/>.

essay itself?[6] The questions brought forward by the initial symmetry – the duplication of ciphers in the chapter's name – are hardly a 'foreign piece joined to the thing'. In greater likelihood they are an 'ambitious subtlety' (964), turned about in the tabular or diagrammatical order of the *incipit* in respect to what crowns it. 'Il ne faut pas se clouër ci-fort à ses humeurs & complexions' (818) [We must not nail ourselves so strongly to our humors and complexions]. *Three* commerces stand over what would be the *four* humors of inherited medicine that are described by *two* substantives. A tension of difference is written into a configuration in order, it appears, to destabilize the fixating effect of geometrical reason imposed upon the chapter. Because the title of the essay is coordinated with its number the tradition of the *emblema triplex* is made manifest. The motto or hieroglyphic device at the top would be the cipher of the chapter's Roman numerals, and the 'inscriptio' or image the title that, because of its partitive character (*De ... trois commerces*) redistributes its elements through what would be infinite comparison. In *subscriptio*, the second and third sentences appear to 'underwrite' the motto-like dictum of the *incipit*: a virtue of suppleness and movement, a sly or clever adaptability is the basis of living (*vivre*) favoured over the stasis of being (*estre*), a term that the essay will later twist and turn for its own ends.

6 Montaigne avows, 'j'ay un dictionnaire tout à part moy' (1111) [I have a dictionary that is all my own]. In his decisive *Les Commerces de Montaigne* (Paris: Nizet, 1994) Philippe Desan studies how the *Essais* are fraught with the tensions of archaic and modern modes of exchange in ways related to what in a book of the same title (New York: Routledge, 2004 re-edition) Marshall Sahlins had studied in the name of 'stone-age economics'. 'De trois commerces' distinguishes itself for the reason that in the way they are treated its commodities, bearing little exchange-value, gain incomparable use-value for the author when they are set in a relation of comparison or analogy.

Figure 1: *De trois commerces*, Chap. III, Bordeaux copy.

In the Exemplaire de Bordeaux a brown inkstain and smudge over *tenir* calls attention to an addition in the left margin that draws the reader's eyes away from the text (Figure 1). An initial deictic, *Voylà* (with which here and elsewhere the formula draws immediate and striking attention to itself) appears iterated to call attention to the simultaneously visual and spatial registers of the essay: '(b) Voylà un honorable tesmoignage du vieil Caton: (c) Huic versatile ingenium sic pariter ad omnia fuit, ut natum ad it unum diceres, quodcumque ageret' (818) [(b) Now there's an honourable testimony in old Cato: (c) His mind could be plied to everything so equally that whatever he undertook it would have been said born uniquely for that]. Cato's *ingenium*, his mind, his wit or sense of ruse, here implied to be of tactical virtue, has military and architectural inflection. He twists and turns so as not to be held captive or enslaved to inclination. His inventive bent, drawn from memory of Livy, identifies Montaigne's aim of bringing torque and torsion fixed ways of being. Evidence is shown in some of the minor emendations visible only on the Bordeaux copy:

> (b) Si c'estoit à moy à me dresser à ma [poste] mode, il n'est aucune si bonne façon où je vouleusse estre [planté] fiché: pour ne m'en sçavoir [destourner] desprendre. La vie est un mouvement inegal, irregulier et multiforme. Ce n'est pas estre amy de soy et moins encore maistre, c'est en estre esclave, de se suivre incessamment, [&] Et estre si pris à ses inclinations qu'on n'en puisse fourvoyer, qu'on ne les puisse tordre. (818)

[(b) If it were up to me to erect myself as I am, there is no fitting fashion by which I might wish to be [~~planted~~] fixed: in order to be unaware about how to [~~turn away~~] be undone. Life is an uneven, irregular and multiform movement. It's not to be friend of oneself and even less master: we are enslaved when we incessantly follow ourselves. [~~&~~] And to be so taken by our inclinations that we can't lead ourselves stray or that we're unable to twist them.]

The inked corrections indicate that the writer seeks in his words effects of movement that undo fixed positioning or pigeonholing: '[À] ma *mode*' (Cotgrave: 'manner, fashion, guise, use, custome, way, meanes') lays stress on the style of the discourse. And 'à ma poste' ('unto my liking, after my mind, according to my humour, even as I would have it'), it appears, would have been static, much as 'planté', in counterpoint, would have been less fixating than 'fiché', while 'destourné' might have drawn undue attention away from the tonic *puisse tordre* that caps the reflection. Where Montaigne declares that life 'is' multiform, uneven and irregular', he draws attention to the deadening effect of the diagrammatical – Ramist – ossature of a sentence whose static form, marked in the use of the copula *estre*, would fix meaning in the shape of a prescriptive aphorism.

The beguiling simplicity of these shifts and others invites speculation on the way that meditation is based on comparison as a principle of mediation. Two major *alongeails* or additions penned into the margins of the essay deviate from the tripartite order announced in the title and taken up in much of the text. In these places the writing draws attention to the way its form crafts the space in which it is placed. Noting that our minds (*esprits*) need foreign matter to set cogitation and reflection into motion, Montaigne notes how invention, understood in the sense of what is selected or 'comes to mind' (from *invenire*) belongs to the same order as judgment. He adds and no sooner strikes over a five-part formula that equates thinking with moving: '~~Mon ame se sonde, se contrerolle, range, modere et fortifie se promenant par ses discours~~' [~~My soul examines, reviews, ranges, moderates and fortifies itself in walking by ways of its discourse~~]. The final three verbs are displaced into a sentence above in order to give way to a topic written in the margins of the essay (Figure 2) – *not* included among the three commerces – whose form embodies the process of analogy. Here is the beginning of the first of the two major additions:

Figure 2: *Essay on Meditating.*

Le *mediter* est un puissant estude et plein, à qui sçait se taster et employer vigoureusement: j'aime mieux *for*ger mon ame que la meubler [et la grossir que la farcir]. Il n'est point d'occupation ny plus foible, ny plus *for*te, que celle d'en*rete*nir ses pensées selon l'ame que c'est. (819, stress added)

[Meditating is a full and powerful study for those who have the touch and can work vigorously: I prefer to forge my soul than to furnish it [and to expand it than to stuff it]. No occupation is either or stronger than that of keeping with one's thoughts according the soul as it is.]

The infinite substantive which inaugurates the sentence signals that a third term, *ter*, is lodged in *mediter* – suggesting in the visual gist or emblematic character of the word that meditation is tantamount to negotiation (*neg-otium*). To meditate is to mediate. If Montaigne's fancy is taken at the foot of the letter it would not be overarching to note that the *M* inaugurating the noun can be seen, surely, as 'une piece estrangiere jointe à la chose' but also as the median digit in the alphabet, a fulcrum and a mirrored shape that splits into two equal halves, its form here becoming a

miniature diagram of the word to which it is attached.[7] Montaigne negoti-
ates words and their letters and spacings in a fashion that charts a relation
between desire for knowledge that generates inquiry into knowledge, what
he desires, *ce qu'il aime*, and the site (both the tower where he writes and
the soul or *âme*) to which the desire is led.[8]

Wordsmith that he is, when Montaigne seeks to 'forge' his soul he fig-
ures himself in a furnace of invention. In the first principal emendation in
the Bordeaux Copy the 'full and powerful study' that he fantasizes appears
to be a mental space. By setting *meubler* adjacent to *forger* he confuses the
soul with a domestic space (including furniture, a chair and a table) where
the event of the writing of the essay takes place. Later in the chapter, in a
second addition, an effusive piece of marginalia that runs over the right
hand side and bottom of the folio 262r (Figure 3), a description of the
tower corresponds with his remarks about the force of *le mediter*. He sug-
gests that the *estude* or discipline he advocates is also (or catachrestically)
the very tower in which he writes. In the 1588 stratum, after extolling the
pleasure of having books accompany his 'human voyage' and mediate the
absence of friends and women he returns to his library:

<hr />

7 In their gloss of toponyms on the map accompanying Béroalde de Verville's *Le Voyage*
des princes fortunés (Paris, 1610), editors of a recent transcription of the oriental and
pastoral novel (Albi: Passage du Nord à l'Ouest, 2005) note that the Equator is
designated by a line running from A to Z. The median character is M, and as such
it is pronounced 'âme'. Citing his own words in his *Cabinet de Minerve*, in the novel
Béroalde writes, "'the mind (*esprit*) is the part of the soul (*âme*) which contains the
power of learning, and the reason by which we discern according to the knowledge
(*connaissance*) of several things'" (n46, 704–5). For both Béroalde and Montaigne
equivocation and comparison are given in the pronunciation and the visual aspect
of 'M', a stenograph (or for Béroalde, a 'steganograph') of both *âme* and *aime*.

8 'Il n'est desir plus naturel que le desir de connoissance' [No desire is more natural
than the desire of knowledge]: Montaigne's translation of Aristotle that begins 'De
l'experience' (III, xiii), the crowning essay of the third volume brings together the
art of analogy, invention, judgment and experience in the empirical sense that it will
gain in the modern era.

Figure 3: Folio 262r.

(b) Chez moy, je me destourne un peu plus souvent à ma librairie, d'où tout d'une main je commande à mon mesnage. Je suis sur l'entrée et vois soubs moy mon iardin, ma basse cour, et dans la pluspart des membres de ma maison. Là, je feuillette à cette heure un livre, à cette heure un autre, sans ordre et sans dessein, à pieces descousues; tantost ie resve, tantost i'enregistre et dicte, en me promenant, mes songes que voicy. (828)

[While at home I turn about a little more often in my library where, in a glance, I have command over my household. I am over the entry and see below me my garden, my lower courtyard, and into most of the members of my house. Here I am paging through a book, and now and again another, with neither order nor design, in unkempt pieces; sometimes I dream, sometimes in walking about I record and dictate my dreams that you see right here.]

Que voicy: when considering the books on the shelves around him he reflects on the would-be panoptic view from the third floor of the tower both on his property and on his way of thinking – that is, of parsing, negotiating and comparing.[9] But only right here: readers who imagine Montaigne reading and editing the Bordeaux copy, now and again inking notes in the margins, are quick to observe how *que voicy* prompts him to take immediate stock of where he is and how the page that he is emending takes part in the invention of median spaces – at once graphic, architectural and oneiric – of the tower.

The long addition, unlike any other and arguably one of the most vital to the mental and physical architecture of the *Essais*, describes the tower in accord with the logic announced at the beginning of the chapter. His library is on the third floor, the first being his chapel, the second a bedroom and an adjoining closet (in past time, he added, the most useless place of the house), and the third the library itself where he spends most of his daily hours. If possible he would attach a walkway to the floor because his thoughts fall asleep when he sits down. At that juncture a graphic description of its face and plan is penned into the margin:

9 In this passage *commander* carries inflection of the author's own use of *commer*, 'to make comparisons', that appears elsewhere in the *Essais*. Throughout the chapter *comme* is taken in the strong sense of a term initiating a similitude, but here it gains uncommon optical valence.

La figure en est ronde et n'a de plat que ce qu'il faut à ma table et a mon siege, et vient m'offrant en se courbant, d'une veuë, tous mes livres, rengez à cinq degrez tout à l'environ. Elle a trois veuës de riche et libre prospect, & seize pas de vuide en diametre. En hyver, j'y suis moins continuellement; car ma maison est juchée sur un tertre, comme dict son nom, et n'a point de piece plus esventée que cette cy; qui me plaist d'estre un peu penible et à l'esquart, tant pour le fruit de l'exercice que pour reculer de moy la presse. C'est là mon siege. J'essaie à m'en rendre la domination pure, et à soustraire ce seul coin à la communauté et conjugale, et filiale, et civile. (828)

[Its figure is round and is flat only for the needs of my table and seat, and offers to me in turning, in a single view, all my books arranged in five levels all around. It has three views of rich and free prospect, and sixteen steps wide in diameter. I am there less continually in winter because my house is perched on a hillock, as its name states, and has no windier room than this one; which I find somewhat bothersome and remote, as much for the profit of the exercise as for a retreat from public pressure. That is my throne. I try to give myself to pure domination and to remove this sole corner from the conjugal, filial and civil community.]

Montaigne's seat, his *siege*, would be the axis of the circle from which he obtains a panoramic view of the inner wall along which his books, stacked horizontally, are set on shelves below the windows (Figure 4). Yet since the tower is *à l'esquart*, both separated from the chateau and in the shape of a square (which is echoed in '*car* ma maison ...'), the configuration suggests that it might be where the circle of the tower finds its quadrature.[10] When

10 It is the area in the *Apologie de Raimond Sebond* where he had fantasied the swal-
 lows he saw nesting in the crannies of local houses. 'Les arondelles, que nous voyons
 au retour du printemps fureter tous les coins de nos maisons, cherchent elles sans
 jugement et choisissent elles sans discretion, de mille places, celle qui leur est la
 plus commode à se loger? Et, en cette belle et admirable contexture de leurs basti-
 mens, les oiseaux peuvent ils se servir plustost d'une figure quarrée que de la ronde,
 d'un angle obtus que d'un angle droit, sans en sçavoir les conditions et les effects?'
 (454, stress added) [Are the swallows that we see at the return of spring ferret-
 ing all crannies of our houses seeking without judgment, and are they choosing
 without discretion, from a thousand places, the one that is the most appropriate
 for their lodging? And, in this handsome admirable contexture of their buildings,
 can the birds, with no sense of the conditions and effects, employ a square rather
 than a round figure?]. A detailed reading of this passage is taken up in my *Errant*

he imagines the tower perched on an apex, 'as its name indicates', implied reference is to 'montaigne', the mountain Montaigne makes of a Gascon molehill. Reference is made not only to the site itself, to *tertre* ('a little hill, hillocke, or barrow'), in which the integer legitimating meditation and mediation, *ter-*, is seen twice, but also to the art of comparison, signaled by '*comme* dict son nom', in which a proper name, a common noun, and a number are fused.

His house thus becomes a 'secret' laboratory, a public palace of secrets, where experiments with language are made; where letters and signifiers of words and concepts are graphed or morphed into one another in order to yield uncommon configurations. At this juncture the essay begs readers to cast their eyes upon its ciphers as places and spaces where a new kind of experience is produced: not merely in the verbal recall of times and circumstances past that comprise an author's autobiography but, more likely, in the construction of an arena where *events* take place wherever the unconscious force of the writing is glimpsed. It can be sensed that the windy atmosphere of the room – *la plus esventée* – draws attention to the micro-sensations that are the substance of events themselves.

The event that the essay makes of the tower can be understood as something that opens consciousness to the intensities of the ambient world and that, simultaneously, releases unconscious forces from those who are in the flux of experience produced within its confines. Like (or better than) any philosopher, within it the writer creates events at moments where language gives way to scintillation of sensation. In those moments a private and public space is 'invented' and no sooner evanesces.[11] The tower becomes an arena in which events emerge from the 'happenings' of comparison and analogy that the writing causes to 'take place' within the space indicated, *que voicy*.

Eye: Poetry and Topography in Early Modern France (Minneapolis: University of Minnesota Press, 2011), chapter 6.

11 Gilles Deleuze, 'L'épuisé', preface to Samuel Beckett, *Quad* (Paris: Editions de Minuit, 1994) 73–5.

'Qu'est-ce qu'un événement?' [What is an event?]: in reply to the question he poses in the title of a pivotal chapter of *Le Pli: Leibniz et le baroque* philosopher Gilles Deleuze notes that an event amounts to a 'nexus of prehensions' which emanate both from the environs in which they are experienced and the subject or being who 'prehends' them. The event is a series of 'captures' and of 'releases' of conjoined forces that are, paradoxically, simultaneously and alternately private and public. The event becomes what it is when it is felt, yet it is 'apprehended' in terms that allow it to have common currency. Subjectivation and objectivation of sensation occur in the same instant.[12] Which the Bordeaux copy makes clear in the play between the printed text and the inked addition or *alongeail* in manuscript: drawing himself into the confines of the tower, away from the madding crowd [*la presse*] he both mediates and meditates in an intermediate zone, in the scribbles penned in the margins of his private copy of the 1588 edition (Figure 4). This is where a public experience becomes, as it were, privatized, prior to when executors who negotiate a new edition transcribe the writing into the expanded text of 1595.

The event of the essay is found where its inked and printed characters are linked to the material mode of production – the mediation – of their meaning. It may be that the indeterminate substantive, *la presse*, alludes both to the public world and that of the screw or *vis infinie* of the printing press responsible for the imprint – the signature – of the essay. By analogy and resemblance the 'press' belongs to a nexus of connections that include, objectively, the world at large and, subjectively, the tower and its spiral staircase. When the printed page on which notes are written is tied to the description of a room words printed and written coalesce with an

12 In *Le Pli: Leibniz et le baroque* (Paris: Éditions de Minuit, 1988) 102. In a reading of 'De l'exercitation' [Of Practice] (II, vi) I have tried to show how Montaigne constructs a fully-fledged event through the shift from a piece of autobiographical narrative (when he fell from a horse two or three leagues away from his domicile) to meditation upon it. The latter mediates the character of the narrative by drawing unforeseen intensity of experience from its very writing. In Tom Conley, *An Errant Eye: Topography and Poetry in Early Modern France* (Minneapolis: University of Minnesota Press, 2011) 24–8.

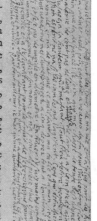

rience & vfage de cette fentence, qui eft tref-veritable, confi-
fte tout le fruict que ie tire des liures. Ie ne m'en fers en effect,
quafi non plus que ceux qui ne les cognoiffent poinct : f'en
iouys comme les auaritieux des trefors, pour fçauoir que i'en
iouyray quand il me plaira : Mon ame fe raffafie & contente
de ce droict de poffeffion. Ie ne voyage fans liures, ny en paix,
ny en guerre. Toutesfois il fe paffera plufieurs iours, & des
mois, fans q ie les employe: ce fera tantoft, fais-ie, ou demain,
ou quand il me plaira : le temps court & f'en va ce pendant,
fans me bleffer. Car il ne fe peut dire combien ie me repofe,
& feiourne, en cette confideration, qu'ils font à mon cofté
pour me donner du plaifir à mon heure : & à reconnoiftre,
combien ils portent de fecours à ma vie : c'eft la meilleure
munition que i'aye trouué à cet humain voyage, & plains
extremement les hommes d'entendement, qui l'ont à dire.
I'accepte pluftoft toute autre forte d'amufement, pour leger
qu'il foit, d'autant que cettuy-cy ne me peut efchapper. Chez
moy, ie me deftourne vn peu plus fouuent à ma librairie, d'où

Figure 4

architectural plan or diagram. An implicit comparison is tendered between a two-dimensional surface, the plan or map of the tower, and the twisting staircase that leads the author from the ground level to the third floor where the drawing and description are executed. A strange turn of phrase conveys a paradoxical attraction in being drawn away from the public sphere, 'qui me plaist d'estre un peu penible et à l'esquart' (828) [which affords me pleasure for being a nuisance]. All of a sudden the fact that he can *be* [*estre*] one with the space (or the event that creates it) bears resemblance to the triadic shape of the *tertre* on which the tower is built. Context suggests that to 'be' is to move or even spin about relations that require median terms and that, sitting where he is, in his seat [*siege*], in retracting himself from 'la communauté et conjugale, et filiale, et civile' (829) [the conjugal, filial and civil community], he is free to create events through the art of comparing and commixing. Thus, in an existential turn, he adds,

(b) Je vis du jour à la journée; et, parlant en reverence, ne vis que pour moy: mes desseins se terminent là. J'estudiay, jeune, pour l'ostentation; depuis, un peu, pour m'assagir; à cette heure, pour m'esbatre; jamais pour le quest. (829)

[(b) I live from day to day; and, speaking in reverence, I live only for myself: my designs end there. I studied, in youth, for ostentation; since then, a little, to become wise; now, to dally; never for quest.]

Given the paradox in which Montaigne declares that he retreats from the 'press' the proverb that captures the spirit of a retiree's espousal of everyday life – *je vis du jour à la journée* – carries within it the torque and torsion of the panoptic view obtained when he looks at the world from the tower. In Montaigne's idiolect, in the play of sight and sound *je vis* can be glossed as *je visse*: to live is to screw, to turn about in the fashion of the *escalier à vis* that connects the three floors. The visual pun recalls a remark stated earlier, that we are slaves to ourselves when we are so taken up with our inclinations that we cannot either bend or twist them (818).

Now, at the end of the essay, the formula sums up the quasi-Baroque point of view that the author takes of himself and his world. In a strong sense point of view is the condition under which Montaigne as a viewing or thinking subject has of all possible angles on himself in his ambient space. It is panoramic, and it is part and parcel of an *event*.[13] The author is aware that he can see inside and out from every possible angle. If his *desseins* or mental diagrams end there [*là*], where they were first shown right here [*voicy*], they continue in the enumeration of the three 'stages' of his life-study before, at the conclusion an indexical marker [*voilà*] draws the reader's eyes back to friends, women and books, his 'three favourite' and particular occupations. Although the summary seems clear as a mechanical drawing, the spin and torque within the formulation turn the conclusion away from itself.

Seen and read in light of critical appraisals of the Renaissance that attribute modernity to its proximity to contemporary literature, Montaigne's short piece becomes an event. It invents 'other spaces' in the commanding articulation of its meaning.[14] The essay calls into question the craft of

13 Deleuze, *Le Pli*, 25. Leibniz and Henry James are adduced to make a point that applies equally, and perhaps more fittingly, to this essay of Montaigne.

14 In another breath a reader, in view of *Renaissance Now!*, would be tempted, in linking 'De trois commerces' to Herman Melville's 'I and my chimney' [in *The Piazza Tales*

analogy through analogy. In staging the geometry of comparison the essay asks its reader to find in the twists and turns of its writing a meditation on the process of mediation. Such, in Montaigne, the Renaissance *que voicy*.

and Other Prose Pieces, ed. Harrison Hayford, Alma A. MacDougall, G. Thomas Tanselle et al.; historical note by Merton M. Sealts, Jr. (Chicago: Northwestern University Press, 1987)], to retitle the essay as 'I and my Tower'. The same reader might compare the effects of the spatial invention to what Elizabeth Bishop does with the space of writing in her highly geographical poetry [in *Poems, Prose and Letters*, ed. Robert Giroux and Lloyd Schwartz (New York: Library of America, 2008)], especially in the context of Kevin Kopelson's readings in *Neatness Counts: Essays on the Writer's Desk* (Minneapolis: University of Minnesota Press, 2004).

7 Fashioning Service in a Renaissance State:
 The Official Journals of the Elizabethan Viceroys
 in Ireland

On 10 September 1594 the English viceroy of Ireland Sir William Russell
did nothing; which is to say, he performed none of his official duties. As the
secretary charged with keeping his diary noted, on that day 'my lord reposed
himself' in his private apartment in Dublin Castle where recently he had
moved in with his wife and infant son. It was early in the week, a Tuesday,
yet 'little was done'. Sir William likewise did nothing on Wednesday. In fact
for a period of five consecutive days it seems he barely stirred, only return-
ing to state service the following Sunday to finalize a packet of letters for
a post-boat docked in Dublin harbour that was about to sail for England.
Nor did the viceroy exert himself after the boat had departed to Chester. On
Monday 16 September he read some official correspondence, on Tuesday
17 he entertained two Irish noblemen, but from Wednesday 18 until the
following Monday 23 he did so little that his secretary and diarist Francis
Mitchell recorded not a word, leaving the entries for these days entirely
blank.[1] Turning the pages of this section of his diary, it seems remarkable
that the viceroy could have absented himself from the business of state for
so many days. With a major rebellion in Ulster fast spreading into south
Leinster and the Midlands it was hardly as if there was nothing for him
to do.[2] Nevertheless, the fact remains that during a two-week period in
September 1594 Sir William Russell only worked three days.

1 Lambeth Palace Library [hereafter=LPL] Ms 612, ff 71–v.
2 Hiram Morgan, *Tyrone's Rebellion: The Outbreak of the Nine Years War in Tudor
 Ireland* (Woodbridge, UK: Boydell & Brewer, 1993), 172–8; David Edwards, 'In

It did not improve. During the remainder of 1594 Russell continued to spend much of his time away from public affairs, in private with his family and friends. Thus on 27 September it is recorded that he 'took the air', but otherwise did nothing of note.[3] Likewise in October: his diary contains the phrase 'nothing done' for no less than eleven days of the first three weeks of the month.[4] And so into November: from Tuesday 29 October until Sunday 3 November 'little [was] done save some letters written',[5] while 'Nothing done' summed up his use of his time during two five-day periods, 7–11 and 22–26 November respectively.[6] There was no discernible change in the run-up to Christmas. 'Little done' describes the nineteen days 28 November to 16 December, while the Christmas season itself seems to have been marked by Russell's virtual abandonment of government activity: his diary is completely blank for more than four weeks (18 December to 15 January).[7] Eventually, though, on 16 January 1595 Sir William bounded into action, setting out at the head of the crown forces to confront rebels in Wicklow on what was gallantly termed 'a hunting journey'. It was not destined to be a lengthy campaign. He returned to Dublin Castle just two days later.[8]

<p style="text-align:center">* * *</p>

This was not how the English chief governors of the Tudors' second kingdom were supposed to behave; nor, significantly, was it how they usually had their periods of service recorded. The viceroys of Ireland occupied one of the greatest and most demanding public offices in the Tudor dominions. As the proxy of the English monarch they had charge of all the secular and

Tyrone's shadow: Feagh McHugh O'Byrne, forgotten leader of the Nine Years War', in Conor O'Brien, ed., *Feagh McHugh O'Byrne: The Wicklow Firebrand* (Rathdrum: Rathdrum Historical Society, 1998), 228–9.

3 LPL Ms 612, fol. 7v.
4 *Ibid.*, ff 8r–v.
5 *Ibid.*, fol. 9r.
6 *Ibid.*, ff 9r, 10r.
7 *Ibid.*, fol. 10r.
8 *Ibid.*, fol. 12r.

religious structures of crown government. Moreover, because the polity itself – the 'kingdom of Ireland' – remained a work in progress, with large areas barely subjugated decades after the Tudors' first declaration of royal title in 1541, the martial function of the viceroys was of especial importance.[9] In the pithy phrase of one historian, the 'kingdom' was in reality 'a half-conquered borderland'.[10] Commanding a professional standing army that was constantly called into use, the viceroys who ruled over it were frequently required to advance the conquest piecemeal, where possible, and always to uphold royal authority by the strong hand.[11] Time after time they had to assert the kingdom, and defend it, quite as much as they governed it.

According to numerous documents that describe their performance as English royal governors, practically all of Russell's predecessors in Ireland had been veritable Action Men of the Tudor state. The third Earl of Sussex (chief governor 1556–65) had had his various military expeditions around the kingdom written up by one of the officers of arms, the Athlone pursuivant Philip Butler. The pursuivant's campaign journals, recounting Sussex's exploits in the hills and woodlands of east Ulster or the bogs of Offaly, among other theatres, represent one of the principal formal records of the earl's time in government.[12] Sussex's immediate successors Sir Henry Sidney (1565–71, 1575–8) and Sir William Fitzwilliam (1571–5) continued

9 Ciaran Brady, 'England's Defence and Ireland's Reform: The Dilemma of the Irish Viceroys, 1541–1641', in Brendan Bradshaw and John Morrill, eds, *The British Problem, c.1534–1707: State Formation in the Atlantic Archipelago* (London: Palgrave Macmillan, 1996), 89; David Edwards, 'Ireland: Security and Conquest', in Susan Doran and Norman Jones, eds, *The Elizabethan World* (London: Routledge, 2011), 183–7.

10 Steven G. Ellis, 'The Tudors and the origins of the modern Irish states: A standing army', in Thomas Bartlett and Keith Jeffery, eds, *A Military History of Ireland* (Cambridge: Cambridge University Press, 1996), 132.

11 For the frequency of crown military operations after 1546, see David Edwards, 'The escalation of violence in sixteenth-century Ireland', in David Edwards, Padraig Lenihan and Clodagh Tait, eds, *Age of Atrocity: Violence and Political Conflict in Early Modern Ireland* (Dublin: Four Courts, 2007), 63–78.

12 Trinity College Dublin [hereafter=TCD] Ms 581, ff 75r–90r; LPL Ms 621, ff 15r–26v.

this practice.[13] Sidney actually augmented it. A tireless self-promoter,
he composed several personal accounts of his campaigns and 'journeys'
through the provinces that were markedly more stylish than the dry and
formulaic accounts of the pursuivant, and which were designed to leave
his readers, the members of the Privy Council, in no doubt about the
strength of his endeavour on the crown's behalf, or his achievements.[14]
Thereafter viceroys such as Sir William Drury (1578–9),[15] Arthur, Lord
Grey de Wilton (1580–2)[16] and Sir John Perrot (1584–8)[17] had ensured
that they too had had special records kept of their services, emphasizing
their military accomplishments and the lengths to which they had gone
to put down rebellion and extend royal power. It seems quite remarkable,
therefore, that Russell's diary, the principal document of his viceroyalty,
should record so much inactivity on his part – all the more so considering
its full title, as it was rendered by Mitchell, his secretary, 'The Journal of *all*

13 Edmund Curtis, 'Extracts out of Heralds: Books in Trinity College, Dublin, relating
 to Ireland in the 16th Century', *Journal of the Royal Society of Antiquaries of Ireland*
 [JRSAI] 62 (1932), 28–49.
14 Arthur Collins, *Letters and Memorials of State [...] written and collected by Sir Henry
 Sidney, Sir Philip Sidney and Sir Robert Sidney* (2 vols, London: Printed for T.
 Osborne, 1746), i., 18–31, 75–80, 81–5, 89–97, 102–10, 149–56, 240–4. Later, of
 course, Sidney would go one step further, composing a full-blown autobiographical
 account of his experiences derived from these journals, his 'Booke', better known
 as his *Memoir* of government in Ireland. As this was not itself a journal, written
 close to the events, but was rather written years afterwards, it will not form part of
 the present discussion. For a fine modern edition see Ciaran Brady, ed., *A Viceroy's
 Vindication: Sir Henry Sidney's Memoir of Service in Ireland, 1556–78* (Cork: Cork
 University Press, 2002).
15 The main record of Drury's service, known as 'The journeyes of Sir Wm Drury while
 he was Lo: Justice', is no longer extant. It was consulted by Sir James Ware early in the
 seventeenth century: Gilbert Library, Dublin: Gilbert Ms 169, ff 60–1. Fortunately,
 however, two of his smaller journals, recording his southern and western journeys in
 1578, do survive: Drury to the Privy Council, 24 March 1578 (The National Archives
 of England, Kew [hereafter=TNA] State Papers, Ireland, Elizabeth I [hereafter=SP
 63]/60/25, and LPL Ms 628, ff 386r–393r).
16 Grey's declaration of service, n.d., circa Dec. 1583 (SP 63/106/82).
17 LPL Ms 632, ff 72r–80v.

the passages and accidents of note which happened during ye government of Sir William Russell'.[18]

There are two reasons for this apparent incongruity. Both lie in the document itself. First, because Russell's principal journal is a diary, it records every single day of his three years as viceroy, from his formal interview with Queen Elizabeth at Enfield Palace on 25 June 1594, before leaving for Dublin, until his final departure from Ireland, in a ship bound for the Welsh coast, on 26 May 1597. In contrast the journals of service that were kept by Sussex, Sidney and most of the rest are best described as military narratives. Providing descriptions of particular service episodes they were (intentionally) much less complete, and omitted many more days than they included. Indeed, generally the only periods of inaction that they mention occurred in the middle of otherwise intense activity, during army operations in the field, and were enforced – due to bad weather, for instance, or the need to await the delivery of fresh supplies.[19]

The second reason why Russell's diary notices so many days of inaction is because it was meant to be a *private* document, kept solely for Russell's own use by his secretary, as a complete record of his time in Ireland; as such it was also a *primary* or source document, from which his secretary extracted material for other smaller journals that only noticed his soldiering exploits.[20] Almost all the other service journals of the Elizabethan viceroys in Ireland were created as *public* records for the governors whose activities they recorded, and were meant to be read by others: either soon afterwards, by the queen and Privy Council at Whitehall; or much later, by posterity.

18 My emphasis.

19 Thus the journal of Mountjoy's expedition into the Moyry in 1600, which recorded ten days between 21 Sept. and 1 Oct. when 'the army lay still' 'by the extremity of the weather' (LPL Ms 604, fol. 266r).

20 The main one of these was 'A Brief Journal of the services in Ireland during the deputation of Sir William Russell, extracted out of his own Journal Book' (LPL Ms 600, ff 123r–141r); another was of his Ulster expedition in June–July 1595 (LPL Ms 632, ff 130r–137v).

The only journal to bear comparison with Russell's diary is the 'Breviate' of the proceedings of Sir William Pelham (chief governor 1579–80).[21] This too comes in diary-form and appears to have been a private record of Pelham's time in office, kept by his secretary, Morgan Coleman. It accounts for everything the viceroy did every day, whether soldiering in the wilds of Limerick and Kerry, boating up the Shannon, or attending Council meetings, dictating letters and issuing warrants. Hence it also contains evidence of do-nothing days. However, unlike Russell's diarist, Pelham's does not record his master's inactivity directly, instead preferring to simply omit the days on which Pelham rested up. Careful reading of the 'Breviate' reveals that Pelham carried out no discernible service on only 14 of the 330 days of his term of office[22] – a very creditable performance, to be sure, but also one that it must be suspected most other viceroys, like Russell, might not have matched, despite the rousing accounts of energetic services that they commissioned.

This divergence between active and inactive periods of service is important for rather more than the insights it affords into the daily work practices, and comparative work-rates, of the Tudor viceroys in Ireland, significant though that is. Despite several general histories of the Irish wars of Elizabeth I,[23] and a small but growing number of specialist studies of the various confrontations between the English crown forces and dissident native rulers in the provinces,[24] knowledge of how the crown conducted its fighting

21 LPL Ms 597, ff 20r–74r.

22 These were as follows: 8 Nov., 4, 8–9, 12, 23, 30 Dec. 1579, and 1 Jan., 2 Feb., 4 March, 9 and 12 May, 10 July, and 2 Sept. 1580.

23 Cyril Falls, *Elizabeth's Irish Wars* (London: Methuen, 1950); G.A. Hayes-McCoy, *Irish Battles: A Military History of Ireland* (London: Longman, 1969), 87–173; idem, 'Conciliation, Coercion, and the Protestant Reformation, 1547–71', and 'The Completion of the Tudor Conquest and the Advance of the Counter-Reformation, 1571–1603', both in T.W. Moody, F.X. Martin and F.J. Byrne, eds, *A New History of Ireland, III: Early Modern Ireland* (Oxford: Clarendon, 1976), 69–93, 94–141; Grenfell Morton, *Elizabethan Ireland* (London: Longman, 1971).

24 Covering the period in roughly chronological order, these include: Tom Glasgow, 'The Elizabethan Navy in Ireland', *Irish Sword* 7/39 (1966), 291–307; Brian C. Donovan, 'Tudor Rule in Gaelic Leinster and the Rise of Feagh McHugh O'Byrne', in O'Brien,

in the different theatres in which it fought, and of how the viceroys and other senior commanders directed operations, remains decidedly patchy for most of the reign (until the siege of Kinsale, 1601–2, which in contrast has been very well studied).[25] In this regard, the fact that Viceroy Russell spent so long killing time in Dublin rather than killing rebels in the field in the last quarter of 1594 reveals much about the hesitancy of crown policy at the beginning of the Nine Years' War (1594–1603), and helps explain why the Ulster rebellion was able to spread as far and as fast as it did. By any reckoning Russell's periods of apparent idleness, and the extraordinarily detailed diary in which they are recorded, demand careful scrutiny in order to obtain a clearer understanding of the subsequent military crisis over which he had to preside. Reliance on a printed Victorian summary of his diary which emphasizes his periods of valiant action, while omitting

ed., *Feagh McHugh*, 118–49; David Edwards, 'Ideology and Experience: Spenser's *View* and Martial Law in Elizabethan Ireland', in Hiram Morgan, ed., *Political Ideology in Ireland, 1541–1641* (Dublin: Four Courts, 1999); J. Michael Hill, *Fire and Sword: Sorley Boy McDonnell and the Rise of Clan Ian Mor, 1538–1590* (London: Athlone Press, 1993), ch. 8–10; Vincent Carey, 'John Derricke's *Image of Irelande*, Sir Henry Sidney, and the Massacre of Mullaghmast, 1578', *Irish Historical Studies* 31/123 (May 1999), 305–27; Anthony McCormack, *The Earldom of Desmond, 1463–1583: the decline and crisis of a feudal lordship* (Dublin: Four Courts, 2005), 145–57, 167–78; Anthony J. Sheehan, 'The killing of the Earl of Desmond, November 1583', *Cork Historical and Archaeological Society Journal* 88 (1983), 106–10; John McGurk, 'The Pacification of Ulster, 1600–3', in Edwards, Lenihan and Tait, eds, *Age of Atrocity*, 119–29; Hiram Morgan, 'Missions comparable? The Lough Foyle and Kinsale landings of 1600 and 1601', John McGurk, 'English naval operations at Kinsale', and Vincent Carey, '"What pen can paint or tears atone?": Mountjoy's scorched earth campaign', all in Hiram Morgan, ed., *The Battle of Kinsale* (Bray: Wordwell, 2004), 73–90, 147–60, 205–16.

25 Besides the contributions to Morgan, ed., *The Battle*, noted above, see esp. John J. Silke, *Kinsale: The Spanish Intervention in Ireland at the End of the Elizabethan Wars* (Liverpool: Liverpool University Press, 1970); Cyril Falls, *Mountjoy, Elizabethan General* (London: Odhams, 1955); and F.M. Jones, *Mountjoy, 1563–1606: The last Elizabethan Deputy* (Dublin: Clonmore and Reynolds, 1958).

almost completely his frequent inaction,[26] has led historians to pass much too quickly over his handling of the earliest months of the war.

Likewise the highly active Viceroy Pelham, in 1579–80: his sheer commitment to the task of crushing the Desmond rebellion in Munster and settling unrest in other parts of the country has been mostly unrecognized in the historiography because scholars have been content to rely on a two-page sample from his 'Breviate' rather than consult the original,[27] which stretches to over a hundred pages (fifty-four folios) in manuscript. Better awareness of Pelham's unrelenting – and frankly ruthless – efforts as revealed in his 'Breviate' should not only cause a reconfiguring of his place among the Elizabethan viceroys, but more importantly it may even lead to a major reassessment of the Desmond war.

Pelham has often been cast as a mere stop-gap governor whose main task was to keep the viceregal seat warm before the arrival in August 1580 of his renowned successor, Arthur, Lord Grey, the patron of Edmund Spenser and future perpetrator of the massacre of Smerwick.[28] The 'Breviate' of Pelham's proceedings suggests a very different scenario. From October 1579, when he replaced Sir William Drury, he had taken direct charge of the war in Munster. He had made Limerick the centre of operations and the *de facto* seat of government as he planned and led one expedition after another deep into rebel territory, camping in open country, and spreading terror through the local population as he ordered his forces to set everything ablaze and leave no-one alive.[29] In June 1580 he came close to capturing Desmond in Kerry, in August he came as close again, and this just days after learning of Grey's arrival in Dublin as his replacement.[30] Given that

26 *Calendar of the Carew Manuscripts preserved in the Archiepiscopal Library at Lambeth*, ed. J.S. Brewer and W. Bullen (6 vols, London: Longmans, Green, Reader, & Dyer, 1867–73), iii, 220–60.

27 *Ibid.*, ii, 312–14.

28 For an important new assessment of Grey's role at Smerwick see Vincent Carey, 'Atrocity and History: Grey, Spenser and the slaughter at Smerwick (1580)', in Edwards, Lenihan and Tait, eds, *Age of Atrocity*, 79–94.

29 LPL Ms 597, ff 42v, 45r, 47v, 48r, 49v–50r, 51r, 52v–55v, 56v–58v, 59v–60r, 64r–67v.

30 *Ibid.*, fol. 70v.

the earl of Desmond recovered and actually grew in strength during Grey's viceroyalty, it might be wondered why Queen Elizabeth appointed Grey at all, and did not retain Pelham long enough to finish Desmond off – all the more so as comparing the 'Breviate' with Grey's own journal it is clear that, Smerwick apart, Grey was never as active a commander as Pelham. Grey's 'Brief Declaration of […] the services done during the time of that my government', addressed to Elizabeth I after his dismissal, is a remarkable text in many ways, not the least of which is how it sashays across large tracts of time, pretending personal military action when actually Grey was ensconced in Dublin waiting on reports of the service of others instead of doing the soldiering himself. Indeed, for all the word-play and rhetoric of the 'Declaration', one suspects that he was at least as much a Governor Do-little as Russell was to be later, probably more so. (In the text of his 'Declaration' elegantly disguised *lacunae* account for perhaps as much as half of one year, 1581, and most of the next, until his eventual departure in August 1582. In comparison, Russell actually campaigned more).[31]

These are just some of the fresh perspectives on the Elizabethan Irish wars that close comparison of the service journals of successive viceroys, their action and inaction, makes possible; regrettably, considerations of space preclude inclusion of other examples. Suffice it to say, however, that when the journals are viewed all together in their various guises ('journeys', 'breviates', 'declarations', etc.) they comprise a distinct class of document that record the experiences of those charged with one of the thorniest undertakings of the Elizabethan state – the military security of Ireland. Hopefully the forthcoming publication of the full texts of a selection of the service journals (currently nearing completion)[32] will facilitate a stronger scholarly engagement with these sources. They provide crucial data about many of the key questions concerning the conduct of crown military policy, such as the frequency of operations; the role of indigenous

31 Grey's declaration of service, n.d., circa Dec. 1583 (SP 63/106/82); Russell's 'Brief Journal' (n. 20 above) conveniently summarizes his numerous expeditions.

32 As I write this I anticipate the volume appearing in 2014. It will be published by the Irish Manuscripts Commission under the title *Campaign Journals of the Elizabethan Irish Wars.*

Irish troops as auxiliaries; the government's knowledge or ignorance of the terrain in which its soldiers campaigned; the scale of combat casualties inflicted and incurred; the treatment of prisoners, women and children, the elderly, and the poor; and, chillingly, the recourse to scorched earth and famine inducement. Plainly, they are too important to be left to the occasional intrepid researcher; they must be much more fully integrated into the standard literature of the period.

* * *

Critical though the journals are to an understanding of the Elizabethan Irish wars, their military content comprises just one element of their collective importance. The rest of this brief paper will concentrate on their significance as evidence of a related phenomenon, which is no less apparent – the emerging 'service culture' of the English political elite during the second half of the sixteenth century. The journals shed a revealing light on the response of the viceroys – all well-born men – to one of the main problems of public office, accountability and how to manage it. As major officeholders far from Whitehall, the viceroys often faced close and unsympathetic scrutiny by the crown. As royal servants they had to play along with this; as career servants they had to protect themselves.

'Service culture' was in no way unique to the English nobility and gentry, of course; it was consistent with broader trends in Late Renaissance Europe: to wit, the developing notion of government service as a major source of social respect, wealth and status among the noble and knightly classes, something which, it is now recognized, was one of the key foundations of the mounting centralization of authority in Renaissance states generally.[33] The service journals of the Elizabethan viceroys and other senior commanders in Ireland are closely paralleled by similar records that survive

33 Samuel Clark, *State and Status: The Rise of the State and Aristocratic Power in Western Europe* (Cardiff: University of Wales Press, 1995); Ronald Asch, *Nobilities in Transition, 1550–1700* (London: Hodder & Stoughton, 2003); Jonathan Dewald, *The European Nobility, 1400–1800* (Cambridge: Cambridge University Press, 1996); Hillay Zmora, *Monarchy, Aristocracy and the State in Europe, 1300–1800* (London: Routledge, 2001); Jay M. Smith, *The Culture of Merit: Nobility, Royal Service and*

for places as far apart as the Holy Roman Empire and the Spanish colonies in Mexico, Peru, Guatemala and Florida. In the Empire in the mid-sixteenth century, officers serving along the vast frontier with the Ottomans began to be required to submit formal reports of their operations to the Imperial War Council, or *Hofkriegsrat*, in Vienna;[34] in the New World, meanwhile, much of what is known about the extension of Spanish settlement is derived from *relaciones*, *diarios* and other journal types that were written by or for the commanders of numerous expeditions there.[35] What all of these journals share is a belief in the virtue, even superiority, of military service as a basis for honour and position – a very traditional attitude; but equally they also share a commitment to scrupulously careful record-keeping – something very new, and a direct response to the growing level of control attempted by Renaissance governments over senior office-holders. Lurking, worryingly, behind the pages of each of the Irish viceregal service journals, from those kept for the earl of Sussex at the start of the queen's reign to those for Lord Mountjoy at the end, was the spectre of the monarch and her ministers seated at Whitehall, expecting all manner of policy to be implemented successfully and along agreed lines, according to specific instructions, on time

Making Absolute Monarchy in France, 1600–1789 (Ann Arbor MI: University of Michigan Press, 1996).

34 T.M. Barker, *Double Eagle and Crescent* (Albany NY: State University of New York Press, 1967), 164–78 provides a sense of this material; for the administrative changes of Ferdinand I in which it originated see R.J.W. Evans, *The Making of the Habsburg Monarchy, 1550–1700* (Oxford: Clarendon, 1979), 146–50.

35 See e.g. Patricia de Fuentes, ed. and trans., *The Conquistadors: First-Person accounts of the Conquest of Mexico* (New York: Orion, 1963); Sedley Mackie, ed., *An Account of the Conquest of Guatemala in 1524* (New York: Cortes Society, 1924); Herbert Bolton, ed., *Spanish Exploration in the Southwest, 1542–1706* (New York: C. Scribner's sons, 1916); George Hammond and Agapito Rey, eds and trans., *Narratives of the Coronado Expedition, 1540–1542* (Albuquerque NM: UNMP, 1940); Herbert Priestly, ed. and trans., *Luna Papers: Documents relating to the Expedition of Don Tristán de Luna y Arellano for the Conquest of La Florida in 1559–1561* (2 vols, Deland FA: Florida State Historical Society, 1928); Albert Schroeder and Dan Matson, eds and trans., *A Colony on the Move: Gaspar Castano de Sosa's Journal, 1590–1591* (Santa Fe NM: [School of American Research], 1965).

and within budget. Irish military policy was watched particularly closely as sometimes it comprised the crown's single biggest expense anywhere in its dominions.[36] To a large extent the pressure of such considerations underpinned the composition of the service journals; which is another way of saying that behind each journal lurked the viceregal fear of dismissal and dishonour for falling short of royal expectations.

The viceroys' anxieties were exacerbated by the fate of several incumbents of the office. In 1556 Sir Anthony St Leger's long association with the Irish government had ended in personal disaster as he and his chief financial officers were all sacked for malfeasance; when he died three years later, ruined, the crown was still pursuing him and his family for several thousand pounds that he had failed to account for.[37] Scandals and allegations of misrule were never far away for most of St Leger's successors. To an extent this only reflected viceregal behaviour, which was often arbitrary and high-handed, but it was also due to the continuing influence at court of Irish lords such as the earls of Kildare and (especially) Ormond, and their representations to the Queen and her ministers of the anger and frustration felt by many native loyalists in the east and south of the country at the growing oppressiveness of government.[38] Sir Henry Sidney was sacked

36 Anthony J. Sheehan, 'Irish revenues and English subventions, 1559–1622', *Royal Irish Academy Proceedings* 110 C (1990), 35–65; Paul E.J. Hammer, *Elizabeth's Wars: War, Government and Society in Tudor England, 1544–1604* (Basingstoke: Palgrave Macmillan, 2003), 236–53.

37 BritishLibrary [=BL] Add. Ms 4767, ff 136r–v.

38 Vincent Carey, *Surviving the Tudors: The 'Wizard' Earl of Kildare and English Rule in Ireland, 1537–1586* (Dublin: Four Courts, 2002); David Edwards, 'Elizabeth's favourite Irishman: The Black Earl of Ormond as a Tudor courtier', in Brendan Kane and Valerie McGowan-Doyle, eds, *Elizabeth I and Ireland* (Cambridge, forthcoming); Valerie McGowan-Doyle, *The Book of Howth: Elizabethan Conquest and the Old English* (Cork: Cork University Press, 2011); David Heffernan, 'Tudor Reform Treatises and government policy in sixteenth-century Ireland' (PhD thesis, University College, Cork 2012); Nessa Malone, 'The social, cultural and intellectual milieu of the Burnell family of Dublin, 1562–1649' (PhD thesis, National University of Ireland, Maynooth 2009); Ruth Canning, 'War, Identity and the Pale: The Old English and the 1590s Crisis in Ireland' (PhD thesis, University College, Cork 2011).

in 1578 because of rumours – 'whispers', he called them – spread around Whitehall of his tolerance of widespread corruption in Dublin, and Arthur, Lord Grey was undone by similar allegations in 1582.[39]

Evidence of military achievement was the single best retort the viceroys could give to their detractors. In this regard it should be noted that for all the recent scholarly concentration on the viceroys as champions of administrative and constitutional reform, intent on imposing English 'civility' on the Irish,[40] only Sidney and Drury emphasized this in their journals of service.[41] Soldiering was what mattered most. As one of Sidney's servants put it when composing a memorial of service on his behalf, he deserved the honour and esteem of the Queen and her Council because of 'His many, long and painful journeys in the hardest seasons of the year, and his sudden expeditions upon the enemy, whereby he broke the courage and hearts of the Irishry and brought them to obedience'.[42]

The journals are steeped in the rich language of chivalry and martial prowess; claims of bravery and sacrifice ooze from their pages. Recounting a battle with the McDonnells in a woodland pass in north-east Ulster in July 1556 which his forces won 'full nobly', Sussex's first campaign journal spreads the praise between 'the noble lord the Earl of Ormond', 'the worthy knight Sir George Stanley', and 'the worthy captains' Warren, Williamson and Lyppiat, who had had the vanguard. Returning, bloodied but victorious, to Sussex's camp after the set-to, the viceroy strode out to embrace them all, 'both English and Irish', 'giving unto them his most hearty thanks'

39 David Edwards, ed., 'A Viceroy's Condemnation: Matters of Inquiry into the Sidney administration, 1578', *Analecta Hibernica* 42 (2011), 1–24; Julian Lock, 'Arthur Grey, fourteenth Baron Grey of Wilton (1536–1593)', *Oxford Dictionary of National Biography* (Oxford 2004), xxiii, 807.

40 The classic statements of this interpretation are Ciaran Brady, *The Chief Governors: The Rise and Fall of Reform Government in Tudor Ireland, 1536–1588* (Cambridge: Cambridge University Press, 1994); Jon G. Crawford, *Anglicizing the Government of Ireland: The Irish Privy Council and the Expansion of Tudor Rule, 1556–1578* (Dublin: Irish Academic Press, 1993).

41 Drury to Privy Council, 24 March 1578 (TNA SP 63/60/25); Collins, *Letters and Memorials*, I, 18–31, 75–80, 240–4.

42 Brief memorial of Sidney's service, n.d., c.1577–8 (LPL Ms 607, fol. 32r–v).

for what they had done.[43] A year later almost to the day Sussex himself
is shown in the role of hero, riding up and down with his cavalry outside
the walls of Cloghan Castle in Offaly while the Irish garrison inside fired
their handguns at him.[44] Sidney assumed a similar role in 1569, following
the outbreak of the Butler revolt. Taking his troops south to Gowran, Co.
Kilkenny, deep inside Butler country, he there proclaimed them traitors
in the face of their suspected sympathizers, and a few weeks later, besieg-
ing Moycarky Castle, Co. Tipperary, he and his men were repeatedly shot
at by the defenders so that they had to construct 'a certain defence' to
cover themselves.[45] These themes continued right to the end of the reign:
the journal of Sir Thomas Norris, the Lord President of Munster (and a
former Lord Justice, or acting viceroy), describing the repulse he and his
cavalrymen gave to a large force of rebels near Mallow, Co. Cork, in April
1599, doubles back over the confrontation to stress that 'The attempt was
dangerous [...] to charge so many'.[46]

Not only were such reports exciting, they were also reassuring. The
message the journals imparted was that Elizabeth and her council were
served in Ireland by the manliest of men, square-jawed types equal to the
sternest of tests. Their sheer gallantry avowed their right to retain office;
the queen's second kingdom, so often beset by rebels and threatened with
invasion, was in strong hands.

But in addition to showing their aptitude for heroics, the viceroys'
journals of service tended to emphasize something even more important
– their ability to prevail. According to his first journal, the Earl of Sussex
quelled the McDonnells, forcing their chieftain James in desperation to
flee in a boat to Scotland at night-time, during a storm, the sky filled with
thunder and lightning;[47] in his second journal, he put manners on the rebel
O'Connors and O'Maddens by destroying their fortress at Meelick;[48] in

43 LPL Ms 621, fol. 17r.
44 *Ibid.*, fol. 19r.
45 TCD, Ms 660, 78, 84.
46 Norris's journal, 27 March – 4 April 1599 (TNA SP 63/205/13).
47 LPL Ms 621, fol. 17v.
48 *Ibid.*, fol. 20r.

his third he resumed his harrying of the McDonnells, laying waste to much of Antrim and sending a raiding party to Rathlin Island to 'spoil and kill as many as they might come by';[49] and in his fourth he gave Shane O'Neill a setback by preying the countryside around Armagh and setting fire to the ancient episcopal city, where O'Neill had intended to quarter his army.[50] Sidney's journals were just as positive. Though less often personally engaged in combat than many other viceroys, the accounts of Sidney's 'journeys' dwelled at length on whatever military successes he had had, for instance over Sir Edmund Butler, the Cantwells, and James FitzMaurice in 1569, the Burkes in 1576, and the O'Mores and O'Connors in autumn 1577 and early 1578.[51] The 'Declaration' of Arthur, Lord Grey went to considerable pains to assert that he had actually laid the basis for the crown's subsequent defeat of Desmond and had prevented the southern lord's rebellion prompting a more general conflagration. Through 'God's great favour', he told the Queen, he had put the Spanish invaders (sic) to the sword at Smerwick harbour in November 1580 and made a forbidding 'spectacle' of their dead bodies that he deemed suitable '[for] the eyes of all that land's hollow hearts'. This was only part of his achievement. Covering more than twenty pages, his 'Declaration' continued to enumerate his successes as commander-in-chief of the royal army: he had dissuaded Turlough Luineach O'Neill from rebellion, and so saved the Pale, with a well-considered show of force; he had inflicted numerous reverses on the Wicklow O'Byrnes so that their leader, Feagh McHugh, 'was glad to seek peace'; in Connacht his men had tamed the rebel Burkes, and O'Rourke also; and last but not least, thanks to the ferocity of his campaigning the Catholic rebel Baltinglass had fled overseas to Spain.[52] It was a proud and impressive list. Grey's critics could say what they liked. His martial achievements were incontrovertible proof of his worth, secured by blood and struggle, and could not be taken from him. He laid it on with a trowel.

49 TCD, Ms 581, fol. 88v.
50 LPL Ms 621, fol. 25v.
51 TCD Ms 660, 78–91; Collins, *Letters and Memorials*, I, 149–56, 240–4.
52 Grey's declaration of service, n.d., circa Dec. 1583 (SP 63/106/82).

It would be a mistake to view the service journals as mere vehicles for bragging about military accomplishment. They were central in the construction of the viceroys' self-image, some of the best evidence we have of their determination to shape their reputation, in their own lifetime and with half an eye on the future – what Stephen Greenblatt famously dubbed self-fashioning, and was such an important feature of Renaissance political culture.[53] Considerable thought went into the journals' construction: the format in which they were written, the content they selected, the style and language they employed, all were carefully chosen.

The fact that they were 'journals' is highly significant. Had the viceroys simply wished to regale Elizabeth and the Privy Council with reports of victories they could have done so in a routine letter of state. The state papers of this period are stuffed full of such reports, containing hundreds of official letters sent from Dublin Castle to Whitehall in which news of military successes large and small was passed on. The journal format suggested itself because it lifted the viceroys' services out of the mundane, placing them on a higher level as something to be recorded formally, and in detail, as a record of their most momentous contributions to the preservation of the monarchy and the state. According to the *Oxford English Dictionary* by the sixteenth century the word 'journal' had assumed multiple meanings in English. Originating in the Middle Ages as an ecclesiastical term denoting a book of daily religious service, by the early 1500s it referred also to a daily record of occurrences, travel, and financial transactions. But for members of the English political elite the word had a much grander association, invoking Ancient Rome and the writings of Julius Caesar. As William Camden, the Elizabethan scholar, chronicler and topographer noted in *Brittania*, his *magnum opus*, Caesar had written extensively of Britain 'in his journals, or day-books'.[54] In making this allusion Camden had not needed to elaborate, knowing that his readers would have been

53 Stephen Greenblatt, *Renaissance Self-Fashioning: More to Shakespeare* (Chicago: University of Chicago Press, 1980).

54 William Camden, *Britain, or a chorographical description of the most flourishing Kingdomes England, Scotland, and Ireland, and the ilands adioyning ... Translated newly into English by Philémon Holland* (London 1610), 18.

familiar with the 'journals' of Caesar's martial exploits contained in his *De Bello Gallico*, having read them as children in school.[55] And, to cite a leading expert on Sir Henry Sidney, given that Caesar ranked as 'the most illustrious provincial governor in Western history', it is easy to understand the attraction of the journal format for the viceroys who served in Ireland.[56]

Journals, however, were complex. To properly adhere to the format, the various accounts of the viceroys' services had to present time and space in a certain way. Ideally, they should show the day-to-day progression of particular campaigns or 'journeys', from start to finish, while recording the territories through which the viceroys led the crown forces, and describing the terrain and the local population groups encountered along the route. Confrontations with the rebels, and observations of their strengths and weaknesses, obviously should lie at the heart of any journal, but just as important were the circumstances that impinged on the crown's performance, such as weather conditions, the efficacy of communications systems, food and munitions supplies, and the behaviour of local lords and allies. Finally, the actual journal entries, describing the events of each day, should be composed close to the events described, preferably within hours of their occurrence; or at the very least the entries should appear as though they were written soon afterwards. This latter feature was fundamental. If written correctly, journals could seem more authentic than reports or correspondence that was written later; likewise they could appear more neutral and free of subsequent editorializing. They also could seem more immediate, and could give the reader the impression of being literally 'inside' an expedition, accompanying it entry by entry, page by page.

Not all of the journals adhered rigidly to this format – Lord Grey's deviated a great deal – but most of them did. Sussex's journals, composed for him by a pursuivant, as noted earlier, established the classic version, and even in the 1590s it had not changed much, except for being rather better written, as any examination of the journals of Norris, Mountjoy, and the

55 Joan Simon, *Education and Society in Tudor England* (Cambridge: Cambridge University Press, 1966).

56 Brady, ed., *A Viceroy's Vindication*, 8–9.

second Earl of Essex will testify.[57] Sidney's preference for incorporating his
journals within the structure of a letter was the main alternative form that
emerged, and served to facilitate a more elaborate writing style, but also,
more importantly, to insure that reports of his services reached Whitehall
regularly, as part of the ordinary flow of state correspondence. This method
was copied by two of his nearest successors, Drury and Perrot. However,
the main development in all this viceregal 'journalism' was the emergence of
private diaries, in the latter half of the reign. Pelham's 'Breviate' of 1579–80
may have taken its title from an earlier document, one of the most widely
disseminated manuscripts in sixteenth-century Ireland, Patrick Finglas's
c.1533 Irish reform treatise of the same name,[58] but in terms of both format
and content it owed nothing to its predecessor. Pelham's is not the earliest
diary of the period – that distinction belongs to John Hooker's diary of
the Irish Parliament, written in 1569[59] – but it is the first to be kept by a
chief governor of the kingdom. It is also far more detailed than Hooker's,
incomparably so, and together with the even longer and more detailed
diary that was kept for Russell after 1594 it is significant for taking viceregal
journal-keeping to a whole new level of comprehensiveness and exactitude.

Not that the viceroys would do the work. That was what secretaries
were for. It is important to realize that the secretaries tasked with main-
taining the viceroys' service journals were not ordinary crown servants, let
alone mere notaries or scriveners; they were, rather, the viceroys' *private*
secretaries. They formed a class apart in the royal administration, serving
the viceroy alone. The viceroy was their patron, and they his clients; they
took up their position on his appointment, and forfeited it on his departure
from office. Besides Edmund Spenser, who was Lord Grey's secretary, they
are barely mentioned in scholarly studies of Elizabethan Ireland, lost in

57 Essex's journals have been very well calendared: see *Calendar of State Papers, Ireland,*
 1599–1600, 36–40, 76–7, 144–7; *Calendar of Carew Manuscripts*, iii, 301–12, 321–5.
58 Heffernan, 'Tudor Reform Treatises' provides an important new analysis of Finglas's
 abiding influence.
59 Cambridge University Library, Ms Mm. I. 32; published in C. Litton Falkiner, 'The
 Parliament of Ireland under the Tudor sovereigns: Supplementary paper', *Royal Irish
 Academy [=RIA] Proc.* 25 C (1904–5), 563–6.

the deep shadows that were cast by their masters.[60] Yet their contribution to viceregal government was significant. They were highly learned men, proficient in Latin and Greek, and probably French and Italian also, as befitted their Renaissance humanist training.[61] Spenser's position among the *literati* of his era requires no comment. Of the others, the surviving journals show that sometimes Morgan Coleman (successively secretary to Viceroys Drury and Pelham) employed archaic words and phrases that typically are only found in literary sources in the sixteenth century,[62] and he was probably the author of an important treatise on plantation policy that was written in 1584.[63] For his part Francis Mitchell, Russell's secretary, is known to have befriended the Kilkenny humanist and poet, and Oxford alumni, Helias Shee, with whom he discussed literature and exchanged 'Platonicall Ideas' in 1595.[64] A secretary such as these could add sheen and lustre to the presentation of the viceroys' services, and it was largely their input that accounted for the marked improvement in the written style of the viceregal service records that occurred later in the queen's reign.

60 Crawford, *Anglicizing the Government*, 73–4, though very brief, at least manages to disentangle them from the fledgling office of secretary of state for Ireland with which others had confused them.

61 Jason Lawrence, *'Who the Devil Taught Thee So Much Italian?' Italian Language Learning and Literary Imitation in Early Modern England* (Manchester 2005); see also the comments of Andrew Hadfield, *Edmund Spenser: A Life* (Oxford 2012), 58–9. The learning of French became a desired accomplishment of crown servants and English gentlemen generally during Elizabeth's reign: Freyja Cox Jenson, 'Intellectual Developments', in Doran and Jones (ed.), *The Elizabethan World*, 511–30.

62 E.g., the verb 'shent', meaning to put to shame or disgrace (LPL Ms 597, fol. 51r).

63 David Heffernan has identified Coleman as the author of the anonymous treatise 'Short Notes [...] for the reducing and settling of Munster' (LPL Ms 607 ff 110r–111v).

64 Some of Mitchell's private letters survive among the Lismore Manuscripts: see Shee to Mitchell, n.d. c.1595 (National Library of Ireland [=NLI] Ms 12813/1, no. 13). Shee's poetry was known in England: see Anthony á Wood, *Athenae Oxonienses* (4 vols, London: Printed for White, Cochrane and Co. Fleet Street; and J. Hatchard, Piccadilly, 1813–20), i, 386.

But that is not all that they contributed. As hinted at in Richard Rambuss's pioneering study of Spenser's secretarial career,[65] a private secretary was often as dedicated to covering up a viceroy's activities as to revealing them. Like the secretaries-of-state in England, the viceregal secretary in Ireland dealt in all manner of secrets – secret diplomacy, secret intelligence, secret payments – and spent much of his time dealing with codes and ciphers, 'espials', slush funds, and so on. And just as the English secretaries-of-state often concealed things from the queen and from their fellow royal ministers, to protect themselves, so in Ireland (with one notable exception) the viceregal secretaries helped the viceroys obscure whatever was inconvenient or embarrassing about their service.[66] Spenser's outspoken defence of Lord Grey's reputation, which he maintained even after the latter's death in 1593, has attracted much attention,[67] but it was unusual for a secretary to demonstrate his faithfulness in this way. More habitually a private secretary carried out his viceregal defence measures unobtrusively, through the dispersal of 'gifts' and other inducements on his master's behalf, but also through the preparation and presentation of carefully drafted reports of service. No less than other more easily recognizable exemplars of secretarial secret-keeping, such as the books of ciphers or the lists of 'rewards' among the state papers, the service journals that the secretaries compiled should be viewed as part of their covert activity. As often as not the journals are exercises in deception, or what Renaissance politicos called 'artifice'. To read them is sometimes to marvel at the capacity of Elizabethan crown servants for duping the crown while ostensibly doing its bidding.

* * *

65 Richard Rambuss, *Spenser's Secret Career* (Cambridge: Cambridge University Press, 1993).
66 The exception was Philip Williams. Private secretary to Sir John Perrot, his testimony against his former master was central to the prosecution during Perrot's treason trial in 1592. It has yet to be discovered what motivated Williams. For his testimony see Roger Turvey, *The Treason and Trial of Sir John Perrot* (Cardiff: University of Wales Press, 2005), 146–8.
67 E.g., H.S.V. Jones, *Spenser's Defence of Lord Grey* (Urbana, Ill. 1919); Richard McCabe, 'The fate of Irena: Spenser and political violence', in Patricia Coughlan (ed.), *Spenser and Ireland* (Cork 1989), 109.

Take for instance the recorded services of Viceroy Russell, with whom we began. Queen Elizabeth and her ministers never saw the extraordinary diary that Francis Mitchell kept for him; that was not why it was kept. Instead Mitchell, aided by one of his under-secretaries, prepared other more narrowly focused journals that his master deemed more appropriate for the eyes of the queen and her Council. One of these was called 'A note of such journeys as the right honourable Sir William Russell, knight, Lord Deputy of Ireland, hath gone [on] in his own person'.[68] It is just a single side of paper, written in spring 1596, shortly after Russell's return from O'Madden's country beside the Shannon. There is nothing to indicate why this very short journal was written at that time, but checking through extant government papers, it seems to have coincided with a major political crisis affecting Russell's viceregal authority. Immediately after his return from the west the tensions that for months had been bubbling under the surface between him and Sir John Norris had finally erupted into full-scale faction. Norris's troops had run amuck in the north of the Pale during Russell's absence; on the viceroy's return he had issued a proclamation condemning Norris's men, to which Norris 'hath refused to put his hand'.[69] Intrigue ensued. Within weeks the queen was forced to intervene, her court astir with allegations spread by the messengers of both camps. From her letter to Russell and the Irish Council of 25 May it is clear that the allegations circulating against Russell in London included something to the effect that his service was generally slack, and in particular that he had failed to improve conditions in the west by taking the governor there, Sir Richard Bingham, in hand.[70] The one-page service journal, recording Russell's every military outing since first assuming the viceroyalty, was an obvious response. Like other journals it made an impressive case, listing plainly, in strict chronological sequence, the eight expeditions he had undertaken in Ireland since August 1594 in which he had ventured into three provinces, reversing the rebels' gains in a number of places and restoring key fortresses to royal control; regarding the west

68 TCD Ms 581, fol. 53r.
69 *Calendar of Carew Manuscripts*, iii, 174–5.
70 *Ibid.*, 176–7.

and Bingham, it simply stated that Sir Richard had been dealt with. This was all fine, as far as it went – except that, of course, it only amounted to a half-truth. All those days of doing nothing, which were such a feature of Russell's principal journal, his private diary, for the last weeks of 1594, had continued throughout 1595 and into 1596, albeit less frequently than before, and for shorter periods of time. More seriously, consulting his diary it emerges that since last meeting Bingham at Athlone in November 1595, rather than take measures against the provincial governor Russell had actually swung in behind him regarding the necessity of harsh measures in the west, and on 14 January 1596 had given Bingham a wide-ranging commission to do whatever he thought fit in Connacht.[71] The one-page journal of Russell's services, composed by Mitchell and his underlings, glides effortlessly over this complication. The queen wanted Bingham reined in; the one-page journal allowed Russell to maintain the charade that he agreed with her and was on the job. By such means the viceroy maintained a more abrasive policy than Elizabeth had agreed to.

The service journals accommodated numerous other half-truths and evasions that are no less revealing of the conduct of viceregal rule. Probably the biggest half-truth of all was something noted earlier – the journals' ability to present a viceroy as militarily successful and as a great commander in the field. Journal after journal emphasizes victories attained, the rout of enemy forces, the extension or recovery of royal power. The trouble is, though, that while all of the feats of arms that are described in the journals certainly took place, they often did not occur in the manner that the journals described. Indeed sometimes the victories that the journals asserted were barely victories at all. It is not just that in many cases what the journals depict as battles or large confrontations were actually merely skirmishes; this sort of exaggeration characterizes most types of combat reporting (and, indeed, continues to do so to the present day). Rather, what makes the journals particularly challenging for historians of the period is the way in which they only depict the rebels as beaten down or beaten off by the viceroys, and rarely deal with rebel successes in the field. Lord Grey

71 LPL Ms 612, fol. 54v.

de Wilton's journal of service is unusual for the space it gives to a discussion of the defeat of English forces under his command by Feagh McHugh O'Byrne in August 1580, at Glenmalure, though it quickly makes up for this by outlining all manner of reverses that Grey inflicted on the O'Byrnes and their allies subsequently. When Grey submitted the journal, however, he was in disgrace, battling to save his reputation after being sacked by the queen, and as a result his journal is unusually frank in places.[72]

Most other service journals avoided such frankness. All of Sussex's, for instance, succeeded in depicting the earl's expeditions as uniformly successful. They were nothing of the sort. From other sources we know that his ferocious assault on the McDonnells in Ulster failed to destroy them;[73] even his invasion of Rathlin Island had a limited impact, and the clan soon recovered. His journals include details that do suggest the McDonnells remained intact, but these are quickly passed over. Thus the observation that after the island raid, in September 1557, his forces were attacked on the mainland by McDonnell troops when passing by Kilwarlin Wood is depicted merely as the Scots 'showing themselves',[74] when in fact it was highly significant. Sussex had exhausted his troops in a field campaign that had lasted six weeks and cost a fortune, only for the McDonnells to bounce back, necessitating another expedition the following year (and another after that). The claims that his journals make of victories over Shane O'Neill are more egregious still. According to one, recording his burning of Armagh in 1557, this was a setback for O'Neill, whereas days later O'Neill's forces had entered part of Co. Louth, thereby posing a greater danger to the Pale than before the expedition; this latter fact, crucial to any proper analysis of Sussex's effectiveness, is only included in the journal to record how bravely the earl went looking for O'Neill 'with as many light horsemen as were able to follow'. Rebel strength is thus trivialized. Likewise his final journal, recording his expedition through central Ulster in June 1563: it lays great stress on the strong penetrative presence he achieved in parts of Tyrone

72 Grey's declaration, etc.
73 J. Michael Hill, *Fire and Sword*, 43–76.
74 TCD Ms 581, fol. 89v.

and Armagh, but at least as important is the tale it relates of MacMahon, the chieftain of Monaghan, refusing to cooperate with Sussex, and instead supporting Shane.[75] It was in the choices made by native leaders such as MacMahon that the true extent of English power was determined; predictably the journal makes no comment, proceeding instead to deal with Sussex's divvying out of the spoils he had taken. Because other sources exist with which to question Sussex's journals of military service, it is not difficult to see through their pretence of martial success. But what happens when other sources don't survive: how then should we judge the journals and safely incorporate them into studies of the period?

It is a conundrum. Viceroy Perrot's account of the siege of Dunluce in September 1584 is the only contemporary description among government records. Characteristically Perrot takes all the credit for himself, bragging about how at first the defenders had refused to surrender but were soon persuaded to change their mind 'after they had overnight felt a little of the force of [his] battery'.[76] What Perrot neglects to say is that the battery was directed by the Earl of Ormond, who he had specifically required to accompany the expedition weeks earlier. Ormond's military reputation was then at its peak, and like other viceroys Perrot was both dependent on the Earl's service and jealous of the fact; in his journal, contained Sidney-style in a letter to the Privy Council, he saw no reason to allude to the Earl's role. It is only because years later Ormond's part in the taking of Dunluce was included in an epic Latin praise poem recording the Earl's military career that we know anything else about the siege – and this only came to light very recently.[77] Fitzwilliam's 1574 journey against Desmond[78] and Drury's of autumn 1578 into Munster and the south-west[79] are other examples,

75 LPL Ms 621, fol. 25r.
76 LPL Ms 632, fol. 73r.
77 David Edwards and Keith Sidwell, eds and trans., *The Tipperary Hero: Dermot O'Meara's Ormonius (1615)* (Officina Neolatina I: Turnhout: Brepols, 2011), V: 37–53 (328–9).
78 TCD Ms 660, p. 92, printed in Curtis, 'Herald's accounts', 46.
79 LPL Ms 628, ff 386r–393r, extensively printed in *Calendar of Carew Manuscripts*, ii, 140–5.

but as yet no additional accounts of these expeditions have come to light, despite new research on Desmond-government relations and more general political developments in Munster during the period.

* * *

In the final analysis the fact that the viceroys continued to commission the creation, or fashioning, of journals of their Irish service, all the way down to the siege of Kinsale in 1601–2, is instructive in and of itself. Even if we can tell, through other evidence, that the information the journals contain is neither an entirely accurate summation of the administrations that the viceroys headed nor of the campaigns they waged in the field, the fact remains the journals contained information that the crown wanted, recording where the money was spent, how authority extended. But if the journals testify to the power of Whitehall to compel reportage and accountability, the fact that viceroys were allowed to commission them, had private servants compose them, revealed the limits of crown authority and the remarkable latitude viceroys enjoyed.

The viceroys recorded what they wanted recorded about their conduct in office and said it how they wanted it said. Such testimonies could be used to head off criticism and justify reappointment, or achieve redeployment to another branch of government, unless the queen and her ministers had other better sources of information. Sometimes they did; oftentimes they didn't. Historians should remember this. Beware of official records.

JOSÉ MONTERO REGUERA

8 Cervantes and Renaissance:
A Chapter in the History of Hispanic Studies

To Juan Bautista Avalle Arce, in memoriam

There is no doubt that Cervantes's dates link him to the Renaissance, at least to the late Renaissance. As is well known, he was born in Alcalá de Henares, a small town close to Madrid, in 1547, when the Emperor Charles V was still at the head of the Spanish Empire. Cervantes lived through the end of the Emperor's reign, and was familiar with the difficulties experienced by Philip II (1556–1598) in his attempts to maintain Spanish supremacy in Europe and, of course, he lived into the reign of Philip III (1598–1621), when most of his masterpieces were written: *Don Quijote* (1605, 1615), the *Novelas ejemplares* (1613), and *Los trabajos de Persiles y Sigismunda* (1617), among others.[1]

In this chapter, my intention is to deal with a very important issue in Hispanic studies: how did Cervantes become a Renaissance writer for critics and readers after a period of two centuries during which he was considered to be an uneducated man and, therefore, unable to read the most important texts of the Renaissance?

1 I would like to thank my colleague Stephen Boyd for inviting me to come back to Cork to participate in the conference *Renaissance Now*, organised by the Graduate School of the College of Arts, Celtic Studies & Social Sciences. I would also like to thank Professor Brendan Dooley, the first incumbent of the new Chair of Renaissance Studies at Cork. Both of them have been very kind to me.

The reign of Charles V was an especially significant time when Spain developed a much closer relationship with Europe and opened up to the world with the discovery of the Americas that began in 1492; it was a dynamic, aggressive and cosmopolitan time that allowed Spain to receive important influences from Europe in the areas of politics, ideology and culture. Many people from Europe travelled to Spain and brought with them new ideas, especially concerning religion: it was the time of new heterodoxies such as Erasmianism or Lutheranism, some of which enjoyed the support of people very close to the Spanish Court (e. g. Alfonso and Juan de Valdés, both followers of Erasmus). It is possible that Cervantes may have become familiar with these ideas through Juan López de Hoyos, the man who was his teacher at the Estudio de la Villa in Madrid when he was living there between 1566 and 1569. The index of López de Hoyos's library has survived, and it lists several books by Erasmus.[2]

In the cultural field, Spain experienced the fascination of the classical world, rediscovered by Italian humanists in fifteenth and sixteenth centuries, as well as the enthusiasm for nature and the interest in man as the centre of the universe, but, at the same time, it kept its own traditions alive. This is the original, distinguishing feature of the Spanish Renaissance; as Dámaso Alonso put it:

> [...] nuestro Renacimiento y nuestro Post-Renacimiento Barroco son una conjunción de lo medieval hispánico y de lo renacentista y barroco europeo. España no se vuelve de espaldas a lo medieval al llegar al siglo XVI, sino que, sin cerrarse a los influjos del momento, continúa la tradición de la Edad Media [...].[3]

2 Américo Castro, 'Erasmo en tiempo de Cervantes', *Revista de Filología Española* 18 (1931), 329–89, *El pensamiento de Cervantes y otros estudios cervantinos* (Madrid: Trotta, 2002) 501–29.

3 'Our Renaissance and our Post-Renaissance Baroque represent a conjunction of the Hispanic medieval world with the European Renaissance and Baroque. Spain does not turn its back on the Middle Ages with the advent of the sixteenth century; rather, without closing itself off from the influences of the time, it continues the medieval tradition'. *Poesía española. Anotología* (Madrid: 1935), 9.

In poetry, the Italian trends that arrived in Spain in the late sixteenth century found a brilliant exponent in Garcilaso de la Vega, who was able to exploit to the maximum the possibilities of the Italianate eleven-syllable line. Traditional Castilian poetry not only did not disappear, but was assiduously cultivated by a significant group of sixteenth-century writers; Cervantes is a prime example: a follower of Garcilaso, as Blecua, Canavaggio and Rivers have pointed out, he was also a very successful *romancista* [writer of traditional Spanish (octosyllabic) ballads]; as he himself says in his *Viage del Parnaso*: 'Yo he compuesto romances infinitos' [I have composed infinite numbers of ballads].[4]

Cervantes was also influenced by Italian epic poetry, books of chivalry, such as *Amadís de Gaula, Tirante el Blanco*, which were the best sellers of their time, and which he used to create his *Don Quixote*, and, also by a book published in the Emperor's very last years, *La vida de Lazarillo de Tormes, y de sus fortunas y adversidades* [The Life of Lazarillo de Tormes, and of his Fortunes and Adversitites] which has claims to be considered as the first modern novel. It appeared in four places at the same time, in 1554: Burgos, Medina del Campo, Antwerp and Alcalá de Henares.

4 See José Manuel Blecua, 'Garcilaso y Cervantes', *Cuadernos de Ínsula, I. Homenaje a Cervantes* (Madrid: Ínsula, 1947) 141–50; Jean Canavaggio, 'Garcilaso en Cervantes: "¡Oh dulces prendas por mi mal halladas!"', *Busquemos otros montes y otros ríos. Estudios de literatura española del Siglo de Oro dedicados a Elías L. Rivers* (Madrid: Castalia, 1994) 33–42; Elías L. Rivers, 'Cervantes y Garcilaso', Manuel Criado de Val (dir.), *Cervantes. Su obra y su mundo* (Madrid: EDI-6, 1981) 963–8; 'Cervantes y Garcilaso', *Homenaje a José Manuel Blecua* (Madrid: Gredos, 1983) 565–70; José Montero Reguera, 'El primer garcilasista' [2001], *500 años de Garcilaso de la Vega* (Alcalá de Henares: Centro Virtual del Instituto Cervantes). <http://cvc.cervantes.es/actcult/garcilaso> accessed 15 November 2011; 'Los preliminares del *Persiles*: estrategia editorial y literatura de senectud', Jean Pierre Sánchez, coord., *Lectures d'une oeuvre: Los trabajos de Persiles y Sigismunda* (Nantes: Éditions du Temps, 2003) 65–78; '*Entre tantos adioses*: una nota sobre la despedida cervantina del *Persiles*', *Peregrinamente peregrinos. Actas del V Congreso Internacional de la Asociación de Cervantistas*, Alicia Villar Lecumberri, ed., (Palma de Mallorca: Asociación de Cervantistas, 2004) 721–35.

The reign of Philip II was at its height when Cervantes's life was at its most hectic: he travelled in Italy, soldiered in various campaigns around the Mediterranean and in North Africa, and was held prisoner in Algiers ... He was very close to three of the most important events of the second half of the sixteenth century: he fought in the great naval battle of Lepanto on 7 October 1571, where he sustained a wound to his left arm; he also suffered the consequences of the new Spanish politics after the annexation of Portugal in 1580: from that point on, or even before, indeed, Philip II was more interested in controlling the Portuguese nobility than rewarding an old soldier wounded at Lepanto. Finally, as *comisario de abastos* [Commissioner of Supplies], he participated in the preparation of the Armada, the great sea-borne invasion force launched against England which was destroyed by fire ships and the weather in 1588. From 1587, Cervantes was living and working in Seville.

A great change took place in Spanish politics under Philip II. Frontiers were virtually closed and every aspect of life was made subject to the control of the Catholic church, which persecuted any manifestation of heterodoxy. Good examples of this are the severe inquisitorial indexes of prohibited and expurgated books; the ban, from 1559, on pursuing university studies abroad (except at Coimbra, Bologna, Rome and Naples); and the way in which Archbishop Carranza and Fray Luis de León were persecuted and imprisoned for long periods, from 1558 to 1576 in the case of Carranza, and from 1571 to 1576 in that of Fray Luis.

By that time, Garcilaso de la Vega was already acknowledged as a classic, as witnessed by the annotated editions of his works produced by El Brocense in 1574 and 1577, and by Fernando de Herrera in 1580; Fray Luis de León and San Juan de la Cruz introduced subtle nuances of colour to Italian-style poetry by incorporating new elements that renewed it. The ballad tradition was reborn through the artistic reformulations developed by poets such as Cervantes himself, by Pedro de Padilla, López Maldonado, Pedro Laynez, and other young talents who would later mature into great writers: Lope de Vega, Francisco de Quevedo, Luis de Góngora. The *Flor de varios romances nuevos y canciones* [Flower of various new ballads and songs], published in Huesca in 1589, and the various anthologies that followed it provided a channel for this form of poetry. With Lope de Vega as

its principal exponent from 1590, the *comedia nueva* [New Theatre] was an absolutely contemporary phenomenon: it incorporated several previous theatrical traditions and created a form of drama that was to have a very long success. Cervantes provided a graphic description of the origins of this form of theatre in the preface to his volume of *Ocho comedias y ocho entremeses nuevos, nunca representados* [Eight plays and eight new interludes, never before performed], published in 1615. It is also responsible for the development and refinement of the place of performance itself (the open-air public theatre) and of everything connected with the world of the stage: scenery, props, professional companies of actors, etc. The books of chivalry were still being published, but in smaller formats, with very few new titles. In fact, the place they had occupied in the affections of readers was being taken over by the pastoral novel, with many titles appearing from the 1560s onwards: *The Diana* (1559), by Jorge de Montemayor, *The Shepherd of Fílida* (1582) by Luis Gálvez de Montalvo.

Returning now to Cervantes's first literary productions, we can see that his beginnings as writer reveal a close relationship with various Renaissance trends.

The death of Queen Elizabeth of Valois occasioned the beginning of Cervantes's career as a poet. He contributed to the rituals of national mourning in the form of a few poems published in a volume entitled *Hystoria y relación verdadera de la enfermedad, felicíssimo tránsito, y sumptuosas exequias fúnebres de la Sereníssima Reyna Doña Isabel de Valoys, nuestra Señora* Compuesto y ordenado por el Maestro Juan López [de Hoyos]. Cathedrático del Estudio d'esta villa de Madrid (Madrid: Pierres Cosin, 1569) [History and True Report of the Illness, Happy Passing and Sumptuous Funeral Exequies of the Her Most Serene Majesty, Our Sovereign Lady, Queen Elizabeth of Valois. Compiled and Put in Order by Master Juan López [de Hoyos]. Profesor of the Studium of this City of Madrid (Madrid: Pierres Cosin, 1569)]. The sonnet that begins 'Aquí el valor de la española tierra' ['Here the treasure of the land of Spain'] reveals a still inexperienced poet, who organizes the composition around an over-obvious structure: the quartets, arranged around the anaphoric repetition of the adverb 'here' (ll. 1, 2, 3, 5 and 7) offer an apologetic description of the queen ('valor de la española tierra' ['treasure of the land of Spain']; 'flor

de la francesa gente' ['flower of the French people']; 'quien concordó lo diferente' ['who brought concord out of division'], and the tercets, similarly, which are structured around the imperative, 'look', repeated in lines 8 and 11, no longer focus on the Queen but reflect on the nature of the world and the pitilessness of death. Something similar happens in the *Copla real* that begins '*Cuando un estado dichoso*' ['When a blissful state'], where the general tone of complaint leads to a heartfelt evocation of the Queen in her youth. She has left on earth 'las prendas que más quesiste' ['the treasures that you loved the most'], her daughters, Isabel (1566–1633) and Catalina (1567–1597). Finally, the 'Castilian Redondilla' that begins, 'Cuando dejaba la guerra' ['When the war left'], written on a subject referred to earlier: the advent of the Franco-Spanish peace, signed in Cateau-Cambrésis in 1559, and the betrothal of Philip II to Elizabeth of Valois. Then, all too suddenly, death unexpectedly comes to the Queen, 'la mejor flor de la tierra' ['the earth's finest flower'], and to evoke this Cervantes turns to the classical image of the flame: 'fue tan oculto a la gente / como el que no ve la llama / hasta que quemar se siente' (vv. 8–10) ['It was hidden from people / as the flame that is not seen / until it burning is felt'].(vv. 8–10).

Some of these texts belong to a long classical tradition, which Cervantes knew and practised: that of the epitaph.[5]

In fact, considered in terms of the poetics of the epitaph, the sonnet dedicated to Queen Elizabeth of Valois can be seen to incorporate many of its characteristic features: there is a mention of the tomb of the deceased ('Aquí yace enterrada' ['Here lies buried ...'], v. 7), the repetitive elements of the quartets and tercets ('Here'; 'Look') not only correspond – as is so often observed in relation to Cervantes's poetry– to the taste for formality that is typical of the late Renaissance, but also contribute to creating cohesion between the two parts of the sonnet: the *narratio* (ll. 1–8, with their reference to the French origins of the Queen-of-Spain-to-be, her role in securing peace between the two nations, and their statement of objective fact, recalled repeatedly by use of the adverb of place); and the more

5 See my own 'Trayectoria del epitafio en la poesía cervantina (I)', in Actas del VII Congreso Internacional de la Asociación de Cervantistas, Münster, October 2009.

subjective *acumen* or *aprosdóketon*, where the word that is repeated to give cohesion to the tercets is no longer an adverb of place, but an imperative verb form introduced by the reflection on the passing of time and the inevitable triumph of death. Similarly, the poem ends with a Sapphic hendecasyllable which is more subjective in tone than the narrative mode present in most of the text:

> Mirad quién es el mundo y su pujanza,
> y cómo de la más alegre vida
> la muerte lleva siempre la victoria.
> También mirad la bienaventuranza
> que goza nuestra reina esclarecida
> en el eterno reino de la gloria.

> [Behold who the world is and its power, / and how even over the happiest life / death always claims the victory. / Behold, also, the bliss / our illustrious Queen / enjoys in the eternal realm of glory].

There are elements that imbue the text with wit, elegance and richness, such as the striking displacement of the main verb ('yace'), which does not appear until the seventh line; very carefully chosen diction, which incorporates a constant play of opposites (France, Spain; good, evil; death, life), in order to emphasize the supreme value of Elizabeth of Valois as a woman who brings Concord; and clear alliterative play: the repetition of words that have a strong acute stress accent on the vowel [o] at the beginning of the poem, for example 'valor' 'flor', 'concordó' ['value' 'flower', 'Concord']; strategic interplay of rhotic and liquid consonants, and the closure of the poem with a preponderance of vowels: '[...] reina esclarecida / en el eterno reino de la gloria' ['[...] illustrious Queen / [...] in the eternal realm of glory'].

The other composition penned by Cervantes in memory of Elizabeth of Valois is a *Castilian Redondilla*, 'Cuando dejaba la tierra' ['When war left the Hispanic land'], which also incorporates characteristic elements of the epitaph. Studied from this point of view, the text incorporates such common features as bipartite structure, cohesion between the two parts of

the poem, specialized lexicon, the concluding sententious conceit ... There is, however, no explicit reference to the tomb or grave, as in other poems explicitly designed as epitaphs, such as, for example, the sonnets on the fall of La Goleta (1574) included in *Don Quixote* I, 40.

On the one hand, Cervantes reverts to a regular metrical scheme in such texts, the *Castilian Redondilla*, based on an eight-syllable line with full/consonantal rhyme (abbabcddcd) and displaying specific features of internal organization, notably, division into two parts: the *narratio* (ll. 1–6), which metaphorically evokes the death of the Queen, and the *acumen* (ll. 7–8), in the form of an ingenious reflection that ends with a familiar metaphorical image. This is couched in clever *conceptista* [conceptist] language organized around the image of Elizabeth of Valois as a flower: it has been severed from its branch/stem and transplanted to another place, in this case, the heavens. The cutting of the flower signifies death: this is the reason for the expression 'the deadly misadventure' (l. 7). All this culminates in the final lines with their reference to the flame, which is not seen until its burning is felt: this is a metaphor which can be traced in many literary texts of the period; it probably originates from Petrarch's amatory works, and is also found in emblem literature.

This conceptual organization offers, first, a strong syntactical cohesion achieved through constant hyperbaton and by the reiteration of the main verb (ll. 5 and 8); second, plays with opposite terms (earth, ground, flight, sky); the use of words related to the semantic field of the idea being developed (flower, land, transplanted, cut, branch, deadly misadventure), and the use of alliteration to evoke in the reader as sense of the sadness of what happened: 'la mejor flor de la tierra / fue trasplantada en el cielo. / Y al cortarla de su rama / el mortífero accidente [...]' (ll. 4–7). ['The earth's finest flower / was transplanted to the heavens. / And as it was cut off from its branch / the deadly misadventure [...]'].

Cervantes began his literary career as a prose writer some time later when he returned to Spain after five years in an Algerian jail. In 1585, and in his native town of Alcalá de Henares, he published a pastoral romance, *La Galatea* (Madrid, 1585). It was passed for publication by the censor, Lucas Gracián Dantisco, and furnished with preliminary sonnets by Luis Gálvez de Montalvo, Luis de Vargas Manrique and Gabriel López Maldonado,

all of them close friends of Cervantes. They were members of the literary group with which he socialized in those first years back in Madrid, near to the Court, and it also included Pedro Laynez, Juan Rufo, Pedro de Padilla, and Francisco de Figueroa. It was a classic literary training school, one that reverenced Garcilaso and Fray Luis, and with a profound interest in poetry, but not over-original in its output. This was the environment that gave rise to *La Galatea*.

To make his debut in the arena of prose literature, Cervantes, as many other writers did, chose a genre that enjoyed particular success in the period: the pastoral romance. Indeed, although they did not reach such a wide public, in terms of popularity these books had come to replace the books of chivalry which had long enjoyed a great vogue in the Peninsula. Since the advent in Spain of the first of these, the *Diana* by Jorge de Montemayor in 1558 (or 1559?), until 1629 – the year in which Gabriel del Corral published his *Cintia de Aranjuez*, and when the genre was already in decline – no less than forty titles were published, each of them in multiple editions. Thus, the *libros de pastores* (books of shepherds) can be considered as true 'Best Sellers' in the Spain of the second half of the sixteenth century and first third of the seventeenth. Cervantes, then, chose a genre already familiar to readers that virtually guaranteed success in both literary and economic terms: through his literary production, Cervantes sought not only fame but also a way out of his precarious economic situation. *Galatea* was reprinted twice in Cervantes's lifetime; his success extended beyond the borders of Spain, for, as the *licenciado* Márquez de Torres testifies in his censor's report on *Don Quixote* II, there were several gentlemen at the French court who knew it 'almost by heart'.[6]

La Galatea adheres to the traditional canon of the Renaissance pastoral romance while also adding elements taken from Byzantine romance, which Cervantes used later in several of his *novelas* and in the *Persiles*: amazing

6 *DQ*, II, Aprobación. See J. Canavaggio, 'El licenciado Márquez de Torres y su aprobación a la Segunda Parte del *Quijote*: las lecturas cervantinas de unos caballeros franceses', Dian Fox, Harry Sieber and Robert Ter Horst, eds, *Studies in Honor of Bruce W. Wardropper* (Newark, DE: Juan de la Cuesta Hispanic Monographs, 1989) 33–9.

adventures, strange coincidences, rewards, long-delayed reunions, etc. These elements, along with many others, anticipate the novelistic techniques that Cervantes used so brilliantly in *Don Quixote*.

Indeed, it is possible to find in *La Galatea* many features that will appear again, developed and improved, in Cervantes's later novels. In 1971 Celina Sabor de Cortázar defined the *Galatea* as 'Cervantes's first laboratory of storytelling';[7] this statement is still valid today and it attributes to *La Galatea* qualities of originality and innovation usually reserved for discussions about his masterpieces. There is no doubt that this is a difficult book for readers of our own time unaccustomed to the narrative modes of the sixteenth century. And when people do read it, they often do so because of its literary-historical value as the first work of this major national writer which is obviously closely linked to the flowering of the Renaissance. But it must also be looked at from the other side, as a work that stands at the beginning of the author's literary career and contains many elements, even in embryonic form, that Cervantes later refined. Because here it is already possible to find, as in *Don Quixote*, evidence of Cervantes's preoccupation with the problem of the relationship between life and literature, and with the precise geographic location of fictional events. These features distance the *Galatea* from its models. It is a work set in a particular time and place – the Spain of Philip II – with references to specific people and events, and several variations and modulations of narrative rhythm that anticipate those used in some of the *Novelas ejemplares* and *Don Quixote*; and it evidences the complex and successful intertwining of multiple plot strands and an air of verisimilitude easy to find in his later works.

Cervantes's early theatre is also linked to the classical tradition of self-representation as renewed by the Renaissance. *Numancia* must be considered as a great tragedy in the Senecan mode in which, through a carefully planned structure, the author projects the historical story of the Roman siege of Numancia into the Spain of his own time. And *La conquista de Jerusalén por Godofre de Bullón* [*The Conquest of Jerusalem by Godfrey of*

7 Celina Sabor de Cortázar, 'Observaciones sobre la estructura de *La Galatea*', *Filología* 15 (1971), 227–39. See 238–9. My own translation.

Boulogne], a play traditionally attributed to Cervantes, is not likely to be understood without reference to Tasso's *Gerusalemme liberata* (Parma, 1581).[8]

Up to this point, I have been dealing with some of Cervantes's first works, but if we turn to some of his masterpieces we also find important Renaissance features.

Since Burckhardt (1860), the idea of the discovery of the individual has been repeatedly claimed as one of most important defining characteristics of the Renaissance. Cervantes best expresses that idea through the aphorism that appears in *Don Quixote*: 'cada uno es hijo de sus obras' [everyone is the child of his actions].[9]

The way that Cervantes works with dialogue in *Don Quixote* and the *Novelas ejemplares* cannot be properly understood without its Renaissance bonds. As is well known, the generic models that Cervantes had in mind when he came to present a good number of the characters in the *Novelas ejemplares* as pairs are varied: the Byzantine novel, the *comedia de capa y espada* ['cloak-and-dagger' plays], the *cuestiones de amor* [love debates] and the humanist dialogue along with its Lucianic antecedents. In the last case, Cervantes found a way of avoiding the awkward repetition of the *dicendi* verbs, a rationale, certainly not exclusive to him but belonging

8 Stefano Arata, '*La Conquista de Jerusalén*, Cervantes y la generación teatral de 1580', *Criticón*, 54 (1992), 9–112; Idem, 'Notas sobre *La conquista de Jerusalén* y la transmisión manuscrita del primer teatro cervantino', *Edad de Oro* XVI (1997), 53–66; José Montero Reguera, '¿Una nueva obra teatral cervantina? Notas en torno a una reciente atribución', *Anales cervantinos* XXXIII (1995–1997), 355–66; and Miguel de Cervantes (attributed), *La conquista de Jerusalén por Godofre de Bullón*. Héctor Brioso Santos, ed. (Madrid: Cátedra, 2009).

9 '– Importa poco eso – respondió don Quijote –, que Haldudos puede haber caballeros; cuanto más, que cada uno es hijo de sus obras'. DQ, I, 4. See Juan Bautista Avalle-Arce, 'Cervantes and the Renaissance', in Michael McGaha, ed., *Cervantes and the Renaissance* (Newark, DE: Juan de la Cuesta Hispanic Monographs, 1980), pp. 3–10.

to long-standing tradition,[10] that provided a means of making the narra-
tion of events more enjoyable and attractive, especially when these are
particularly complex or factually dense, and a way of achieving suspense
and entertainment.[11]

Cervantes' debts to the Renaissance are deep and strong throughout
his entire literary career. No-one doubts this today, but it was not always
so; on the contrary, indeed, during the course of almost two centuries,
the idea of Cervantes as a conscious writer closely in tune with the great
cultural developments of his time was dismissed.

In fact, the epithet 'ingenio lego' [untutored wit] applied to Cervantes
for several centuries became one of the most controversial landmarks in
Hispanic studies. It was Tomás Tamayo de Vargas who so defined Cervantes
in his *Junta de libros, la mayor que España ha visto en su lengua, hasta el año
de 1624* [*Gathering of Books, the Greatest that Spain has Seen in her Language
Until the Year 1624*] (manuscript 9.753 of Biblioteca Nacional de España,
ff. 66v–67): 'Migvel de Cervantes Saavedra, ingenio, aunque lego, el más
festivo de las Españas, de Esquivias' [Miguel de Cervantes Saavedra, a wit,
although untutored, the merriest in the Spains, from Esquivias]. Tamayo
was thinking of some lines from Cervantes' own *Viage del Parnaso*: 'A no
estar ciego, / hubieras visto ya quién es la dama; / pero, en fin, tienes el
ingenio lego' [If you weren't blind, / you would have seen who the lady is; /
but, well, you have an untutored wit]. Such an assertion licensed others to
venture more or less risky judgments about Cervantes' culture and literary
work. According to these opinions, issued primarily during the nineteenth
century, Cervantes was considered as a person who lacked education, dim-
witted and of limited reading and whose creative writing was the result of
some divine inspiration or unconscious genius, but had little to do with
his own intellectual and critical effort. This is to a large extent the essence

10 See E.C. Riley, 'Los antecedentes del *Coloquio de los perros*', in *La rara invención.
 Estudios sobre Cervantes y su posteridad literaria* (Barcelona: Crítica, 2001), 241–2.
11 I'm using my '"Entre parejas anda el juego" / "All a Matter of Pairs": Reflections
 on some Characters in the *Novelas ejemplares*', Stephen Boyd, ed., *A Companion to
 Cervantes's Novelas ejemplares* (Woodbridge, Suffolk: Tamesis, 2005), 283–302.

of the Romantic approach to Cervantes' works, whose history has been studied in depth by Anthony Close.[12]

It was Américo Castro who began to demolish this edifice erected by the Romantics and who made a sustained effort to help build up a new way of understanding Cervantes' works that revealed a conscious writer whose wide reading was incorporated in his texts.

Inspired by the conviction that history and literature are closely linked and that literary texts can serve to illustrate the reality of a people, a country or society, Américo Castro studied Cervantes' works (not only *Don Quixote*) according to such premises. Thus, it emerges a crucial book in the history of Cervantine studies, *El pensamiento de Cervantes* (The Thought of Cervantes) (1925), which, in accordance with the then prevailing theories of German *Kulturgeschichte* [cultural history], locates the work of Cervantes within the coordinates of European culture of the period: Erasmus, relations with Italian culture, Renaissance humanism, etc. In this book, and for the first time ever, Castro studied Cervantes' very particular interpretation of honour, his strategic 'hypocrisy' (which became very controversial), and his perspectivism, or what Castro called the 'realidad oscilante' found in his work.

Castro opened the door through which many later scholars have passed. Notable among them is E.C. Riley, who showed not only that Cervantes had assimilated a great many books of very varied kinds, but that he had been able to base some of his works on the body of literary theory generated by the Renaissance and Post Renaissance. Riley's major contribution to Cervantes studies lies in his book, *Cervantes's Theory of the Novel*, which, despite its now relatively remote date of publication (1962) has become an essential work of reference for students of Cervantes. (*Cervantes's Theory of the Novel*, Oxford: Oxford University Press, 1962). For the first time, in this study, Riley provided an extended and searching analysis of various

12 Anthony Close, *The Romantic Approach to 'Don Quixote'. A Critical History of the Romantic Tradition in 'Quixote' Criticism* (Cambridge: Cambridge University Press, 1978.) Note also the Spanish translation of this book, *La concepción romántica del Quijote* (Barcelona: Crítica, 2006) which adds new documents and reflections.

aspects of Cervantes' work in the context of the literary theory of the period; life and literature in *Don Quixote*, the concepts of imitation and invention and the question of how they function in the novel, *admiratio*, entertainment or instruction as ultimate aims of the literary work, unity and variety, and so on. Through the analysis of all these elements as they featured in Cervantes' prose works, E.C. Riley extrapolated a theory of the novel in Cervantes that was 'wide' but not 'exhaustive', and which left some gaps that later criticism has attempted to fill: the nature of the comic, the demands of storytelling, how Cervantes' procedures led to the creation of *Don Quixote*, etc. This theory of the Cervantine novel shows that he attempted to reconcile various aspects of the theory of the time that were in tension or conflict with each other. Riley expressed his conviction that the contemporary novel owed more to Cervantes to any other writer of any time; such input could be synthesized with these words:

> Cervantes' principal contribution to the theory of novel was a product, never properly formulated, of his imaginative-critical method. It was his all but explicit recognition of the fact that the novel must be rooted in the historical stuff of everyday experience, however much it might reach out to the marvellous heights of poetry.[13]

Later scholars have offered objections to and/or further refined Professor Riley's work, but, even after more than fifty years since it first appeared, it must be considered as an essential working tool that students of *Don Quixote* (and other works of Cervantes) need to be aware of. Riley himself took note of the objections that had been identified and he incorporated them into subsequent work on the same subject, now collected in his latest book, *La rara invención*.[14]

After Riley, many scholars have furnished new data that help shed further light on Cervantes' relationship with his cultural environment, i.e. the Renaissance and Post-Renaissance. As an interesting example, one may cite the controversy over Cervantes' debt to Erasmus, which I have considered elsewhere; Alfredo Alvar's research has cast new light on the personality

13 E.C. Riley, *Cervantes's Theory of the Novel* (Oxford: Clarendon Press, 1962), 224.
14 See footnote 10.

of Juan López de Hoyos, Cervantes' teacher in Madrid;[15] his links with Italian culture, which have been profoundly re-evaluated by Frederik de Armas,[16] Caterina Ruta,[17] Bryant Creel[18] and Antonio Gagliardi;[19] Isaías Lerner has extended the repertoire of books known to have been read by Cervantes.[20] Finally, as José Enrique Díaz Martín has convincingly argued, traces of Renaissance magical theory are apparent in *Don Quixote*.[21]

15　See Alfredo Alvar, 'López de Hoyos, el estudio de la Villa y Cervantes. Datos prelim-inares', en *Actas del XV Coloquio Cervantino Internacional. Los tiempos de Don Quijote. Guanajuato en la Geografía del Quijote* (México: Museo Iconográfico del Quijote, 2005), 241–55; Idem, 'López de Hoyos, corógrafo de Madrid', José Manuel Lucía Megías, ed., *Imprenta, libros y lectura en la España del Quijote* (Madrid: Ayuntamiento de Madrid, 2006), 19–45; Idem, 'Tres años y algo más de la vida de López de Hoyos, el "maestro" de Cervantes', Friedrich Edelmayer, Martina Fuchs, Georg Heilingsetzer and Peter Rauscher, eds, *Plus Ultra. Die Welt der Neuzeit. Festschrift für Alfred Kohler zum 65. Geburtstag* (Münster: Aschendorff, 2008), 453–74; —, 'Las enciclopedias y los humanistas en Cervantes y el Quijote', *Las enciclopedias en España antes de l'Encyclopédie* (Madrid: CSIC & Real Sociedad Económica Matritense de Amigos del País, 2009), 427–48.

16　Frederik de Armas, *Cervantes, Raphael and the Classics* (Cambridge: Cambridge University Press, 1998); Idem, 'Cervantes and the Virgilian wheel: The Portrait of a Literary Career', European Literature Careers: The Auctor from the Antiquity to the Renaissance (Toronto: University of Toronto Press, 2002) 268–86; Idem, 'Cervantes and the Italian Renaissance', Antony J. Cascardi, ed., *The Cambridge Companion to Cervantes* (Cambridge: Cambridge University Press, 2002), 32–57; Idem, *Quixotic Frescoes: Cervantes and Italian Renaissance Art* (Toronto: University of Toronto Press, 2006). See also Antonio Sánchez Jiménez, 'Del Quijote al Persiles: rota Virgilii, fortitudo et sapientia y la trayectoria literaria de Cervantes'. RILCE, 27 (2011): 477–500.

17　Caterina Ruta, 'La cultura italiana de Cervantes', in *Memoria del Quijote* (Alcalá de Henares: Centro de Estudios Cervantinos, 2008), 109–24; Idem, 'Italia en el *Quijote*', *ibid.*, 125–36.

18　Bryant Creel, *The Voice of Phoenix: Metaphors of Death and Rebirth in Classics of the Iberian Renaissance* (Tempe: Arizona Center for Medieval and Renaissance Studies, 2004).

19　Antonio Gagliardi, *Cervantes e l'Umanesimo* (Torino: Tirrenia, 2004).

20　Isaías Lerner, *Lecturas de Cervantes* (Málaga: Universidad de Málaga, 2005).

21　José Enrique Díaz Martín, *Cervantes y la magia en el Quijote de 1605* (Málaga: Universidad de Málaga, 2003).

Today, the image people have of Cervantes is very different from the former
Romantic one: among other features, he is clearly seen as an insatiable
reader who did not receive a university education – this is the real mean-
ing of Tamayo de Vargas's epithet – but as someone who read widely and
intelligently, not confining himself to the recreational literature of the
period, also exploring many other works and authors in the fields of his-
tory, science, etc. whose influences he absorbed into his own writing. His
works reveal very wide reading about and sustained meditation on many
of the issues of his time. Cervantes, then, was an extremely complex intel-
lectual figure whose ideas are more in tune with the time of the Emperor,
Charles V times than with that of Philip II: A true 'child of Renaissance'.[22]

22 Avalle-Arce *dixit*, 'Cervantes and Renaissance', quoted, p. 9.

CHRIS BARRETT

9 The Map You Cannot See:
Paradise Lost and the Poetics of Navigation

Even after his eyesight deteriorated to total blindness in 1651, John Milton continued to shop for atlases. Milton had, throughout his life, amassed a substantial collection of the most impressive and authoritative atlases of the period, and in the 1650s, despite the precarious state of his finances, the loss of his vision, and the unlikelihood of ever travelling again beyond the London area, he continued to keep tabs on the newest additions to the field. In a 1656 letter, Milton asks his travelling friend, Peter Heimbach, to report on which of two newly available atlases in Amsterdam was 'the fuller and more accurate'. Heimbach had already written to Milton of the cost of an atlas the poet had asked his young friend to price for him. Perhaps anticipating the perplexity of puzzled Peter Heimbach about the use of an atlas to this economically-straitened, visually-impaired poet, Milton wittily jokes at the cost of such a book and its unlikely appeal to the blind. 'You say that they ask one hundred and thirty florins', Milton writes, 'I think it must be the Mauritanian Mount Atlas, not the book, that you say is to be bought at such a steep price [...]. Since to me, blind, pictured maps could hardly be useful, [...] I fear that the more I paid for the book, the more I should mourn my loss.'[1] Nonetheless, Milton goes on to ask Heimbach to investigate 'which of the two editions, Blaeu's or Jansen's, is the fuller and more accurate' of the atlases. He does not answer the question I imagine Peter Heimbach might have asked: *what good is a map you cannot see?*

[1] 'To the Most Honored Youth Peter Heimbach', November 8, 1656. *Complete Prose Works of John Milton*, Don M. Wolfe, gen ed. Revised ed. (New Haven: Yale University Press, 1980), vol. 7, 494–5. *Complete Prose Works* hereafter CPW.

For an answer, I turn to *Paradise Lost*, which Milton had begun in the mid-1650s, not very long before his letter to Heimbach. In *Paradise Lost*, right reading and spiritually generative interpretation depend on the related practices of cartographic literacy and navigation. Emphasizing readerly labour as a kind of purposeful movement through the world, Milton's epic asserts that it is an insufficient reader who merely wanders through the poem; to ascend by steps to God requires both the capacity to read the environmental surround, and to deploy that literacy in the service of navigating that space. A poetics of navigation governs *Paradise Lost*, though that poetics evinces a churning ambivalence toward the cartographic concepts and technologies undergirding it. Anxious about the ubiquity of the map in the wake of England's cartographic revolution, *Paradise Lost* turns its author's well-attested fascination with geography and the poem's underarticulated mistrust of the map into a manifesto for a radically mobile modernity.

Paradise Lost is a poem with two major preoccupations: pedagogy and geography. The first is not surprising, given Milton's consistent interest in education and educational theories: as Shawcross observes, the 'great purpose of instruction [...] was the goal of [Milton's] life'.[2] This purpose, critics agree, energizes *Paradise Lost*: as Lewalski explains, the poem 'foregrounds education [...]. The Miltonic Bard educates his readers by exercising them in rigorous judgment, imaginative apprehension, and choice.'[3] Dramatizing this pedagogical programme, the poem stages multiple scenes of instruction, often at almost preposterous length. Fully half of *Paradise Lost* involves one angel or another schooling Adam in one thing or another.[4] Similarly, geography dominates the poem's texture: geographical allusions in *Paradise Lost*

2 John T. Shawcross, *John Milton: The Self and the World* (Lexington: University Press of Kentucky, 1993), 97.

3 Barbara Lewalski, *The Life of John Milton: A Critical Biography* (Oxford: Blackwell, 2000), 460.

4 Catherine Gimelli Martin in '"Boundless the Deep": Milton, Pascal, and the Theology of Relative Space', notes this extensive pedagogical programme offered to Adam and Eve in *Paradise Lost* and observes that their pre- and postlapsarian instruction constitutes half the text of the poem (46). For Martin, this pedagogical work is no

outnumber classical references.[5] The work also bears clear signs of having been written alongside atlases and maps;[6] with its dense, extended litanies of place names, the poem often seems to be a kind of atlas without maps.

Milton's interest in spatial practice appears to have overlaid his aesthetic and spiritual interests from the start of his career. Lewalski sees in Milton's earliest extant compositions, paraphrases of Psalms 114 and 136, a 'fascination with unusual geographical names and verbal sonorities'.[7] The atlas has a particular privilege in Milton's works – Milton's own collection of atlases probably included Mercator's atlas (in 1636 English translation), *Atlas; or a geographic description of the world, by Gerard Mercator and John Hondt*, Ortelius's *Theatrum Orbis Terrarum*, a Blaeu atlas, and Jansson's maritime atlas, among others.[8]

Additionally, a shadow language of space and spatial representation murmurs throughout Milton's oeuvre, and is perhaps especially audible in *Paradise Lost*. While transparently cartographic words like 'map' and 'chart' do not appear in the poem, a polysemous vocabulary of spatial representation (words like 'survey', 'project', 'compass') haunts even the most famous lines of the poem. Consider, for example, the epic's most oft-quoted

afterthought, but a crucial and integral part of the text. *ELH*, Vol. 63, No. 1 (Spring, 1996), 45–8.

5 I owe this observation to Gordon Teskey. The notes in his edition of the poem (*Paradise Lost: Authoritative Text, Sources and Backgrounds, Criticism* (New York: W.W. Norton, 2005)) have supplied me with invaluable information and detailed reflection on the descriptions of lands and regions in the poem.

6 John G. Demaray hears in Milton's Third Academic Exercise the echoes of Ortelius: both Milton and the introduction to Ortelius' atlas describe the instructive pleasure of map-reading, which reveals the workings of history. *Cosmos and Epic Representation: Dante, Spenser, Milton, and the Transformation of Renaissance Heroic Poetry* (Pittsburgh: Duquesne University Press, 1991), 187.

7 Lewalski, *Life of John Milton*, 14.

8 Respectively, entries 989, 1060, 196, and 828 in Jackson Campbell Boswell, *Milton's Library: A Catalogue of the Remains of John Milton's Library and an Annotated Reconstruction of Milton's Library and Ancillary Readings* (New York: Garland, 1975).

line: 'And justifie the wayes of God to men' (1.26).[9] Though the legal and theological senses of 'justify' are clearly operative in the line, so, too, is the technical sense of the word ('To make exact; to fit or arrange exactly'), which came into English only a century earlier when Robert Record's bestselling cosmographical manual explained how 'to iustifie your Globe' to make the instrument as precise as possible.[10] Though modern editors often gloss away the spatial connotations of such words, the cartographic resonances of these terms would have been as available to early modern readers as they are to readers in the twenty-first century.

Yet despite the deep critical interest in Milton's geographic fixation and in his engagement with contemporary theories of science and learning, strangely seldom are the poem's investments in pedagogy and geography read as being coextensive and interrelated. This tradition of treating the poem's pedagogical preoccupation and geographic obsession separately surprises, especially since their interconnectedness asserts itself in some of Milton's earliest works. In the Third Prolusion, for example, Milton bemoans in the figure of landscape the torment of busywork assignments handed down by unimaginative pedagogues:

> Believe me, my learned friends, when I go through these empty quibbles as I often must, against my will, it seems to me as if I were forcing my way through rough and rocky wastes, desolate wildernesses, and precipitous mountain gorges.[11]

The disaffected scholar's state is a topography of the banal and dull; the work of learning and interpreting appears as the work of motion, even if that motion lacks pedagogical innovation. Pedagogically innovative himself, Milton included Pierre d'Avity's world geography in his curriculum for

9 John Milton, *Paradise Lost*. Barbara K. Lewalski, ed. (Malden, MA: Blackwell, 2007). All references to the poem hereafter cited in the text.

10 Oxford English Dictionary, 'justify, v.' sense 9. <http://www.oed.com.ezp-prod1.hul. harvard.edu/view/Entry/102230> accessed March 2012. For an overview of Record's influential manual, *The Castle of Knowledge*, see John Rennie Short, *Making Space: Revisioning the World, 1475–1600*, 1st edition (Syracuse, NY: Syracuse University Press, 2004), 45–8.

11 *CPW* 1:243.

his nephews,[12] for reasons articulated in Prolusion Seven, which describes the importance of geographic understanding: to master history and geography is 'to live in every period of the world's history, and to be as it were coeval with time itself', Milton writes.[13] He goes on to deploy a metaphor of travel for the satisfaction of diligent and sustained learning: 'we should be astonished to find, gentlemen, looking back over a period of years, how great a distance we had covered and across how wide a sea of learning we had sailed, without a check on our voyage'.[14] In the brief 'Of Education', Milton goes on to emphasize the importance of learning 'the instrumentall science of Trigonometry, and from thence to Fortification, Architecture, Enginry, or Navigation' alongside the use of maps and globes.[15]

In *Paradise Lost*, this interlacing of the work of knowledge and the topography of the earth becomes overt, as observed by one of the poem's first critics. Andrew Marvell's poem, 'On Mr. Milton's Paradise Lost', which appears in the front matter to the 1668 reissue of Milton's epic, describes Milton's poetic project as being a blend of the navigational and pedagogical. In the context of admitting his initial anxieties about the poem, Marvell reports:

12 Lewalski *Life of John Milton*, 125. Pierre d'Avity's *Les Estats, Empires, et Principautez du Monde* is listed in Boswell at entry 478. Demaray notes that while tutoring his nephews, Milton was also developing 'Adam Unparadiz'd', a fragment later to be absorbed into *Paradise Lost* (187–8).

13 *CPW* 1:297.

14 *CPW* 1:300.

15 *CPW* 2: 392. Demaray, adducing the navigational components of Milton's curriculum, remarks on Milton's debt to Samuel Hartlib's practical educational theories (187). Julian Koslow discusses the innovative nature of Milton's educational treatise, situating in the humanist context and suggesting it sheds light on the Son's surprising rejection of humanist learning in *Paradise Regained* ('"Not a Bow for Every Man to Shoot": Milton's *Of Education*, Between Hartlib and Humanism', *Milton Studies* 47 (2008) 24–53). Melanie Ord (*Travel and Experience in Early Modern English Literature* (NY: Palgrave Macmillan, 2008)) explores the uses of travel and mediated knowledge in the form of books, globes, etc. in the context of broad educational debates over experiential and experimental knowledge, as articulated by Bacon, Lyly, and others (esp. 14, 78, 91–2, 99–100).

> Yet as I read, soon growing less severe,
> I liked his project, the success did fear;
> Through that wide field how he his way should find
> O'er which lame Faith leads Understanding blind;
> Lest he perplexed the things he would explain,
> And what was easy he should render vain.[16]

Marvell describes the epic as a kind of terrain ('that wide field') across which Milton must navigate ('he his way should find') in order to accomplish the instructional work of the text ('the things he would explain'). In short, Marvell articulates the spatial poetics of Milton's epic: the poem is a space that must be traversed, in order to educate the reader.

Marvell's poem infers the adequation of navigation with interpretive labour operative throughout *Paradise Lost*. In Milton's epic, the necessity of navigation – of principled movement that yields spiritual access – makes itself apparent in the instructive example offered by its central figures. Satan's far-ranging journeys, for example, are often adduced by critics as evidence of Milton's geographic imagination, but he nonetheless makes for a terrible navigator. One of the earliest and most haunting descriptions of Satan likens him to a sleeping whale, to whose side the erring pilot of a night-foundered skiff moors his boat.

> ... that Sea-beast
> *Leviathan*, which God of all his works
> Created hugest that swim th' Ocean stream:
> Him haply slumbring on the *Norway* foam
> The Pilot of some small night-founder'd Skiff,
> Deeming some Island, oft, as Sea-men tell,
> With fixed Anchor in his skaly rind
> Moors by his side under the Lee, while Night
> Invests the Sea, and wished Morn delayes:
> So stretcht out huge in length the Arch-fiend lay
> Chain'd on the burning Lake ... (1.200–10)

16 Nigel Smith, ed., *The Poems of Andrew Marvell*. Rev. ed. (Harlow, UK: Pearson Longman, 2007), p. 183.

When the reader first meets Satan, the fallen angel appears as the site of a catastrophic error in navigation: a ship's pilot mistakes a whale for an island. Even more strikingly, the error is not corrected in the context of the analogy; instead, the skiff and its pilot are abandoned by the Satanic description, to moor and wait for the horrific night to come.[17] As Hampton suggests, nautical navigational imagery appears often in *Paradise Lost* and specifically as a figure for interpretive reading: 'To be moored upon Leviathan means for Milton that spiritual life, individual and corporate, is characterized by chronic "misreading"', here, in the context of navigation.[18] For Hampton, this is an instructional moment on multiple levels: the episode challenges readers to submit to the analogy and to be distracted by Satan. In this way, Milton treats the skiff as a lesson in exegesis that becomes an exercise in geography: virtue must be involved in the right interpretation of the text of the poem, as well as the landmass-or-leviathan. The task for readers becomes how to read the 'physical and spiritual landscape of hell'.[19]

This unfortunate mooring of the skiff would not have happened were it not for the error of the Pilot, who assumes the syntactic work of the analogy. The Pilot, 'Deeming [Leviathan to be] some Island', fixes his anchor and moors the skiff to the Leviathan; the beast may be the subject of the analogy, but he is only the grammatical object of the lines. The foregrounded Pilot asserts the primacy of navigational error, while the parable as a whole introduces the concept of successful navigation as right interpretation early on. To navigate a space is to read the landscape or seascape correctly; and transposing the landscape to the spiritual does not change the navigational metaphor. It is worth emphasizing that the disaster imminent to the skiff is not narrated; all that follows this navigational error is a duration of waiting: 'while Night / Invests the Sea, and wished Morn delayes'. The attentive reader is invited to supply the inevitable end to the well-worn story

17 Bryan Adams Hampton ('Milton's Parable of Misreading: Navigating the Contextual Waters of the "Night-Founder'd Skiff" in *Paradise Lost*, 1.192–209', *Milton Studies* 43 (2004) 86–110) reflects on the severity of the trouble posed by this error for the spiritual navigator (86–7 and passim).

18 *Ibid.*, 99.

19 *Ibid.*, 87.

evoked,[20] but not finished, by the analogy. This truncation of a familiar tale suggests that a failure of navigation accompanies a narrative pause: this miniature story, embedded in the analogy of Satan to Leviathan, goes nowhere once the pilot makes his error. The reader is left to supply the fate of the inadvisedly-moored skiff; the error, unremarked by the reader, leave the episode's outcome invisible. In the context of introducing Satan's directional insufficiency, the text simultaneously charges the reader with repairing the narrative ruins of such navigational failures.

Given this introduction, it may not be surprising that Satan fails repeatedly as a navigator. En route from hell to earth, Satan gets 'half lost' (2.975) – incapable, perhaps, of getting even properly, fully lost. Embarrassingly, he has to stop to ask directions (twice). Satan's motives for his navigational efforts, too, never manage to escape suspicion: even when the account of the angel's expansive wanderings reaches adventurous and majestic heights, Satan's movement is still undercut by its spiritually bankrupt origins in interpretive error. The voyaging Satan may see 'sight of all this World beheld so faire' (3.554), but he sees it only 'As [...]. a Scout' (3.543), a spy or interloper in paradise.

Nonetheless, Satan presses on, hurling himself with only the most corrupted sense of direction. At times, Satan's failure to navigate a cosmos as breathtaking as that sketched by the poem is almost heartbreaking. Landing on the edge of Eden and surveying the unbearably verdant magnificence of unspoiled paradise, Satan responds to the jaw-dropping radiance of the unfallen world's awesome beauty with the words, 'Oh Hell!' (4.358). The profundity of Satan's misreading – or at least, his misuse of descriptive language – reveals the angel's incapacity to occupy a space beyond his mobile

20 Joe Roman (*Whale* (London: Reaktion Books, 2006)) explains that the story of sailors mistaking a whale for an island was a long-familiar one, with popular analogues in medieval tradition and antiquity (15–19). One particularly resonant story involves St Brendan, who celebrated Mass on the back of the whale Jasconius. He and the sailors survived the revelation of their mistake, but were commanded to return each year to celebrate Mass on Jasconius's back. In this case, the punishment for initial misreading is repetition, a phenomenon that, like its inverse the stop, is also an obstacle to narrative progression.

hell. The hell seething within him functions as shorthand for Satan's navigational perplexity. As the poetic persona says of Satan's imprisonment:[21]

> ... for within him Hell
> He brings, and round about him, nor from Hell
> One step no more then from himself can fly
> By change of place: (4.20–23)

The sentiment is echoed by Satan himself, who mourns that

> Which way I flie is Hell; my self am Hell;
> And in the lowest deep a lower deep
> Still threatning to devour me opens wide,
> To which the Hell I suffer seems a Heav'n.
> O then at last relent: is there no place
> Left for Repentance, none for Pardon left?
> None left but by submission; and that word
> *Disdain* forbids me ... (4.75–82)

In the end, despite his travels, Satan navigates nowhere: 'One step no more then from himself can fly / By change of place.' True navigation in Milton's cosmos requires a kind of spiritual work, a right interpretation of the merits of submission and obedience; but Disdain prevents Satan from undertaking that labour, just as his faulty navigation of the cosmos betrays his spiritual bankruptcy. What his magnificent flights of cosmic range reveal is not the triumph of navigation, but a fundamentally disordered relationship of the self to the spatial surround.

Indeed, Satan has a great deal of difficulty even locating a place, let alone occupying it. As he mourns while in the garden,

> If I could joy in aught, sweet interchange
> Of Hill and Vallie, Rivers, Woods and Plaines,
> Now Land, now Sea, and Shores with Forrest crownd,
> Rocks, Dens, and Caves; but I in none of these
> Find place or refuge; (9.115–19)

21 Lewalski notes Satan's imprisonment within himself (464–5).

Conscious of the topographical diversity of divine creation, Satan fails to find any landscape except that of the mobile hell that envelopes him. This mobile hell supplants every location the fallen angel journeys through, and prevents Satan from navigating to any 'place' – his is an expansive but incarcerating cosmos of spiritually worthless travels to numerous locations that have no name but share the inescapable interchangeability of hell. There is no place for him; Satan moves only through the catalogue of places outside the hell he carries always. Fenton suggests that Satan, like an avaricious bishop, confuses hope with base things, and, in pursuing the latter, forgets that God is represented in scripture as a refuge, a *place* of hope. Satan erroneously misinterprets place, reducing it to mere land, and thus removing himself from the possibility of inhabiting a place that partakes of the divine.[22] Instead, he cycles endlessly in the hell that he brings everywhere.

That hell, however, is just one of the landscapes worked upon by the figures in the epic. As Lewalski observes, Milton's Hell, Heaven, and Eden are all 'in process: the physical conditions of these places are fitted to the beings that inhabit them, but the inhabitants interact with and shape their environments, creating societies in their own images'.[23] In each of these places, the characters engage their surroundings, and the kind of technologies of landscaping they employ indicate the kind of right or corrupted labour undertaken in those regions. As much as landscape is inseparable from activity and perception, so is the individual's experience inseparable from interaction with and perception of a surrounding landscape.[24] By negative example, Satan demonstrates the subject-making power of

22 Mary C. Fenton, 'Hope, Land Ownership, and Milton's "Paradise Within"' *Studies in English Literature, 1500–1900*, Vol. 43, No. 1, The English Renaissance (Winter, 2003), 151–80; 160.

23 Lewalski, 465.

24 The essays in *Technologies of Landscape: From Reaping to Recycling* (David E. Nye, ed. Amherst: University of Massachusetts Press, 1999) all explore what Nye in his introduction calls the inseparability of landscape from the technologies used to shape it (3–4). As much as the landscape appears to be indexical of the spiritual health of each character in the poem, that health is better mirrored in the mode of engagement each character evinces with the landscape.

the individual's engagement with landscape – though in Satan's case, that landscape is tragically coextensive with his corrupted mind. He does not act upon the landscape except to refuse to recuperate a viable relationship with this spiritual desert.

In this tendency to travel without really going anywhere, Satan comes to resemble a kind of armchair traveller, of the sort John Hall described in his 1646 'Home Travel'.[25] Articulating the appeal of the atlas for the geographically curious, Hall explains that the reader need not travel to Tyre for purple, or Peru for ore, or India for gum, because all the valuable stores and aspects of nations 'Are in this map at large exprest; / That who would travel here might know / The little world in Folio'. The map replaces the need – so frustrated in Satan's wanderings – to visit places, replacing meaningful journeys to destinations with a vapid satisfaction with the representation of those locations.[26]

Satan's resemblance to Hall's home traveller is made stronger by how suspiciously cartographic the angel's view of the newly created world is. Approaching the earth, Satan's first glimpse at the novel earth leads him to 'the sudden view / Of all this world at once' (3.542–3), a perspective he cannot inhabit except cartographically. Additionally, Eden, through Satan's gaze, is described as a 'Lantskip' (4.153) and a 'Theatre' (4.141).[27] By the 1660s, 'lantskip' was still a new word in English, referring exclusively to a

25 John Hall, *Poems by John Hall* (Cambridge: Roger Daniel, 1646), 47.
26 Hall mentions Tyre, the Easter Shores (or Levant), Peru, India, and Africk – all regions spread before Adam's eyes in Book 11 (as, respectively, Sarra at 11.243; passim, and, for example, Syria at 11.218; Peru at 11.408; Indian capitals 'Agra and Lahor' at 11.391; Ercoco, Mombaza, Sofala, and so on, at 11.398–400). Hall overlays this idea of armchair travelling with the conceit of the beloved-as-world or exotic territory; because the beloved contains all the best elements of the world in her demeanour and complexion, one need only look upon her, a sort of gendered atlas of desiring.
27 Mark J. Bruhn notes that Milton describes the view of Eden as both a 'Theatre' and a 'Lantskip', which are 'two figures that imply a distanced and framed search domain that may be scanned from multiple angles without significantly transforming the spatial relations represented or foregrounding (profiling) any literal point of view' (394). 'Place Deixis and the Schematics of Imagined Space: Milton to Keats', *Poetics Today* 26:3 (Fall 2005), 387–432.

framed pictorial treatment of a spatial expanse. Likewise 'theatre' had several
live meanings, including a performative space, a designated region, the text
describing such an area, or – in everyday parlance – an atlas.[28] (Consider,
for example, John Speed's 1611–12 *Theatre of the Empire of Great Britaine*.)
However one couches Satan's view of Eden, the Satanic perspective is pow-
erfully cartographic: his worldly optics are those of visual representation.
This Satanic, cartographic view supplies the first murmur of the poem's
critique of the map, a critique I'll return to in a moment.

Satan emerges as exactly the opposite of the kind of navigator Michael
is charged with training Adam to be. In Books 11 and 12, Michael leads the
postlapsarian Adam to the mountaintop to learn of the future of human-
ity, in what stands as the poem's most dramatic pedagogical episode. Here
Adam acquires a new kind of visual, specifically cartographic literacy that
becomes part of his interpretive, spiritual faculty.

The hill of Paradise Michael and Adam ascend delivers them 'The
Hemisphere of Earth in cleerest Ken / Stretcht out to the amplest reach of
prospect lay' (11.379–80). But what Adam gazes out upon is not the world's
unmediated visual expanse. Adam is also given to see 'In Spirit perhaps'
(11.406) the Americas and other regions that, because of the curvature
of the earth, would dip below the horizon. What Adam looks at, then, is
not a naturalistic prospect of the world itself, but the world as it might
appear, if it could all be seen at once – as in a map.[29] Adam's perspective
has two echoes, then, in the poem: a demonic and a divine. The text of

28 See Henry Turner (*Shakespeare's Double Helix* (London and NY: Continuum, 2007))
 for discussion of theatre (in the sense of a performance space) as a kind of atlas or
 encyclopedia (4). See also William West, *Theatres and Encyclopedias in Early Modern
 Europe* (Cambridge: Cambridge University Press, 2002), for further discussion of
 theatre as encyclopedic text.
29 Morgan Ng notes that the surface of the earth appears in parallel projection when
 Satan's voyage over it is described, and that Satan's view seems to be perpendicular to
 the surface (as the light falls, casting no shadows), wherever the angel moves over the
 earth – aspects of his perspective suggestive of a cartographic view ('Milton's Maps',
 May 2011). I am grateful to the author for sharing his unpublished manuscript with
 me. A version of this article is available as 'Milton's Maps' in *Word & Image*, Vol. 29,
 issue 4 (2013).

Paradise Lost explicitly likens Adam's view from the mountaintop to that later offered a second *Adam*:

> Not higher that Hill nor wider looking round,
> Whereon for different cause the Tempter set
> Our second Adam in the Wilderness,
> To shew him all Earths Kingdomes and thir Glory. (11.381–84)

In *Paradise Regained*, Satan offers the Son from the vantage of the 'specular Mount' (4.236) and the pinnacle (4.549) views of Rome, Athens, and Jerusalem, and – at least by metaphorical extension – of 'all / The Kingdoms of the world' (4.88–89). The implication of the 'strange Parallax or Optic skill' (4.40) by which Satan delivers these stunning views, is that there is something artificial in the perspective, perhaps even treacherously so. The fallen angel mediates the view, this already metonymic representation of the world, in an effort to manipulate the viewer into reading the expanse before him, and *not* reading through it to the deceit that animates this astonishing but suspect visual representation of space.

In this way, both Adam's perspective from the mountaintop and the Son's view of the world's kingdoms bear an insidious resemblance to Satan's view of the newly created world and Eden. No wonder, then, that the quietly cartographic nature of what Adam sees should obstruct his interpretive faculty. The map requires a particular kind of literacy, and to the uninstructed, it can lead to all sorts of misinterpretation.[30] Throughout much of his training in how to read the scenes – the *theatre* of history – unfolding in

30 There are plenty of examples of lapses in cartographic literacy leading to bureaucratic and political hassle. One concerns Saxton's atlas: a tax assessor, not knowing how to read scale, assessed the county of Pembrokeshire four times the rate assessed surrounding counties, because Pembrokeshire had the misfortune to appear on its own folio page in Saxton's atlas, opposite four counties – in life, each the same size as Pembrokeshire – grouped together on the facing page. (The event is described by Victor Morgan in 'The Cartographic Image of "The Country" in Early Modern England', *Transactions of the Royal Historical Society*, Fifth Series, Vol. 29 (1979), 129–54; 138). Map literacy may be taken for granted today, but for early modern readers, it was not a given.

the *lantskip* before him, Adam intuitively resists the techniques of spatial
representation, repeatedly misinterpreting the cartographic panorama, to
the annoyance of an exasperated Michael.[31] Adam is susceptible to multiple
forms of interpretive error, beginning with a self-involved assumption of
universality where there is only the particular, as when Adam's first response
to learning of his son Cain's murder of Abel is a worry that Adam, too,
shall die so violently. Before he leaves the mountain with Michael, Adam
will demonstrate a proclivity for hyperbole (for example, when he declares
that humankind would 'Better end heer unborn' (11.502) and 'Henceforth
I flie not Death, nor would prolong / Life much' (11.547–48)), a suscepti-
bility to the rhetorical suasion of pleasure (as when he views the rollicking
delight of atheist revellers as a portent of peaceful days), and an inability
to extrapolate presented data to his own circumstances (as when he fails
to comprehend how the body made in the image of God can become ill).
Impetuously emotional in his responses to the scenes Michael displays,
Adam naturally resists the representational techniques of the pageant:
without instruction, he cannot grasp the importance of contextual relation-
ships, he fails to read the scenes critically, and he struggles with applying
current knowledge to process new information. For Adam, the map of time
before him is a site of immense interpretive difficulty.[32]

Significantly, while the visual representation of space poses interpretive
difficulty, it also offers the vocabulary for spiritual discernment. Adam,
starting to catch on to how to read the pageant, invokes a kind of life-is-a-
highway motif for expressing the failure of morality that has been played

31 Part of Adam's trouble may be the difficulty of reconciling the two streams Demaray
 proposes Milton blended in order to have 'invented *Paradise Lost*', 'integrating the
 new, empirical eyewitness reporting techniques of contemporaneous travel writing
 with revelations of inner, spiritual vision of a kind drawn from biblical and classical
 tradition' (178).
32 The term 'map of time' is Achsah Guibbory's, though she does not use it to describe
 specifically and only this episode. Guibbory reads the mountaintop pageant as being
 among the most crucial episodes of instruction in the poem, revealing Miltonic atti-
 tudes toward the cyclicity of history. *The Map of Time: Seventeenth-Century English
 Literature and Ideas of Pattern in History* (Urbana: University of Illinois Press, 1986),
 195–7.

out for him in the panorama below: 'O pittie and shame, that they who
to live well / Enterd so faire, should turn aside to tread / Paths indirect, or
in the mid way faint!' (11.629–31). Adam comes to understand morality
and spiritual obligation, by couching them not in the language of repre-
sentation, but in the language of navigation and movement: turning aside,
treading, paths and ways.

The pedagogical triumph of the episode is not Adam's newfound map
literacy, but his understanding that reading a map rightly is not sufficient:
it is his embodied movement over the fallen earth, his navigation in wan-
dering steps and slow, that is the spiritual sine qua non. The map is, at
best, instrumental. It is not enough to learn to read the map; Adam must
turn from the mountaintop vista and begin his movement through time
in the world. When Adam leaves this panoramic view of sacred history,
his relationship to that abandoned map of time becomes, at the level of
language itself, a descriptor of his being. Michael and Adam 'both descend
the Hill; / Descended, *Adam* to the Bowre where Eve / Lay sleeping ran'
(12.606–8). Descended *Adam* – metrically as well as existentially linked
in line 607 to 'Descended' – is descended from the panorama and into the
world, and as a mobile moral actor, he is recognizable to Eve as having a
new, subjectivity-altering relationship to the landscape they are about to
traverse. As she tells him,

> ... with thee to goe
> Is to stay here; without thee here to stay,
> Is to go hence unwilling; thou to mee
> Art all things under Heav'n, all places thou (12.615–18)

Adam here inverts Satan's navigational perplexity: instead of making every
place hell, Adam becomes 'all places'. Adam's wandering steps and slow will
not lead him to redemption – they are the practice of redemption itself,
the recuperation of the relationship of self to landscape.

Indeed, that recuperation of the relationship of self to landscape may
be the reminder – implicit in lyric poetry but often militated against in
narrative poetry – that the subject of discourse is also the situation of dis-
course. Bruhn notes that lyric poetry broadly tends to act by 'collapsing

represented and discourse situations into a single level. In this case, there is no compulsion to explicitly render (e.g., through stage directions or "objective" description) the represented situation, because it is (assumed to be) immediately available as the situation-of-discourse.'[33] Adam's resituation of his spiritual self within a coherent and responsive environment unites the subject and situation in a mode more characteristic of lyric poetry, and certainly at odds with the tragic-epic thrust of the narrative to the Fall.[34]

It is also worth noting that Eve addresses Adam as 'all places thou', elevating Adam above Satan's navigational transfixity, but also above Satan's oozing solipsism. 'Myself am hell' he complains, the problem of his subjectivity being precisely that it contaminates every place he seeks. Adam, by contrast, becomes a recognizable individual, worthy of the pronoun 'thou', who contains 'all places.'[35]

Eve's assessment of Adam's newfound spiritual wholeness recalls Michael's gentle chiding early in Book 11, when Adam expresses sadness that his expulsion from the garden will cut him off from the presence of God. Michael tells him:

33 Bruhn, 398.

34 Rachel Falconer describes the Fall as the cataclysmic event that unmoors Adam 'from time and space', an unmooring that is resolved with the reassertion of a primarily novelistic chronotope (116–17). This use of Bakhtin's formulation of the literary space-time is another way of registering that Adam's recuperation involves an alteration in the relationship of self to temporal and spatial setting. 'Heterochronic Representations of the Fall: Bakhtin, Milton, DeLillo' in Nele Bemong, et al., eds, *Bakhtin's Theory of the Literary Chronotope: Reflections, Applications, Perspectives* (Gent: Academia Press, 2010), 111–29.

35 Andrew Mattison (*Milton's Uncertain Eden: Understanding Place in Paradise Lost* (NY: Routledge, 2007)) identifies in the georgic labourer of the poem's last simile a figure whose status as subject is also rendered by the workings of and engagement with his surround: 'The laborer, for example, becomes transiently reified, even though he is only present to complete the analogy, because Milton surrounds him with a vividly described environment. He *would* be merely a briefly mentioned type [...] but by placing him, by giving him the context of a landscape, Milton makes him a person' (7).

> [...] surmise not then
> His presence to these narrow bounds confin'd
> Of Paradise or *Eden*:
> [...]
> Yet doubt not but in Vallie and in plaine
> God is as here, and will be found alike
> Present, and of his presence many a signe
> Still following thee, still compassing thee round
> With goodness and paternal Love, his Face
> Express, and of his steps the track Divine.
> Which that thou mayst beleeve, and be confirmd
> Ere thou from hence depart, know I am sent (11.340–42, 349–56)

Michael reveals that the purpose of this panorama is to demonstrate that Adam need not remain on top of the mountain, or in Eden. That, in fact, Adam's spiritual recuperation involves this travel of valley and plain. Since God is everywhere, it would be positively perverse to persist in a particular place.

This aversion to place crops up repeatedly, and in diverse contexts, in the critical literature on *Paradise Lost*. Simpson outlines a logic comparable to Michael's suspicion of the idolatry of place in Milton's time and work: in describing the Puritan aversion to the 'divided spaces and jurisdictions' of churches (altar rails, chancel steps, the plaques and signs of intercessory prayer) and the heaven those earthly representations symbolize, Simpson articulates a Puritan 'commitment to placelessness', a suspicion of elevated place or special spatial jurisdiction.[36] Haskin, writing of Milton's engagement with biblical texts, suggests the poet's complicated and revisionary approach to scriptural 'places', both the textual locations topographically described by Luther and the spiritual-existential 'place' sought by readers like Bunyan.[37] Whatever the critical frame, Milton evinces a discomfort with the idea of rooted place, and in resolving that uneasiness, insists on the

36 James Simpson, *Under the Hammer: Iconoclasm in the Anglo-American Tradition* (Oxford: Oxford University Press, 2010), 88–9.

37 Dayton Haskin, *Milton's Burden of Interpretation* (Philadelphia: University of Pennsylvania Press, 1994), xiii–xiv, 1–2.

spiritual necessity of movement. In Book 12 of *Paradise Lost*, for example, the Israelites are delivered from slavery to right government by 'thir delay', their wandering movement through 'the wide Wilderness':

> This also shall they gain by thir delay
> In the wide Wilderness, there they shall found
> Thir government, and thir great Senate choose
> Through the twelve Tribes, to rule by Laws ordaind: (12.223–26)

To know God is to navigate the material world.

In privileging Adam and Eve's movement through their earthly environment over the image – the lantskip or theatre – of that environment, *Paradise Lost* pivots epic poetry from being the genre of nation formation to the genre of subject formation, through encounter with environment. Gregerson traces in *Paradise Lost* (as in *The Faerie Queene*) a sustained attempt to form and re-form the subject, the subject who is 'radically contingent' in her political, religious, and sexual identity.[38] I propose that for Milton, that subject is radically interrelated with his or her spatial environment; and, further, that the subject's consciousness of that environment and obligation to engage with it fundamentally alter that subject's construction.

In this light, both Adam's instruction on the mountaintop and the pedagogical mission of the poem as a whole complete at the moment Adam descends from the mountain, the moment he rejects the lantskip. Once Adam's literacy enables him to read the spatial representation before him, he must reject the representation in favour of ambulatory experience. His wandering steps and slow must form the core of his spiritual practice, not the study of an artificially-rendered (albeit divinely-provided) visual field of represented space. Learning to read a map means learning to turn away from it, to confront the conspiracies it conceals.

Nowhere in the poem are the reasons for turning away from the map more apparent than in the fourth scene Adam is shown from the mountain top. In this nightmarish scene, the language of Adam's mountaintop vision

38 Linda Gregerson, *The Reformation of the Subject: Spenser, Milton and the English Protestant Epic* (NY: Cambridge University Press, 1995), 6.

becomes overtly cartographic. The description of the view is evocative of the oblique planar perspective and subject matter typical of the popular Renaissance city view.[39] Adam

> He lookd and saw wide Territorie spred
> Before him, Towns, and rural works between,
> Cities of Men with lofty Gates and Towrs,
> Concours in Arms, fierce Faces threatning Warr,
> [...]
> ... Others to a Citie strong
> Lay Seige, encampt; by Batterie, Scale, and Mine,
> Assaulting; others from the wall defend
> With Dart and Jav'lin, Stones and sulfurous Fire;
> On each hand slaughter and gigantic deeds. (11.638–41, 655–59)

What Adam sees, in this city view, is the origin of the cartographic revolution itself: though nominally describing the menacing giants of Genesis 6:4–5, the nightmare laid out before Adam looks unnervingly like early modern military engagement. With the late fifteenth-century development of casting cannons and the siege warfare they made possible, came the need for precise topographical information, so as to allow for the siting and aiming of cannonry.[40] This need was supplied by modern cartography, and it perhaps comes as no surprise now to recall that in Milton's 'Of Education,' trigonometry prepares the student not just for navigation, but for 'Fortification' and 'Enginry', too.[41] Like the 'devilish Enginrie' the fallen angels deploy to initial success in their rebellion (6.553) – war machines

39 Lucia Nuti notes the popularity of city views and town portraits. As the 'only chorographic documents that claim to be considered as views genuinely experienced by an observer', town portraits were extremely popular, and were sold either as individual sheets or in book collections. 'Mapping Places: Chorography and Vision in the Renaissance' 90–108 in Denis Cosgrove, ed., *Mappings* (London: Reaktion Books, 1999), 98.

40 See, for example, David W. Waters, *The Art of Navigation in England in Elizabethan and Early Stuart Times* (London: Hollis and Carter, 1958), 96.

41 There is yet another faint echo of cannon fire in the name of the street Milton lived from 1669 on: Artillery Walk, in Bunhill Fields.

ultimately trumped by the militarization of the earth itself (the hurling of mountains at 6.637–52) – the technology of siege warfare undergirds the map, which can only represent the earth and all its latent power.

In gazing on this episode, Adam sees a chilling reminder that the surface of the map discloses both its own history and its uses in a history of bloody nations and brutal politics.[42] Even a divine map must show scene after scene of fratricide, abuse, idolatry, and war. Indeed, the only scene left for Adam to view after this orgy of violence and cruelty that births the map is the absolute destruction of life on earth in the flood. After that, Michael will shift the medium of Adam's instruction from the panoramic map to a spoken narrative. This comes as a welcome reprieve for Adam, who is speechless at the destruction the map discloses after he has learned to look past its stunning beauty:

> As one who in his journey bates at Noone,
> Though bent on speed, so heer the Archangel paus'd
> Betwixt the world destroy'd and world restor'd,
> If *Adam* aught perhaps might interpose;
> Then with transition sweet new Speech resumes.
> Thus thou hast seen one World begin and end [...] (12.1–6)

Michael's narrative is itself analogized to a 'journey,' a purposeful movement over a terrain. Again, the right interpretation of history resembles a navigational undertaking: the horrific map, which must be superseded, gives way to the language of embodied motion through space.

Ainsworth notes another striking feature of the shift from the visual to the audible: the move from Adam's education in reading visual history to Michael's delivery of a spoken narrative of subsequent events (including the incorporation of contemporary history) pulls the reader into the instructional programme. That is, 'we as readers shift from being apart from

42 Michael Lieb suggests that anxiety about the safety and integrity of the body haunts Milton's oeuvre, including and perhaps especially *Paradise Lost*, the self being contained in a form subject to dismembering violence and yet capable of preservation or re-memberment (passim; esp. 3, 9–10). *Milton and the Culture of Violence* (Ithaca: Cornell University Press, 1994).

the lesson to being a part of it', when our experience of the poem comes to resemble Adam's experience of Michael's speech.[43] While watching Adam watch the map of history disclose its brutal biblical episodes, the reader's attention is drawn to Adam's development of an interpretive faculty (cartographic literacy). This preparation for right interpretive action brings the reader, alongside Adam, into the challenge of how to read and move when the mountaintop is abandoned by the angelic tutor and his fallen pupils. The contrast between the metapedagogical scene of Book 11 and the continuing pedagogical programme of Book 12 underscores the necessity of reading the map of time rightly – and the necessity of then moving past the map to confront not the representation of others' actions, but the personal obligations and responsibilities of an embodied spiritual actor in his own spatial and historical moment. In moving the reader from observer to pupil when the poem pivots from map to tale, *Paradise Lost* highlights the dangerously opaque programme of the map, as well as the possibility of learning to read through it, and beyond it.

The poem thus flags the interpretive difficulty of the map, foregrounding the oft-elided trouble of perceiving in a map the lines of political power it quietly delineates. In the last scenes of the historical landscape shown to Adam, before Michael changes the medium of instruction to spoken word, the poem's deep anxiety about the map as representational mode makes itself most apparent. Just as Adam is coming to master a limited cartographic literacy, this theatre of history splays out before him the workings of the human will to power – that is, precisely what J.B. Harley and other scholars of space argue the map is designed to show.[44] Where there was once 'wide terrain', there comes a series of interruptions and violent

43 Ainsworth, 97–8. *Milton and the Spiritual Reader: Reading and Religion in Seventeenth-Century England* (NY: Routledge, 2008).

44 Howard Marchitello describes Harley's intervention in recognizing that, instead of maps being true and neutral and offering an unmediated access to absolute reality, 'cartography as a social practice embedded in both ideology and the politics of power'. Influenced by Foucault, Harley argues for the '*political* readings of maps' (13). 'Political Maps: The Production of Cartography and Chorography in Early Modern England' 13–40 in Margaret J.M. Ezell and Katherine O'Brien O'Keeffe,

discontinuities: cities, walls, towns, and the spaces between that fill rapidly
with contest and bloodshed: as Marchitello observes of maps, they excel at
'rendering the world radically discontiguous' which is 'an entirely political
practice taken up in the service of regional or national identity, political or
military power, personal or private property boundaries and possession'.[45]
The map demonstrates how land is acquired in blood, occupied in corrup-
tion, policed by the enemies of liberty.[46] It contains silences and secrets it
seeks to efface, illuminating spatial relations and occluding the structures
of power dependent on them. (As Terry Eagleton notes, 'Nothing could be
more political than just the way objects are spatially distributed.'[47]) Learning
to read the map, as Adam does at the mountaintop, becomes synonymous
with learning to reject the mechanisms that conspire behind the map to
deprive the bodies in that represented space of their liberty.

Adam learns to read through the map, to temper his intuitive and
emotional responses, to contextualize its content, and to evaluate its disclo-
sures and concealments critically. In other words, he learns to treat the map
not as a space unto itself, but as an image, even an icon, to be superseded
by a practice of moving through the world. Mattison notes that Milton
never locates value in a thing; meaning and therefore truth lies in 'the play
between the thing and its figuration'.[48] This episode trains Adam to move
beyond the map to the navigational act where, as the point of exchange
between interpretation and action, learning is demonstrated. Adam learns
to treat the map as something that has a relationship (however distortive)
to a referent space; his mountaintop instruction brings Adam to appreciate

eds, *Cultural Artifacts and the Production of Meaning: The Page, the Image, and the
Body* (Ann Arbor: University of Michigan Press, 1994).

45 *Ibid.*, 26.

46 For Short, the sixteenth century saw the arrival of the map as an 'administrative/
surveillance device' (101); Saxton's maps were among the first to be 'surveillances
of the national territory' (88), a sea-change in the way the nation represented and
managed itself.

47 Terry Eagleton, foreword to Kristin Ross, *The Emergence of Social Space: Rimbaud
and the Paris Commune* (Minneapolis: University of Minnesota Press, 1988), xiii.

48 Mattison, *Milton's Uncertain Eden*, 13.

the map as useful only when incorporated into a practice of negotiating the world and its image, the thing and its figuration.

In gathering his cartographic interpretive faculty alongside an appreciation of the map's insufficiencies, Adam approaches a capacity for appropriate empathy that complements the salutary self-critique he developed in the two books between his fall and his mountaintop instruction. The encounter with the map – interpreted appropriately, at long last – brings Adam to the understanding of his spiritual obligations in this world. His epiphany somewhat resembles Susan Sontag's account of the potential effect of encountering the visual evidence of others' pain. Though she has in mind documentary photography, her hope for the difficult but salutary effect of such confrontations parallels Adam's realization on the mountain that the (cartographic) representation of suffering may, if read carefully, spur ethical action: 'To set aside the sympathy we extend to others beset by war and murderous politics for a reflection on how our privileges are located on the same map as their suffering, and may – in ways we might prefer not to imagine – be linked to their suffering, as the wealth of some may imply the destitution of others, is a task for which the painful, stirring images supply only an initial spark.'[49] Michael forecloses for Adam – as Eve does earlier – the possibility of surrendering his life and preventing the future's bloodletting: Adam's obligation, learned at the mountaintop, is to move over the earth and in time, cognizant of his complicity in the machinations represented by the map of history.

In learning to appreciate the necessity of moving his own body through the world, Adam comes to appreciate that this topographical practice links him to the sufferings of all those to come. Instructed to observe his own bodily movements as part of his spiritual ascent, Adam is taught, too, to appreciate the real and fragile bodies whose actions and deaths mark the pulse of history. It is probably coincidental that in the year following the second edition of *Paradise Lost*, John Ogilby became the first cartographer to invest the time and resources to represent roads, and to do so accurately,

49 Susan Sontag, *Regarding the Pain of Others* (NY: Farrar, Straus and Giroux, 2003) 102–3.

on English maps.[50] Nonetheless, it is tempting to see in this innovation an echo of the navigational programme in *Paradise Lost*: specifically, a recognition and even privileging of the mechanism by which an individual might move through a mapped terrain. In this new generation of maps, drawn in the wake of Milton's epic, comes a recognition of at least the traces of bodies otherwise elided by the representation of county and nation, an awareness that the map must give way to the footsteps of its readers.

While remarking on echoes, it might be worth considering how Adam's instruction at the height of the mountain recalls Milton's argument against the pre-publication licensure of books in *Areopagitica*, another text with much to say about the postlapsarian instruction of Adam and his progeny, as well as a text that presents its greatest insights as being delivered from an elevated topographical location.[51] *Areopagitica* invokes the necessary mobility of the virtuous, the righteous readiness of the good to move:

> He that can apprehend and consider vice with all her baits and seeming pleasures, and yet abstain, and yet distinguish, and yet prefer that which is truly better, he is the true wayfaring Christian. I cannot praise a fugitive and cloister'd vertue, unexercis'd & unbreath'd, that never sallies out and sees her adversary, but slinks out of the race, where that immortall garland is to be run for, not without dust and heat.[52]

It becomes clear that the exercise of virtue demands a sallying out, a race in the dust and heat: the prime figure for spiritual excellence, and for right interpretation, is bodily movement through space. Furthermore, the famous textual crux of 'wayfaring' – which is, as here, usually emended to 'warfaring' – encapsulates the priority of spiritually-analogous movement in

50 Short, 90–1.
51 While I am interested in the text as describing the instruction of fallen humanity from atop an imagined hill, Stephen B. Dobranski sees in the presentation of the text as a speech, in the tradition of the Areopagites, both 'an interrogation of authorship' (113) and an emphasis on the cooperative efforts required to produce the material object of the tract: the title page and bibliographic nature of the work all hint at the associations and collaborations behind the published work (*Milton, Authorship, and the Book Trade* (Cambridge: Cambridge University Press, 1999)), 111–14.
52 CPW 2:514–15.

the context of a world slouching toward war.[53] The elision of 'wayfaring' by the ascendance of 'warfaring' in the centuries following *Areopagitica*'s publication makes visible the tension between an ambulatory virtue and a map of violent human history.

Later in *Areopagitica*, Milton revisits the urgent imagery of mobility, again in the context of seeking truth and spiritual ascent. The fallen world lies littered with the fractured pieces of truth; in order to reassemble those shards, one has to look at the fragments claiming to offer truth – though some will be reliable and others not. Only wide reading and a robust interpretive faculty will determine which is which.[54] Tellingly, the figure Milton chooses to illustrate this argument is a contrast of the mobile with the stationary.

> There is yet behind of what I purpos'd to lay open, the incredible losse, and detriment that this plot of licencing puts us to, more then if som enemy at sea should stop up all our hav'ns and ports, and creeks [...] ... he who thinks we are to pitch our tent here, and have attain'd the utmost prospect of reformation, that the mortall glasse wherein we contemplate, can shew us, till we come to *beatific* vision, that man by this very opinion declares, that he is yet farre short of Truth.[55]

To license and thus limit the movement available to the fit reader – the navigable havens and ports and creeks – is to impose a kind of rootedness, a lack of mobility. The one who seeks to settle, to pitch a tent in view of a prospect of reformation – even a prospect at the height of the highest hill in paradise – is one who is no longer willing to wander, to navigate

53 Ruth M. Kivette explores the warfaring/wayfaring issue at length in 'The Ways and Wars of Truth' (*Milton Quarterly* 6 (1972): 81–6), offering the wholly viable suggestion that the one word often implies the other, as in passage from *Animadversions* that describes 'Christian warfare' in terms of the military marching it requires.

54 At the start of his study of the interpretive reading techniques Milton articulates, David Ainsworth vividly describes the textual sea in which Milton's readers might find themselves adrift: 'For the seventeenth-century English reader, a crisis of faith might be one book or pamphlet away [...]' (1).

55 CPW 2:548–49.

through the world in search of truth. It is the person who is content to sit and, as John Hall warns, to travel only in folio.[56]

Milton's exhortation that we search for truth becomes not just part of a long convention of the metaphorically navigating soul, so popular in Christian tradition. In *Paradise Lost*, this is a literal injunction: navigate this world, and by steps – literally, by stepping one foot and then the other – ascend to God. Adam is given access to the divine map of time – but his ultimate obligation is the same action that makes the Son triumphant in *Paradise Regained*. He turns from the expansive panorama of human history and power, and walks in a world that is only imperfectly registered by even the most perfect map.

Indeed, the map Adam glimpses at the top of the mountain may be most divine in that it is most transparent about its dangers. After all, the map showcases its own horrific origins, and, as Michael's long-suffering tutelage of Adam shows, there is no ambiguity about the seductively erroneous ways of reading the map invites. The cartographic view, in alluring and repelling its viewer, finally succeeds in accomplishing the overarching pedagogical project of the poem as a whole: redirecting the fit reader to the world, demanding that the literacy learned in reading the map be applied in rigorous critique and interpretive labour.

The map Adam sees, and then descends from the mountaintop having seen, gives him a view of the brutal but ultimately spiritually triumphant course of human history, and then directs Adam to the world he must navigate in order to unleash this tide of time. The map shows him a route, but it is his walking that supplants the map as the spiritual work of a lifetime. In refocusing its narrative on the development of the spiritual subject, Milton's epic recasts the ethical imperative of the fit reader as a matter of spatial practice: the itinerary of movement and travel one undertakes in this lifetime bears real moral weight, and can even be indexical of spiritual

56 Travelling in folio, as Hall proposes, involves surveying the bibliographic terrain supplied by atlases: that is, collections of maps, or, as they were commonly described, 'mirrors of the earth'. There may be some light resonance between this earthly mirror and the Pauline 'glass' to which Milton alludes.

health – and this is a theme social movements, including, recently, Occupy Wall Street, have invoked.[57] But above all, it asserts that a life lived in the sort of radical liberty espoused throughout Milton's oeuvre cannot rely on representations of worldly power. Freedom – to fall or ascend – requires a nimble mind that moves constantly through the world itself, unenslaved to even the most seductive of images. Poetry – of the kind that can first mimic the map and then narrate its supersession by real-world movement and action – asserts itself as an urgent ethical force in the face of vast and rapid and underexamined technological change of any period.

And so we return to Milton, blind and searching for atlases he would never see, perhaps remembering the atlases he would have held in his hands during his European tour. There is a significant difference between these atlases of Milton's youth, possibly encountered in continental libraries, and the atlases he would have purchased in England in his maturing years. Premium atlases printed in sixteenth-century Europe tended to be produced from woodcuts; this printing process tends to leave, on the verso of each page, the tactile impression of the recto's woodcut image. The advent of copperplate engraving in England in the late sixteenth century, by contrast, made the printing of maps a smooth affair, without a tactile impression left on the verso. Milton would have witnessed, between the atlases of his youth and the atlases of his maturity, a flattening not only of the world represented, but of the physical artifact of the representation itself. Compare, for example, the 1568 *Bairische Landtafeln* of Apianus, with its woodcut maps appearing in an easily-felt negative on the reverse of each page; with Hondius' *Nouvel Atlas* of 1640 (printed by Jansson, another of whose atlases Milton would later ask Peter Heimbach to price for him), with copperplate-engraved maps that leave no textured impression on their versos. It is possible that blind Milton would have perceived, as his fingers walked over the pages, that the world was disappearing into

57 It is hard to ignore certain resemblances between the Occupy movement's strategies and preoccupations, and those of seventeenth-century groups like the Diggers or Levellers. Though, as Fenton notes, there is debate over how near or far Milton might have been from radical groups like the Diggers or Levellers, 'it is clear that Milton aligns issues of property with issues of liberty and equity' (154).

the increasingly flat image of the map, losing even the paper texture that made cartographic topography at least pretend to resemble the experience of the landscape it represented.[58]

Had Milton noticed this change, he might have responded with the same concern even Thomas Friedman, the twenty-first century's apostle of the metaphorically flat world, articulates near the end of a lengthy argument for the technologically-determined evening out of the modern world.[59] After acknowledging that 'I don't know how the flattening of the world will come out', he proceeds to 'make a deeper confession: I know that the world is not flat'. He lists 'war, economic disruption, or politics' as factors for unflattening the flattened parts of the world, and obstacles to flattening the unflattened parts.[60] Add 'violence, civil war, and disease' to the mix, and the concern – voiced by Bill Gates in a conversation with Friedman – is real that '"[...] it could just be half the world that is flat and it stays that way."'[61]

Within *Paradise Lost*, a flatness accompanies disaster. 'Flat' adjectively attaches only to the dangerous and fallen. The disgraced idol Dagon 'fell flat, and sham'd his Worshipers' (1.461); Belial describes 'flat despair' as 'our final hope' (2.143, 142), if the fallen angels seek another war with God; and Eve draws Adam into eating the fruit by explaining of her newfound sensory experience of the world 'that what of sweet before / Hath toucht my sense, flat seems to this, and harsh' (9.986–87). Yet the image of Milton running fingers over the flattened world of atlases grown complacent in the easy replacement of image for the world, brings to mind the flat world over which Satan imagines the Son unjustly reigns. Abdiel rehearses Satan's disgruntlement by way of rebuking the fallen angel: 'Flatly unjust, to binde

58 I am grateful to Susan Dackerman, Carl A. Weyerhaeuser Curator of Prints at the Harvard Art Museum, for suggesting the existence of this effect of the shift in printing technology, and for sharing her expertise when I examined these and other atlases Milton may well have encountered.

59 Thomas Friedman, *The World Is Flat: A Brief History of the Twenty-First Century*. Upd. ed. (NY: Farrar, Straus and Giroux, 2006).

60 *Ibid.*, 461.

61 *Ibid.*, 464–5.

with Laws the free, / And equal over equals to let Reigne' (5.819–20). Satan, as accurately ventriloquized in these lines by Abdiel, imagines the elevation of the Son to be unjust, and to be so specifically in the language of flatness. This flat injustice Satan would gladly arrange for himself, had he his druthers, and such is the government Satan would build on the work of his creeping, cartographic company, the army of rebellious angels whose scale is described to Adam by Raphael:

> ... Regions to which
> All thy Dominion, *Adam,* is no more
> Then what this Garden is to all the Earth,
> And all the Sea, from one entire globose
> Stretcht into Longitude; (5.750–54)

Satan's rebellion, likened to the transformation of the seas into a Mercator projection, will flatten the world, unjustly binding the free. The cartographic imagery of stretching into longitude is not accidental: the poem evokes the representational mode most capable of concealing its own artifice, and thus of making a claim for the seemingly natural political agenda it seeks to reify. Injustice and the map accompany one another, just as they accompany spiritual corruption, the works of Satan and the fallen angels, and the civil war in heaven.[62]

One wonders if the flattened world – in the atlases Milton inquired after long after his eyes had ceased to see – would have, in its tactile imperceptibility, have offered the final reminder that maps can blind more often than they illuminate, that the image of a flat world can conceal the very dramatic topographical variety of an emphatically unflat (geologically as well as socio-politically) world. The cartographic drive masks the violent history of place, exempting the reader from responsibility for agential political action.

62 Richard Helgerson famously argues that the maps of the late sixteenth and early seventeenth centuries presaged the civil war in England, too (332). 'The Land Speaks: Cartography, Chorography, and Subversion in Renaissance England', in Stephen Greenblatt, ed., *Representing the English Renaissance* (Berkeley: University of CA Press, 1988), 327–61.

So with Milton running his fingers across the invisible maps of a world unrevived by revolution, unrestored after his decades of screaming for liberty, let me return to the question with which I began: What good is the map you cannot see? In the vision afforded Adam at the mountaintop, in the haunting sight of angels massing like a mapped sea, perhaps there comes an answer: the map you cannot see is a reminder that any map can blind its reader. Without being read critically and interpreted rightly, the map obscures the journeys needed to construct it; it conceals the real and fragile and struggling people elided by the map committed only to showing the political power it instantiates. The map that cannot be seen demands its viewer to look, instead, at the world – not as it is imagined by monarchs or forged by the sword or dreamed by cartographers, but as it is made, everyday, by sin and poetry.

And maybe this is why our blind poet Milton collected atlases and kept them close, modeling for us in a dark world and wide what Adam and the Son model within the early modern English epic: a capacity to read precisely what is represented in the map, and a willingness to reject and repair the loss of liberty the map always already represents. Today, we have more powerful maps than Milton could have imagined, and they share the same troubling origins as the map Adam reads from the mountaintop. As a history of navigation from 1983 reports, 'The Navstar/GPS system [...] is being developed by the United States for military purposes' and 'would be primarily for weapon delivery systems' but might one day 'become available for commercial users',[63] though there is little evidence of this uneasy origin in the chirping dashboard GPS devices or blinking map applications on the smart phones that make such robust use of this fundamentally military technology. Geospatial Information Systems have produced a company of 'super-maps', spatial information matrices capable even of sensing the reader's presence and incorporating the reader's movements into their systems – though, even so, these still tend to elide those

63 J.B. Hewson, *A History of the Practice of Navigation* (2nd edition, Glasgow: Brown, Son & Ferguson, Ltd., 1983), 280–1.

tracked bodily movements in their user interfaces.[64] The constitutionality of GPS technology is challenged in high courts, and the bandwidth required by GPS delivery systems competes against that required for communication systems. The world is being mapped anew and with new precision in the twenty-first century, with effects as transformative and unsettling as those of the first cartographic revolution. In 2014, it may be time to revisit the early modern English epic, which sought to articulate how blind our maps might make us, and how we might still live with them, and beyond them.

64 Paul Carter calls for a new geography that restores the edited-out histories of passage, while also emphasizing those passages as techniques of knowing (20). *Dark Writing: Geography, Performance, Design* (Honolulu: University of Hawai'i Press, 2009).

BRENDAN DOOLEY

10 Keep This Secret! Renaissance Knowledge between Freedom and Restraint[1]

'Del ben vietato il desiderio cresce' – 'the forbidden joy holds irresistible allure' – Giambattista Marino has Sidonio remark to Adonis in his epic-length poem about desire and disaster.[2] By the time Marino began pushing the allowable limits of expression, both in his personal life and in his literary pursuits, attractive transgression was already a powerful topos of Renaissance culture. No young scholar needed any prompting from Ovid's advice to husbands that 'nitimur in vetitum, semper cupimusque negata' – 'we yearn to have what's been forbidden; we always want what's been refused'.[3] Already at the first encounter with the Latin Vulgate's fruit 'beautiful to the eye and of delectable aspect' young minds were faced with the tension between contemporary norms and their own behaviour. Just as potent as the urgings of body lust were the mental urgings of lust for knowledge. Not for trivial reasons, the 'libido sciendi' was a common theme in the confessional literature, in recognition of the human impulse to curiosity, especially regarding 'not necessary things', long before new instruments of communication exercised an incisive influence on mental patterns throughout Europe.[4] Rather than a debate between freedom and restraint, what the following examples will show, including some new

1 My deepest thanks to the members of the Book History seminar at the University of St Andrews, including Andrew Pettegree and Malcolm Walsby, for valuable suggestions as well as hospitality.

2 *Adone*, ed. Giovanni Pozzi (Milan: Mondadori, 1987), canto 14, octave 220.

3 *Amores*, ed. Edward J. Kenney (Oxford: Oxford University Press, 1961), lib. 1, eleg. 4.

4 The citation is to Guillaume d'Auvergne, *Opera omnia* (Venice: Zenaro, 1591), 283.

evidence about sorcery in grand ducal Florence, is a set of practices involving the strategic deployment of knowledge directed to protecting or inhibiting social innovation.[5]

After over a century of printing, carried on amid an increasingly dense forest of regulations, Tommaso Garzoni articulated the reasons why established authorities – political, religious and intellectual – should be worried about the spread of knowledge. Printing was, he opined, 'truly a rare stupendous and miraculous art. By it we are able to tell gold from lead, the rose from the thorns, the wheat from the chaff; we are made acquainted with the good as well as with the bad. Now we know the learned and we know the ignorant and all the world can see the difference. The darkness of ignorance is all gone. No more can lies be passed off as truths nor black be made to seem white. Everyone may give judgement concerning an infinite number of things about which, without printing, they would be unable to open their mouths to speak, much less judge.' Let the mighty beware, he warned. 'This is the art that indicates the fools, that exposes the arrogant, that makes known those who are learned [...] This is the art that gives fame to honourable persons, that scorns and vituperates the vicious, that buries

5 What follows mainly concerns the social aspects, and therefore it is only tangentially related to the current literature on curiosity, wonder, and natural knowledge methodologies, using collectionism and the exotic as the paradigmatic cases, on which, see J. Céard et al., eds, *La Curiosité à la Renaissance* (Paris: C.D.U. et SEDES, 1986); Krzystow Pomian, *Collectioneurs, amateurs et curieux: Paris, Venise: XVIe – XVIIIe siècle* (Paris: Gallimard, 1987); Justin Stagl, *The History of Curiosity: The Theory of Travel 1500–1800* (Australia: Harwood Academic Publishers, 1995); Lorraine Daston, 'Curiosity and Modern Science', *Word and Image* 11, 4 (1995): 391–404; Katharine Park and Lorraine Daston, *Wonders and the Order of Nature, 1150–1750* (NY: Zone Books, 1998); Nicole Jacques-Lefèvre and Sophie Houdard, eds, *Curiosité et Libido sciendi de la Renaissance aux lumières*, 2 vols (Paris: ENS éditions, 1998); Neil Kenny, *Curiosity in Early Modern Europe: Word Histories* (Wiesbaden: Harrassowitz, 1998); Idem, *The Uses of Curiosity in Early Modern France and Germany* (Oxford: Oxford University Press, 2005); Robert John Weston Evans and Alexander Marr, eds, *Curiosity and wonder from the Renaissance to the Enlightenment* (Aldershot: Ashgate, 2006); and I therefore take no position in respect to the general movement away from a previous historiography's narrative regarding emerging technologies.

dead brains in the depths of the earth, that exalts lively and sublime minds to the heavens. This is the art that is the mother of honours to the worthy and the house of shame to the unworthy.'[6]

Even without the benefit of modern book history scholarship, Garzoni appears to adumbrate perfectly the humanist mythology of printing, where mechanical agency supplies the chief explanation for outstanding human achievements in non-artisanal realms.[7] However, his words require careful scrutiny and interpretation before being pressed into service alongside the last generation of textbooks. There is no hint here that printing in some way 'made it possible for fresh findings to accumulate at an ever accelerated pace' or determined the confessional divisions of Christendom;[8] and the reason seems to have nothing to do with the ambiguities of a knowledge system comprised of mixed print and manuscript, or with the tendency of

6 Tommaso Garzoni, *La piazza universale di tutte le professioni del mondo* (Seravalle: Meglietti, 1605), 834. Not mentioned in Elizabeth L. Eisenstein, *Divine Art, Infernal Machine: The Reception of Printing in the West from First Impressions to the Sense of an Ending* (Philadelphia: University of Pennsylvania Press, 2011). The bibliography on censorship is too vast to give but a few suggestions. A key text for our purposes is Mario Infelise, *I libri proibiti: da Gutenberg all'Encyclopédie* (Milan: Feltrinelli, 2009). I was also informed by María José Vega, Julian Weiss, and Cesc Esteve, eds *Reading and Censorship in Early Modern Europe* (Bellaterra: Servei de Publicacions de la Universitat Autònoma de Barcelona, 2010) and María José Vega and Iveta Nakládalová, eds *Lectura y culpa en el siglo XVI / Reading and Guilt in the 16th Century* (Bellaterra: Servei de Publicacions de la Universitat Autònoma de Barcelona, 2012).

7 On the mythology of printing, see Andrew Pettegree, *The Book in the Renaissance* (New Haven: Yale University Press, 2010), 353; as well as Andrew Pettegree and Matthew Hall, 'The Reformation and the Book: A Reconsideration', *The Historical Journal* 47, No. 4 (2004), 785–808.

8 Elizabeth Eisenstein, *The Printing Press as an Agent of Change: Communications and Cultural Transformations in Early-Modern Europe* (Cambridge: Cambridge University Press, 1979), 1: 317–18. Concerning this work, Paul Needham, review of Eisenstein's 'The Printing Press as an Agent of Change', *Fine Print* 6, No. 1 (1980), 23–5, 32–5, and a general appraisal including subsequent work, Sabrina A. Baron; Eric N. Lindquist; Eleanor F. Shevlin, eds, *Agent of Change: Print Culture Studies After Elizabeth L. Eisenstein* (Amherst: University of Massachusetts Press, 2007).

books to disseminate knowledge as well as nonsense.[9] If errors, misperceptions, deliberate falsifications and so on went into the printer's office, and the same came out again, only in far greater quantities, with most readers unable to tell the difference, Garzoni seems oblivious to this.[10] Instead, as a respectable member of the Lateran canons and a theology teacher, one, in other words, whose profession bound him to deal with issues regarding the distribution of grace, and of much else, he focuses on the shifting distribution of knowledge between social classes and social groups.[11]

Garzoni's real point appears to be that knowledge and power are inextricably mixed, not only in the aspect of who has the power to decide what is knowledge, but also in the aspect that knowledge empowers the powerless and undermines the accepted framework regarding who gets what, when and how, i.e. the social and political order.[12] To be sure, his

9 Adrian Johns, *The Nature of the Book: Print and Knowledge in the Making* (Chicago: University of Chicago Press, 1998). Interesting is the AHR Forum entitled 'How Revolutionary was the Print Revolution', *The American Historical Review* 107, No. 1 (2002) moderated by Anthony Grafton and featuring some spirited sparring by Eisenstein and Adrian Johns.

10 Concerning English exceptionalism in the ability to tell truth from falsehood, Barbara J. Shapiro, *A Culture of Fact: England, 1550–1720* (Ithaca: Cornell University Press, 2000). The doubt-riddled continent is on the other hand explored by José Raimundo Maia Neto and Richard Henry Popkin, eds, *Skepticism in Renaissance and Post-Renaissance Thought: New Interpretations* (Amherst, NY: Humanity Books, 2004).

11 On Garzoni, see the entry by Ottavia Niccoli in *Dizionario Biografico degli Italiani* 52 (1999), as well as the Introduction to Tommaso Garzoni, *La piazza universale di tutte le professioni del mondo*, Paolo Cherchi and Beatrice Collina, eds (Turin: G. Einaudi, 1996).

12 Concerning empowerment, compare the insights of Peter Harrison, 'Curiosity, Forbidden Knowledge, and the Reformation of Natural Philosophy in Early Modern England', *Isis* 92 (2001), 265–90, who suggests that the discussion was largely dominated by the theological issue until well into the sixteenth century, at least in Britain. For other traditions, compare Eugene F. Rice, Jr, *The Renaissance Idea of Wisdom* (Cambridge, Mass.: Harvard University Press, 1958); and indeed, Gérard Defaux, *Le curieux, le glorieux et la sagesse du monde dans la première moitié du XVIe siècle: l'exemple de Panurge, Ulysse, Démosthène, Empédocle* (Lexington: French forum, 1982).

inferences were mostly suggestive, not conclusive. Just because censorship advances, directly or indirectly, the material interests of a particular political, professional or religious group, that does not conclusively prove this is its purpose, although such evidence may make a strong circumstantial case, even in respect to the various such systems still in place in some Western European states (qualified, to avoid equivocation, in some cases, as 'Censorship of Publications Board') or in the American communities where classics are banned in schools.[13] Cui prodest? Look at the composition of the board, the committee, the congregation, or what have you, and some part of the answer will occur to you. Long before Garzoni wrote, and long before the Index of Forbidden Books, even Boccaccio, arguably, no enemy of knowledge, reproved Eve for presuming to seek beyond her limits: not just because humans ought to mind their own business, but because the allowable limits differed by sex. Adding his own gloss to what he found in Genesis, Boccaccio characterized her challenge: 'the Enemy, envious of her happiness, impressed upon her with perverted eloquence the belief that she could attain greater glory'[14]

The theme of restraint regarding knowledge seems to be at least as deeply rooted in Renaissance culture as the theme of freedom. Humanist learning, Adriano Prosperi reminds us, excelled in skills of 'correction', 'emendation', 'refinement', in respect to texts as well as in respect to intellects.[15] When Juan Luis Vives wrote about 'the disciplines', he insisted on the 'cultivation of minds', something like the cultivation of plants using precision techniques, which separated humans from beasts and rendered

13 Consider Claudia Johnson, *Stifled Laughter: One Woman's Story About Fighting Censorship* (Golden, Colo.: Fulcrum Pub., 1994); Julia Carlson, *Banned in Ireland: Censorship and the Irish Writer* (Athens: University of Georgia Press, 1990).

14 Giovanni Boccaccio, *Famous Women*, ed. Virginia Brown (Cambridge, Mass.: Harvard University Press, 2001), 8; see Margaret Ann Franklin, *Boccaccio's Heroines: Power and Virtue in Renaissance Society* (Farnham: Ashgate, 2006), chap. 2.

15 Adriano Prosperi, 'La chiesa e la circolazione della cultura nell'Italia della Controriforma. Effetti involontari della censura', U. Rozzo, ed., *La censura libraria nell'Europa del secolo sedicesimo, Convegno internazionale di studi, Cividale del Friuli, 9–10 novembre 1995* (Udine: Forum, 1997), 147–61.

us pleasing to God, who gave us letters.[16] The discovery and diffusion of truths never went unaccompanied by the 'suppression' of 'error'. The Renaissance academies often employed an individual in the guise of a 'censor', responsible for vetting material to be presented for discussion or publication, eliminating what was not 'suitable'. Vincenzo Borghini was by no means the only academic who actually served a more public role as an official censor for the press.[17] Pedagogy too separated the few from the many, infusing minds, not with just anything, but with verified knowledge from trusted sources, carefully sifted and evaluated by the humanists.[18] Authors were not to be chosen at random, but from a list; and those from the 'good ages' were vastly preferred to those of the bad.

Knowledge themes adorned the walls and ceilings of Renaissance buildings; and where the dangers of knowledge were not specifically targeted in representations of the Fall of Man or generic human presumptuousness in the various depictions of the Tower of Babel, Icarus, or even Apollo and Marsyas, thematizations of knowledge seemed to indicate the closed circuit of Old Testament prophecies confirmed and fulfilled, as in Michelangelo's Sistine ceiling, by Christian history. Whether or not Raphael actually intended the Stanze della Segnatura frescoes to demonstrate 'how the theologians reconciled philosophy and astrology with theology, showing all the learned men of the world disputing in various ways', that was how Giorgio Vasari (somewhat confusedly, as it happened) understood the work, for reasons that went beyond the change of sentiment from the more free-wheeling early to the more orthodox later sixteenth century.[19] No doubt, the positioning of the 'School of Athens' on one wall opposite the

16 Juan Luis Vives, *De disciplinis libri xx* (Lyon: Jean Frellon, 1551), Praefatio.

17 In general, concerning Borghini, *Fra lo 'Spedale' e il Principe. Vincenzio Borghini, filologia e invenzione nella Firenze di Cosimo I. Atti del Convegno (Firenze, 21–22 marzo 2002)*, ed. G. Bertoli and R. Drusi (Padua: Il Poligrafo, 2005).

18 Paul F. Grendler, *Schooling in Renaissance Italy: Literacy and Learning, 1300–1600* (Baltimore: Johns Hopkins University Press, 1989), 118ff.

19 Giorgio Vasari, *Vite scelte* (Turin: Unione Tipografico-Editrice Torinese, 1948), 317.

triumph of Christianity on another wall announced an inherent ambivalence between discovery and revelation already in the original project.[20]

Even outside ecclesiastical precincts, the 'natural desire of mankind to know', viewed in a sinister light by champions of the thinking of St Augustine but prized by followers of St Thomas Aquinas, was hedged around by a thousand qualifications.[21] When Federico Cesi chose this Aristotelian theme as the rallying-cry for the new Accademia dei Lincei where Galileo was a member, he well knew that 'studiositas' had to be carefully distinguished from 'curiositas'. In addition, he knew 'studiositas' was not for everyone. His own pronouncements against contemporaries' attachment to outdated ideas gained particular force from having been uttered not by a common person but by the son of a prominent Roman nobleman whom Pope Paul V had elevated to a principate.[22] And the academy, just like the circle of Marsilio Ficino in Florence over a century before, would

20 Concerning the original project, in general, *Raffaello a Roma: il convegno del 1983*, Bibliotheca Hertziana, Max-Planck-Institut (Rome: Edizioni dell'Elefante, 1986); as well as Christiane L. Joost-Gaugier, *Raphael's Stanza della Segnatura: Meaning and Invention* (Cambridge: Cambridge University Press, 2002).

21 Federico Cesi, *Del natural desiderio di sapere*, in Ezio Raimondi, ed., *Narratori e trattatisti del Seicento* (Milan-Naples: Ricciardi, 1960), 39–70; and my *Italy in the Baroque: Selected Readings* (NY: Garland, 1995), 24. Concerning the theme in Antiquity and in St Thomas, P.G. Walsh, 'The Rights and Wrongs of Curiosity (Plutarch to Augustine)', *Greece and Rome* Second Series, Vol. 35, No. 1 (1988), esp. 84. In addition, Thomas S. Hibbs, 'Aquinas, Virtue, and Recent Epistemology', *The Review of Metaphysics* 52, No. 3 (1999), 573–94.

22 Giuseppe Olmi, '"In essercitio universale di contemplatione, e prattica": Federico Cesi e i Lincei', Ezio Raimondi and Laetitia Boehm, eds, *Università, accademie e società scientifiche in Italia e in Germania dal Cinque al Seicento* (Bologna: Il Mulino, 1981), 169–99; and Jean-Michel Gardair, 'I Lincei: I soggetti, i luoghi, le attività', *Quaderni storici* 16 (1981), 763–87; David Freedberg, *Eye of the Lynx: Galileo, His friends, and the Beginnings of Modern Natural History* (University of Chicago Press, 2002), and now, Andrea Battistini; Gilberto De Angelis; Giuseppe Olmi, eds, *All'origine della scienza moderna: Federico Cesi e l'Accademia dei Lincei* (Bologna: Il Mulino, 2007).

exist in a space where the spread of knowledge went accompanied by the development of institutions for disciplining the mind and body.[23]

In this light the printing press is simply one of a number of features of Renaissance knowledge, just as book censorship is only one of a number of features of Renaissance power. To understand fully the world of printed books, we view them in the context of the other means of diffusion at the disposal of the Renaissance writer. Marino's formulation now seems particularly apt: 'del ben vietato il desiderio cresce'. Book history also includes manuscripts and books not there; and the pressure exerted on minds and imaginations by a lack, an absence, a fictive presence, always accompanied the act of reading for knowledge. Controls on printing conferred a particular power on certain kinds of knowledge exactly by virtue of the prohibition, and recent work has uncovered a shady *demi-monde* of traffickers in the forbidden, including what in Elizabeth Eisenstein's terminology ought to be called 'scribal data-pools', whose livelihood depended on these appetites.[24] The aura of danger surrounding their operations, and the efforts

23 Andrea Zorzi, 'The Judicial System in Florence in the Fourteenth and Fifteenth Centuries', *Crime, Society, and the Law in Renaissance Italy*, ed. Trevor Dean and K.J.P. Lowe (Cambridge: Cambridge University Press, 1994), 40–58; concerning the Congregazione di Buon Governo, established by Clement VIII for establishing more state control, G. Santoncini, *Il buon governo. Organizzazione e legittimazione del rapporto fra sovrano e comunità nello Stato Pontificio, secc. XVI–XVIII* (Milan: 2002). On the myth of the Platonic Academy in Florence: James Hankins, 'The Myth of the Platonic Academy of Florence', *Renaissance Quarterly* 44(3) (1991), 429–75.

24 Eisenstein, *The Printing Press*, 518. Work on scribal data pools now includes a special issue of *Italian Studies* 66/2 (2011), ed. Filippo de Vivo and Brian Richardson, entitled 'Scribal Culture in Italy, 1450–1700', Roger Chartier, *Inscrire et effacer: culture écrite et littérature (XIe–XVIIIe siècle)* (Paris: Gallimard/Seuil, 2005); Harold Love, *Scribal Publication in Seventeenth-Century England* (Oxford: Clarendon Press, 1993); Adrian Armstrong, *Technique and Technology: Script, Print, and Poetics in France, 1470–1550* (Oxford: Clarendon Press, 2000); Antonio Castillo, *Escrituras y escribientes: prácticas de la cultura escrita en una ciudad del renacimiento* (Las Palmas de Gran Canaria: Fundación de Enseñanza Superior a Distancia de Las Palmas de Gran Canaria, 1997); Fernando J. Bouza Alvarez, *Corre manuscrito: una historia cultural del Siglo de Oro* (Madrid: Marcial Pons, Historia, 2001). Some contributions by François Moureau are left out only because they are mainly concerned with the eighteenth century.

of acquirers to elude persecution, become themselves part of the play of forces that created and reproduced relations of subordination.[25]

To explain why the age of printing seemed to coincide with the age of the occult, there is no need to suppose, with Alexandre Koyré, the presence of some basic credulity, later overcome.[26] Perhaps his thesis made more sense as a foil for the triumphant age of the open universe that followed, or as seen from the vantage point of the supposed triumph of modern disenchantment and industrial capitalism. According to Pamela Long, printing provided practitioners with an indispensable instrument not only for diffusing occult knowledge but for planting hints about other knowledge that could not be diffused: in other words, knowledge always involved also the judicious dispensing of ignorance. The authors themselves ventured to assert a role in defining the terms whereby divulgation of the highest concepts should or should not take place.[27] The results were mixed.

In his groundbreaking article on 'high and low' Carlo Ginzburg refers to the importance of strategic binaries in traditional thought patterns, which formed part of the earliest classifications of things for ordering experience and storing knowledge as well as the earliest outlooks concerning subject and object.[28] To that particular binary, along with the binary of ritual and normal time (Durkheim), raw and cooked (Levi Strauss) or pure and impure (Mary Douglas), we could add secrecy and openness in the realm of natural knowledge. The binary worked on multiple levels. What was 'secret' to one group might be regarded as vulgar and commonplace to

25 John Christian Laursen, *The Politics of Skepticism in the Ancients, Montaigne, Hume and Kant* (Leiden: Brill, 1992), 3, claims to address 'who can know, and when, how, and what they can know', although his analysis of politics appears somewhat oddly to exclude early modern experiences of power.

26 Concerning Koyré's somewhat puzzling view of the Renaissance, Paola Zambelli, *L'ambigua natura della magia: filosofi, streghe, riti nel Rinascimento* (Venice: Marsilio, 1996), 129.

27 Pamela O. Long, *Openness, Secrecy, Authorship: Technical Arts and the Culture of Knowledge from Antiquity to the Renaissance* (Baltimore: Johns Hopkins University Press, 2001), chap. 5.

28 Carlo Ginzburg, 'High and Low: The Theme of Forbidden Knowledge in the Sixteenth and Seventeenth Centuries', *Past and Present* no. 73 (1976), 28–41.

another group; so that notoriously, Trithemius warned Cornelius Agrippa only to publish those 'secrets' which were no secrets at all ('vulgaria vulgaribus, altiora vero et arcana altioribus atque secretis tantum communices amicis').[29] Appropriation of these, as of any other 'rare goods and practices' could then be regarded (in Pierre Bourdieu's model) as a privilege conceded on the basis of membership in a group.[30] The power of the distinction between secrecy and openness, like other divisions of knowledge, to enact distinctions between persons, especially in regard to differences in status and honour, was proven by its persistence across the centuries.

Giordano Bruno made no secret about his contempt for most contemporary thinkers, but the kinds of knowledge he wished to pursue were by no means meant for diffusion among the multitude. Hidden in the bosom of nature and drawn out by the techniques and genius of the inspired practitioner, this knowledge would be confusing to most, damaging to some, useful only to a tiny group of adepts. 'This burden', he said in print, 'is not fit for the shoulders of just anyone, but only for those able to bear it, such as the one from Nola [i.e. himself].'[31] Bruno and other adepts were well aware of the distinction between, on the one hand, the very obscure and valuable real secrets that only circulated in manuscript and, on the other hand, the so-called secrets that were printed as in the misleadingly entitled 'secreti' or secrets purportedly collected by a certain Alessio, a volume reprinted in over seventy editions across the period and containing everything from fertility enhancements to tooth whiteners, or even the so-called 'secrets' in a medieval collection which circulated under the name of Albertus Magnus and offered formulae for such operations as 'how to tell whether a woman

29 Heinrich Cornelius Agrippa von Nettesheim, *De occulta philosophia libri 3* (Lyons [=Basel?]: Beringen, 1550), letter dated 8 April 1510, included in the unpaginated prefatory matter.
30 Pierre Bourdieu, *Distinction: a social Critique of the Judgement of Taste*, tr. Richard Nice (Cambridge: Harvard University Press, 1984), 124.
31 Giordano Bruno, *La cena de le ceneri*, ed. Giovanni Aquilecchia (Turin: G. Einaudi, 1955), 22.

is a virgin'.[32] True secrets, those withheld from the many because of the dangers, might allow the adept to leverage fortune and destiny; and for the highest elite, there could be much to lose or gain. Bruno spectacularly miscalculated the limits of toleration in his own case and paid with his life; elsewhere the consequences of such intellectual brinkmanship varied according to circumstances.

In order to understand how the accumulation of books went accompanied by persistent patterns of secrecy in grand ducal Florence, rather than focusing on the grand dukes themselves, we turn to the borderlines of protection and favour where changing norms could be crucial, defining what was licit and what was not. Two interrelated cases exemplify the strategic deployment of practices regarding hidden realms of knowledge. Don Giovanni de' Medici was the natural son of Cosimo I, founder of the grand duchy; he is known to historians for his activities as a warrior-prince, architect and musician, as well as for his risky intellectual interests. Benedetto Blanis, Don Giovanni's librarian and much else, now the subject of a book by Edward Goldberg, was a prominent member of the Florentine Jewish community at the origins of ghettoization, with access to cabalistic traditions and Talmudic wisdom. Both were deeply interested in the life-changing potentialities of the occult – with tragically different outcomes.

Don Giovanni grew up at a Medici court steeped in occult interests, where his half-brother Grand Duke Francesco (even in the opinion of Montaigne) spent much time in an alchemical laboratory at the newly-built Casino di San Marco, and the painting by Giovanni Stradano (Jan van der Straet) on the wall of the study in Palazzo Vecchio shows Francesco himself

32 I cite from *Liber secretorum Alberti magni* (Antwerp: Johann Gymnicus, 1555), unpaginated, beginning of *Liber secundus*. In addition, *Secreti del reverendo donno Alessio piemontese nuovamente posti in luce. Opera utile, et necessaria universalmente à ciascuno [...]* (Venice: Sigismondo Bordogna, 1555), a work presumably by Girolamo Ruscelli. In this regard, William Eamon, *Science and the Secrets of Nature: Books of Secrets in Medieval and Early Modern Culture* (Princeton: Princeton University Press, 1994), 155.

in a tradesman's apron working at a stove.[33] He shared interests with his nephew Don Antonio, the putative son of Francesco and Bianca Cappello, who inherited and expanded the lab at San Marco, conferred with the mysterious glassmaker-priest Antonio Neri, possibly in order to procure, for his extensive library on all matters of the occult, precious manuscripts of Paracelsus supposedly containing material not in the printed works, and a notorious manuscript entitled *Donum Dei* containing alchemical *arcana* and instructions about the philosopher's stone.[34] Visitors at Palazzo Pitti in the time of Giovanni's other grand ducal half-brother, Ferdinando I, included Tommaso Campanella, on the run from the Inquisition in Naples; and in return for the invitation to discourse about occult subjects with an elite audience in Florence, he dedicated a philosophical treatise to the grand duke, later confiscated by the Roman authorities.[35]

Once established in his own personal palazzo in Parione, Giovanni built an alchemical laboratory on the model of Don Antonio's. The equipment was less elaborate but nonetheless serviceable. Among the more outstanding items of an inventory that included a wide array of glass beakers, alembics, tubes, brass pots, scales, grinding tools, pulverizers, and a small furnace (so the records specify), were the following: '4 large stills [orinali] for distilling', '4 large glass balls', '4 large separators', '4 pelicans [perlicani]' i.e. blind alembics.[36] The walls here were no less adorned than in Francesco's study in Palazzo Vecchio. There were reminders of scholars who had made

33 On what follows, Paolo Galluzzi, 'Motivi paracelsiani nella Toscana di Cosimo II e di don Antonio dei Medici: alchimia, medicina "chimica" e riforma del sapere', *Scienze, credenze occulte, livelli di cultura* (Florence: Olschki, 1982), 31–62. In addition, Luciano Berti, *Il principe dello studiolo* (Florence: Editore Edam, 1967); Montaigne, *Journal de voyage en Italie par la Suisse et l'Allemagne en 1580 et 1581*, ed. M. Rat (Paris: Garnier, 1955), 86.

34 P.F. Covoni, *Don Antonio de' Medici al Casino di San Marco* (Florence: Tipografia Cooperativa, 1892); Francesco Inghirami, *Storia della Toscana*, vol. 13 (Fiesole: Poligrafia Fiesolana, 1844), 154.

35 *Lettere*, ed. Vincenzo Spampanato (Bari: G. Laterza, 1927), 390. In addition, Luigi Amabile, *Fra Tommaso Campanella, la sua congiura, i suoi processi e la sua pazzia*, vol. 1, part 1 (Naples: Morano, 1882), 57.

36 Florence, Archivio di Stato, Pupilli [hereafter =Pupilli] 765, fol. 242r and following.

something of their studies: seven portraits of 'men famous for distillation', i.e. alchemists, done by Giovan Maria Casini, admittedly a better poet, comic actor, writer, singer, or lute player than a painter.[37] Giovanni apparently did not mind. All he wanted was to feel that Paracelsus, Albertus Magnus, Hermes Trismegistus, perhaps Zosimus, Morienus, and still others, might be staring down into whatever operation was going on. He did more than just look at the surroundings; he engaged with the learning and with the materials. One particular recipe he shared with Orazio Morandi elicited the enthusiastic comment, 'the method and procedure of that operation is the most precious gift that ever a great prince could bestow'.[38]

No list of his extensive library has survived, but the effort that went into shelving it for use and eventually boxing it for travel suggests the inventory must have run to the hundreds; and the correspondence mentions many dangerous items along with innocuous ones.[39] Texts of Cicero, Plautus, Tasso, Ariosto, stood next to authors represented on the Index of Forbidden Books, such as Paracelsus, the cabalist Johann Reuchlin, the

37 Pupilli 765, fol. 120r. Undated. 'L'Ecc.mo Sig. D. Giovanni Medici de' dare: Prima per sei ritratti di huomini illustri per estilatione fatti fino l'anno 1610 a suo ordine et con segniati alla sua persona a ducati tre luno = 18. E piu' per un altro ritratto nomato il paracellso di braccia dua in circa in aovato fatto con l'istesso ordine, e con segniato similmente ducati cinque.' A note identifies the sender as 'Giovan Maria Casini pittore.' Concerning Casini: Anna Maria Testaverde, '"Valente Pittore ed eccellente Poeta": Giovan Maria Casini tra drammaturgia e "primato della Pittura"', *Culture teatrali* no. 15 (2006), 15–33.

38 Florence, Archivio di Stato, Archivio Mediceo del Principato [hereafter =MdP] 5149, fol. 627r, 8 August 1615.

39 MdP, 5150, fol. 93r, Blanis to Giovanni, dated 16 October 1616: 'Mando a Vostra Eccellenza Illustrissima la nota delli libri et ho ben fatto adagio, ma anco poco bene, poichè non sono con l'intero ordine che io desideravo, e questo perchè la mutatione del luogo et anco per non entrare in manifattura di scaffali ci siamo valsi di alcuni scaffali che erano per la casa. [...] Lascio poi che molti titoli sono mezzi volgari e mezzi latini, però V.E.I. suplirà il tutto. [...] In tanto stanno benissimo conditionati e subito si vede il libro che un vole, un tavolino è in mezzo alla camera, i libri intorno che farebbeno venir voglia di studiare a chi non l'havesse già mai hauta. [...]'.

philosopher Bernardo Telesio.[40] The probate records include payments
made to the Giunti bookselling firm in Florence for the acquisition of still
other titles relating especially to alchemical studies: three volumes of the
Theatrum chemicum published in Strasburg by Zetzner, including works by
Gerhard Dorn, Bernardo Trevisan, Thomas Muffett along with Trithemius;
there was the *Praxis Alchimiae* of Andreas Libavius, the *Basilica Chymica*
of Oswald Croll.[41] When Cosimo Ridolfi, a Florentine nobleman with
occult interests, died, Don Giovanni engaged in a good-natured competi-
tion to acquire the library of exotic texts from the widow, which he lost to
fellow-occultist Orazio Morandi.[42]

His studies in occult matters had no discernible or recorded effect
on his hopes for a suitable career in Florence; more probably, they were a
symptom of an increasing estrangement.[43] His illegitimate birth inevitably

40 MdP, 5149, fol. 716r, dated May 1, 1620; here Orazio Morandi refers to books exist-
 ing in Giovanni's collection. Prohibited texts by these writers are discussed by Franz
 Heinrich Reusch, Der Index der verbotenen Bücher, 2 vols (Bonn: Max Cohen,
 1893), I: 497 (Paracelsus's *Libri tres chirurgiae*, 1573, and *Chirurgia magna*, 1570, both
 forbidden in 1583–4), I: 536 (Telesio's *De rerum natura* and other works, forbidden
 in 1596); I: 62 (Reuchlin's *Augenspiegel, Speculum oculare, De verbo mirifico*, and *Ars
 cabalistica*, prohibited in 1557).
41 Pupilli 765: 273v, message marked 'Giandonato e Bernardo Giunti, adi 4 di marzo
 1621 [but original date is 1609]:'L'Ill.mo et Eccmo Sig Don Giovanni Medici de' dare
 addi 26 di settembre 1609 per i sottoscritti libri hauti da noi; seno', il s. d. Orazio
 Morandi, cioe''. The work published by Zetzner is *Theatrum chemicum, præcipuos
 selectorum auctorum tractatus de chemiæ et lapidis philosophici antiquitate, veritate,
 iure, præstantia et operationibus, continens* ... (Strasburg: Zetzner, 1602).
42 MdP 5150, fol. 277r, letter dated 19 January 1619, where Blanis suspects foul play in
 the matter, but exonerates Morandi, considering him an honest man.
43 Concerning Giovanni's career, Gaetano Pieraccini, *La stirpe de' Medici di Cafaggiolo*,
 2nd edition, 3 vols (Florence: Vallecchi, 1947), vol. 1, 222ff; G. Sommi Picenardi,
 'Don Giovanni de' Medici, governatore dell'esercito veneto in Friuli', *Nuovo archivio
 veneto*, n.s. 7, 25 (1907): 104–42; 26 (1907): 94–136; and my 'Le battaglie perse
 del principe Don Giovanni', *Quaderni Storici* 115 (2004): 83–118. The biography
 of Don Giovanni written by his secretary Cosimo Baroncelli is still fundamen-
 tal, and it exists in numerous copies in Florence, among which, Archivio di Stato,
 Miscellanea Medicea, filza 833bis, insert no. 20; Biblioteca Nazionale Centrale, Codici

aroused certain prejudices within a dynasty striving for legitimacy on the European scene; there were other issues too. As a diplomat, he was replaced by career diplomats such as Belisario Vinta, regarded as more dependable; as an architect, he could scarcely compete with Bernardo Buontalenti; as an intellectual he was no match for Galileo Galilei.[44] His search for a generalship from the king of Spain, the king of France or the emperor was thwarted by the Medici dynasty's interest in avoiding any favouritism to any one of the three powers. His liaison with Livia Vernazza, the daughter of a Genoese mattress-maker and eventually his wife, was no help: it created problems of protocol on official occasions and difficult questions of succession in regard to any offspring.[45] Finally Giovanni left Florence altogether, accepting a generalship for the Venetian republic in Friuli, and there he brought Livia and many of his possessions. In Venice he lived as a prince in exile, revered by his hosts in Venice and untouchable by relatives increasingly vexed by the Livia matter. Here he might safely pursue his search for secret powers and enjoy the sweetness of his transgressions.

During his retirement from service Giovanni attempted to distil all his his years of study in a work to be entitled 'The Mirror of Truth', apparently a compendium of occult knowledge. In formulating the title, there is no way of telling whether he had in mind the treatise by the same name,

Capponi, no. cccxiii, fols. 180–212. Now see *Il discorso del Sig.re Cosimo Baroncelli fatto a' suoi figliuoli dove s'intende la vita di don Giovanni Medici*, ed. Marina Macchio (Florence: NICOMP, 2009). In addition, for the present paragraph, Alessandra Contini, 'Aspects of Medicean Diplomacy in the Sixteenth Century', in *Politics and Diplomacy in Early Modern Italy: the Structure of Diplomatic Practice, 1450–1800*, ed. Daniela Frigo, tr. Adrian Belton (Cambridge: Cambridge University Press, 2000); and Eadem, 'Dinastia, patriziato e politica estera: Ambasciatori e segretari medicei nel Cinquecento', *Cheiron*, special issue entitled *Ambasciatori e nunzi: figure della diplomazia in età moderna*, vol. (2001): 57–131. Concerning the general context, Franco Angiolini, 'Diplomazia e politica dell'Italia non spagnola nell'età di Filippo II', *Rivista storica italiana* 92 (1980), 432–69.

44 Concerning this aspect, my 'Narrazione e verità: Don Giovanni de' Medici e Galileo', *Bruniana e Campanelliana*, 2 (2008), 391–405.

45 On this episode, see my *Amore e guerra nel tardo Rinascimento: le lettere di Livia Vernazza e Don Giovanni de' Medici* (Florence: Polistampa, 2009).

concerning the philosopher's stone, signed by 'Joannis de Porta Claudorum', supposedly John Dee (from Cripplegate).[46] In any case, at 'six fingers thick' in quarto (according to Benedetto Blanis), his manuscript, replete with citations in Hebrew, would have been far longer than the latter treatise, which was more or less pamphlet-length.[47] Before his sudden death in 1621 he was already engaged with publication plans, and there were sheets from the printer containing elaborate diagrams, which he submitted for proofreading to his one-time rival in esoteric matters in Florence, Raffaele Gualterotti. How far along he was before he had to abandon the work, we do not know, since nothing has survived.

In this project, as well as in many other occult enterprises of Giovanni, Benedetto Blanis was in some way involved, as his voluminous correspondence with Giovanni suggests. The two men's paths seem to have crossed some time before June 1615, but in exactly what context, whether commercial or otherwise, we do not know. Blanis may already have acquired a reputation for esoteric knowledge, although the only evidence comes from his later report to Giovanni about being solicited for an incantation by the grand ducal secretary Camillo Guidi.[48] Eventually, in esoteric matters, he became Giovanni's factotum. He supplied a knowledge of the Hebrew language, of which he eventually became an instructor to the Medici court, and which Giovanni required for studies involving Christian and Jewish cabala. He also provided access to the networks along which manuscripts containing occult wisdom circulated within the Jewish community in Florence. Although the occult supplied a lever for him to move into court circles

46 Cambridge University Library, ms. Dd.4.45 (=220); see *A Catalogue of the Manuscripts Preserved in the Library of the University of Cambridge*, Volume 1 (Cambridge: Cambridge University Press, 1856), 242.

47 MdP 5159, fol. 679r–680v. Edward L. Goldberg, *Jews and Magic in Medici Florence: the Secret World of Benedetto Blanis* (Toronto: University of Toronto Press), 2010), chap. 9.

48 MdP 5150, fol. 11r, 21 July 1615; see Edward L. Goldberg, *Jews and Magic*, 18. The letter is also translated in Goldberg, ed., *A Jew at the Medici Court: The Letters of Benedetto Blanis Hebreo (1615–1621)* (Toronto: University of Toronto Press, 2011), 6–7.

and escape the increasingly claustrophobic and meticulously regulated environment of the newly created Florentine ghetto, the risks were great.

The effort to satisfy Giovanni's appetite for the forbidden involved Blanis in a number of highly dangerous moves even outside the realm of the occult. Acquiring the complete works of Rabelais, for instance, he could be accused of defying the 1564 Index, where the author's name was included among those whose entire oeuvre was proscribed.[49] The same went for works by 'Raymundus Neophytius', not to be confused with Raymond Llull, and particularly notorious because of a *Liber de daemonium invocatione*, on the invocation of demons. He was only slightly safer in dealing with works by Cornelius Agrippa, now best known for *De incertitudine et vanitate scientiarum*, on the uncertainty and vanity of the sciences, but in his own time known for works on magic, astrology and alchemy, which circulated in a grey area of semi-toleration because the prohibition by the University of Louvain, pronounced in a period before there was any Roman Index, was regarded as indicative in Catholic countries but not binding.

Blanis knew as well as Giovanni that manuscripts from a security standpoint possessed the advantage of not being printed books; and the many ways to disguise them and keep them from detection, in spite of frequent efforts to control them, gave them a value all their own, as forbidden merchandise. Accordingly, within the prohibited underground there circulated a so-called 'book of Raimondo regarding the secrets of the Lapis' – purporting to be a treatise by the prohibited 'Raymundus' about how to make the philosopher's stone, a panacea for maladies as well as an aid for accomplishing extraordinary exploits.[50] An overlap between the real works of Llull and the spurious ones by 'Raymundus' was the inter-

49 On Blanis and Giovanni's books, Goldberg, *Jews and Magic*, 119.

50 MdP 5150, fol. 221, dated 20 December 1620: 'Qui si trova un amico che si ritrova la quarta parte di Cornelio in penna et hora gli replico che qui si trova un libretto in lingua hebraica carattero rabinico intitolato libro di Raimondo sopra li secreti del lapis, e per quello ho potuto brevemente vedere mi pare che sia la chiave d'un altro libro scritto dal detto Raimondo non so a dire; nel quale mostra havere in quello scritto in cifera et occultamente e che questo sia la chiave e dichiaratione di tutta quell'opera et è opera breve.'

est in cabala, or the adaptation of Jewish cabala to Christian cabala; and therefore the use of Hebrew characters among other characteristics. So for supplying a copy of pseudo-Llull's work on the philosophers stone, i.e. a handwritten copy from one of the manuscripts in circulation, Benedetto Blanis's knowledge of Hebrew and of cabala came in handy.

For the seeker after curious books, spurious works could hold a particular attraction because of the air of mystery surrounding them. Another spurious work sought by Blanis for Giovanni was supposed to be by Cornelius Agrippa. His *De occulta philosophia* was printed in Paris in 1531 and Cologne in 1533, Lyon in 1550, etc., and circulated widely. It was divided into three books covering everyday magic, number magic and demonic magic. A fourth book on the very dangerous topic of ceremonial magic by an unknown author was attributed to him; and this was first printed in the Lyon 1550 edition with the rest of the other three books, but it took on a life of its own. The circulation in manuscript enhanced its value within the underground of the curious – but when Blanis made a copy of it, we do not know whether he utilized the 1550 printed edition or another manuscript. In any case on 10 February 1619, he writes, 'I immediately arranged to see the fourth book of Cornelius. I have already gotten my brother Salamone to begin copying it and we will copy it entirely before I return the original.'[51]

Not all went as planned. Salamone turned out to be insufficiently skilled so Blanis looked elsewhere – unfortunately, with disastrous results. 'I wanted that book by Cornelio (i.e. Agrippa's spurious fourth book) to be copied quickly and well', he wrote to Giovanni; 'So I passed it on to a priest who is a friend and confidant of mine; however he brought it back to me on Saturday morning after copying only five pages and he made a scruple of it – telling me that he needed to confess to the inquisitor and ask his permission to continue. Unfortunately, my brother (Salamone) doesn't know Latin and even if I read out loud what he needs to write, it

51 MdP 5150, fol. 237r, dated 10 February 1619. The letter is transcribed in Goldberg,
 ed., *A Jew at the Medici Court*, 189–90. Goldberg, *Jews and Magic*, chap. 10.

is difficult for him to avoid errors. I will however think of the way to do what needs to be done as expeditiously as possible.'[52]

Copying the tree of the Sephiroth, a key image belonging to both Christian and Jewish cabala, on the other hand, went without any mishaps. The fine drawing on vellum would serve as a mnemonic device enabling the seeker to contemplate, as Agrippa recommended in his Third book, the process of Creation, the powers in the universe and the path to God, with a view to drawing from this contemplation 'new virtues from above' as he had already announced in Book One.[53] To serve as a model Blanis procured a version from an acquaintance in Lippomano outside Florence. Since the image has not survived, there is no way of telling whether or not it relied on the printed tradition, such as the striking frontispiece to Paolo Riccio's Latin translation, published in Augsburg in 1516 as *Portae lucis*, of a work by the fourteenth-century Spanish cabalist Joseph Gikatilla, with the Latin translations of the ten branches in the tree on the opposite side of the page.

To supply Giovanni with what could be had from the shrinking inventory of real secrets beyond the increasingly capacious world of printed text – secrets, in other words, unlike those revealed and published in a public forum which were hardly worth the name – Blanis reached into his circle of acquaintances. A certain 'Dr. Samuel from Fez', called by a surname variously reported as 'Caggesi', 'Hagges', etc., seemed to possess the necessary requirements of magical knowledge, imagination and daring.[54] Giovanni had already met him on some occasion in Don Antonio's laboratory, so no introduction was necessary. Blanis assisted this magician in performing an elaborate ritual combining geomancy, hydromancy and ichthyomancy, whose details the magician revealed not all at once but over a certain period,

52 MdP 5150, fol. 250r, 24 March 1618; see Goldberg, ed., *A Jew at the Medici Court*, 193–5.
53 Agrippa, *De occulta philosophia*, book 3, chaps 10–11. Also note book 1, chap. 1: '[...] Non irrationabile putant Magi, [...] non solum his viribus, quae in rebus nobilioribus praeexistunt, fui posse, sed alias praeterea novas desuper posse attrahere.'
54 For what follows, apart from the sources mentioned, Goldberg, *Jews and Magic*, 132–8.

ensuring that the seekers (Blanis and Don Giovanni) would never possess more than isolated elements of a secret known in its entirety only to the practitioner.

Also unmentioned in the instructions but well known to all involved, was that the location had to be in some remote area out of view of the Inquisitors, since ceremonial magic was strictly regulated. Contravening Pope Innocent VIII's bull *Summis desiderantes affectibus*, sent to all the churches and included as a preface to the *Malleus maleficiarum* compiled by the Dominican inquisitor Heinrich Kramer at the height of the witch craze, might have serious consequences, however honest the intention might be. Most studiously to be avoided (according to the bull) was the eventuality of being confused with the '[m]any persons of both sexes, unmindful of their own salvation and straying from the Catholic Faith', who in Pope Innocent's view had 'abandoned themselves to devils, incubi and succubi, and by their incantations, spells, conjurations, and other accursed charms and crafts' committed 'enormities and horrid offences'.[55] And in case anyone had forgotten the 1484 bull, Sixtus V issued the bull *Coeli et terrae creator* in 1586, 'against those who exercise the art of judicial astrology and any other sort of divination, sorcery, witchcraft or incantations', explicitly because of the implications regarding free will.[56]

In the first years of the seventeenth century, natural philosophers had to defend more than ever the distinctions so carefully made by Marsilio Ficino and others in the fifteenth century, and contested by Pico della Mirandola, between execrable demonic magic and the magic of the legitimate practitioner. Not long before Blanis began his ceremony, Giambattista Della Porta, among other things founder of an academy 'of Secrets', who was accused of 'demonomania' by no less an adversary than Jean Bodin, and persecuted by the Neapolitan inquisition, produced a second edition of his

55 Alan Charles Kors and Edward Peters, eds, *Witchcraft in Europe, 400–1700: A Documentary History* (Philadelphia: University of Pennsylvania Press, 2000) 180.
56 *Bullarium romanum* (Turin: Franco et Dalmazzo, 1857–72), VIII, 646–50; and see Zambelli, *L'ambigua natura della magia*, 158.

On Natural Magic less friendly to demons.[57] The Florentine inquisitor in Blanis's time gave specific instructions regarding the evidence of sorcery: 'If writings or other materials related to sorcery are found, they must be burned after you conclude the case against the principal and his accomplices.'[58]

Not everyone in the Medici orbit was equally vulnerable to the thrills of the forbidden and the lure of the occult. At the University of Pisa, in these years, a transplanted French scholar with Medici connections, named Jules César Bulenger, wrote a series of treatises discussing the current state of research 'On the Casting of Lots' and 'On Auguries and Soothsaying'. The treatment was essentially historical, but the conclusion referred very obviously to current circumstances. 'There were many absurd and inane things in the old superstitions', he pointed out.[59] For instance, 'divination by examining entrails was vain and ridiculous, and there was nothing reasonable about it'.[60] While dutifully accounting for all the forms of divination mentioned in the ancient sources, he warned, 'there was nothing more absurd and inane than the notion that any good or evil to humans could be predicted from the chirping or flight of birds, from the peeping of mice, from the movement of serpents, dogs or weasels'.[61] If no other proof was convincing enough, the enormous variety in the kinds of divination from time to time and from place to place should itself indicate that the practice had nothing to do with nature itself, which was always and everywhere the same. And even if there might be any truth in the matter, 'sacred writings forbid all forms of augury'.[62]

57 On Della Porta, see the entry by Raffaella Zaccaria in *Dizionario biografico degli Italiani* 37 (1989): 170–8; as well as Maurizio Torrini, ed., *Giovanni Battista Della Porta nell'Europa del suo tempo: Atti del Convegno* (Naples: Guida, 1990).

58 Goldberg, *Jews and Magic*, 186.

59 Jules César Bulenger, *De sortibus*, chap. 6. Read in the edition in Johannes Georgius Graevius, ed., *Thesaurus antiquitatum Romanarum*, 12 vols (Leyden: Halma and Van der Aa, 1694–1699), vol. 5, where the entire work is between pp. 361 and 404. Bulenger also produced *De serenissimae Medicaeorum familiae insignibus et argumentis* (Pisa: Fontana, 1617).

60 *De sortibus*, chap. 7.

61 *De sortibus*, chap. 6.

62 *De auguriis et auspiciis* (405–40 in Graevius, vol. 5), lib. 2, chap. 1.

Nonetheless, according to the instructions relayed by Blanis, the microcosm and the macrocosm could be joined magically in preparing a site for putting questions and receiving answers. The four Aristotelian elements must be represented. In and around a pool or pond of water five hollow poles were to be plunged into the earth. The pond was to be stagnant, filled neither by a spring nor by the artifice of the practitioner, with a stand of trees before it, presumably to add some shade. The bottom had to be of mud and earth: no rocks or bricks to disturb the view down from the surface. Size was important: at least 1⅓ *braccia* all around and a *braccia* deep (*braccia* standing for a unit of measurement of just over two feet). In the event, Blanis found a suitable location: 'the place that was found according to his specifications he praised as being perfect for his purposes – 9 *braccia* around, over 1½ *braccia* deep, with the bottom as he wanted'.[63] To this place, the spirits, and in particular a familiar known as 'Hlechamar', were eventually to be summoned.

As his site took shape according to the magician's instructions, Blanis revealed new symbols whose meaning challenged the intelligence of even the most learned seeker. He arranged the poles with one in the centre of the pond and the other four equidistant around a perimeter drawn one-half *braccia* away from the pond's circumference. He then connected the poles by a length of red thread drawn out at ground level, as follows: from a pole on the circumference to the pole in the centre, then from the one in the centre to a second pole, from the second pole to the third pole, from the third pole to the centre, from the centre to the third pole, from the third to the fourth, from the fourth to the centre, from the centre to the fourth, from the fourth back to the first, and from the first to the centre and then from the centre to the second. Thus was formed a square within the circle of the pond, crossed by two diagonals and missing one side (between poles one and two), making three triangles. Every pole was connected to every other by the red thread (in some cases, only by the mediation of the centre pole), but if this thread refers to the thread that appears in the purification rituals in Leviticus, or the healing rituals in Agrippa, there is

no explicit indication.[64] On successive days, another red thread was to be drawn out at the level of the middle of the poles, forming the same three triangles, and yet another thread at the tops of the poles, forming the three triangles once again.

If 'trinity' was the theme here, there was plenty of material in Agrippa on the topic: 'The number of three is an uncompounded number, a holy number, a number of perfection', he says; indeed, 'a most powerful number.'[65] He went on, 'this number conduceth to the Ceremonies of God, and Religion, that by the solemnity of which, prayers, and sacrifices are thrice repeated'. Again, 'the whole measure of time is concluded in three, viz. Past, present, to come; All magnitude is contained in three; line, superficies, and body, every body consists of three Intervals, length, bredth [breadth], thickness. Harmony contains three consents in time, Diapason, Hemiolion, Diatessaron. There are three kinds of souls, Vegetative, sensitive, and intellectuall.' What was more, 'saith the Prophet, God orders the world by number, weight, and measure'. If Agrippa had the Holy Trinity of Christian belief in the back of his mind, such concerns could by no means have been latent in mystical writings with which he, and certainly people in Blanis's environment, would have been conversant, such as the ancient Hebrew text called *Sepher Yetzirah* or *Book of Formation*, where God, pronouncing the combinations and permutations of the three letters of the Divine name, seals the universe in six directions.[66]

We pass over an early test run of the site, and an early version of the suffumigations that were to be made in the five hollow poles, involving only burning coriander. At this stage, once the air around the site had been filled with the perfume, the pool could be read for the first questioning. Blanis reported: 'there will be the appearance of the fish, which one can consult and it will respond'.[67] If this was a case of hydromancy, which

64 Agrippa, *De occulta philosophia*, book 1, chap. 48. Compare Leviticus 14–16.

65 Agrippa, *De occulta philosophia*, book 2, chap. 6.

66 *The Book of Formation, or Sepher Yetzirah*, Akiba ben Joseph; Knut Stenring; R.A. Gilbert; Arthur Edward Waite; H. Stanley Redgrove, eds (Berwick, Me: Ibis Press, 2004), chap. 1.

67 MdP, 5150, fol. 71r, 6 February 1616.

comprehended any sort of divination where water was involved, there was a precedent not only in Don Giovanni's own practice (as the crystal ball in his laboratory bore witness), but also in the ancient sources ranging from the divining cup used by Joseph in Genesis 44:5 to the water gods summoned by Numa Pompilius in Varro's fragment *De cultu deorum*.[68] Cornelius Agrippa, relying on ancient sources, connected hydromancy with ichthyomancy, divination by fish; indeed, 'hither also may be referred the divination of Fishes, of which kind there was use made by the Lycians in a certain place, which was called Dina, neer the Sea, in a Wood dedicated to Apollo, made hollow in the dry sand, into which, he went to consult of future things'.[69] Blanis was apparently satisfied enough at this stage to continue receiving instructions.

After the test run, Blanis, following the instructions of his magician, proceeded to the mature version of the ceremony. In this version, the five hollow poles would each contain seven burning spices. Such a mix, accompanied by the approprate incantations (in Arabic, specifies Blanis), could work not only to draw down the spirits but also to attract the influence of the seven planets, Sun, Moon, Mercury, Venus, Mars, Jupiter, Saturn. Each planet referred to a particular odour, said the most famous magical text of the time, the *Ghayat al-hakim*, dating from the twelfth century and known in Renaissance Europe by its Latin name *Picatrix*.[70] Among the substances in the mix prepared by Blanis, only one was specifically recommended in

68 Marcus Terentius Varro, *Varros Logistoricus über die Götterverehrung (Curio de culto deorum) Ausg. und Erklärung der Fragmente von Burkhart Cardauns*, ed. Burkhart Cardauns (Würzburg: K. Triltsch, 1960): 'Quod ergo aquam egesserit, id est exportaverit, Numa Pompilius, unde hydromantiam faceret, ideo Nympham Egeriam conjugem dicitur habuisse.'

69 Agrippa, *De occulta philosophia*, book 1, chap. 57.

70 *Picatrix: Das Ziel des Weisen von Pseudo-Magriti*, tr. Hellmut Ritter and Martin Plessner (London: Warburg Institute, 1962), book 1, chap. 2. Concerning this work, Willy Hartner, 'Notes on Picatrix', *Isis* 56, No. 4 (1965), 438–51. On the Renaissance fortunes, Paola Zambelli, *Magia bianca magia nera nel Rinascimento* (Ravenna: Longo Editore, 2004), Introduction and chap. 1. Also available in English translation, entitled *White Magic, Black Magic in the European Renaissance*, tr. by various (Leyden: Brill, 2007).

the *Picatrix*, namely, pepper, characteristic of Mars, due to the affinity with 'hot things'; two others in the mix, namely, mastic and benzoin, could relate to what the *Picatrix* stated as Saturn's affinity with 'fetid things'; there is no telling whether the other substances somehow related to the affinities of the other planets: Jupiter and the Sun with everything even and good, Venus with the strong and sweet, Mercury with the composite, the Moon with icy things.[71] Though not mentioned in the *Picatrix*, at least three of the remaining spices in the mix – coriander, mastic and *almea* [i.e. storax bark] – were standard magical ingredients, considering that they could instead be found in the *Book of Raziel*, a late antique or early medieval text purported to have been revealed by the angel Raziel and, according to tradition, given to Adam and Eve in recompense for the loss of knowledge following their expulsion from the Garden of Eden, to the great annoyance of the other angels.[72]

The timing of the ceremony pointed once more to the Sephiroth image sought by Blanis, and the divine act of creation. Hlechamar, the earth spirit, he reported, was related to the heavenly orbs, created on the Fourth Day according to Genesis: namely, a Thursday. Since the point of the whole exercise was to harness the creative powers in the cosmos (a recurrent theme in Agrippa, in Neoplatonism, and in Jewish mysticism), the ceremony would have to take place on a Wednesday, in preparation for a result on the following day. That Blanis's magician was expecting to recover from an illness on that day after having had to cancel an appointment for the previous Sunday, could thus be regarded not only as opportune but as providential. The astrological significance was not to be overlooked: the presence of, say, Jupiter, the 'king' of the planets, in the ascendant, could

71 *Picatrix*, book 3, chap. 3.

72 On the book, Stephen Skinner and Don Karr, *Sepher Raziel, Also Known as Liber Salomonis: a 1564 English Grimoire from Sloane MS 3826* (Singapore: Golden Hoard Press, 2010). On the tradition, A.G. Avilés, 'Alfonso X y el Liber Razielis: imágenes de la magia astral judía en el scriptorium alfonsí', *Bulletin of Hispanic Studies* 74, Number 1 (1997), 21–39.

have favourable effects, and so also could the phase of the moon, especially if waxing.[73]

Passing weeks turned into passing months, and the inconclusiveness of the proceedings frustrated even Blanis. He naturally blamed the magician rather than the magic, this being the aspect where he was more comfortable passing judgments. The 'prattle and procrastination of that man' became irksome as he began considering that Giovanni's initial diffidence, based on first impressions from a brief meeting months before, had in fact been well-placed.[74] He stops short of calling Dr Samuel a fake or a charlatan. After all, who was to tell? Blanis knew as well as anyone else that magic was an empirical activity, indeed, an experimental one. Though he was no Kepler, nor any of the other masters of observation and of the occult studied by Lynn Thorndike and others as examples of the mutual influence between two bodies of premodern knowledge, he was well aware that verification could come only by trial and error. The failure with Dr Samuel would only lead to other attempts based on other principles.

Blanis was free to pursue his occult interests with impunity as long as he enjoyed the powerful protection of his princely patron. Things began to change after summer of 1619, when Don Giovanni finally married Livia Vernazza, the daughter of a lowly Genoese mattress-maker, thus incurring the strong resentment of Grand Duke Cosimo II along with that of the grand duchesses Maria Maddalena and the dowager Cristina of Lorraine.[75] Blanis was suddenly reminded that he was no noble dilettante himself but the servant of one. While Giovanni began to turn attention to the wife and child and the Medici family began conceiving strategies for dividing the new couple, the Inquisition began closing in on Blanis.

The Inquisition's mild curiosity in April 1619 thus turned serious by the following February 1620; and allegations about encouraging Jewish converts

73 MdP 5150, fol. 71r, 6 February 1616.
74 MdP 5150, fol 123r, 9 April 1616. On 'prattle', MdP 5150, fol. 81r, 27 March 1616. I borrow Edward Goldberg's translation in *Jews and Magic*, 136.
75 Concerning the approaching end, my 'Donna Livia's New Clothes', in Assonitis, ed., *The Medici and their Archive: Power and Representation in Early Modern Tuscany* (Rome: Viella Editore, 2014).

to convert back to Judaism formed a pretext for a more general investigation into Blanis-related matters by the Magistracy of the Eight responsible for discipline in the Florentine Ghetto. Blanis wrote to Giovanni: 'my house is full of policemen who are searching through all of my writings and letters and taking them away. I don't know if they are going to seize other things as well.'[76] Once again, because of his connections, he got off with a warning. Finally in April of the same year due to more allegations of the same kind, he was clapped in irons, and he wrote to Giovanni, obviously attempting to develop a future defence: 'if the tribunal calls me to account for the time I spend in your Excellency's company reading, writing and virtuously studying holy Scriptures you might do well to bring that most precious book the Mirror of Truth which publicly demonstrates the veracity of all I say. In those printed pages of scholarly doctrine full of Hebraic, Greek and Latin writings, they will see how you and I passed our time.'[77]

Don Giovanni died in July 1621 without ever having been asked about his occult interests. Nor was he in the slightest way implicated when suspicions began circulating about possible magic involved in the illness and death of Grand Duke Cosimo II back at the beginning of that year.[78] In spite of the changing intellectual climate between the age of Cosimo I and the age of the grand duchesses Cristina of Lorraine and Maria Maddalena, Giovanni inhabited a space where status was to some degree defined by the ability to pursue forbidden knowledge undisturbed; and where the only barrier to the extent of the pursuit was possible punishment from God. When his possessions were transferred to Florence under the guidance of the Florentine ambassador to Venice, the ambassador wrote back

76 Goldberg, *Jews and Magic*, 195, translating from MdP 5150, fol. 364r, 3 February, 1620.

77 Goldberg, *Jews and Magic*, 222, translating from MdP 5150, fol. 391r, 26 September 1620.

78 Benedetto Blanis's brother Salamone also wrote to Giovanni, reporting about rumors in the ghetto that a spell had been put on Grand Duke Cosimo II, who was gravely ill: and a certain monk asked the spirits who had done it, and they replied, his mother Grand Duchess Cristina of Lorraine. Goldberg, *Jews and Magic*, 223, translating from MdP 5150, fol. 31r, 3 October 1620.

to the Florentine secretariat these words calculated to flatter the spiritual conformism that had begun to pervade the court: 'In a cabinet there were found things which I am sorry to have to send back, considering their effect on the reputation and the memory of His Excellency: there is a quantity of writings about superstitious matters, and I do not know what sort of Cabala or Magic, or maybe both; but the little I saw impressed me as being very nasty and fit to contaminate any person.'[79]

Blanis, on the other hand, as a consequence of Giovanni's death, was thrust back into the margin between legality and illegality, with an emphasis on the latter. Although never actually accused of sorcery, the threat of an accusation was held over him for as long as he remained in Florence. There was no need to proceed formally in the matter. With various other cases pending against him he was a valuable witness in the court proceedings aimed at dissolving Livia Vernazza's Medici marriage and dispossessing the widow and the orphan. In return for more lenient treatment in a variety of indictments at various stages of preparation, he was called to testify that Livia's Medici marriage was procured under false pretenses and her annulment from a previous marrage was invalid. As soon as something like the required testimony was elicited, Blanis was returned to prison and the accusations against him were developed in new directions.[80] Tortured regarding his involvement in yet another case of Jewish converts relapsing into Judaism, he refused to supply the requested confession; instead he was required to pay a security bond in assurance that, once out of jail (which was not to be soon), he would be available for further indictments. In return for formal closure of the current proceedings against him, he applied for exile in the year 1627 and accordingly left the state.

The persecution of Benedetto Blanis, and of others similarly involved in the world of the occult, was significant well beyond the specific issues in dispute. And in drawing attention to the boundaries between licit and illicit, open and secret, between freedom and constraint, such cases served as powerful reminders about the social dimension of knowledge that often

79 MdP 3007, fol. 388r, Sacchetti to the grand ducal secretary, dated 18 September 1621.
80 Goldberg, *Jews and Magic*, chap. 13.

went unexpressed. Verified or not, knowledge became operative inasmuch as it was shared, appropriated, hidden, or deployed. Since the varying kinds and degrees of knowledge mapped onto the varying kinds and degrees of people, every regime had a vested interest in ensuring that the boundaries remained in place. However, the very nature of knowledge as an activity of verification guaranteed the persistence of conflict; and conflicts of knowledge spilled over into conflicts in society.

Empowerment from knowledge remained a basic theme in Western epistemology well beyond the Renaissance, as did the theme of knowledge as a revealing of secrets, often those which nature itself keeps most concealed. No doubt, research on natural phenomena was often conceived as a *venatio*, i.e. a search or a hunt aimed at bagging that elusive quarry, the natural fact. Nature was no more passive in this quest than were the researchers. At the height of the Enlightenment, Lazzaro Spallanzani, speaking of a certain process in biology, refers that 'assimilation is still one of the secrets that nature has not wished to reveal to us', implying that there were still other secrets that nature wished to keep for itself – although, tellingly, he seems to think that the quantity of secrets is finite.[81] In Spallanzani's terms, of course, unlike in those of Blanis and his magician, the revelation of secrets could be a collective activity empowering the whole community of the learned – indeed, the whole community. He made no conjectures regarding what might happen to the role of the researcher when nature's secrets had been exhausted; nor did he refer to secrets that were kept by humans, not by nature. Who gets credit for the revelation, and how much that credit is worth, in the developing professional world of science, and in society at large, was becoming a matter of great importance even as he wrote. Current experience suggests such concerns will not go away any time soon.

81 'L'assimilazione è ancora tra i segreti che la natura non ci ha voluto svelare', note by Spallanzani in *Contemplazione della natura del signor Carlo Bonnet*, tr. and ed. Lazzaro Spallanzani (Venice: Giovanni Vitto, 1781), II: 233.

FEDERICO BARBIERATO

11 Popular Atheism and Unbelief: A Seventeenth-Century Venetian Point of View

For a long time the history of unbelief and free thinking has essentially been a history of intellectuals, based primarily on the study of printed books and clandestine manuscripts.[1] It has naturally also focused on authors, notably in biographical studies, and in the best cases has strived to reconstruct the groups and networks of these practitioners of the written word: scholars, teachers, poets, journalists and so on.[2] This class-based approach made irreligiousness in the *Ancien Régime* seem a rare phenomenon, marginal, strictly elitist and reduced by censorship to a clandestine existence. Completely isolated in a society which was hostile to their ideas and threatened by religious and secular powers alike, authors had to develop writing strategies which could only be deciphered by the initiated. These strategies were necessary both to protect intellectuals from persecution and to stop their fellow citizens from having access to secular arguments which even the authors themselves recognized as a serious danger to public order.[3] Indeed,

1 At the very least I should mention the work based on the recovery of sources by Frédéric Lachèvre, *Le libertinage au XVIIᵉ siècle* (15 vols, Geneva: Slatkine, 1968), and, as far as clandestine literature is concerned, the pioneering work by Ira O. Wade, *The clandestine organization and diffusion of philosophical ideas in France from 1700 to 1750* (Princeton: Princeton University Press, 1938).

2 René Pintard, *Le libertinage érudit dans la première moitié du XVIIᵉ siècle. Nouvelle édition augmentée* (Geneva: Slatkine, 1983). Martin Mulsow's more recent works are also noteworthy, putting forward the notion of a 'philosophical constellation'. See in particular Prekäres Wissen. Eine andere Ideengeschichte der Frühen Neuzeit (Berlin: Suhrkamp Verlag, 2012).

3 Leo Strauss, *Persecution and the art of writing* (Chicago; London: The University of Chicago Press, 1988).

as one branch of the history of mentalities has never tired of repeating, the 'masses' largely remained profound 'believers', extending the stereotype of medieval crowds chained to their faith through to the eve of the French Revolution and beyond.[4] At most the superstitions of the masses were evoked as evident signs of the persistence of a pre-logical mentality, capable of leading them to the worst excesses (witchcraft, witch-hunting, magic and so on).

Historians hence drew heavily from Christian apologetics, but also subscribed to the depiction of 'the people' as credulous and superstitious victims of their own imaginations and passions, a stereotype propagated by the 'enlightened' elite. Indeed, the total repudiation of the people defined by categories of ignorance and superstition was a fundamental element of elitism championed by those who defined themselves as 'shrewd' and 'cured of foolishness' (*Naudeana*). This condescending attitude revisited the anthropology of Averroism whereby the difference between a wise man and the people is the same as the distinction that separates a real man from a portrait.[5] One of the most frequently recurring scenes in so-called 'libertine' literature – whose scholarly verisimilitude is difficult to establish even when its content is entirely plausible – involves the 'philosopher' or sharp 'wit' whose sagacity leads to threats of lynching by superstitious folk stirred to hatred (Tallemant des Réaux, Cyrano de Bergerac, Dassoucy, etc.).

As a result of this elitism, those dogmas and doctrines of revealed religions which lacked an exclusively elite character were frequently questioned. However, the existence of popular irreligiousness from medieval times onwards was undeniable for those such as Le Roy Ladurie and others familiar with cases that filled the inquisitorial register kept by Bishop Fournier of Pamiers (early fourteenth century). These cases feature simple country folk, both men and women, who question the immortality of the

4 This image, still widespread today, is based above all on the notable work by Lucien Febvre, *Le problème de l'incroyance au xvi⁰ siècle. La religion de Rabelais* (Paris: Albin Michel, 1942).

5 Luca Bianchi, 'Filosofi, Uomini e bruti, note per la storia di un'antropologia averroista', *Rinascimento*, 32 (1992), 185–201.

soul, Mary's virginity, the real presence of Christ in the Eucharist among other issues.[6]

Now, the fact that some denied the existence of God on the basis of the inadequacy of His attributes when compared to scriptural images or personal expectations clearly does not suggest that these doubters had a better candidate or better exponents in mind, nor does it suggest that their doubt was limited to absolute denial. Hence the problem of defining unbelief and atheism, and consequently these same concepts in the modern age, was and still is at the centre of a wide-ranging debate, as is the historical evolution of such phenomena. In brief, according to the traditional interpretation of this process, the Renaissance handed down secular knowledge in some way free of the influence of the Church. In turn, by favouring the individual interpretation of holy texts, the Reformation opened the way to free thinking. The Scientific Revolution then revived the Renaissance terms, making daring use of them in light of the intellectual freedoms of the Reformation. From here it was a short step to the Enlightenment and then to atheism.

It is clear that such a rigidly established causal chain is inevitably confined to a partial vision, the result of an evolutionist perspective that tends to undervalue certain factors. For example, wherever the Reformation was implemented, it tended to replace old orthodoxies with new ones, thus creating new controls on freedom of thought.[7] It also tended to consider some cultural phenomena simply as having survived earlier periods, rather than analysing their role in the social context in which they occurred.[8] Finally, it overlooked 'the fact that the idea that history moves in a certain

6 Emmanuel Le Roy Ladurie, *Montaillou, village occitan de 1294 à 1324* (Paris: Gallimard, 1975); and above all Jean-Pierre Albert, 'Hérétiques, déviants, bricoleurs', *L'Homme*, 173 (2005), 75–94.

7 Wootton, 'New Histories of Atheism', in Michael Hunter and David Wootton, eds, *Atheism from the Reformation to the Enlightenment* (Oxford: Clarendon Press, 1992), 15–16.

8 There are a few considerations on this type of approach to the study of social phenomena in Jack Goody, *The Domestication of the Savage Mind* (Cambridge: Cambridge University Press, 1977), 2ff.

direction and only in that direction, instead of moving simultaneously in
different directions, which might even be contradictory, is simply our *a
priori* judgement'.[9]

In 1942, with the publication of *Le problème de l'incroyance au XVI^e
siècle. La religion de Rabelais*, Lucien Febvre put the problem in new terms,
attempting to resolve whether it was possible to be an atheist in the six-
teenth century. He concluded that there were simply no opportunities for
atheism or unbelief at the time owing to a lack of mental tools through
which an individual could define himself as an atheist. Febvre felt that the
terms defining certain phenomena were inconclusive because these words
were applied continually to a wide variety of different situations with the
emphasis always on controversy, mainly to attack those who did not fully
conform to orthodoxy. The tools that made it possible to form the concept
of atheism in the modern sense were not made available until Descartes'
materialism well into the seventeenth century.[10]

Even if we accept the chronological scheme of Febvre's arguments as
valid, we still need to identify the moment at which atheism could start
to be regarded as a widespread phenomenon, given that it is reasonable to
expect a certain interval between the publication of Descartes' theories
and their translation and widespread reception. According to some, this
path was not clearly drawn, and the figure of the atheist emerged gradu-
ally, touted first by theologians in need of controversy. Since nobody could
rationally affirm that God did not exist, theological Aristotelianism needed
to create controversial points of reference to counter possible stances along
these lines. It was therefore theologians who proposed a series of arguments
against the existence of God, ultimately creating 'atheists without atheism'

9 Giorgio Spini, *Alcuni appunti sui libertini italiani*, in Sergio Bertelli (ed.), *Il liberti-
 nismo in Europa* (Milan: Ricciardi, 1980), 117–24, at p. 118.
10 Paris: Editions Albin Michel, 1942. The English translation is *The Problem of Unbelief
 in the Sixteenth Century: The Religion of Rabelais* (Cambridge, MA: Harvard
 University Press, 1985). Among the many critical stances adopted towards Febvre's
 work, see David Wootton, 'Lucien Febvre and the Problem of Unbelief in the Early
 Modern Period', *Journal of Modern History*, 4 (1988), 695–730, which analyses
 Rabelais in light of Febvre's other texts on unbelief.

and 'atheism without atheists', i.e., people who lacked the conceptual tools to reach atheism using concepts not actually employed by anybody. The matter consequently played out entirely within the world of theologians. The atheist was a product of their imaginations and slowly came to life like a kind of Golem to turn against its creator.[11]

It is undeniable that many elements used by theologians helped to form a philosophically grounded disbelief and that Catholic apologists often became involuntary promoters of the doctrines they were fighting against.[12] The debate between the Cartesians and the Aristotelians was conducted before the many readers of *Nouvelles de la république des lettres* and decisively contributed to the circulation of arguments against the existence of God and the holiest, most fundamental dogma. These arguments were then incorporated into clandestine manuscripts, thereby entering a genuinely irreligious context.[13] Nevertheless, offering a form of atheism contained within and dependent on orthodoxy risked transforming what at the time must have seemed like a real and dreaded enemy into pure fancy,

11 See Kors, *Atheism in France*: 'Atheism without Atheists' and 'Atheists without Atheism' are the titles of Chapters 1 and 3. Among the many reviews which criticized this reading, see those by Dale K. van Kley, *Eighteenth-Century Studies*, 1 (1992), 138–42 and Alice Stroup, *Journal of Modern History*, 1 (1994), 149–50. Although he starts from different assumptions, similar conclusions are also reached by Michael J. Buckley, *At the Origins of Modern Atheism* (New Haven: Yale University Press, 1987). Moreover, before Kors, Kristeller developed the idea that non-atheist writers contributed to the formation of atheist readers: Paul O. Kristeller, 'The Myth of Renaissance Atheism and the French Tradition of Free Thought', *Journal of the History of Philosophy*, 6 (1968), 233–43. Similar considerations were also expressed about the term 'libertinism', sustaining that the libertine was no more than the product of an apologetic invention – Father François Garasse played a predominant role in this – which grafted expressions generically associated with Vanini and his predecessors on to biblical elements: Louise Godard de Donville, 'L'invention du "libertin" en 1623 et ses conséquences sur la lecture des textes', *Libertinage et philosophie au XVIIᵉ siècle*, 6 (2002), 7–18.

12 Of interest with regard to this topic is Isabelle Dubail, 'Le bel esprit entre ostentation et dissimulation dans la Doctrine curieuse du Père Garasse', *Libertinage et philosophie au XVIIᵉ siècle*, 5 (2001), 23–46.

13 Kors, *Atheism in France*.

all without taking into consideration the extensive clandestine output with all the characteristics of atheism.[14]

The question is clearly complex, linked first to different concepts and definitions of 'atheist', a term often used in the early modern age as a rhetorical instrument for expressing the utmost disapproval. Atelastrio, one of the two characters in Filippo Maria Bonini's conversation, *L'ateista convinto dalle sole ragioni*, was an 'atheist' because he had learnt about philosophers such as Descartes and Gassendi during a trip to France and admired them.[15] There was a short and sometimes non-existent step between the definitions of 'atheist' and 'Lutheran'. This step was taken by those who had the professional task of defining heterodox phenomena but did not demonstrate very clear ideas. Nor was there more clarity between believers and unbelievers. There were also those who raised the problem of whether it was possible to distinguish completely between a coherent denial of God and a sort of agnosticism or 'sceptical atheism', aimed not so much at rationally denying God as at asserting that no evidence could demonstrate His existence. Therefore, if it was impossible to know God, many felt that it was legitimate to act as if He did not exist.[16]

Beyond the often limited distinctions and groupings adopted to reduce the phenomenon, it is sensible to admit two things. First, even before 1650 and the spread of the Cartesian separation of body and soul, some believed it possible that God did not exist, in ways and means that

14　On this point, see Gianni Paganini, 'Legislatores et impostores. Le *Theophrastus redivivus* et la thèse de l'imposture des religions à la moitié du XVIIᵉ siècle', in Jean-Pierre Cavaillé and Didier Foucault, eds, *Sources antiques de l'irréligion moderne: le relais italien* (Toulouse: Presses Universitaires du Mirail, 2001), 181–218.

15　Filippo M. Bonini, *L'ateista convinto dalle sole ragioni* (Venice: Nicolò Pezzana, 1665).

16　The distinction between metaphysical and sceptical atheism was offered by Winfried Schröder, 'From Doubt to Rejection: The Impact of Ancient Pyrrhonism on the Emergence of Early Modern Atheism', in Gianni Paganini, Miguel Benitez and James Dybikowski, eds, *Scepticisme, clandestinité et libre pensée* (Paris: Champion, 2002), 67–77; and Winfried Schröder *Ursprünge des Atheismus. Untersuchungen zur Metaphysik- und Religionskritik des 17. und 18. Jahrhunderts* (Stuttgart: Frommann-Holzboog, 1998).

were perhaps highly personal.[17] Secondly – as I will show on the following pages dedicated to Venice, it is difficult to fit the manifestations and forms assumed by atheism, at least in the seventeenth century and the first decades of the eighteenth century, into the current rigid definitions. While I can fully accept that the term 'atheist' – in its many different forms – designated not only a contentious subject built by controversialists and others, it is difficult to deny the presence of people or writings that affirmed the non-existence of a divinity, or other atheistic doctrines. However, it is clear that the religious authorities at least had expertise and were equipped with mental tools that let them easily distinguish between atheism and heresy in theoretical terms. In 1535, for example, the Synod of Strasbourg defined atheists as those who 'croient que cette vie n'est suivie d'aucune vie éternelle, ou encore qu'il n'y a ni jugement, ni damnation après cette vie-ci et ni diable, ni enfer'. They were also 'tous ceux qui prétendent que Dieu ne se soucie pas de nos actes, et qui nient toute autre vie après celle-ci'.[18]

The most recent historiography has underlined the presence of medieval atheism[19] and it is fairly obvious that the theoretical opportunity to

17 When Giovan Battista de Pizzoni asked him 'what atheism meant', Tommaso Campanella answered 'that it meant that there was no God, and when I asked him if he really believed it, he answered that he did, but that the truth cannot be told': Luigi Amabile, *Fra Tommaso Campanella. La sua congiura, i suoi processi e la sua pazzia* (3 vols, Naples: Morano, 1882), vol. 3, 314, which includes Pizzoni's testimony on 22 August 1600.

18 Jean Wirth, 'Libertins et épicuriens: aspects de l'irréligion en France au XVIᵉ siècle', in *Sainte Anne est une sorcière et autres essais* (Geneva: Droz, 2003), 25–67, at pp. 59–60.

19 See, for example, Didier Ottaviani, 'L'intellectuel laïque: de Siger de Brabant à Pietro d'Abano', in Emmanuel Chubilleau and Éric Puisais, eds, *Les athéismes philosophiques* (Paris: Kimé, 2001), 13–25; Graziella Federici Vescovini, 'Il problema dell'ateismo di Biagio Pelacani da Parma, Doctor Diabolicus', in Friedrich Niewöner and Olaf Pluta, eds, *Atheismus im Mittelalter und in der Renaissance* (Wiesbaden: Harassowitz, 1999), 193–210; Wirth, 'Libertins et épicuriens', 22; John Arnold, *Belief and Unbelief in Medieval Europe* (London: Hodder Education, 2005); Paolo Golinelli, *Il Medioevo degli increduli. Miscredenti, beffatori, anticlericali* (Milan: Mursia, 2009).

deny God is implicit in the very statement that He exists;[20] generating
different forms which may have led to this denial in different contexts.[21] I
also find it is difficult to establish a concept clearly defining the rejection
of such a vague, ambiguous, contradictory and personal category as 'belief',
given that a close definition of atheism – or even unbelief – presupposes
an equally precise definition of what 'belief' represented in a particular
time, place and environment. To do so would require fitting the whole
repertoire of individual emotions, thoughts and states of mind into a model
that presupposed consistent answers to needs and questions perceived in
constantly contrasting ways by each individual.[22]

Any attempt to categorize atheism purely as unbelief must therefore
contend with this irreparably individual dimension; it is perhaps just as
difficult to find a pure form of incredulity regarding a divine being as it is
to identify a way of believing that corresponds to an ideal type of belief, as
both were linked to biographical and intellectual paths in which rejection
became the norm. Therefore, while the events discussed here sometimes

20 See the considerations by Jean-Pierre Cavaillé, 'Pour en finir avec l'histoire des men-
 talités', *Critique*, 695 (2005), 285–300, review of Jean Wirth, *Sainte Anne est une*
 sorcière.
21 Indeed, the problem is not only chronological but also a question of social circles. To
 this end Fritz Mauthner observed that when a religious belief is rejected, the forms
 assumed by the rejection reflect the rejected religion. Therefore, pagan atheism is not
 the same as Christian atheism or Muslim atheism: Fritz Mauthner, *Der Atheismus*
 und seine Geschichte im Abendland (4 vols, Frankfurt am Main: Eichborn, 1989),
 vol. 1, 10. On this aspect, see also Sarah Stroumsa, 'The Religion of the Freethinkers
 of Medieval Islam', in Niewöner and Pluta, eds, *Atheismus im Mittelalter und in der*
 Renaissance, 45–58.
22 The starting point is obviously Ludwig Wittgenstein, in particular *Lectures and*
 Conversations on Aesthetics, Psychology, Religious Belief (Oxford: Blackwell, 1966) and
 Remarks on Frazer's 'Golden Bough (Retford: Brynmill Press, 1983). Also important
 along the same lines is Rodney Needham, *Belief, Language, and Experience* (Chicago:
 University of Chicago Press, 1972). See also Francisca Loetz, *Dealings with God:*
 From Blasphemers in Early Modern Zurich to a Cultural History of Religiousness
 (Aldershot: Ashgate, 2009), and Michael F. Graham, *The Blasphemies of Thomas*
 Aikenhead: Boundaries of Belief on the Eve of the Enlightenment (Edinburgh:
 Edinburgh University Press, 2008).

featured clear rejection of any truth transcending the earthly sphere – although these were not always coherent or definitive positions – on other occasions it seems that the denial of the divinity was precisely that which was known and referred to.[23] In other words, many did not contest the existence of a supreme being, but rather the existence of the god their religious congregation believed in. Therefore, if it is possible to draw conclusions about 'philosophical atheism' and its less elaborate manifestations, I believe it prudent to accept a broad definition of atheism propounded by people who were not only seen as atheists but who believed that they were and were happy to be so, often in a steadfast and vociferous way.[24] After all, it was this broad interpretation that found precise answers to the following question: who were the masters of Italian unbelief? The answer offered by observers in the seventeenth and eighteenth centuries employed cultural traditions which were difficult to assimilate, and the resulting overview was hazy and confused. Among the clearly identified libertines, unbelievers and 'atheists' were Aretino, Poggio Bracciolini, Clement VII, Alexander VI, Pomponazzi, Cremonini, Vanini and Galileo, or Ermolao Barbaro,

23 Vittorio Frajese, 'Ateismo', in *Dizionario storico dell'Inquisizione*, eds. V. Lavenia and J. Tedeschi, 4 vols (Edizioni della Normale Superiore di Pisa, 2010), vol. 1, 114–18.

24 It has been written that the term 'atheism [...] seems to us to best encapsulate the articulate assault on Christianity and, often, on religion in general that is to be found in this period', and so it is not possible to study exclusively people who were openly atheist in the sense of the present-day meaning: Michael Hunter and David Wootton, 'Introduction', in Michael Hunter and David Wootton, eds, *Atheism from the Reformation to the Enlightenment* (Oxford: Clarendon Press, 1992), 2. Instead, Silvia Berti offered a distinction not so much between 'piety and impiety (including all forms of unbelief, from irreverence to atheism)', as between 'mere unbelief and atheism. The world of unbelief and blasphemy lives on within the world of faith. He who asserts, however courageously, that he does not believe in God, in the end does nothing more than say, "I *believe* that God does not exist"'. In order to break away definitively from the world of faith, a philosophical grounding in atheism was required, combined with a new form of biblical criticism. This break was made by Spinoza Berti, 'At the Roots of Unbelief', *Journal of the History of Ideas*, 56/4 (1995), 555–75: 562, italics in text.

Ficino, Poliziano, Porzio, Berigardo and Cardano.[25] Others could also be found without great difficulty. Widely varying archetypes were used due to confusion and complexity.

Explicit denial of the existence of God could also be reached in degrees – the idea of progression from heresy to athesim was widespread – and assume different forms.[26] In short, a fairly elastic concept was used to identify both those who did not believe in God and those who did not believe in something which made His existence irrelevant, such as the immortality of the soul.[27] Indeed, denial of the soul's immortality was seen as the first step towards structured rejection of the very existence of the divinity. When reporting Dr Troilo Lanzetta to the Sant'Uffizio of Venice in 1661, the Somascan Giovan Francesco Priuli noted that Lanzetta was 'vehemently suspicious' with regard to faith and in particular 'regarding the immortality of the soul, and consequently every other mystery of the Catholic faith.'[28] Don Carlo Filiotti was also 'known as an atheist, because he had been repeatedly heard speaking about the mortality of the rational soul, held extravagant principles, that the soul was mortal.'[29] In this sense the rejection of single elements whose denial constitutes a corollary of atheism as currently conceived – the immortality of the soul, the afterlife, or the authority of a sacred text and so on – was immediately associated with atheism,

25 The lists are in Johannes Micraelius, *Historia ecclesiastica* (Magdeburg, 1699), 887–8; Thomas Philipps, *Dissertatio historico-philosophica de atheismo* (London, 1716), 75–96.

26 'Even in religious matters little sparkles of superstition, of an almost imperceptible alteration, turn into great fires, because as time passes superstitions change into heresies, heresies transform into unbelief, and the latter becomes atheism': Traiano Boccalini, *Commentari sopra Cornelio Tacito*. I am quoting from a manuscript preserved in ASV, *Consiglio di Dieci, Miscellanea codici*, n. 104, cc. 965v–966r.

27 Wootton, *New Histories of Atheism*, pp. 25–6. There is reference to the implicit connection between atheism and denial of the immortality of the soul in seventeenth-century theological output and polemics in Tullio Gregory, *Theophrastus redivivus. Erudizione e ateismo nel Seicento* (Naples: Morano, 1979), pp. 107–8.

28 ASV, *Sant'Uffizio*, b. 110, Fra' Fontanarosa file, trial against Troilo Lanzetta, written document by Fra' Giovan Francesco Priuli presented on 28 October 1661.

29 ASV, *Sant'Uffizio*, b. 107, trial against Don Carlo Filiotti, deposition by Don Bartolomeo Franzino on 19 December 1652, cc. 17r–v.

likewise any denial of a 'divine economy of rewards and punishments, in heaven and hell'.[30] With regard to assertions by a Spresiano peasant at the Sant'Uffizio of Treviso that religion and the Gospels had been invented 'by priests and prelates', that hell did not exist and that the soul was mortal, Fra' Giovanni Maria Bertolli, the *Consultore in Iure*, wrote in 1703 that it was 'a heresy of those atheists who are currently in Amsterdam, who have it that souls die with bodies, that hell is a flight of fancy, and heaven an illusion'.[31] A few years later Bertolli was echoed by his Servite colleague Fra' Celso Viccioni, who stated that 'although he says he is a believer [...], he does not really believe either in God or in his godly son Jesus Christ'. Whoever sullied himself with such an opinion was either 'an out-and-out madman or a wicked atheist'.[32]

Beyond the philosophical and theological debate it was perhaps not so much the existence of a superior being that interested the dedicated non-professional polemicists in Venice as the degree to which this being was involved in human affairs. In 1647 a simple woman, Faustina Cortesia, fell ill and commended herself to God, the Virgin and the saints. It seems she did this with a certain degree of conviction. Nevertheless, in the end 'not having been satisfied, I said that [...] there is no God, no most holy Virgin, no saints, no such things, otherwise it would be impossible not to be satisfied'.[33] The first stage of a structured form of atheism was often the recognition of the absolute extraneousness of God with regard to what happened on earth. In 1655 Giovan Francesco Vantaggi wrote that 'that God does not look after the low things', hence reiterating considerations by a gold-beater colleague. As proof of divine detachment, Carlo Vanali put forward an extremely *laissez-faire* argument: 'if one man kills another, it does not happen because God has arranged it, but only because of the prowess of the man who kills, just as if one merchant negotiates better than

30 David Wootton, 'Unbelief in Early Modern Europe', *History Workshop Journal*, 20 (1985): 82–100, at p. 86.

31 ASV, *Senato, Deliberazioni Roma, Expulsis papalistis*, f. 18, 12 June 1703.

32 ASV, *Senato, Deliberazioni Roma, Expulsis papalistis*, f. 22, 14 December 1710.

33 ASV, *Sant'Uffizio*, b. 103, Salvatore Caravagio file, trial against Faustina Cortesia, spontaneous appearance by Faustina on 28 April 1647.

another, it happens because he is better at such dealings'.[34] In the 1670s
Teodoro Stricher claimed that providence definitely did not exist, given
that 'things in this world happen at random'. Divine disinterest in human
affairs, Stricher claimed, went so far that 'God does not even know that we
are in this world'.[35] Going further, Grando de Grandi from Vicenza stated in
1692 'that he doesn't know what God is, and that he hasn't seen Him except
in fancy dress on Good Friday'. De Grandi saw priests as ignorant, as they
had not studied like him and did not realize that 'we are like lots of lost
kittens'.[36] Such positions at different times ranged from the simple expres-
sion of doubts regarding the immortality of the soul to a fairly structured
form of materialism like the one proposed by Giuseppe Rossi in 1692 that
denied the existence of God, the Virgin and the saints. Christ had obvi-
ously been an imposter, 'a real genius who went around persuading those
poor ignorant people'. He felt that there was 'no heaven, or demons in hell,
and [...] the world has always been here and naturally always will be, and ...
when we die the soul dies together with the body'.[37] In 1697 Dario Doria,
a goldsmith, also unequivocally denied the existence of God: 'what is this
God, I don't believe in God and I'm not afraid of God. There is no God'.
He saw the soul in the same way as God: 'when I die, everything dies, there
is nothing else, like an animal'.[38]

It is a difficult, perhaps even impossible undertaking to offer a plausible
overview of unbelief in a context such as Venice in the early modern period.
The explicit or implied denial of the existence of God or His main attributes
coupled with the evidence presented in support of this conviction during

34 ASV, *Sant'Uffizio*, b. 108, Carlo Vanali file, trial against Carlo Vanali, spontaneous
 appearance by Giovan Francesco Vantaggi on 19 March 1655.
35 ASV, *Sant'Uffizio*, b. 117, trial against Teodoro Stricher, spontaneous appearance by
 Francesco Priuli on 10 April 1674.
36 ASV, *Sant'Uffizio*, b. 127, trial against Grando de Grandi, spontaneous appearance
 by Antonio della Chiesa and Zanetta de Grandi on 3 September 1692.
37 ASV, *Sant'Uffizio*, b. 126, trial against Tobia Haselberg, undated written document,
 marked A, presented by Domenico Paterno during session on 22 May 1692, c. 2*v*.
 With regard to demons, 'the rebellion of angels is an invention and [...] was not true'.
38 ASV, *Sant'Uffizio*, b. 129, Doctor Neri file, trial against Dario Doria, spontaneous
 appearance by Don Francesco Pedrini on 12 November 1697.

conversations give the impression of a mild form of unbelief, a world in which the boundaries between belief, disbelief and erroneous belief were quite unstable and constantly being crossed. Just as it was possible to believe superficially, it was also possible to disbelieve in an equally superficial way.[39] Because specific statements and the available intellectual tools and vocabulary were gradual in nature, even the most animated denial of the existence of God or the soul did not always entail a denial of the afterlife in general. For example, the next world was always useful to those invoking demons or making pacts with the devil to obtain financial or sexual gratification or to guarantee protection for whatever reason. However, the denial of the existence of demons – the consequence of failed invocations – fairly frequently evolved into a more general dissolution of the Christian afterlife.[40]

Consider also how people expressed their unbelief or general nonconformism. Religious dissent manifested itself through extremely diverse forms difficult to define on the basis of models. In this context even formulations which were simplified or reduced to their minimum sometimes constituted forms of expression and distribution of feelings of unbelief or ideas that were probably more elaborate than they appeared when first expressed. Blasphemy was a boundary case; it was such a common, well-established element of conversation that a separate magistracy – the *Esecutori conto la bestemmia* – was specially devoted to curbing the most extraordinary manifestations of the phenomenon, as it was felt that it could seriously endanger society and the state.[41] The thin line that sepa-

39 Giovanni Scarabello wrote with regard to the work of the Venetian Inquisition in the seventeenth century that rather than lives in opposition, 'lives of steadfast dissidence, one has the sensation of irreverent or cynically scornful lives': Giovanni Scarabello, 'Paure, superstizioni, infamie', in *Storia della cultura veneta. Il Seicento* (10 vols, Vicenza: Neri Pozza, 1982), vol. 4/II, 343–76, at p. 374.

40 From this, although on the one hand there was a major focus of attention on doctrines that tended to deny the existence of the devil, on the other hand great importance was attributed to exorcism. On these aspects, see the cases quoted in Barbierato, *Nella stanza dei circoli*, 131–45.

41 To give an idea of the phenomenon in the second half of the seventeenth century, when the *Esecutori* decided to proceed by way of inquisition against blasphemers instead of relying on denunciations in 1684, twenty-three guilty parties were identified

rated heretical blasphemy from the ordinary variety, a simple explosion of rage which did not question God's divine attributes, was barely visible. In any case, doctrine accepted that a blasphemer was not *ipso facto* considered heretical. The difference was taken for granted by those witnessing to blasphemy in professional contexts; it was almost inevitable that a *cavadenti* (tooth-puller) like Giovan Battista Cocciolo, interrogated in 1682, heard a reasonable amount of it. However, he must have seen such blasphemy as completely justified, as he made a point of specifying to the Inquisitor that he had never heard it, 'except on the occasion of pulling out teeth'.[42] The same was regularly said of gambling or love affairs. Boundaries between what was and was not heretical belonged to the area of intention and thus the conscience. Establishing these boundaries implied a careful analysis of other factors such as the blasphemer's habits, whether he led a 'bad life', and especially whether he usually supported blasphemy with detailed reasoning. Heterodox propositions could therefore vary widely, and they might be characterized as blasphemy or not. To put it another way, those who blasphemed continuously and contentedly might have done so out of habit or purely because blasphemous terms were widely used. However, a blasphemer's behaviour was sometimes unequivocally aimed at the divinities. Such rebellion often waxed into demonic invocation, an extreme rejection of the divine figure and the highest acceptance of his opposite number. The juxtaposition of topics and stances openly based on unbelief was often accompanied by interests, readings and practices based

in just one day in the parish of San Geremia alone, five of whom were imprisoned immediately. They included the Vice Grand Captain, Antonio Coa, who had to submit himself to judgment by the *Capi del Consiglio dei Dieci*. However, it seems that the persecutory zeal of the *Esecutori* did not last long, perhaps also because of the estimated number of people who would have probably ended up in prison: ASV, *Consiglio di Dieci, Parti criminali*, b. 116, *Esecutori Contro la Bestemmia* document dated 8 February 1683.

42 ASV, *Sant'Uffizio*, b. 122, trial against Giuseppe Toscani, known as l'Orvietano, deposition by Giovan Battista Cocciolo on 5 March 1682.

on magic that involved recourse to the evocation of demons and complete acceptance of their authority.[43]

Besides the oral dimension, which, although diverse, constituted the main channel of expression, heterodox convictions could also be translated into actions and gestures. It would certainly be hard to claim that those who blasphemed, 'roasted Christs, and burnt images' or abused crucifixes in various ways were expressing theoretically founded unbelief.[44] It is possible, however, that they were adhering to ideas and suggestions they had made their own yet lacked the tools to express themselves differently or perhaps even to think in an alternative way. In the 1670s Girolama Bonotti, unable to separate thought from action, earned a reputation as a 'wicked woman' who 'did not want to hear or say prayers, and never went either to church or to confess'. When widowed, she moved into a room decorated with images of saints, as was the habit, but flew into a rage: 'what kind of saints, what kind of vanities did you put in my bedroom? Let God stay on his side, and I will be on mine'. She took the images and ripped them up, in keeping with her vision of a world in which 'God does not govern us, but everything happens by chance, and once you have died, everything has died'.[45] The expression of these sentiments, for lack of better word, was entrusted to actions, especially violent ones carried out against images. In 1683 Laura Tagliapietra swore at and hurled crucifixes and cut images of the Madonna with scissors.[46] 'I don't believe in God,' she explained. 'There is

43 On the question of links between demonolatry and scepticism in the Republic of Venice, see Barbierato, *Nella stanza dei circoli*, 131–45.

44 ASV, *Sant'Uffizio*, b. 110, trial against Fra' Cherubino from Venice and Fra' Giovan Battista from Este, deposition by Fra' Girolamo from Piove di Sacco at the Sant'Uffizio of Padua on 19 August 1663, c. 25v. Moreover, the association of blasphemy and contempt of images was quite common. See, for example, the case of Alessandro Monti, an innkeeper from Breganze, tried in 1666 and 1676 by the Inquisition courts of Vicenza and Padua 'ob blasphemias hereticales, et percussionem sacrarum imaginum': ACDF, S.O., *Decreta 1676*, c. 198r, 14 September 1676.

45 ASV, *Sant'Uffizio*, b. 121, trial against Girolama Bonotti, written denunciation presented on 22 August 1679 by Giovanni Radicio.

46 ASV, *Sant'Uffizio*, b. 122, Angela Soave file, trial against Laura Tagliapiera, written denunciation presented by Giovan Battista Dolobella on 29 July 1683.

no God, I don't believe in the existence of God. There is only the Devil.'[47] Such iconoclasm was fairly widespread, often depicting a general rejection of norms and authorities, frequently combined with rejection of the accepted divinity and adherence to the cult of demons.

Unbelief also transformed thoughts and theories into concrete actions. When, on the night of January 21, 1695, someone defaced an image of the Madonna in Vicenza, it may have been the work of a staunch unbeliever, a playful japester or simply someone dissatisfied with the painting. However, the addition of 'many signs of black grease on the face in the form of moustache, beard and other features' at least denoted a somewhat free relationship with the sacred.[48] Numerous similar episodes of 'contempt of holy images' took place in cities and rural areas on the mainland, although most were isolated acts of rage and unmediated expressions of rebellion aimed at anti-clerical targets. However, there was no lack of cases in which the violation of the image clearly constituted a concrete continuation of more structured heterodox ideas: in general the history of unbelief cannot be reduced to a history of abstractions, arguments and ideas.[49] The language that non-believers of varying degrees used to communicate their feelings was not merely verbal but belonged to a huge range of communication. Gestures, attitudes, clothing, tastes and much else could express or underline personal thoughts. Nonetheless, it is difficult to definitively connect behaviour with closely-held convictions; we cannot say for sure that those who ate fat on days when it was forbidden or went around naked near monasteries – to quote two well-documented cases – were staunch unbelievers; they might simply have been drunk. In the same way, those who blasphemed constantly in a reasoned way might just have become accustomed to using such expression without being interested in expressing a

47 *Ibid.*, deposition by Maddalena Bertazzo on 16 March 1684.

48 ASV, *Consiglio di Dieci, Parti criminali*, b. 122, 19 December 1696.

49 David Wootton, 'New Histories of Atheism', in Michael Hunter and David Wootton, eds, *Atheism from the Reformation to the Enlightenment* (Oxford: Clarendon Press, 1992), 14–15. Some useful considerations can be found in David L. D'Avray, *Rationalities in History: A Weberian Essay in Comparison* (Cambridge: Cambridge University Press, 2010), 89.

deep-rooted disapproval of orthodoxy. Equally, it is certainly not a given that unbelief led to a wicked life devoid of all moral restraints. It is true that for many the rejection of normal ethical codes sometimes justified their behaviour, but this was not necessarily the case.

It is clear that the heterodox themes and propositions circulating during the seventeenth and early eighteenth centuries were a legacy of both the reformist drive of the previous century and Renaissance irreligious trends. Ideas such as the mortality of the soul, the purely earthly destiny of man, the eternity of the world and the falsity of religious dogma and its use for self-serving purposes all belonged to a long-running tradition. Starting from Aristotelian doctrines, or more precisely from Averroist Aristotelianism with its suggestion of integral rationalism, the tradition had been part of European thought since at least the thirteenth century.[50] During the fifteenth and sixteenth centuries, groups linked to Paduan Aristotelianism developed the tradition and spread it throughout Europe.[51] In many respects the 'connection between the extreme results of Renaissance naturalism and Machiavellian theses' formed the basis of the radical irreligiousness of a text such as the *Theophrastus redivivus*.[52] Widespread radical Antitrinitarianism, whereby Christ was not seen as the natural son of Mary and Joseph, was still preserved in the enduring Anabaptist climate in Italy and the Serenissima in particular, which constituted proof of the special nature of the readings of Reformation doctrines made on the peninsula. The theme of the 'sleep of souls', according to which impious souls would die along with their bodies, while the chosen ones would await the Day of Judgment in peaceful sleep, was a common feature of Anabaptism, even in its special Venetian version. Other features were

50 Ernest Renan, *Averroès et l'Averroïsme* (Paris: Auguste Durand, 1852). On the relationship between Aristotelianism and libertine trends of thought, see Tullio Gregory, 'Aristotelismo e libertinismo', *Giornale critico della filosofia italiana*, 2 (1982), 153–67.

51 For example, on the spread of Paduan ideas in sixteenth-century France, see Henri Busson, *Les sources et le développement du rationalisme dans la littérature française de la Renaissance (1553–1601)* (Paris: Letouzey et Ané, 1922). See also Charles B. Schmitt, *Aristotle and the Renaissance* (Cambridge, MA: Harvard University Press, 1983).

52 Gregory, *Theophrastus redivivus*, 113.

the denial of the existence of supernatural beings such as angels or demons and the rejection of the divine origin of the human soul. All these elements were being circulated independently by the end of the following century.[53] Therefore, Anabaptist theological radicalism, which had been expressed at the Venetian 'council' in 1550, constituted the 'premise for the successive anti-trinitarian developments of Italian heretical emigration, destined to mature in the seventeenth-century Socinian tradition until the crisis of the European conscience and the Age of Enlightenment.'[54] Equally, themes such as the denial of papal authority and Church hierarchy, purgatory, the effectiveness of the mediation of saints and the Madonna, good deeds, or all rites and sacraments and the real presence of Christ in the Eucharist could all form part of the mental accoutrements of some supporters of the Reformation. These themes were also embraced by the sizeable number of Venetian disciples of Giorgio Siculo, who might have read the *Libro maggiore* or *Libro grande*, now lost but fervently persecuted by Inquisitors in the past. Among other things, the same line of thought could also include the conviction that the soul was mortal, 'created [...] by men together with the body.'[55] In the same way, 'there had always been and continued to be [...] manifestations of incredulity or popular materialism,'[56] which were inserted into a long-standing facet of Italian culture, the 'minority but enduring tradition of "radical humanism"', which then merged into

53 Davidson, Nicholas, 'Unbelief and Atheism in Italy, 1500–1700', in Michael Hunter and David Wootton (eds), *Atheism from the Reformation to the Enlightenment* (Oxford: 1992), 55–85. 'Insistence on the simplicity of the word of God, rejection of sacred images, ceremonies, and the sacraments, the denial of Christ's divinity, the adherence to a practical religion based on works, the polemic with the stamp of pauperism against ecclesiastical "pomp", the exaltation of tolerance, are all elements that can be traced to the religious radicalism of the Anabaptists': Ginzburg, *The Cheese and the Worms*, 18.

54 Massimo Firpo, *Riforma protestante ed eresie nell'Italia del Cinquecento* (Rome and Bari: Laterza, 1993), p. 148.

55 On Giorgio Siculo, see Adriano Prosperi, *L'eresia del Libro Grande. Storia di Giorgio Siculo e della sua setta* (Milan: Feltrinelli, 2000).

56 Adriano Prosperi, *Dare l'anima. Storia di un infanticidio* (Turin: Einaudi, 2005), 229.

philosophies of French origin.[57] The new factor during this period was the social role assumed by such elements and manifestations. Huge resonating cracks emerged from the Counter-Reformation doctrines, creating a new level of danger, not because these doctrines questioned Catholic dogma and articles of faith. That had always been true, but with the Counter-Reformation, the doctrines also unleashed a heated attack against religion in general.[58] Individuals embraced fragments of these doctrines, personally identifying themselves with an imaginary society of nonconformists rather than with the Church. This society was not socially determined but was potentially extended to all classes and was defined according to individual levels of intellectual interpretation.

One advantage of dealing with a later period and an unusual urban context such as Venice is avoiding a clear answer to the genealogical question regarding libertinism among the popular classes, as emerged from the debate between Carlo Ginzburg and some of his critics. In *The Cheese and the Worms*, Ginzburg analyses the case of Menocchio the miller, identifying a hidden layer of popular culture linking cultural contexts separated in time and space, and creating a filter for subjecting Menocchio's readings to radical reinterpretations. Some, however, offered a different interpretation, suggesting that the miller's theories were distorted versions of doctrine from the educated tradition, which had reached Montereale through

57 Vittorio Frajese, *Profezia e machiavellismo. Il giovane Campanella* (Rome: Carocci, 2002), 10–11.

58 Indeed, this was a European phenomenon rather than one confined to Venice. As Jonathan Israel wrote, after 1650 everything was questioned, opposed and often replaced on the basis of philosophical analysis, regardless of how fundamental or deep-rooted it was considered to be: Jonathan I. Israel, *Radical Enlightenment: Philosophy and the Making of Modernity 1650–1750* (Oxford: Oxford University Press, 2002), 3. To a certain extent, in Venice, like elsewhere, the moment seemed ripe, for 'The day of heterodoxy has dawned, of every kind of heterodoxy, the day of malcontents, the rebels who [...] had multiplied out of sight and had been awaiting the hour of their emancipation; of learned men, who declined to accept tradition at its face value, and insisted on inquiring into its credentials; of the Jansenists, who were to kindle new fire from their dim but never wholly extinguished embers; of the Biblical exegetists; of the philosophers': Paul Hazard, *The European Mind, 1680–1715* (Hammondsworth: Penguin, 1964), p. 123.

different but nevertheless identifiable channels.[59] It is plainly difficult to establish the genealogical pattern of this knowledge in the Venetian context during the period in question. What is historically proven, however, is that chains of contact and means of communication provided a link between the different social strata. Moreover, heterodox unrest with leanings towards Averroism, Machiavellianism and Aristotelianism was widely present among the patriciate in Venice.

Irreligious themes, blasphemy and an extreme desire to transgress are all present in one spontaneous confession which, although exaggerated, seems to capture the mood of the Venetian patriciate in the middle of the century, a mood that in some way continued to survive secretly until the following century.

While there is no doubt that popular unbelief and irreligiousness emerged even without academic stimuli – after all, anyone could doubt divine participation in human affairs on the basis of personal experience and intellectual ability – it is just as certain that the relevant set of ideas was available from at least the mid-seventeenth century onwards. The mid-1600s created a climate rife with heterodox unrest. Heterodoxy had become common property, individually interpreted through different forms of communication and appropriation. As a result, each idea could be taken in, adapted and imparted again by a potentially huge number of people. In the special urban context of Venice, the problem was not so much the presence of a person like Menocchio, but the fact that there were hundreds of similar figures divulging statements, ideas, depictions and visions of the world, each open to individual interpretation. Venetians must have been bombarded with information and interpretations.[60] It was normal for edu-

59 See, for example, Zambelli, 'Uno, due, tre, mille Menocchio?'; id., 'Topi o *topoi*? Intervento sulla relazione di Carlo Ginzburg', in Paolo Rossi, Lucilla Borselli, Chiaretta Poli and Giancarlo Carabelli, eds, *Cultura popolare e cultura dotta nel Seicento* (Milan: FrancoAngeli, 1983), 137–43; Giorgio Spini, 'Noterelle libertine', *Rivista storica italiana*, 88 (1976), 792–802.

60 As Jean Wirth noted, 'Les cadres historiques, géographiques et sociaux du phénomène sont difficiles à tracer, car les assertions libertines réapparaissent identiques dans les contextes les plus différents'. One might think, as it has been suggested for witchcraft,

cated and popular thought to converge, and for erudite libertine themes and arguments to spread widely among the artisan and popular classes in the city, although more in terms of their formulation than structure. In this sense heterodox discourse could assume a nearly infinite number of forms, each embellished by the individual character of its proponent.

The success and resulting spread of an idea also depended on the language through which it was expressed, or the images into which it could be translated. These depended on the underlying communicative potential of the idea itself. For example, Teodoro Stricher, a doctor in law, was a supporter of God's indifference towards human affairs and the material nature and mortality of the soul. He was eager to take part in a new *Concilium* so that he could voice his opinions. He shared his views with a broad group of people including lawyers, notaries, drapers and workers from craftsmen's *botteghe*, and argued them persuasively. He not only quoted 'doctors' to support his beliefs, but also offered bold interpretations of divine signs; when he could not find any fish at the market during Lent, he said that 'as God hadn't sent any fish, it was a sign that he wanted us to eat meat, thereby telling the Gospel'.[61]

The ability to move an idea beyond the world of reflection and into concrete, sensory and perceivable ground involved a series of linguistic instruments, first and foremost the metaphor. Metaphors compared the soul to smoke from a cooking pot, the Evangelists to gazetteers and so on. The visual rendering of a concept anchored it in reality, made it easy to understand, and fostered its use during discussions. The social space in which all this took place was the discussion or debate, a dialectical exchange between two or more people, a common occurrence given the ample social opportunities. It is not especially important whether the words expressed were well thought out or were nothing more than juxtaposed images rather

that this was due to invention on the judges' part, but 'cette opinion, nullement prouvée pour ce qui est de la sorcellerie, devient intenable à propos du libertinage, puisque nous avons des sources très différentes des calomnies et des aveux extorqués': Wirth, 'Libertins et épicuriens', 67.

61 ASV, *Sant'Uffizio*, b. 117, trial against Teodoro Stricher, spontaneous appearance by Francesco Priuli on 10 April 1674.

than homogenous ideas. The result was not complex theories but reworkings of discourse assembled by accumulation, ideas heard in discussions and adapted to personal inclinations or an individual understanding.[62] This frequently used patchwork technique intersected with objectification processes anchoring formulae or ideas that needed to be presented in an understandable form.[63] For example, the presence of God and the credibility of religion were primarily measured by everyday facts in terms of moral values and prescriptive codes. Religion and the next world answered to a very earthly kind of logic made up of exchanges, payments and compromises. Whether the currency in question was a prayer or a good deed, something was expected in return. This made it easier to move from one belief to another, or in extreme cases to pass from belief to unbelief. In this way orthodoxy could not ignore the field of experience, where it competed with a heterodoxy that could satisfy everyone's needs by being individualized and making no claims about universal values.

This scepticism towards Church teachings did not require solid arguments, being self-evident, based on experience and boasting a strong tradition. Back in 1576 Matteo Vincenti, a turner, said that if he really had to believe in something, then he preferred to believe that he had money in his pocket.[64] Then in 1646 a certain Orsola Ciuran, a ragman's wife, did not hesitate to say that 'the soul is filth, and those who do not love their body do not love their soul either. What is hell? Nobody has met anyone that came here to tell us'. Ciuran also regretted having wasted her time on confession and the Eucharist.[65]

62 Silvana Seidel Menchi noted something similar with regard to the spread of Erasmus's theories: 'some Erasmian formulae broke free of their contexts and circulated autonomously [...] once in circulation, those formulae lost sight of their origins and, together with this, the toned-down moderate mould that Erasmus had given them': *Erasmo in Italia*, p. 117.

63 Willem Doise, 'Atteggiamenti e rappresentazioni sociali', in Denise Jodelet (ed.), *Le rappresentazioni sociali* (Naples: Liguori, 1992), 249.

64 ASV, *Sant'Uffizio*, b. 40, trial against Marcantonio de Simon and Francesco Paluelo, denunciation on 1 May 1576.

65 ASV, *Sant'Uffizio*, b. 103, Ludovico Fugarola file ..., trial against Orsola Ciuran, spontaneous appearance by Antonia Sgambozza on 5 June 1646.

Depositions clearly reveal the aesthetic way such ideas were expressed. The very fact that heterodox concepts were frequently the subject of conversations and arguments shows that for many people they were like a calling card bearing the qualification 'virtuoso'. In 1651, when Dominican Fra' Tommaso Onorio claimed that religion was, literally, a diabolical idea, that everyone was saved in their own law, that the Trinity was an invention, that friars could have carnal relations with anyone and that, consequently, the government of 'papists' was tyrannical, the prior of the monastery found no reason to be unduly upset. He had often heard Fra Onorio say such things, but felt that he was still a good friar at heart since one 'says certain things only to be a *bel ingegno*, or as we usually say, a *galant'huomo*'.[66] Those brave enough to express such unbelief in public, or at least hint at it, knew they would become objects of both scandal and esteem, or at the very least would be noticed.

One therefore became a '*bel ingegno*' [a wit] and '*galant'huomo*' [a noble spirit] by putting forward propositions, theories or simple formulations that could create a scandal, treating lightly subjects usually considered sacred. Similar language was used in the ongoing development of social models characterized by freedom of thought and unprejudiced intelligence. It was now firmly established that the wise, sage and virtuous were not those who led lives of solid moral principle and piety, but those who did not believe in anything, who shrewdly questioned even the most untouchable dogma and were not deceived by the artifice of religion. In 1682 Abbot Francesco Muselani claimed that 'idiots believe that purgatory

66 ASV, *Sant'Uffizio*, b. 106, Caterina Tordana file ..., trial against Fra' Tommaso Onorio, deposition by Fra' Ludovico from Murano, Prior at the monastery of San Pietro di Murano, on 6 July 1651. For the accusations against Tommaso: *ibid.*, spontaneous appearances by Fra' Girolamo Pranda on 3 February 1651 and Fra' Angelo Maria on 15 February 1651. This stance was common to more or less all anti-libertine polemics and literature. According to Filippo Maria Bonini, wits ended up renouncing religion because of 'avarice of knowledge', shipwrecked 'in the stormy sea of fluctuating philosophies'. It was 'wanting to pass for a singular mind' that put the soul in danger: Bonini, pp. 20, 36.

and the house of the devil exist, but not good educated men like myself'.[67]
Even when the existence of heaven and hell was acknowledged, Giuseppe
Rossi, a doctor, claimed in 1692 that it would be preferable by far 'to go
where many faithless emperors such as Tiberius Nero and others have gone
for company, rather than go to heaven with four fishermen for company'.[68]
Giacomo Stecchini learnt from a painter who taught him the profession
that 'children' go to heaven, but expounded his own variation in around
1711, according to which 'heaven was the heaven of idiots'.[69] Daniele Alberti,
the *Cancelliere Pretorio* in Mestre, took a more argumentative approach in
1719 when he tried to persuade friends and servants 'that souls move from
one body to another, speaking about the souls of men because he was talk-
ing about great *virtuous* figures, also saying in the same place, at the same
time and on the same occasion that only idiots and ignorant people go to
hell and that only great *virtuous* men go to hell, and that he wanted to go
to hell among the great and *virtuous* men'.[70]

This was a restatement – duly adapted by the theory of the transmi-
gration of souls – of Machiavelli's dream – that the connection between
individual intellect and lack of involvement in matters of faith was implicit,
though clearly seen by many.

But if the reference model was 'great men' or 'philosophers', there was
certainly not much point in hiding one's thoughts, as they became instru-
ments used to earn social distinction. A few decades before Alberti took
his stand, the author of *Theophrastus redivivus* had stated that all truly wise
men knew how to examine reality and discover the deceit of religion.[71]

67 ASV, *Sant'Uffizio*, b. 123, trial against Francesco Muselani, spontaneous appearance
 by Don Giuseppe Mauccio on 11 August 1682, c. 5*v*.
68 ASV, *Sant'Uffizio*, b. 126, trial against Tobia Haselberg, undated written document,
 marked A, presented by Domenico Paterno during session on 22 May 1692, c. 2*v*.
69 ASV, *Sant'Uffizio*, b. 135, trial against Giacomo Stecchini, spontaneous appearance
 by Bernardo Testi on 21 May 1711 and declaration by Giacomo on 23 February 1712.
70 ASV, *Sant'Uffizio*, b. 138, Margherita Mazzer file [...], trial against Daniele Alberti,
 deposition by Michelangelo Bellotto on 6 February 1721.
71 See *Theophrastus redivivus*, eds G. Canziani and G. Paganini (2 vols, Florence: La
 Nuova Italia, 1981), and Gregory, *Theophrastus redivivus*, 14–15.

In this sense, the attempt to distinguish oneself from common people, a typical feature of *libertinage érudit*, included an elitist conservative component and was more a question of attitude and speech than social belonging. Such libertine elitism was more a personal vindication of specificity than a social fact, an attempt to classify society on the basis of freedom of thought rather than social class. Nobody in principle questioned the theory according to which politics, knowledge, culture, readings and unbelief were matters for the elect few and that there would be disastrous consequences if they became common property. Common consensus held it proper for these areas to be separate and protected; secrecy was an essential requirement both for official holders of 'high' knowledge and users of discourse about that knowledge. The fact was that from the mid-seventeenth century onwards an increasingly large number of individuals felt that they could join this once-proscribed group and therefore become one of those detached from the masses. The implicit agreement was that there were things which others should not speak about, special hidden sectors of knowledge reserved for a few people. In other words, as Arlette Farge stated some years ago, 'Everyone *assumed* the right to speak and think, and this universal self-licensing, punctuated by a repression which did nothing to weaken it, gave rise not so much to new forms of subversion as to a refinement in cognitive and reflective capacities. The originality of this period lies in the forms taken by discussion and criticism rather than in their actual content'.[72]

The development of dangerously deviant ideas and the acceptance of religion as an instrument of social control made people feel that they belonged to an elite group by right. They used terms such as 'ignorant' or 'idiot population' as distinctions wholly founded on the idea of doctrine regardless of their personal positions. Selection therefore took place according to the image of an educated man, an image each person tried to apply to himself, changing language and ideas to present himself as a social model. 'A large number of great and literate people' told Orsola Ciuran, a junk dealer, that hell did not exist, that the sacraments were ineffective

72 Arlette Farge, *Subversive Words: Public Opinion in Eighteenth-Century France*, tr. Rosemary Morris (University Park, Pa.: Pennsylvania State University Press, 1995), 179.

and that the soul was mortal, indeed so many that they were described
as 'almost the whole world'. Ciuran shared these truths with her fellow
tenant Maddalena, and 'they both decided to refuse to receive the holy
sacraments'[73] in an attempt to imitate educated people. 'One really needs
to say something in order not to come across as a baboon,' said Grando de
Grandi in 1692, after he had been reprimanded for suggesting that the soul
was mortal, the hereafter did not exist, and religion was an imposture.[74]
Expressing ideas associated with 'wits' introduced an element of differ-
ence, creating distance between the proponent and the 'baboons' who
were unable to understand such sentiments.

In order to limit disputes with authorities, Menocchio the miller fre-
quently told fellow villagers that he wanted to speak to the authorities
about his opinions regarding faith.[75] The taste for argument, the chance to
exchange ideas, and the agnostic element of thought were well-defined by
Giovanni Bresciani in the early eighteenth century. Bresciani often asked
himself questions about divine justice and concluded that it did not exist.
He soon tired of speaking 'to myself' though, and so

> I was extremely tempted by the desire to find a learned man to have a discussion with,
> and I thought that nobody would be able to convince me and settle my doubts about
> faith [...] therefore I wanted to meet the most learned men in the world, because
> I had wanted to discuss these things for a long time [...] and on other occasions I
> expressed my doubts to others to put forward some problems.[76]

This 'close-up' use of verbal exchanges narrated by witnesses helps to
dissolve the cumbersome categories of the history of ideas and philosophy,
demonstrating their limited use in grasping the transience, agility, rapidity
and violence of the positions embodied in real people.

73 ASV, *Sant'Uffizio*, b. 103, Ludovico Fugarola file ..., trial against Orsola Ciuran,
 spontaneous appearance by Antonia Sgambozza on 5 June 1646.
74 ASV, *Sant'Uffizio*, b. 127, trial against Grando de Grandi, spontaneous appearance
 by Zanetta de Grandi on 3 September 1692.
75 Ginzburg, *The Cheese and the Worms*, 8.
76 ASV, *Sant'Uffizio*, b. 136, trial against Giovanni Bresciani and Antonio Legrenzi,
 spontaneous appearance by Giovanni Bresciani on 26 March 1709.

PAUL R. WRIGHT

12 The Raw and the Cooked: The Renaissance as Cultural Trope in Times of Crisis

Introduction

As a means of interrogating the philosophical and historical assumptions that animate nineteenth- and twentieth-century conceptions of the Italian Renaissance, this paper frames two moments of acute cultural crisis wherein the Renaissance past becomes a touchstone for a tortured present. The first instance involves the intensely conservative reaction to the age of revolution in which Jacob Burckhardt lived and constructed his historiographical template of the Renaissance; the second involves the post-World War II malaise that infuses Graham Greene's novella *The Third Man*, as well as its cinematic incarnation in Sir Carol Reed's iconic film. In each case, the interplay between historiographical practice and popular culture suggests that the Renaissance as a cultural construct is a painful negotiation between the traces and artifacts of early modernity; the historian's instinct to periodize and categorize; and the contemporary anxieties that fuel that process of re-imagining the past. To borrow from Lévi-Strauss's famous formulation, the question becomes how the 'raw' material of the Italian Renaissance is 'cooked'[1] – and under what ideological conditions.

1 See Claude Lévi-Strauss, *The Raw and the Cooked: Mythologiques, vol. 1*, trans. John and Doreen Weightman (Chicago: University of Chicago Press, 1983).

Part I:
Jacob Burckhardt and the Tumultuous Nineteenth Century

The first case returns us to Burckhardt's foundational work on the Renaissance, but not in the vein of the usual re-assessments of *The Civilization of the Renaissance in Italy*.[2] Rather than mining that well-travelled ground, I am instead interested in how Burckhardt's commentary on nineteenth-century political and cultural developments shaped his seminal contribution to the discourse of the Renaissance. By returning to Burckhardt's lecture notes from his teaching at the University of Basel, we come to see how Burckhardt's anxieties about popular culture fuelled his analysis and critique of the Renaissance. These notes – a treasure-trove of theoretical and historical insights from twenty years' worth of lectures – were posthumously published in German and later translated into English in 1943 as *Reflections on History* for George Allen & Unwin, and as *Judgments on History and Historians* for the Beacon Press in 1958.[3] If Burckhardt's masterful publications on *The Age of Constantine*

2 All quotations from this text are drawn from Jacob Burckhardt, *The Civilization of the Renaissance in Italy*, trans. S.G.C. Middlemore, 2 vols (New York: Harper, 1958).

3 The conventional German title has been *Weltgeschichtliche Betrachtungen* [*World-Historical Reflections*] ever since Burckhardt's nephew posthumously arranged the notes. All quotations from the lectures here are drawn from Jacob Burckhardt, *Reflections on History*, trans. M.D. Hottinger (Indianapolis, IN: Liberty Classics, 1979). Where references to the German original are necessary for clarification and for evoking Burckhardt's original sense, they are rendered parenthetically; the source for the German is *Weltgeschichtliche Betrachtungen*, Kröners Taschenausgabe, vol. 55 (Leipzig: Alfred Kröner, 1952). Another English translation that collates Burckhardt's notes rather differently is Jacob Burckhardt, *Judgments on History and Historians*, trans. Harry Zohn (New York: Harper, 1958). Beyond the scope of this essay, a source and translation study of these lecture 'texts' would be well rewarded, and would tell a great deal about the differing interpretive effects of their varying organization and emphases at the hands of different editors, translators, and publishers. The English titles for the various translations mentioned here already indicate quite different critical orientations at work in Burckhardt's reception.

the Great (1853) and *The Civilization of the Renaissance in Italy* (1860) are the Platonic forms of nineteenth-century historiography, his lecture notes – never intended for publication and collated by others – put him in the company of Aristotle. As with that ancient thinker, Burckhardt the teacher comes to us mediated and piecemeal.

It is striking throughout these lecture notes how self-aware Burckhardt is of the troubling fact that 'our historical pictures are ... pure constructions, ... mere reflections of ourselves'.[4] It is this narcissistic ailment of historicism that leads Burckhardt to reject traditional conceptions of fortune and misfortune as historical explanations; Burckhardt locates in this conceptual framework a perverse attachment to the desire for self-justification on the part of his contemporary 'moderns', who seem always to seek themselves as the providential inheritors of the past's 'necessary' brutality. And yet despite this awareness, Burckhardt nevertheless allows his own deeply conservative discomfort with the revolutions of 1789 and 1848 to drive him deeper into a tortured fascination with the Renaissance as the spiritual origin point of the horrors of post-1789 Europe as he imagined them. Burckhardt's primal conservatism also instilled in him a marked distaste for journalism, popular culture, and other forms of emergent mass culture. I will trace this virulent anti-populism as a key ingredient not only in Burckhardt's teaching, but in his historiographical practice as well.

Students of the early modern period know well the tropes we have inherited from Burckhardt on Renaissance individualism. How he located in Renaissance figures that dynamic interplay of ambition, violence, and creativity – resulting in the application of the highest artistry, the highest aesthetic sensibility, not only to painting, literature, and architecture, but also to the most violent enterprises, including warfare, civil strife, and that most private of feuds made public, the vendetta. Evoking the Renaissance Italian's 'play of power in shaping whatever subject he dealt with in word or in form', Burckhardt found in this widespread intensification of subjectivity both the grand achievement and the moral devolution of the period: 'The fundamental vice of this character was at the same time a condition

4 Burckhardt, *Reflections on History*, 35.

of its greatness – namely, excessive individualism.'[5] Burckhardt's overall reaction to such a culture is a heady mixture of admiration and repulsion.[6] The viability and conceptual underpinnings of Burckhardt's account have become a source of perpetual debate, particularly in light of post-structuralism's denial of the subject and in light of the usual battles and occasional rapprochement between political historians, cultural historians, and historians of ideas. Nevertheless, what compels me more than this well-traveled ground is not the accuracy of Burckhardt's social history, but its narrative of historical character itself, particularly its underlying assumptions regarding the correlation between cultural production and violence in their many forms.

In the *Civilization*, Burckhardt seemingly eschews any sustained moral critique of the culture he describes, recognizing matter-of-factly the genea-logical affinity between the Renaissance and his own age. He writes:

> But this individual development did not come upon [the Italian Renaissance indi-vidual] through any fault of his own, but rather through an historical necessity. It did not come upon him alone, but also, and chiefly by means of Italian culture, upon the other nations of Europe, and has constituted since then the higher atmosphere which they breathe. In itself it is neither good nor bad, but necessary; within it has grown up a modern standard of good and evil – a sense of moral responsibility – which is essentially different from that which was familiar to the Middle Ages. But the Italian of the Renaissance had to bear the first mighty surging of a new age. Through his gifts and passions he has become the most characteristic representative of all the heights and all the depths of his time. By the side of profound corruption appeared human personalities of the noblest harmony and an artistic splendor which shed upon the life of man a luster which neither antiquity nor medievalism either could or would bestow upon it.[7]

5 Burckhardt, *Civilization of the Renaissance*, 2: 426–7.
6 Writing of the Renaissance individual in his characteristic style, Burckhardt's ambiva-lence is always evident: 'In face of all objective facts, of laws and restraints of what-ever kind, he retains the feeling of his own sovereignty, and in each single instance forms his decision independently, according as honor or interest, passion or calcula-tion, revenge or renunciation, gain the upper hand in his own mind' (Burckhardt, *Civilization of the Renaissance* 2: 442).
7 *Ibid.*, 2: 442–3.

Yet despite Burckhardt's periodizing faith that the Renaissance had 'shed upon the life of man a luster which neither antiquity nor medievalism either could or would bestow upon it', it is in his lecture notes that he more clearly indulges a conservative and almost allergic reaction to the very structures of emerging modernity he had detailed so well elsewhere.[8]

In these lectures, he posits history as a defining discipline for any culture, attributing ignorance or renunciation of it only to 'barbarians or to Americans', whom he sees as representative of 'unhistorical cultures [*ungeschichtliche Bildungsmenschen*] who cannot quite shake off the old world'.[9] The general outline of Burckhardt's historical theory follows a pattern consonant with much of nineteenth-century Hegelian thought. He describes the interplay of state, religion, and culture, with state and religion as relative constants undergoing critique and elaboration from the realms of culture as 'the sum total of those mental developments which take place spontaneously and lay no claim to universal or compulsive authority'.[10] He adduces a corresponding interaction between the convulsive crises of historical revolutions ('the theory of storms', or *Sturmlehre*) and the 'condensation [*Verdichtung*] of the historical process' in 'great individuals'.[11] As we will see in a moment, Burckhardt's unique contribution to the historical discourse of his time lies in his critique of the concepts of fortune and misfortune as interpretive tools. Rejecting the conceptual crutches of fortune and misfortune is, for Burckhardt, the only way 'to safeguard our

8 In this regard, Burckhardt shares certain perspectives with Nietzsche's account of the *Genealogy of Morals* as an inherently historical process leading to the impossibility of absolute moral judgement. In fact, Nietzsche claimed in his own typically bold fashion that he was the only person really to understand Burckhardt's lectures and ideas. If Burckhardt could not consistently espouse Nietzsche's radical rejection of moral systems as fundamentally illegitimate (or at least unsubstantiated), he nonetheless shared with Nietzsche a powerful sense of the difficulties inherent in explicating moral standards *vis-à-vis* history itself, i.e., the *illegibility* of moral standards in the chaos of collective human experience.

9 Burckhardt, *Reflections on History*, 39.

10 *Ibid.*, 93.

11 *Ibid.*, 31.

impartiality against the invasion of history by desire' [*unsere Objektivität gegen Übertragung des Wünschbaren in die Geschichte zu wahren suchen*].[12]

For Burckhardt, it is precisely desire and self-interest that most distort and cloud historical understanding. He elaborates:

> After all, our historical pictures are, for the most part, pure constructions, as we shall see more particularly when we come to speak of the state. Indeed, they are mere reflections of ourselves. ... Nor can we ever rid ourselves entirely of the views of our own time and personality, and here, perhaps, is the worst enemy of knowledge. The clearest proof of it is this: as soon as history approaches our century and our worthy selves we find everything more 'interesting' [*interessanter*]; in actual fact it is we who are more 'interested' [*interessierter*].[13]

The contrivance of our 'historical pictures' [*unsere Bilder*] as 'mere reflections of ourselves' [*bloße Reflexe von uns selbst*] speaks to Burckhardt's uneasiness about the potential narcissism of historicism, both with respect to the individual historian and to self-interested cultural communities grounded too deeply in their own moment to see or even care about their own distortions of the past. In the face of such limitations, Burckhardt prefers historical endeavour as an anthropological perspective on human suffering defined in the broadest, most encompassing terms. Embarking 'from the one point accessible [*möglichen*] to us, the one eternal center of all things [*einzigen bleibenden ... Zentrum*] – man, suffering, striving, doing, as he is and was and ever shall be', Burckhardt offers an historical method that he deems 'pathological in [nature]' [*pathologisch*].[14] As he puts the ambition of this method: 'We wish experience to make us, not shrewder (for next time), but wiser (for ever)' [*Wir wollen durch Erfahrung nicht sowohl klug (für ein andermal) als weise (für immer) werden*].[15]

12 *Ibid.* 32.
13 *Ibid.*, 35, 41.
14 *Ibid.*, 34.
15 *Ibid.*, 39. Burckhardt here elaborates: 'The mind must transmute into a possession the remembrance [*Erinnerung*] of its passage through the ages of the world. What was once joy and sorrow must now become knowledge, as it must in the life of the individual. Therewith the saying *Historia vitae magistra* takes on a higher yet a humbler sense.'

If Burckhardt's ideal historian must know the difference between next time and forever, and must become the pathologist of historical suffering to calculate the net gains of cultural experience, it is fascinating how his conception of the vocation is so embedded in the very rhetoric of possession, exchange, and commerce of which he was often so critical. To be sure, Burckhardt positioned himself as no fan of the levelling effects of modern commerce and communication. He writes of how patriotism is yet another form of self-delusion that 'often consists simply in causing pain to others' [*nur in Wehetun gegen andere*], an agony whose appropriate chronicler is only the lowly journalist [*Publizist*]. His deepest cynicism about modern commercialism can be felt in these notes, wherein he is simultaneously utterly dependent on the metaphors enabled by commerce:

> Vehement proclamations of metaphysical notions, vehement definitions of good and right, condemning everything outside their limits as high treason [*Hochverrat*], may subsist side by side with the most platitudinous round of life and moneymaking [*kann ein Fortleben im ordinärsten Philisterleben und Erwerbtreiben bestehen*].
>
> ...
>
> In the realm of thought [*im geistigen Gebiet*], it is supremely just and right that all frontiers should be swept away. There is too little of high spiritual value strewn over the earth for any epoch to say: we are utterly self-sufficient [*wir genügen uns vollständig*]; or even: we prefer our own [*wir bevorzugen das Einheimische*]. That is not even the case with the products of industry [*Industrie produkte*], where, given equal quality [*gleicher Qualität*], and due account [*mitberechnet*] being taken of customs dues and freight charges [*Zoll und Transport*], people simply take the cheaper, or, if the price is the same, the better. In the realm of mind we must simply strive for the higher, the highest [*Höchsten*] we can attain.[16]

Throughout his lectures, Burckhardt insists upon the necessity of protecting historical endeavour from the taint of commerce and other baser forms of linguistic traffic, including popular culture and mass communication forms like historical novels and print journalism, perpetrators of the noisy 'acoustic illusion in which we live' [*die große akustische Täuschung in Betracht, in der wir leben*].[17] Yet in the passage above he not only employs

16 *Ibid.*, 42, 43.
17 *Ibid.*, 44.

commercial metaphors, but overindulges them in a sense; he likens things of 'high spiritual value' [*Höchsten*], history's rare luxuries, to products of cultural industry whose consumers should not obsessively check for time or country of origin as a measure of value, but rather consider comparable in quality. Levelling the intellectual trade deficit is Burckhardt's way of both alluding and glossing over the historical suffering implicit in those cultural products.

Citing originality as 'the intellectual pest of our time' [*die jetzige geistige Pest*], Burckhardt bemoans originality's deep-rooted affiliation with the dominance of intellectual property, by which exchanges are discouraged: 'It is only very vigorous epochs [*kräftige Zeiten*] that can give and take without wasting words [*geben einander und nehmen voneinander ohne ein Wort zu verlieren*]'.[18] Tenaciously retaining the commercial metaphors even in the midst of challenging them, he suggests that the contemporary intellectual 'must be very rich [*muß einer schon sehr reich sein*] to allow others to take from him without protest, without "claiming" [*reklamieren*] his ideas as his own, without squabbling about priority [*ohne Prioritätenhader*]'.[19] The epochs most qualified for overcoming this pettiness in his estimation are classical Athens and Renaissance Florence, which represent the achievement of 'the free intellectual mart' [*die freien geistigen Tauschplätze*] in 'clarity of all expression and the unerring sense of what men want', such that 'the arbitrary and the strange are shed, a standard and a style won' [*der Gewinn eines Maßstabes und eines Stiles*].[20] Despite all his fundamental discomfort with the conceptual power of the commercial, Burckhardt cannot avoid figuring the republic of letters as a well-managed marketplace wherein the consumptive supply and demand of aesthetics are coordinated. As he most strongly asserts, 'Originality must be possessed, not striven for' [*Originalität muß man haben, nicht danach streben*].[21]

Burckhardt characterizes the broader 'economy of world history' [*die Ökonomie der Weltgeschichte*][22] as the shifting deployment of force,

18 *Ibid.*, 170.
19 *Ibid.*, 170.
20 *Ibid.*, 171–2.
21 *Ibid.*, 170.
22 *Ibid.*, 335.

suffering, and culture. As in his studies of Renaissance culture, his lectures describe the potential, perhaps necessary, convergence of 'high refinement in social life and the state [...] side by side with a total absence of safeguards for individual life and the perpetual urge to enslave others in order to avoid being enslaved by them'. Envisioning modern subjectivity as an increasingly fine-tuned 'domestication of individuality' [*Bändigung des Individuums*], he sees its most abdicating gesture in the triumph of commercial culture, 'where moneymaking predominates [*Vorherrschen des Gelderwerbs*] to the exclusion of everything else, ultimately absorbing all initiative [*alle Initiative absorbiert*].'[23] Modernity for Burckhardt is at last the crass and fundamental urge to protect commerce and the comforts it codifies, its sustenance neither of body or spirit, but of a 'secret mental reservation [...] that moneymaking is today easier and safer than ever' [*geheime Vorbehalt [...] daß das Geldverdienen heute leichter und sicherer sei als je*].[24] Burckhardt sums up his sweeping critique of commercial life and its various forms of security, insurance, and epistemological reassurance in a simple, nostalgia-laden defence of the culture of the European Middle Ages: 'Our life is a business, theirs was living' [*Unser Leben ist ein Geschäft, das damalige war*

23 *Ibid.*, 103.
24 *Ibid.*, 104. Elsewhere in the lecture notes, Burckhardt delivers one of his most devastating critiques of modern commodification: 'According to this judgment, the prime condition of any happiness is the subordination of private purposes [*die Unterordnung der Willkür*] to a police-protected law, the treatment of all questions of property by an impartial legal code and the most far-reaching safeguarding of profits and commerce [*die Sicherung des Erwerbs und Verkehrs im größten Maßstab*]. The whole morality of our day [*unsere ganze jetzige Moral*] is to a large extent oriented toward this security, that is, the individual is relieved of the most vital decisions in the defense of house and home, in the majority of cases at any rate. And what goes beyond the power of the state is taken over by insurance [*die Assekuranz*], that is, the forestalling of definite kinds of misfortune by a corresponding annual sacrifice [*durch bestimmte jährliche Opfer*]. As soon as a livelihood or its revenues [*die Existenz oder deren Rente*] have become sufficiently valuable [*wertvoll*], the neglect to insure it is considered culpable [*ein sittlicher Vorwurf*]. Now this security was grievously lacking at many times which otherwise shine with an immortal radiance and till the end of time will hold a high place in the history of man' (Burckhardt, *Reflections on History*, 325).

ein Dasein].²⁵ It should be clear by now how Burckhardt's objections to commerce and popular culture continually resurface in and thereby reify the very rhetoric he would combat.

On the home front, Burckhardt acknowledges both the relative misfortune of contemporary 'wage earners' [*Erwerbenden*] and their acceleration of the state's extension, the price of which is 'the enormous competition in every detail of life, and their own unrest' [*die enorme Konkurrenz vom Größten bis ins Geringste und die Rastlosigkeit*].²⁶ Denying ultimately the utility and meaning alike of fortune and misfortune [*Glück und Unglück*], he notes how happiness is predicated on an economy of suffering, finding happiness a 'desecrated word' [*entweihtes [...] Wort*] whose underlying impurities could not be altered one bit, even were there 'a world plebiscite to decide on the definition'.²⁷ These anxieties reach a fever pitch as he takes the absurd bait of his own challenge to fortunate falls everywhere, and he is left ironically, yet still magisterially, trying to consolidate contemporary opinion on the great crises of history, in what amounts to a singularly bizarre passage in nineteenth-century historical writing.

> We, however, may judge as follows:
> It was fortunate that the Greeks conquered Persia, and Rome Carthage; unfortunate that Athens was defeated by Sparta in the Peloponnesian War; unfortunate that Caesar was murdered before he had time to consolidate the Roman Empire in an adequate political form; unfortunate that in the migrations of the Germanic tribes so many of the highest creations of the human spirit perished, but fortunate that they refreshed the world with new and healthy stock; fortunate that Europe, in the eighth century, on the whole held Islam at bay; unfortunate that the German emperors were defeated in their struggle with the papacy and that the church was able to develop its terrible tyranny; unfortunate that the Reformation triumphed in only half of Europe and that Protestantism was divided into two sects; fortunate that first Spain and then Louis XIV were eventually defeated in their plans for world dominion, etc. The nearer we come to the present, of course, the more opinions diverge [*Freilich, je näher der Gegenwart, desto mehr gehen dann die Urteile auseinander*].²⁸

25 *Ibid.*, 103.
26 *Ibid.*, 106.
27 *Ibid.*, 328.
28 *Ibid.*, 318–19.

It is impossible to gauge adequately the mix of high seriousness and playful irony at work in this passage, not to mention the conceptual vocabulary that makes it possible. These evaluations of historical turning points are indeed essentially consistent with Burckhardt's attitudes throughout his lectures and writings, yet he also claims a broadly self-reflective critique of this kind of thinking, holding his opinions as learned insights while wondering himself how he got to them. If his account of historical suffering seems absurd, I think it is by theoretical and rhetorical design.

Burckhardt warily identifies his own synthesized account of fortune and misfortune with the 'optical illusion' [*optische Täuschung*] of historical thinking on which desire continually intrudes; he figures the past as a countryside cottage whose 'smoke rising [...] in the evening gives us the impression of intimacy [*Innigkeit*] among those living there'.[29] It is this domestication of the past and its horrors that Burckhardt finds the most objectionable, this effort to render the past intelligible, manageable, and comfortable, an effort he risks making his own. Burckhardt's critique of happiness is that it is a hollow, literary consolation, a rhetorical feature of 'the mysterious law of compensation' [*das geheimnisvolle Gesetz der Kompensation*][30] in which we pretend that various sorts of benefits resulting from suffering outweigh its brutal origins, as exemplified by Burckhardt's own ledger of historical misfortune discussed above. Whether historical compensation comes in the form of population growth, cultural achievement, or spiritual development is to Burckhardt irrelevant, merely a shift in what he calls 'the accent of the world' [*Weltakzent*].

> The compensation, however, must not be taken as a substitute for suffering [*ein Ersatz der Leiden*], to which its originator [*der Täter*] might point, but only as a continuance of the life of wounded humanity [*verletzen Menschheit*] with its center of gravity shifted. Nor must we hold it out to the sufferers and their dependents. [...] The theory of compensation is, after all, generally the theory of desirability [*die Lehre von der Wünschbarkeit*] in disguise, and it is and remains advisable to be exceedingly chary in the use of such consolation as is to be gained from it, since we cannot fully assess these losses and gains [*diese Verluste und Gewinste*]. Bloom

29 *Ibid.*, 319.
30 *Ibid.*, 335.

and decay are certainly the common lot, but every really personal life [*jedes wahre Einzelleben*] that is cut off by violence, and (in our opinion) prematurely, must be regarded as absolutely irreplaceable [*schlechthin unersetzlich*], indeed as irreplaceable even by one of equal excellence.[31]

At last, it becomes clear that Burckhardt's account of historical suffering denies by methodological design the rationalization or calculability of violence and force in historical process. 'Since we cannot fully assess these losses and gains', as he puts it, the language of commerce remains a dead end, a conceptual cul-de-sac that Burckhardt cannot escape, despite all his self-reflective efforts. For Burckhardt, self-reflection and historical reflection on suffering each remain rooted in the paradigms of the economic. Burckhardt sees the paradox perfectly, finding that in the communicative and commercial traffic of modernity, 'the realization and impatience of suffering [*des Leidensbewußtseins und der Ungeduld*] are visibly and rapidly growing',[32] while the fantasy of calculable control of suffering reveals how 'so much discussion, reading, and travel have a stupefying effect' [*die Leute eher abstumpfe*].[33] Burckhardt's frustration with the historical amnesia of his contemporaries is illustrated in his claim that 'it is generally impossible for the present-day average "educated" man to find anything appealing in the ancient world' because of 'the total egoism of today's private person who wants to exist as an individual and asks of the community only the greatest possible security for himself and his property, for which he pays his taxes amid sighs'.[34] This amply demonstrates that there are few charges we might level at Burckhardt's age in which we have no continuing share.

To conclude this reflection on Burckhardt, we hopefully have some new insights into why the Renaissance held such fascination for him. These go well beyond the usual claims that conceptions of nineteenth-century German *kultur* animated Burckhardt, as they most surely did. Lionel Gossman, Christopher Celenza, and Peter Watson have all rightly

31 *Ibid.*, 336–7.
32 *Ibid.*, 340.
33 *Ibid.*, 226.
34 Burckhardt, *Judgments on History and Historians*, 5–6.

seen Burckhardt in the light of complex German cultural developments. Gossman finds his Burckhardt in the context of the city-republic of Basel that Burckhardt famously idealized as his 'Archimedean point outside events'; Celenza's masterful study of *The Lost Italian Renaissance* sees a misleading linguistic nationalism in Burckhardt's preference for the Italian vernacular and de-emphasis on Latinate writing culture; and Watson's provocative study of *The German Genius* asserts unequivocally that 'the Italian Renaissance was a German idea' and that Burckhardt was part of what Watson calls 'Europe's third renaissance' by way of German culture.[35] Yet for all of this, the Burckhardt I want to portray here is that of an historian who was driven as much by his allergic reactions to commerce and popular culture as he was by the 'higher ideas' he loved and documented so well.

Part II:
Graham Greene, Orson Welles, and the Post-war Malaise

My second and final case brings us to another moment of crisis in the aftermath of the Second World War, one in which the Renaissance is deployed as an historical trope to explain the cataclysm of Europe as an inevitability. Sir Carol Reed's masterful film *The Third Man* (1949), scripted by British novelist Graham Greene and starring Joseph Cotten and Orson Welles, is set in a post-war Vienna divided amongst American, British, French, and Russian forces. The film depicts Cotten as Holly Martins, an American writer of hard-boiled pulp-fiction and westerns who comes to Vienna in

35 See Lionel Gossman, *Basel in the Age of Burckhardt: A Study in Unseasonable Ideas* (Chicago: University of Chicago Press, 2002); Christopher Celenza, *The Lost Italian Renaissance: Humanists, Historians, and Latin's Legacy* (Baltimore: Johns Hopkins University Press, 2005); Peter Watson, *The German Genius: Europe's Third Renaissance, the Second Scientific Revolution, and the Twentieth Century* (New York: Harper, 2011).

search of his long-time friend, Harry Lime (Welles). Cotten discovers
that Lime has apparently been murdered, only later to find that Lime is
in fact not at all dead, but instead the head of a ruthless gang of post-war
racketeers selling penicillin diluted with sand on the black market for an
exorbitant profit. The tainted penicillin is worse than useless; it has caused
the death of numerous children suffering from meningitis.

In a now iconic scene set atop a swaying Ferris wheel revolving above
the war-torn city, Cotten confronts his old friend with the immorality
of his new profession. Let us look at their exchange as given in Graham
Greene's original script treatment:

> 'Were you going to cut me in on the spoils?'
> 'I've never kept you out of anything, old man, yet.' He stood with his back to
> the door as the car swung upwards, and smiled back at Rollo Martins,[36] who could
> remember him in just such an attitude in a secluded corner of the school-quad,
> saying, 'I've learned a way to get out at night. It's absolutely safe. You are the only
> one I'm letting in on it.' For the first time Rollo Martins looked back through the
> years without admiration, as he thought: He's never grown up. Marlowe's devils wore
> squibs attached to their tails: evil was like Peter Pan – it carried with it the horrifying
> and horrible gift of eternal youth.
>
> Martins said, 'Have you ever visited the children's hospital? Have you seen any
> of your victims?'
>
> Harry took a look at the toy landscape below and came away from the door.
> 'I never feel quite safe in these things,' he said. He felt the back of the door with
> his hand, as though he were afraid that it might fly open and launch him into that
> iron-ribbed space. 'Victims?' he asked. 'Don't be melodramatic. Look down there,'
> he went on, pointing through the window at the people moving like black flies at
> the base of the Wheel. 'Would you really feel any pity if one of those dots stopped
> moving – for ever? If I said you can have twenty thousand pounds for every dot that
> stops, would you really, old man, tell me to keep my money – without hesitation?
> Or would you calculate how many dots you could afford to spare? Free of income
> tax, old man. Free of income tax.' He gave his boyish conspiratorial smile. 'It's the
> only way to save nowadays.'[37]

36 Rollo Martins becomes 'Holly' in the final script for Joseph Cotten's role.
37 Graham Greene, 'The Third Man' and 'The Fallen Idol' (London: Penguin, 1963),
 104.

This original script treatment has what is already an oblique reference to the Renaissance, with Martins recognizing the contrast between Christopher Marlowe's squib-tailed 'devils' in *Doctor Faustus* and the child-like, Peter Pan evil of Harry Lime – perhaps Graham Greene's commentary on both the disarming nature of 'genuine' evil, and on the specific character of decidedly 'modern' evil. The essence of that modern evil, Greene seems to suggest, lies not only in the Peter Pan syndrome, but also in the temptation to economic rationalization of human misery. Harry conceptualizes his victims' suffering as an abstraction from on high, an economic opportunity for unparalleled tax-free profit that transcends morality. This ought to lead us to question the connection between economic language and representations of suffering, the interplay of what we might call a metaphoric calculus of suffering and the profit motive. One should bear in mind that Harry describes his cruel enterprise as the 'only way to save nowadays', alluding not to a profligate waste of resources, but rather to an ethic of saving for the future that would have made Max Weber's Protestant burghers proud.

Yet still more famous (and even more relevant to the invention of the discourse of the Renaissance) is the final, filmed version of this scene. Harry's final, ironic rejoinder to his friend's moral censure is a parting shot from Welles to Cotten that was inserted into the final shooting script by Welles himself:

> 'Don't be so gloomy. After all, it's not that awful. You know what the fellow said. In Italy for thirty years under the Borgias, they had warfare, terror, murder, and bloodshed. But they produced Michelangelo, Leonardo da Vinci, and the Renaissance. In Switzerland, they had brotherly love. They had five hundred years of democracy and peace. And what did that produce? [...] The cuckoo clock.'[38]

It is impossible to render textually the confident, suave delivery that Welles gives these lines. Harry's chilling mixture of school-boy sarcasm, total self-awareness, and unfeeling indifference to suffering may seem easy to dismiss as a feeble, sophistic attempt at self-justification. Even Harry's facts are a

38 Carol Reed, director, *The Third Man* (David Selznick, Alexander Korda, and Carol Reed, producers, 1949).

little off-kilter – the cuckoo clock by most accounts hails from the Black Forest of Germany; and of course the logic of the connection between Renaissance culture and his own criminal pursuit of self-interest leaves much to be desired. Nevertheless, it is important to remember how Harry's answers give his troubled friend pause, stopping the encounter dead in its tracks – not so much for their logic as their nihilistic seductiveness. Harry's Lucifer-like temptations to his friend as they survey the shattered earthly kingdom below them are meant as a moral test of friendship and cultural ethics alike. And meta-narratively, Harry provocatively suggests to the post-war audience of *The Third Man* that by analogy to the Renaissance, the horrors of the Second World War will pay for the new wonders of modernity – assuming the victorious Allies want to be atomic powers and not mere makers of 'cuckoo-clocks'.

Graham Greene and Orson Welles's summation of the relationship between amoral violence, unmerited suffering, and high culture provides us with a picture of the Renaissance and historical change that Burckhardt would have recognized. The cinematic example of *The Third Man* suggests that to whatever extent popular culture continues to dialogue with the concept of the Renaissance (and even less so with the reality of its artifacts and traces), this dialogue happens via the glamorization of Renaissance culture as 'compensation' for the worst excesses of human cruelty – or even the quasi-commercial assessment of that cruelty as a 'necessary price' to pay for that culture. This theme of cultural achievement paid for in the currency of amoral cynicism – a notion which both enthralled and disturbed Burckhardt in his lectures – continues to resonate in popular culture today, including in such recent television shows as *The Tudors* and *The Borgias*.

Conclusions

To conclude, the examples of Burckhardt and *The Third Man* remind us in turn how the Renaissance continues to haunt and shape us – and how we continue to re-shape it to our own purposes. Whether Orson Welles made

his addition to the *Third Man* screenplay in direct response to the Swiss Burckhardt ('you know what *the fellow* said') is worth considering,[39] but more important is recognizing how in the chaos of both the nineteenth and twentieth centuries, the Renaissance remained a powerful touchstone for processing European crisis. All three writers I have discussed – Burckhardt over a lifetime of scholarship, Greene as a novelist and screenwriter, and Welles in an actor's improvised addition to a scene needing a proper gut-punch to end it – were looking to process the perceived horrors of their own moments. Burckhardt, paradoxically, deployed the Renaissance as both an elitist, nostalgic alternative to the mass culture of his own time, and as the era whose moral pathology led to that mass culture and social unrest. Welles, himself a product of theatre and cinema – the emblem *par excellence* of twentieth-century mass culture – also found himself drawing on the Renaissance to critique the amorality of the post-war world, all the while allowing his character of Harry Lime to justify that amorality in the most charismatic way possible.

This charisma of amorality is the breeding-ground of culture, if we accept this line of reasoning about the Renaissance. Perhaps the paradox is never more frankly summed up than by one of Burckhardt's teaching colleagues, Nietzsche, who famously wrote in *The Genealogy of Morals*, 'How much blood and horror lies at the basis of all "good things!"'[40] Neither

39 To my knowledge, one of the only efforts to make this connection directly is a culture piece by Jonathan Jones, 'Jacob Burckhardt: The Renaissance Revisited', *The Guardian*, 9 July 2010. Jones suggests that 'Burckhardt felt the same way [as Welles's Harry Lime] – and he was Swiss. Indeed, he is presumably the fellow Welles meant. From his vantage point of a Swiss citizen of conservative politics and modest habits, Burckhardt envied 16th-century Italians their wars and assassinations.' While Jones may overstate here both Welles's knowledge of Burckhardt and Burckhardt's Swiss envy of Italian chaos, I agree with Jones that Welles must be drawing on at least a fashionable, undergraduate fascination with the Burckhardtian thesis. This raises a larger question that should be of great interest to collaborating film scholars and historians – i.e., the historical and philosophical education of Orson Welles. This is a project I intend to pursue as an outgrowth of the current study.

40 Friedrich Nietzsche, *'On the Genealogy of Morality' and Other Writings*, trans. Carol Diethe, ed. Keith Ansell-Pearson (Cambridge: Cambridge University Press), 39.

Burckhardt, Greene, nor Welles strike me as the sort of people to necessarily celebrate that truth (although Harry Lime certainly seems content to revel in and profit by it). Yet I would wager that all three – Burckhardt, the Swiss historian alienated from and fascinated by European modernity; Greene, the iconic British novelist of post-war skepticism and 'seediness'; and Welles, the quintessentially tragic prodigy of American cinema – all found this Nietzschean paradox an impossibly stubborn notion to clear out of their incisive and creative minds. In one manner or another, subtly or otherwise, the Renaissance enabled that paradox to take root in and to shape each of their cultural projects. And now, they in turn have shaped the discourse of the Renaissance for us, bequeathing us its legacy of haunting questions.

13 The History of 'Scientific Method' (*methodus scientifica*) in the Early Modern Period and its Relevance for School-Level and University-Level Instruction in Our Time

Francis Bacon (1561–1626) is often associated with the concept of scientific method (*methodus scientifica*); however, it cannot be documented that he directly refers to it within his writings.[1] Yet it does appear that this concept began to be mentioned and discussed no later than during Bacon's lifetime.[2]

1 While Chapter 2 of Book 6 of Bacon's *De dignitate & augmentis scientiarum* is devoted to the subject-matter of method, he does not mention scientific method as such; see Francis Bacon, *Opera Francisci Baronis de Verulamio [... tomus primus: qui continet de dignitate & augmentis scientiarum libros IX.* (Londini [London]: In officina Joannis Haviland, 1623) [hereafter Bacon (1623)], 284–92; in that same Chapter, however, he makes the following comment (289, lines 9–14): 'Neque (ut iam diximus) Methodus uniformis in Materia multiformi commode se habere potest. Equidem quemadmodum Topicas particulares ad Inveniendum probavimus ita & Methodus particulares ad Tradendum similiter aliquatenus adhiberi volumus.' At the beginning (135) of Book 3 Chapter 1 of that same work, Bacon divides 'science' [scientia] into theology and philosophy; the latter is divided into natural theology [numen], natural philosophy [natura], and the study of man [homo], which includes a range of additional subject-matters beyond theology and natural philosophy; also see pages 141, 144, 145, and 181–2 with regard to Bacon's classification of the subject-matters falling within the (broad) scope of science.

2 Scientific method is apparently not mentioned in any of the three works by Francis Bacon – *The Twoo Books of Francis Bacon. On the proficence and advancement of learning, divine and humane* (London: Printed [by Thomas Purfott and Thomas Creede] for Henrie Tomes, 1605.) [hereafter Bacon (1605)], Francis Bacon [= Franciscus de Verulamio], *Instauratio magna.* (Pars secunda, Novum organum.) Apud Joannem Billium typographum regium, 1620. [Oxford, Bodleian Library: Arch. A. c. 5]

Scientific method was discussed by what appears to have been a relatively small number of authors during the sixteenth, seventeenth, and eighteenth centuries.[3] Yet these early discussions of this concept are relevant to present-day debates concerning the utilization of the scientific method when placed in the context of academic instruction at the school-and university-levels.

Scientific method appears to have its origin as a sub-category of the concept of method. Method [methodus] apparently began to be discussed as an independent concept from about the year 1550 onwards.[4] Textbooks on logic frequently (if not usually) contained a chapter or a section on method; monographic treatises and disputations devoted to this same

[hereafter Bacon (1620)], and Bacon (1623) – cited in fn. 1. But here the following point must be noted. The subject-matter of the present study limits itself to those writings where 'scientific method' – and its Latin-language equivalent, *methodus scientifica* – are specifically mentioned. One could argue that a discussion of the history of the scientific method should not be so limited. In that case, however, one would need to find a viable and defensible way of deciding what does and does not fall within the framework of scientific method over a given extended period of time.

3 This assertion is to be understood with respect to the tens of thousands of academic writings from the sixteenth, seventeenth, and eighteenth centuries (almost all of which were written in Latin) that are extant – in published and in manuscript form – at libraries in and beyond Europe. The overwhelming majority of these writings have not been utilized beyond the eighteenth century (or earlier).

4 The first published work – or one of the first published works – devoted specifically to the concept of method is Jodocus Willichius, *De methodo omnium artium et disciplinarum informanda opusculum, una cum multis utilibus et necessarijs exemplis.* Francofordii ad Viadrum [Frankfurt/Oder]: Johannes Eichorn, 1550. Berlin SB: A 1573 (nr. 1) [hereafter Willichius, *De methodo* (1550)]. The best general survey concerning the concept of method during this period remains Neal Ward Gilbert, *Renaissance Concepts of Method* (New York: Columbia University Press, 1960). Also refer to the following two discussions of method: Joseph S. Freedman, 'The Diffusion of the Writings of Petrus Ramus in Central Europe, c.1570–c.1630', *Renaissance Quarterly* 46, no. 1 (Spring 1993), 98–152: 107–11; Joseph S. Freedman, 'Encyclopedic Philosophical Writings in Central Europe during the High and Late Renaissance (c.1500–c.1700)', *Archiv für Begriffsgeschichte* 37 (1994), 212–56: 221–3, 245–6. These two articles have been reprinted in Joseph S. Freedman, *Philosophy and the Arts in Central Europe, 1500–1700*, Variorum Collected Studies Series, CS626 (Aldershot, UK and Brookfield, VT: Ashgate/Variorum, 1999), IV and V, respectively.

concept are also extant.[5] Method was often considered to have (at least) the two basic sub-categories of synthetic method and analytic method.[6]

5 For example, refer to the following: Bertius, Petrus and Burgius, Matthaeus Adriani, resp., *Theses logicae de ordine et methodo*. Lugduni Batavorum: Ex officina Ioannis Patii, 1603. [Geneva, Bibliothèque Publique et Universitaire: Cd 145* (111)] [hereafter Bertius and Burgius (1603)]; Liungh, Petrus Erici, praes. and Achrelius, Petrus Johannis, resp., *Disputatio de methodo [...] publicae disquisitionis subjecit [...] In Auditorio Vet. Maj. ad diem 13. Decemb. Anni 1651. horis a 7. Matut.* Ubsaliae [Uppsala]: Excudebat Johannes Pauli & Petrus Joh. academiae typographi. [Uppsala UB: Diss. Ups. Praes. P.E. Liung 1. 1644–1656 (8)] [hereafter Liungh and Achrelius (1651)]; Ludovicus, Jo[hannes] Petr[us], praes. and Schwerdner, Gottfr(edus), resp., *Lineamenta quaedam generalia de methodo in veritatem inquirendi. [...] Pro Magisterii gradu rite consequendo [...] publicae disquisitioni submittit [...]* Halae [Halle]: Aere Henchelinio: 18. Jan. 1694. [Munich BSB: 4 Diss. 408, Beibd. 59 [hereafter Ludovicus and Schwerdner (1694)]; Holzman, Bernardus, praes. and Zeitler, Castorius, resp., *Usus practicus logicae breviter expensus, et in communi studio philosophico [...] Congregat. Benedictino-Bavaricae p.t. in exempto monasterio Rottensi ad SS. Marinum & Anianum erecto, unacum positionibus ex universa philosophia disputationi publica propositus [...] Anno 1733. Ad diem 3. Septemb.* Typis Tegernseensibus. [Munich BSB: Diss. 2215 (7)] [hereafter Holzman and Zeitler (1733)], 1–47 (Quaestio I. De Methodo); *Compendium logicae* (1784), 37–46 (Pars Quarta. De Methodo seu Logica Practica).

6 '[...] ordo prior est & universalior Methodo [...] Verum cum philosophia duplex sit: Theoretica, quae nudam cognitionem habet, ut Metaphysica, Physica, Mathematica: Practica, quae actionem sibi proponit, ut Ethica & Politica: Ordo quoque duplex statui debet, alius Syntheticus; alius Analyticus. Tertius non datur. [...]' Bertius and Burgius (1603), A2r (III.). Bertius and Burgius equate *ordo syntheticus* with *ordo compositivus* and *ordo analyticus* with *ordo resolutivus*; and accordingly they distinguish – as does Zabarella (1578) – between *methodus compositiva* and *methodus resolutiva*; refer to Bertius and Burgius (1603), A3r (VIII., IX.), A4r–A4v (XVII., XVIII.) as well as to footnotes 7 and 8. 'Methodus dividitur secundum Keckerm. & alios communissime in universalem, & particularem suae partialem. [...] Distinguitur haec [Univeralis Methodus] in Syntheticam seu Compositivam, & Analyticam seu resolutivam.' Liungh and Achrelius (1651), fol. A3 verso (IX.–XI.). '§III. Ergo methodus vulgo duplex statuitur. Una, qua veritatem ipsi invenimus, altera, qua veritatem ipsis invenimus, altera, qua inventam cum aliis communicamus. Unde primam inventionis, secundam doctrinae appellant. [...] §XVII. Unde methodus non male iterum subdividetur in analyticam & syntheticam.' Nico(laus) Hieron(ymus) Gundlerus,

The concept of scientific method itself is mentioned no later than in the year 1578, when Jacob Zabarella briefly discusses it within his published treatise on method [*De methodis*].[7] According to Zabarella, scientific method has two component parts, one of which is 'synthetic' [demonstrativa] and the other 'analytic' [resolutiva].[8] It is possible that other

Via ad veritatem cuius pars prima arte recte id est logicam [...] Halae Magdeburgicae [Halle/Magdeburg]: Prost. in officina Rengeriana, 1713 [hereafter Gundlerus (1713)], 89, 91; Holzman and Zeitler (1733), 47: 'Quisnam est ergo connectandae veritatis ordo? [...] Quot modis istud consequimur? Duobus maxime, methodo nimirum synthetica, id est *componente*, et analytica, i. e., *resolutoria.*' *Compendium logicae in usum studiosorum Academiae Basiliensis.* Basileae [Basel]: Typis J.J. Thurneysen, 1784. [Basel UB: K.f.VI 10], [hereafter *Compendium logicae* (1784)], 44. As is evident here, *analytica* and *synthetica* were among a group of terms used in discussions of the *methodus* concept; a full discussion of the use of this terminology during the early modern period is beyond the scope of this study.

7 See Jacobus Zabarella, *Opera logica.* (Venetiis [Venice]: Apud P. Meietum, 1578) [hereafter Zabarella (1578)]; here the 1597 edition of Zabarella's *Opera Logica* (as reprinted in 1966) has been used; see id., *Opera logica [...] affixa praefatio Joannis Ludovici Hawenreuteri [...] editio tertia.* (Coloniae [Cologne]: Sumptibus Lazari Zetzneri, 1597; reprinted with an edition by Wilhelm Risse. Hildesheim: Georg Olms, 1966), [hereafter Zabarella (1597)]. It is possible that Zabarella utilized this term elsewhere in a work (in printed or manuscript form) prior to the year 1578.

8 '[...] duae igitur scientificae methodi oriuntur, non plures, nec pauciores [...] Has duas methodos in Aristotelis disciplina reperio, demonstrativam, & resolutivam; alias nec posuit Aristoteles, nec ratio videtur admittere, quod cum ex iis, quae modo dicta sunt facile colligi potest, tum ex iis, quae dicenda manent, fiet manifestissimum; nos autem fortasse non incongrua appellatione uteremur, si demonstrativam vocaremus compositivam, quam enim compositio sit via contraria resolutioni, necesse est ut quemadmodum progressus ab effectu ad causam dicitur resolutio, ita cum qui est a causa ad effectum, liceat appellare compositionem; sub resolutivam methodum reducitur inductio, ut postea declarabimus. Praeter has nullam dari aliam scientificam methodum, nullumque aliud sciendi instrumentum ergo constanter existimo, quod mihi & ipsa ratio, & Aristotelis authoritas persuasit; omnino enim credere, atque confiteri debemus praecipuum eius scopum in logica fuisse methodorum traditionem, haec enim instrumenta sciendi sunt, unde logica vocatur instrumentalis, non est igitur asserendum aliquam methodum ab Aristotele omissum fuisse de qua non docuerit; attamen nullam aliam methodum tradit, nisi demonstrativam, &

sixteenth-century authors – prior to, in, or after the year 1578 – utilized this concept as well.[9]

The first known work published specifically on the subject-matter of scientific method appeared in the year 1606. Its author, Joannes Bellarinus, was an Italian, Roman Catholic cleric whose writings – first published during the late sixteenth and early seventeenth centuries – were largely theological in content.[10] He published a large work which included a compilation of Tridentine doctrine and Roman Catholic catechism; that work apparently was first published in 1607 and went through at least twelve editions, including one from the year 1877. His treatise on scientific method, on the other hand, appears to only have been republished once (in 1630); very few copies of the 1606 edition of this treatise appear to have survived.[11]

Bellarinus's treatise on scientific method, which was first published in Milan in 1606, has the following title: Praxis *scientiarum, seu methodus scientifica practicae considerata. Ex Aristotele potissimum accepta*.[12] It consists of a dedication, a detailed table of contents, a short index, and the text. The text consists of an introduction and four 'Books' [libri]. In the

resolutivam; ...' Zabarella (1578), cols. 89–224 (De methodis libri quatuor), cols. 154–5 and Zabarella (1597), col. 133–334 (De methodis libri quatuor), cols. 230–1.

9 Refer to the point made in footnote 3.

10 Joannes Bellarinus's treatise on scientific method is discussed in detail – together with brief discussion of his theological writings – in the following article: Joseph S. Freedman, 'A Neglected Treatise on Scientific Method (methodus scientifica) published by Joannes Bellarinus (1606)', Jörg Schönert und Friedrich Vollhardt, eds, *Geschichte der Hermeneutik und die Methodik der textinterpretierenden Disziplinen*, Historia Hermeneutica. Series Studia 1 (Berlin, New York: de Gruyter, 2005), 43–82: 43–5, 65–6.

11 The only copy of Bellarinus published in 1630 that I have located to date is Joannes Bellarinus, *Speculum humanae atque divinae sapientiae, seu Praxis scientiarum et methodus scientifica*. (Mediolani [Milan]: Apud haeredes P. Pontii, 1630) [Paris, Bibliothèque Nationale: Z 11253]. Concerning extant copies of the 1606 edition, refer to Freedman, 'Bellarinus' (fn. 10), 43.

12 The only copy of the 1630 edition that I have located date is the following: Joannes Bellarinus, Speculum humanae atque divinae sapientiae, seu Praxis scientiarum et methodus scientifica (Mediolani: Apud haeredes P. Pontii, 1630). [Paris, Bibliothèque Nationale: Z 11253].

introduction, Bellarinus equates scientific method [methodus scientifica] with the practice of the sciences [praxis scientiarum].[13]

In Book 1 [Concerning science and the knowable], Bellarinus defines science [scientia] in terms of cognition [cognitio].[14] Cognition is perfect if it is true [vera], adequate [adaequata], distinct [distincta], certain [certa], and evident [evidens].[15] Bellarinus defines 'the way to acquire knowledge' [modus sciendi] – which he equates with scientific method – as all of that which leads the human intellect towards perfect cognition [quaedam ratio, qua quis possit talem perfectam cognitionem obtinere].[16] The way to knowledge requires the three operations of the [human] intellect: 1. simple apprehension, 2. [construction of] propositions, and 3. reason.[17] In Book 2

13 Bellarinus (1606), 3 (Num. 4).
14 Bellarinus (1606), 19, 35.
15 Bellarinus (1606), 32–4.
16 Bellarinus (1606), 39.
17 'Hoc autem ita declaratur: Tres sunt operationes intellectus; prima dicitur simplicis, rei apprehensio, id est cognitio unius tantum rei, ut ignis: secunda dicitur affirmatio, vel negatio, veluti ignis est calidus; In hac autem secunda operatione fiunt propositiones [...] tertia operatio dicitur ratiocinatio [...]' Bellarinus (1606), 58–9; Bellarinus also refers (20, lines 2–3 and 34, lines 3–4) to simple apprehension [rei apprehensio] as *manifestatio/manifestatio rei* and to affirmative and negative propositions as *iuditium*.

 The three operations of the (human) intellect, or: of the (human) mind, are commonly discussed within seventeenth-century treatises on logic; see the following examples: 'Caeterum, quod ad numerum instrumentorum attinet bene disserendi & sciendi, illa in genere sunt quatuor, nempe Argumentum, Enuntiatum, Syllogismus, & Methodus. [...] Ex quibus etiam primum instrumentum primam operationem intellectus humani, nempe simplicium apprehensionem; alterum secundam, nempe compositionem & divisionem terminorum simplicium. Tertium denique & quartum tertiam operationem, quae dicitur Dianoia, hoc est, Discursus.' Clemens Timplerus, *Logicae systema methodicum.* (Hanoviae [Hanover]: Typis haeredum Guilielmi Antonii, 1612), [hereafter Timplerus (1612)], 95–6; 'Partes logicae sunt duae: [...] Proceditque secundum tres mentes operationes, quae sunt: I. Simplicum apprehensio. II. Compositio & divisio. III. Discursus.' *Systema logicum [...] ad usum Gymnasii Gothani. (Gothae [Gotha]: Typis Reyherianis exscrib. Joh. Mich. Schallius, 1659),[hereafter Systema logicum (1659)]*, 3; the following treatise is specifically devoted to this same topic: Christophorus Bechtlin SJ, praes. and Jordan, Michael, resp., *Tres mentis operationes.* (Oeni(ponti) [Innsbruck]: (Typis Michäelis Wagneri, 1662)

[Concerning rules of logic] it is noted that science focuses on universals.[18] He states that these logical rules are to be used for the following four purposes [i.–iv.]: i. to distinguish 'knowables' [scibilia] from 'unknowables' [non scibilia], ii. to distinguish knowables from one another, iii. to 'find' [invenire] and 'gather' [colligere] all knowables, iv. to understand any given knowable precisely [in sua praecisa ratione].[19]

In Book 3 [Concerning the instruments of knowledge], is stated that there are ten instruments [instrumenta], through which cognition [cognitio] is made certain [certa] and evident [evidens].[20] There two of these ten instruments are given special importance [i.–ii.]:

i. demonstration using principles known through themselves [demonstratio per principia per se nota], the most important of which is the principle of contradiction; ii. definition [diffinitio], which Bellarinus considers to be the origin of all scientific knowledge; definition requires classification [divisio].[21] Bellarinus equates divisio demonstrativa with divisio scientifica; the latter form of classification involves perfect cognition [cognitio perfecta].[22] In Book 4 [Concerning method] Bellarinus defines method [methodus] as the correct way to discover, 'be taught', and teach [scientific]

[hereafter Bechtlin and Jordan, *Tres mentis operationes* (1662).] Concerning the use of the three operations of the human intellect in Joachimus Jungius, *Logica Hamburgensis, hoc est, institutiones logicae in usum schol. Hamburg. conscriptae, & sex libris comprehensae.* (Hambu(r)gae [Hamburg]: Sumptibus Bartholdi Offermans literis Rebelinianis, 1638), i.e. the first ed., and in the enlarged second edition, ed. Johannes Vagetius, *Logica Hamburgensis, [...] Editio Secunda quidem, sed primae servans paginas, versus verba & characteres, emendationibus auctoris & tabula quadem calci subjecta.* (Hamburgi [Hamburg]: Literis Rebenlinianis senatus & gymnas. typ. sumptibus Georg. Wolfii, 1681), see footnote 33 and the corresponding passages in the text of this article; some eighteenth-century examples thereof are presented in the textbook passage corresponding to footnote 42 and as well as in footnote 74.

18 Bellarinus (1606), 138–42.
19 Bellarinus (1606), 142 (Num. 10).
20 Bellarinus (1606), 150–1.
21 Bellarinus (1606), 152, 159, 167 (lines 1–2); also refer to the detailed discussion of these two instruments of logic in Freedman, 'Bellarinus' (fn. 10), 51–2, 74.
22 Bellarinus (1606), 234, 237–40.

knowledge [recta ratio scientiam inveniendi, discendi, atque docendi]; he equates method with scientific method when this knowledge is perfect knowledge.[23] Bellarinus divides methodus into naturalis and intellectualis. The latter is sub-divided into inquisitiva and doctrinalis; methodus intellectualis inquisitiva is used to acquire [invenire] and 'be taught' [discere] scientia, while methodus intellectualis doctrinalis is used to teach [docere] that scientia which has already been acquired.[24]

The following two points can be made concerning Bellarinus's treatise. First, he describes his own treatise as a combination of logic and metaphysics [logica metaphysicalis, vel metaphysica logicalis [...] haec praxis ex logica, & metaphysica, quasi ex grossioribus lignis].[25] However, the content of his treatise appears to fall almost entirely within the domain of logic. For him – and for Zabarella – scientific method was a sub-category of method, which in turn (beginning no later than the second half of the sixteenth century) was widely considered to be a component part of the discipline of logic. And second, as noted here, Bellarinus defines method as the correct way to discover, teach, and 'be taught', or study, (scientific) knowledge. However, in this treatise he does not discuss how knowledge is discovered.

Bellarinus's treatise on scientific method appears to have had relatively little impact; with the exception of at least one additional author – Joachim Jungius (1587–1657) – the concept of scientific method itself seems to have been largely ignored during the remainder of the seventeenth century.[26]

23 Bellarinus (1606), 6. Here (and in the text passage corresponding to footnote 24) 'be taught' is given as an English-language translation of discendi/discere; the terms 'learn' and/or 'study' might also be used. Bellarinus also (255) defines method as 'recta ratio omnes partes scibiles colligendi, collectas congruo ordine disponendi; dispositas ad rationes scitas logicis instrumentis, & regulis reducendi.'

24 Bellarinus (1606), 260–1; Bellarinus does not comment further concerning the concept of *inventio* and its relevance to discovery.

25 Bellarinus (1606), 3.

26 In some instances where the scientific method is mentioned (in writings published from the seventeenth century onwards, continuing into the twenty-first century) the meaning(s) attached to it is (are) not explained. For example, refer to the following: Christianus Dreier, *Sapientia seu philosophia prima ex Aristotele & optimis antiquis, Graecis praesertim commentatoribus methodo scientifica conscripta, et XX.*

The term scientific method is referred to and briefly discussed within a logic textbook – the *Logica Hamburgensis* – first published by Jungius in the year 1638; it was republished with very few changes in the year 1681.[27] He defines scientific method [methodus scientifica] as the rational process [dianoeticus processus] by means of which one gains knowledge of a previously unknown universal proposition with the use of some given better known proposition; for Jungius, it has two parts: 1. scientific induction and 2. demonstration narrowly understood.[28] In the former, one proceeds

disputationibus in Academia Regiomontana in usum discentium publice proposita. (Regiomonti [Koenigsberg]: Typis Johannis Reusneri prostat apud Martinum Hallevordium, 1644) [hereafter Dreier (1644)]; Robertus König, praes. and Joannes Franciscus Gentilott, resp., *Tractatus juridicus de iure matrimoniali principium aeque, ac privatorum [...] scientifica methodo concinnatus [...] post [...] examen publicae disputationi expositus [...] die 31. Augusti 1694.* (Salisburgi [Salzburg]: Typis Johannis Baptistae Mayr typographi aulico-academici) [hereafter König and Gentilott (1694)]. In addition, scientific method is nowhere mentioned within the texts of the following two articles: James M. Ayers and Kathleen M. Ayers, 'Teaching the Scientific Method: It's All in the Perspective', *The American Biology Teacher* 69, no. 1 (January 2007), 17–21; William J. Thomas, 'The heuristics of war: scientific method and the founders of operations research', *British Journal for the History of Science* 40, Issue 145 (June 2007), 251–74.

27 Jungius (1638); Jungius (1681). The pagination of the text of the *Logica Hamburgensis* in these two editions is identical, and the differences in content between the 1638 and 1681 editions are minimal; larger differences are to be found between those two editions and the 1657 edition of that same work. [Jungius, Joachim]. Compendium logicae Hamburgensis. Hamburgi: Typis Jacobi Rebenlini, 1657. [Hamburg SUB: Scrin A/64: 2] The edition of this logic textbook prepared by Rudolf W. Meyer in the year 1957 collates the texts of the 1638, 1657, and 1681 editions of the *Logica Hamburgensis*. His introduction to this edition is very useful; see Joachimus Jungius, *Logica Hamburgensis.* Edited by Rudolf W. Meyer. Published by the Joachim-Jungius-Gesellschaft der Wissenschaften, Hamburg. (Hamburgi: In aedibus J.J. Augustin, 1957) [Hereafter Jungius (1957)], v–xxiii. Here the 1681 and 1957 editions have been utilized.

28 'Methodus scientifica est dianoeticus a notioribus propositionibus ad ignotam aliquam universalem propositionem processus. Estque vel inductio scientificalis vel demonstratio.' Jungius (1681), 280; Jungius (1957), 201, lines 5–7. The copy of the 1681 edition held by the Berlin State Library (with the call number Nl 11320) has been used

from simpler assumptions to a universal; in the latter one proceeds from a universal assumption to a universal conclusion.[29] This partition of the scientific method in two parts is roughly the same as the one that Zabarella presented in the year 1578.[30]

While *methodus scientifica* does not appear on the title page of the *Logica Hamburgensis* – and is only mentioned very infrequently in this same work – it nonetheless has considerable importance therein.[31] The text of this work is divided into six Books. Book [Liber] 4 has the title Apodectica sive Demonstrativa, which is equated with methodus scientifica.[32] For Jungius, scientific method clearly falls within the domain of logic. The three operations of the human mind have a fundamental role within his logic textbook; the utilization of the second and third operations

here. It contains a 110-page introductory treatise – and a secondary title page – by Johannes Vagetius, the editor of the 1681 edition; the text of the *Logica Hamburgensis* follows thereafter. This introduction by Vagetius – and the secondary title page – are not included in the copy of the 1681 edition of the *Logica Hamburgensis* at the Herzog August Bibliothek Wolfenbüttel (with the call number M: Li 4233). [Joachim Jungius], Compendium logicae Hamburgensis (Hamburgi: Typis Jacobi Rebenlini, 1657). [Hamburg SUB: Scrin A/64: 2]

29 'Complectitur insuper, si ita placet, particularem demonstrationem, quae ex universali majore sumptiones particularem, vel singularem conclusionem colligit.' Jungius (1681), 276 (no. 15); Jungius (1957), 198 (lines 25–7).

30 While Jungius himself does not mention Zabarella's two-part division of the scientific method, Rudolf Meyer does so – and quotes a portion of the relevant passage in Zabarella's *Opera logica* – in Jungius (1957), page 201, footnote 5f. The *Logica Hamburgensis* contains three citations of Zabarella; see Jungius (1681), 3 (no. 4), 313 (no. 4), 343 (no. 10) and in Jungius (1957), 2 (lines 9–10), 219 (lines 12–13), 235 (lines 34–6).

31 The following passages in the *Logica Hamburgensis* mention *methodus scientifica*: Jungius (1681), 276 (no. 16), 280 (no. 1), 348 (nos. 1, 2, 4); Jungius (1957), 199 (lines 3–4, 22–4), 200 (lines 4–5, 15–17), 240 (lines 3, 5, 7).

32 Book 4 of the *Logica Hamburgensis* is to be found in Jungius (1681), 272–354 and in Jungius (1957), 197–244; concerning the equation of the subject-matter of Book 4 with *methodus scientifica* refer to Jungius (1681), 273 (no. 1), 275–6 (nos. 11–16) and to Jungius (1957), 197 (lines 1–11), 198 (lines 16–30), 199 (lines 1–3).

lie at the centre of his definition of the scientific method.[33] And the scientific method is to be utilized in order to construct what he refers to as 'the system of a complete science' [scientia totalis systema], which can be roughly equated with a systematically constructed textbook.[34]

Christian Wolff (1679–1754) was apparently the first eighteenth-century author who consistently referred to this concept over a period of decades.[35] Wolff taught at the University of Halle from 1706 to 1723 and again from 1740 to 1754; he taught at the University of Marburg from 1723 to 1740. From the year 1728 onwards until Wolff's death, the title of his Latin language textbooks on individual philosophical disciplines consistently included the term scientific method [methodus scientifica].[36]

33 The text of the *Logica Hamburgensis* begins as follows: 'Logica Prolegomena. 1. Logica est ars mentis nostrae operationes dirigens ad verum a falso discernendum. 2. Tres autem sunt mentis nostrae operationes Notio sive conceptus, Enuntiatio, et Dianoea sive Discursus.' Jungius (1681), 1 (nos. 1–2); Jungius (1957), 1 (lines 1–5). In his definition of the scientific method, Jungius uses the term *propositio* [*propositionem; propositionibus*] to refer to the second operation of the human intellect; *propositio* is equated with *enunciatio* [*enunciatio*] and *pronuntiatum* in Jungius (1681), 205 (nos. 1–2) and Jungius (1957), 67, lines 6–9.

34 '4. Scientia totalis systema est conclusionum per methodus scientificas illatarum, una cum earundem methodorum principiis.' Jungius (1681), 345 (no. 4); Jungius (1957), 240 (lines 7–8). The concept of *systema* [systematic textbook] does not appear to have entered the academic vocabulary – at least in Central Europe – until the end of the 16th century. Refer to the brief discussion of the use of the term *systema* during the seventeenth century in Freedman, 'Encyclopedic Philosophical Writings' (fn. 4), 230–2, 249 (Table Q, no. 8), 251–2 (Table R: B. 3.). Also see Otto Ritschl, *System und systematische Methode in der Geschichte des wissenschaftlichen Sprachgebrauchs und der philosophischen Methodologie*. Programm zur Feier des Gedächtnisses [...] am 3. August 1906 (Bonn: C. Georgi, 1906).

35 Concerning Wolff's career and writings, see Martin Schönfeld, 'Wolff, Christian', Daniel M. Borchert, general editor, *Encyclopedia of Philosophy*, 2nd edition, 10 vols (Detroit, MI, et al: Thomson-Gale, 2006): 9: 822–32; also refer to the following website: <http://galileo.rice.edu/Catalog/NewFiles/wolff.html> (The Galileo Project) [retrieved on 1 September 2012].

36 Christian Wolff [=Christianus Wolfius], *Philosophia rationalis sive logica, methodo scientifica pertractata [...]*, (Francofurti et Lipsiae [Frankfurt and Leipzig]: Prostata in officina libraria Rengeriana, 1728) – to be referred to in the following footnotes as

Yet it appears that these same textbooks only contain three brief comments pertaining thereto. In Wolff's textbook on logic (first published in 1728), it is noted that scientific method – which he identifies in this context with philosophical method and with mathematical method – requires 'the accurate application of the rules of logic' [regularum logicarum accurata applicatio].[37] In his textbook on metaphysics (first published in the year 1730) it is noted that 'scientific method is needed in order to constitute academic disciplines.'[38] A more oblique comment is contained in an obituary that is appended to the first volume – published in the year 1754 shortly following Wolff's death – of his lengthy textbook on family life [oeconomica]. In this obituary for Wolff, it is noted that he began work on his 'philosophical system' (that is, on his series of published textbooks on individual disciplines) in the year 1728.[39]

But in the year 1741 Wolff published a programmatic lecture [Programma] which is devoted in large part to the concept of scientific

Wolff (1728). The 1740 edition of this same work was reprinted in Christian Wolff, Gesammelte Werke, II. Abteilung, Lateinische Schriften, Band 1.3. (Hildesheim et al.: Georg Olms, 1983).

37 Wolff (1728), 571 (§792), 572 (§§793).

38 'Methodi scientificae necessitas in condendis disciplinis. [§] 167.' Wolff, *Philosophia prima sive ontologia, methodo scientifica pertractata.* (Francofurti et Lipsiae: Prostat in officina libraria Rengeriana, 1730), fol. xxxxiv; Wolff, *Philosophia prima sive ontologia, methodo scientifica pertractata [...] editio nova priori emendatori.* (Francofurti et Lipsiae [Frankfurt and Leipzig]: Prostat in officina libraria Rengeriana, 1736), 706.

39 'Nemini obscurum esse potest, *Perillustrem* hujus libri *Auctorem* jam anno hujus seculi vigesimo octavo animum ad scribendum veri nominis systema Philosophicum adpulisse, quo omnia ordine haud interrupto, summa cum perspicuitate, atque soliditate, ad convictionem comparata, exponerentur, eorum usibus inserviturum, qui scripta ipsius minora, germanico idiomate evulgata, omnesque Philosophiae partes complexa, non solum attente legissent, sed etiam rite intellexissent, atque in succum & sanguinem convertissent.' Christian Wolff, *Oeconomica methodo scientifica pertractata. Pars prima in qua agitur de societatibus minoribus, conjugali, paterna, et herili.* (Halae Magdeburgicae [Halle/Magdeburg]. Prostat in officina Libraria Rengeriana, 1754), 409–10.

method.[40] There he equates scientific method, with the 'method of Euclid' [methodus Euclidis], with the mathematical method [... quae vulgo mathematica appellatur], and with the 'true method' [vera methodus].[41] True method requires [1] the use of definitions – by means of which that which is defined is properly delineated – followed by [2] the use of propositions, and [3] the use of demonstrations; these three steps – referred to by Wolff in his textbook on logic as the three operations of the (human) mind [tres operationes mentis] – are discussed there at some length.[42]

The scientific method [i.] is contained within the rules of logic and [ii.] is to be utilized to teach the proper use of the faculties of the human mind in order to recognize the truth.[43] Scientific method is used to bring human cognition to certitude and is necessary for theology, jurisprudence, medicine, philosophy, and mathematics.[44] For Wolff, scientific method is a necessity; without it, the learners are not able to be taught effectively.[45] In this lecture and his textbooks, Wolff clearly places scientific method within the domain of logic, and considers its use as necessary for teaching purposes; it is needed in order to constitute individual academic disciplines as well as for the textbooks used to teach those same disciplines.

Wolff's consistent references to the scientific method in these textbooks – coupled with his considerable influence during own his professional career – appear to have prompted at least a fair number of his contemporaries to make at least some mention of it in their own writings;

40 Christian Wolff, *Programma de necessitate methodi scientificae et genuino usu iuris naturae ac gentium quo lectiones suas in Friericiana in posterum habendas intimat.* (Halae Magdeburgicae [Halle/Magdeburg]: 1741). [Halle Universitäts- und Landesbibliothek: o 1 A 6594 (1)]; according to the date on the final page (xxxii) of this oration, it was held in Halle on 14 January 1741.

41 Wolff, *Programma de necessitate methodi scientificae* (1741), vii (lines 3–4), xv.

42 Wolff (1728), 125–42.

43 'Methodus scientifica regulis Logicae continetur, quippe quae nomen suum non tuetur, nisi doceat rectum facultatum mentis humanae in cognoscenta veritate usum.' Wolff, *Programma de necessitate methodi scientificae* (1741), XVI–XVII.

44 Wolff, *Programma de necessitate methodi scientificae* (1741), XV.

45 Wolff, *Programma de necessitate methodi scientificae* (1741), XVI, lines 25–30.

here attention is given to five writings published between 1731 and 1754 within which the subject-matter of scientific method is specifically discussed.[46] Wolff is frequently cited as an authority within a disputation on

46 These five published writings – 1. Samuel Klingenstierna, praes., and Johan Gottschalk Wallerius, resp., *Articuli generales de natura & utilitate methodi scientificae, quos consensu [...] examini pro gradu sistit [...] ad diem {5} Aprilis Anni 1731.* (Stockholmiae [Stockholm]: Literis Wernerianis) [hereafter Klingenstierna and Wallerius (1731)], 2. Friedrich Christian Koch [=Friedericus Christianus Kochius], praes. and Samuel Henoch Frideric(us) Neubauer, resp., *Dissertatio philosophico-philologica de methodo scientifica in addiscendis per artem linguis haud contemnenda et de analysi vocum hebraearum legitime instituenda [...] d. 12. Mai. a. c. loco consueto.* (Jenae [Jena]: Litteris Croekerianis, 1740) [hereafter Koch and Neubauer (1740)], 3. Philippus Steinmeyer SJ, *Regulae praecipuae methodi mathematicae seu scientificae, in usum lectionum suarum collectae.* (Augustae Vindelicorum et Friburgi in Brisgoja [Augsburg and Freiburg im Breisgau]: Sumptibus Joannis Ignatii Wagner bibliopolae academici typis Maria Luciae Shallin viduae, 1750) [hereafter Steinmeyer (1751)], 4. Jacobus Carpzov [=Jacobus Carpovius], *Commentationis de adplicatione methodi scientificae ad theologiam revelatam specimen tertium [...] die 2. Jun. 1753 [...] eodem die hora 8 matutina in Ill. Gymnasio debita religione obeundum praemissum.* (Vinariae [Weimar]: Litteris Mumbachianis) [hereafter Carpzov (1753)], and 5. Joannes Fridericus Stiebritzius, praes. and Mauritius, author and resp., *Dissertatio philosophica inauguralis de methodo scientifica eiusque applicatione ad linguas docendas quae consentiente [...] philosophorum ordine [...] pro summis in philosophis honoribus rite obtinendis d. 17. August. a. 1754 placido eruditorum examini subiicit.* (Halae Magdeburgicae [Halle/Magdeburg]: Typis Joannis Friderici Grunerti) [hereafter Stiebritzius and Mauritius (1754)] – have been located in the course of work on this article; it is possible – if not probable – that additional writings devoted in whole or in part to the concept of scientific method are extant. Numerous additional writings published during Wolff's lifetime mention this same concept; the following writings that do so have been consulted: Franciscus Schmier OSB, *Jurisprudentia publica universalis, ex jure tum naturali, tum divino positivo, nec non jure gentium nova et scientifica methodo derivata, et juris publici facta.* (Salisburgi [Salzburg]: Impensis & literis Johannis Josephi Mayr, 1722); idem, *Jurisprudentia publica Imperii Romano-Germanici, nova et scientifia methodo concinnata. In tres tomos distincta, et juris publici facta.* (Salisburgi [Salzburg]: Impensis et literis Joannis Josephi Mayr, 1731); Joannes Adamus Ickstatt, *Meditationes praeliminares de studio juris ordine atque methodo scientifica instituendo [...] in alma Julio-Fridericiana post ferias autumnales instaurandis praemittendas censuit.* (Wirceburgi [Wuerzburg]: Typis Marci Antonii Engmann, 1731); Andreas Carolus Grosse (autor)

scientific method – titled *Articuli generales de natura et utilitate methodi scientificae* – held by Samuel Klingenstierna and Johannes G. Wallerius at

and (Friedrich Hoffmann), *Dissertationem philosophico-medicam inauguralem methodo scientifica conscriptam qua sistitur verum universae medicinae principium in structura corporis humani mechanica reperiundum [...] in alma Fridericiana universitate facultatis medicae pro gradu doctoris [...] submittit Andreas Carolus Grosse [...] ad diem Maji 1732.* (Halae Magdeburgicae [Halle/Magdeburg]: Typis Jo. Christiani Hilligeri acad. typogr.); Jacobus Carpzov [=Carpovius], Theologia revelata dogmatica methodo scientifica adornata. (Francof. & Lipsiae [Frankfurt and Leipzig]: Sumptibus Joh. Adam. Melchior, 1737); idem, *Elementa theologiae naturalis dogmaticae a priori methodo scientificae adornata.* (Jenae [Jena]: Sumptibus Christiani Henrici Cuno, 1742) [hereafter Carpzov (1742)]; Christianus Jo[hannes] Antonius Corvinus, *Institutiones philosophiae rationalis methodo scientifica conscriptae.* (Jenae [Jena]: Jo[hannes] Adam(us) Melchior, 1739); idem, Institutiones philosophiae rationalis methodo scientifica conscriptae. (Jenae[Jena]: Melchior, 1756); Nicolaus Engelhardus, *Institutiones logicae in usum auditorii sui domestici adornatae. Editio altera.* (Groningae [Groningen]: Typis Jacobi Sipkes typographi et bibliopolae, 1742) [hereafter Engelhardus, Nicolaus (1742)]; Regnerus Engelhardus, *Specimen iuris feudorum naturalis methodo scientifica conscriptum.* (Lipsiae [Leipzig]: Apud Jo[hannem] Christianum Langenhemium, 1742); Joann[es] Albertus Berckenkamp, *Commentatio logica de affectionibus propositum relativis qua regulae oppositionis subalternationis aequivalentiae conversionis et contrapositionis earumque consequentiarum methodo scientifica explicantur.* (Lemgoviae [Lemgo]: Ex officina Joannis Henrici Meyeri, 1743); Dan[iel] Wyttenbachius, *Tentamen theologiae dogmaticae methodo scientifica pertractatae. Tomus I (II, III).* 3 vols (Francofurti ad Moenum [Frankfurt a. Main]: Apud Benj[amin] Andreae et Henr[icum] Hort, 1747, 1749); Georgius Widmer, Chymia corporis animalis cum lithgeognosia et artificio aquas salsa dulcificandi methodo scientifica pertractata. (Argentorati [Strasbourg]: Typis Johannes Henrici Heitz, 1751), Anselmus Desing OSB, *Diatribe circa methodum Wolffianum, in philosophia practica universali, hoc est, in principiis iuris naturae statuendis adhibitam, quam non esse methodum, nec esse scientificam, ostenditur.* (Paedeponti, vulgo Stadt am Hof bey Regensburg: Sumptibus Johannes Gästl, 1752); idem, *Super methodo Wolffiana scientifica aut mathematica.* (Augustae Vindelicorum et Monachii [Augsburg and Munich]: Sumptibus Ioannis Urbani Gästi bibliopolae, 1754; Joannes Ulricus L.B. de Cramer [Johann Ulrich von Cramer], *Primae lineae logicae juridicae ad normam logicae Wolfianae adornatae, ex reliquis suis scriptis illustratae et methodo scientifica pertractatae.* (Ulmae, Francofurti et Lipsiae [Ulm, Frankfurt and Leipzig]: Apud Johannem Conradum Wohlerum, 1767).

the University of Uppsala in the year 1731.[47] Klingenstierna and Wallerius begin the text of this disputation by noting that when scientific method [methodus scientifica] is utilized, universal truths are expounded in such a manner that the certitude of consequent propositions follows from antecedent propositions.[48] In order to arrive at this certitude, it is required that antecedents are defined accurately and that contradictory statements are not contained within these definitions.[49]

In those cases where such definitions cannot be arrived at, Klingenstierna and Wallerius allow that observations and experiments which are 'conducted with the requisite rigor' [ad requisitam rigorem instituta] can be utilized in order to help arrive at certainty.[50] Yet certainty is still required. Without the use of scientific method there is no certain knowledge within philosophical writings; the scientific method is not applicable to philosophy in those cases where propositions neither can be understood sufficiently nor can be evidently recognized as true.[51]

A disputation by Friedrich Christian Koch and Samuel Friedrich Neubauer on the use of scientific method in order to teach languages was published in Jena in 1740. According to Koch and Neubauer, experience continually presents many objects to the mind and cogitation results therefrom.[52] When these cogitations are not ordered, confusion results; method

47 Klingenstierna and Wallerius (1731). Discussion of the use of variant terms – including *disputatio* and *dissertatio* – in order to refer to academic disputations falls outside the scope of the present study; see the following article (and the resources cited therein): Joseph S. Freedman, 'Published academic disputations in the context of other information formats used primarily in Central Europe (c.1550–c.1700)', Marion Gindhart, Marion and Ursula Kundert, eds, *Disputatio 1200–1800. Form, Funktion und Wirkung eines Leitmediums universitärer Wissenskultur.* Trends in Medieval Philology. Vol. 20 (Berlin and New York: Walter de Gruyter, 2010), 89–128.

48 'Per methodum scientificam, ordinem intelligo, ita universales veritates proponendi, ut certitudo consequentium semper ex antecedentibus pateat.' Klingenstierna and Wallerius (1731), 1 (§§I.).

49 Klingenstierna and Wallerius (1731), 2–3 (§VII.–IX.).

50 Klingenstierna and Wallerius (1731), 4 (§X.).

51 Klingenstierna and Wallerius (1731), 12 (§XXV.), 14 (§XXVIII.).

52 Koch and Neubauer (1740), 7 (§12).

[methodus] provides them with order.[53] Demonstrative method is utilized when method – which can be either analytic or synthetic – is utilized to order cogitations.[54] Methodically ordered cogitations are used in order to result in principles which are asserted using propositions; these propositions are used for the purposes of proof [probatio] and 'demonstrations' [haec methodus nititur demonstrationibus].[55] In this disputation, demonstrative method is equated with scientific method.[56] Systematic treatises bring to completion that which is set forth by scientific method.[57]

The rules of mathematical method – which is equated with scientific method – are the focus of a treatise published in 1751 by Philipp Steinmeyer. Mathematical method is utilized [i.] to distinguish between various kinds of notions [ii.] to utilize appropriate categories of notions in constructing definitions and propositions, and [iii.] to utilize these propositions in order – via demonstrations – to arrive at certitude and proof.[58] In Steinmeyer's discussion of experience (which includes observations and experiments) it is noted that experience is beyond the realm of proof; however, he provides detailed discussion of how experience – which focuses on singulars – can be utilized in order to construct universal propositions (which in turn can be used for the purposes of proof and certitude).[59] Steinmeyer concludes his treatise with a discussion of the usefulness of the mathematical method

53 Koch and Neubauer (1740), 7 (§13–15).
54 Koch and Neubauer (1740), 12 (§29).
55 Koch and Neubauer (1740), 9 (§19) 12–13 (§28–32).
56 'Quum vero ordo cogitationum demonstrata ratione determinatus, audiat methodus demonstrativa, dexteritas vel habitus demonstrandi scientia, subiective talis, ipsae veritates demonstratae, obiectivae talis. [...]Per methodum demonstrativam pervenimus ad utriusque generis scientiam, et ob id ipsum, audit scientifica.' Koch and Neubauer (1740), 13 (§32, lines 6–13).
57 'Systema[ta] ea perficiunt, quae methodo scientifica proponuntur.' Koch and Neubauer (1740), 14 (§33, lines 1–2); 'Systematic treatises' could also be referred to here as 'systematically constructed and ordered textbooks'.
58 See Steinmeyer (1751), Pars I (3–18), II (19–108) and his excellent summary [Compendium sive Epitome methodi Mathematicae] thereof on 113–15 (Pars III, §5).
59 See Steinmeyer (1751), Pars II, Articulus III (60–7).

– which can be used to construct an elementary system – for academic disciplines.[60]

In a short treatise published in the year 1753, Jacob Carpzov examines how mathematical method – which he also refers to as scientific method – is properly applied to the domain of revealed theology.[61] In theology, two distinct kinds of proof are to be utilized: immediate and mediate. Immediate proof occurs when the truth of a Sacred Scripture passage allows for a theological proposition to be proved directly using a syllogism; this is suited for those cases where that which is to be proved is brief and not difficult to understand – as in the case within many church sermons.[62] Mediate proof, on the other hand, is utilized when proving a theological proposition using a group of properly connected syllogisms in accordance with 'synthetic demonstration' [demonstratio synthetica]; mediate proofs are confirmed by one's faith [analogia fidei].[63] In the final section (XVI.) in the text of this short treatise, Carpzov notes that the points of doctrine discussed within his own (theological) 'system' [systema theologicum] have been properly connected to one another.[64]

60 Steinmeyer (1751), Pars III (109–116); 'Initio nimirum fundamenti inconcussi loco ponebant systema veritatum paucarum, earumque maxime communium, quod systema elementare appellare possumus. In hoc non collocabant nisi experientias indubitatas, definitiones, axiomata, & postulata, quae principia omnia ab observationibus & notionibus communibus derivaverant, easdem ad notiones distinctas & propositiones determinatas revocando.' Steinmeyer (1751), Pars III, §VI (115–16).

61 Carpzov (1753); also refer to the passage – contained in the 1742 edition of Carpzov's textbook on natural theology – as quoted in footnote 71.

62 Carpzov (1753), 52 (IV., lines 1–19); 'Fateor hinc etiam, probationes thesium theologicarum immediatas ob brevitatem ac facilitatem suam captui simpliciorum potissimum accommodatas esse. Et quia sermones sacros, coram habendos in ecclesia, praecipue ad simpliciorum captum, quippe quorum numerus est maximus, accommodare, fas est, probationes thesium theologicarum immediatas praecipue pro concione ecclesiae adhibendas esse, sequitur.' (IV., lines 13–19).

63 Carpzov (1753), 53 (V.), 54 (VII.; VIII, lines 1–13), 56 (X., lines 1–6). Synthetic demonstration appears not to differ here from (what many authors refer to as) synthetic method; concerning the latter, refer to footnotes 8, 28, 29, 30, and 55 as well as to the corresponding passages in the text of this article.

64 'Neque vero hic loci opus est, aut ordinem doctrinarum enarrare, aut rationes copulationis et quasi coagmentationis reddere, quia priorem docet ipsa systematis, ad finem

A disputation focusing specifically on the scientific method – considered generally as well as when applied to the teaching of languages – was held in 1754 by Joannes Fridericus Stiebritzius and Fridericus Maximilianus Mauritius; this disputation, titled *Dissertatio philosophica inauguralis de methodo scientifica eiusque applicatione ad linguas docendas*, was published in Halle.[65] According to Stiebritzius and Mauritius, scientific method is understood within the context of the general concept of method; method can only be utilized when 1. two are more concepts are linked and when 2. a number of similarities are found between these linked concepts.[66] Eleven laws [leges] of scientific method are given; they focus on propositions that need to be explained and defined in order that other propositions can follow from them.[67] Scientific method may be utilized in language instruction insofar as one can begin with relatively simple subject content and then link it to relevant subject content having greater complexity.[68]

On the basis of these discussions of the scientific method by Christian Wolff as well as by some of his contemporaries, the following three points can be made. First, scientific method is used synonymously with other terms by some of these authors. Wolff equates scientific method with mathematical method, with the method of Euclid, with philosophical method, and with true method.[69] Steinmeyer and Carpzov equate scientific method

fere perducti, inspectio, posterioris autem rationes locis debitis indicatae fuerunt.' Carpzov (1753), 63 (XVI, lines 12–15). In this same section (XVI) Carpzov also comments further on his 'theological system' as follows: '[...] Ego systema theologicum ita construxi, ut nihil eorum, quae scitu cognituque necessaria sunt, omiserim, nihil a theologia alienum receperim, et ubique memoriae hominum consulere studuerim.' Carpzov (1753, 64 (lines 12–15).

65 Concerning the use of the terms 'disputation' [*disputatio*] and 'dissertation' [*dissertatio*] refer to the article (and the resources cited therein) in footnote 47.

66 Stiebritizius and Mauritius (1754), 1 (§1), 2 (§2).

67 These eleven laws are listed in Stiebritizius and Mauritius (1754), 34–5 (§25).

68 Stiebritizius and Mauritius (1754), 55–6 (§46).

69 Refer to footnote 41 and to the corresponding passages of the text in this article.

with mathematical method, while Koch and Neubauer equate the former with demonstrative method.[70]

Second, scientific method falls directly within the realm of logic.[71] Wolff emphasizes the importance of logic for scientific method.[72] While observations and experiments are accorded attention by Klingenstierna and Wallerius as well as by Steinmeyer, these authors closely link their use to the rules of logic.[73]

According to Wolff and according to Klingenstierna and Wallerius, the three operations of the human intellect (or: the human mind) – 1. simple apprehension (utilized when gathering all that which is knowable), 2. judgement, or affirmative and negative propositions (resulting when these knowables are ordered), and 3. rational discourse (used in constructing proofs and explanations) – are linked to scientific method; during the seventeenth and eighteenth centuries, the three operations of the human intellect were generally considered as having a central role in logic.[74] Although somewhat different terminology is used, this same three-

70 Refer to footnotes 56 and 61 as well as to the corresponding passages of the text in this article.

71 Also note the following affirmation of the connection between logic and the scientific method: 'Methodi scientificae haec indoles est, ut ex primis principiis nexu ratiociniorum continuo conclusiones proponendae deriventur; unde fit, ut longissima saepe ratiociniorum cohaerentium series ante sit mente perspicienda, quam veritas conclusionis plene intelligatur. Quod uti ex Logicorum praeceptionibus qua theoriam, sic ex exemplis eorum, quae iam ex ratione sola de Deo disputamus, abunde constat.' Carpzov (1742), 405 (§678).

72 Refer to the passages quoted in footnotes 37 and 43 as well as to the corresponding passages in the text of this article.

73 Refer to footnotes 50 and 59 as well as the corresponding passages of the text in this article.

74 Concerning connections between the tree operations of the mind, logic, and scientific method in Wolff's writings refer to footnotes 40, 41, and 42 as well as to the corresponding passages in the text of this article. 'In methodo scientifica res primo simpliciter apprehenditur [...] inde judicium elicitur [...] tandem adscita tertia idea legitime concluditur [...] Sed hi tres operandi modi sunt tres mentis nostrae operationes [...]' Klingenstierna and Wallerius (1731), 10 (XXI.) The three operations of the human intellect – discussed using variant terminology – have a prominent place

step-process is evident in the discussions of scientific method by Koch and Neubauer as well as by Steinmeyer.[75] Components of this three-step-process are also discussed by Carpzov (syllogisms) and by Stiebritizius and Mauritius (definitions and propositions).[76]

And third, eighteenth-century discussions of scientific method place this concept clearly within the domains of teaching and learning, not discovery.[77] Wolff notes that the scientific method is needed for teaching; Koch and Neubauer as well as Stiebritzius and Mauritius use it for purposes of language instruction considered generally.[78] And in the works by Wolff, by Koch and Neubauer, by Steinmeyer, and by Carpzov that have been examined here, the scientific method is utilized in order to construct systematic treatises and textbooks used to teach academic disciplines.[79]

within many (if not the vast majority of) eighteenth-century treatises on logic. For example, refer to the following text passages: "Hinc tres sunt Mentis operationes: Apprehensio simplex, Compositio et divisio, et denique Discursus, seu ratiocinatio." Samuel Grosserus, Pharus intellectus, sive logica electiva ... Editio tertia (Lipsiae et Budissae: Impensis Johannis Wilischii, 1710), p. 18. [Halle ULB: Fb 494d] 'Q. 22. Quaenam est primae mentis operatio? R. Simplex rei apprehensio [...] Q. 167. Quaenam est secunda mentis operatio [...]? R. Judicium [...] Q. 271 Quaenam est Tertia mentis operatio [...]? R. Ratiocinatio [...]' Engelhardus, Nicolaus (1742), 5, 36, 60; 'Propter hanc tum mentis humanae operationum tum etiam vocis divisionem, in tres partes dividitur logica; quarum prima agit de voce simplici sive simplici apprehensione: secunda de voce complexa sive judicio: tertia de voce decomplexa sive discursu.' Elementa logicae. Subjicitur appendix de usu logicae: et conspectus organi Aristotelis. Editio quarta. (Oxonii: Impensis J. Cooke, 1795), 9–10. Concerning the use of these three operations within seventeenth-century writings on logic, refer to footnotes 17 and 33 as well as to the corresponding passages in the text of this article.

75 Refer to footnotes 52, 53, 54, and 55 as well as to the corresponding passages of the text in this article.

76 Refer to footnotes 62, 63, and 67 as well as to the corresponding passages of the text in this article.

77 With regard to the (unexplained) role of discovery according to Bellarinus (1606), refer to footnote 24 as well as to the corresponding passage of the text in this article.

78 Refer to footnote 52 through 57 and 68 as well as to the corresponding passages of the text in this article.

79 Refer to footnotes 38, 39, 57, 60, and 64 as well as the corresponding passages of the text in this article. This same point is also made by Joachim Jungius in his Logica

Interest in the concept of scientific method apparently began to wane following Christian Wolff's death in 1754. References to scientific method within the titles of published works appear to have been rare during the subsequent six decades.[80] It was not until the final quarter of the nineteenth century that the concept of scientific method again became a topic of interest within published writings, and subsequent attention thereto – especially from the early twentieth century onwards – appears to have substantially overshadowed that of all earlier periods.[81]

It would appear that *The Principles of Science. A Treatise on Logic and Scientific Method* – first published by William Stanley Jevons in 1874 – may have played a significant role in this resurgence of interest.[82] Here Jevons clearly – as was the case during the early modern period – places

 Hamburgensis; see footnote 34 and the corresponding passages of the text in this article.

80 Refer to the writings published in 1756, 1764, 1767, 1784, 1786, 1803, and 1807 as cited in these footnotes.

81 One indication of this substantial increase in interest is the founding of *The Journal of Philosophy, Psychology, and Scientific Methods*, which began publication in January of 1904. Also refer to the following very useful and well-documented article: John L. Rudolph, 'Epistemology for the Masses: The Origins of "The Scientific Method" in American Schools', *History of Education Quarterly* 45, No. 1 (Fall 2005), 341–75.

82 The opening paragraph of the preface to the first edition of this treatise can be quoted here in this connection: 'It may be truly asserted that the rapid progress of the physical sciences during the last three centuries has not been accompanied by a corresponding advance in the theory of reasoning. Physicists speak familiarly of the Scientific Method, but they could not readily describe what they mean by that expression. Profoundly engaged in the study of particular classes of natural phenomena, they are usually too much engrossed in the immense and ever-accumulating details of their special sciences to generalise upon the methods of reasoning which they unconsciously employ. Yet few will deny that these methods of reasoning ought to be studied, especially by those who endeavor to introduce scientific order into less successful and methodical branches of knowledge.' W[illiam] Stanley Jevons, *The Principles of Science. A Treatise on Logic and Scientific Method* (London: Macmillan, 1874) [hereafter Jevons (1874)], vii; this preface is also contained in the second edition (1877) of his treatise; idem, *The Principles of Science [...]. Second Edition, Revised.* (London and New York: Macmillan and Co., 1877)[hereafter Jevons (1877)], xxvii.

the scientific method within the context of logic.[83] The text of this treatise consists of thirty-two chapters. The first thirty-one chapters are devoted to logic (as understood in Jevons's time); the final chapter – 'Reflections on the Results and Limitations of Scientific Method' – focuses largely on (what can generally be understood – then and today – to fall within the parameters of) natural science.

In the decades that followed the publication by this treatise of Jevons, some authors did in fact closely link the concept of scientific method to natural science.[84] But this concept was also used in writings pertaining to

<hr/>

83 In the same preface, refer to the following: 'In following out my design of detecting the general method of inductive investigation, I have found that the more elaborate and interesting processes of quantitative induction have their necessary foundation in the simpler science of Formal Logic. [...] In attempting to give an explanation of their view of Scientific Method, I have first to show that the sciences of number and quantity repose upon and spring from the simpler and more general science of Logic.' Jevons (1874), viii, ix and Jevons (1877), xxviii, xxix. Jevons was not alone in his time with his belief that the principles of natural science are properly discussed within the context of logic. To give several examples, Thomas Fowler and Alexander Bain both divide logic into the two broad categories of deduction and induction, and both treat each of these two categories in separate volumes. Deductive logic (Fowler) and deduction (Bain) are devoted to traditional logic, with a primary focus on the three operations of the human intellect. Inductive logic (Fowler) includes discussion of induction (generally considered), classification, observation, experiments, other sub-categories of induction, fallacies, and false analogies. Induction (Bain) includes discussion of induction (generally considered), observation, experiments, experimental methods, hypotheses, definition, classification, logic applied in individual disciplines (including logic of mathematics, physics, chemistry, biology, psychology, politics, and medicine), sciences of classification (mineralogy, botany, and zoology), logic of practice, fallacies, analysis, synthesis, the art of discovery, and history of evidence. See Thomas Fowler, *The elements of deductive logic, designed mainly for the use of junior students in the universities.* (Oxford: Clarendon Press, 1867), idem, *The elements of inductive logic, designed mainly for the use of students in the universities* (Oxford: Clarendon Press, 1870), Alexander Bain, Logic. Part First. Deduction (London: Longmans, Green, Reader, & Dyer, 1870) and idem, *Logic. Part Second. Induction* (London: Longmans, Green, Reader, & Dyer, 1870).

84 Refer to the publications by R[ichard] B[urdon] Haldane, 'The Categories of Scientific Method', *Proceedings of the Aristotelian Society* 1, No. 4 (1890–1891), 22–7, Henry E.

biblical exegesis and pertaining to theology considered more generally.[85] Some writings concerning the scientific method in education understood that concept to refer to the use of method in teaching a wider range of subject-matters.[86] And in his *How We Think* (1910), John Dewey not only connects the scientific method to natural science, but also places it within the context of logic and within the more general context of philosophy.[87]

An examination of the extent to which the concept of scientific method has been linked to (or identified with) natural science over the course of the twentieth century is beyond the scope of this study. However, the bulk of the recent published criticism of the scientific method has occurred within the context of natural science. Particularly insightful – and relevant to early modern discussions of this concept – are the points made and documentation given by Henry H. Bauer in his *Scientific Literacy and the Myth of Scientific Method* (1992).[88] One important distinction made by him is particularly pertinent here.

Bauer distinguishes between 'textbook' science and 'frontier' science; in the context of Bellarinus's treatise on scientific method, they could be

Armstrong, 'The Teaching of Scientific Method', *Science* (New York: May 22, 1891), 281–85 [hereafter Armstrong (1891)], and H. Heath Bawden, 'The Necessity From the Standpoint of Scientific Method of a Reconstruction of the Ideas of the Psychical and the Physical', *The Journal of Philosophy, Psychology, and Scientific Methods* 1, No. 3 (February 4, 1904), 62–8.

85 For example, see the article by Frank Sargent Hoffmann, 'The Scientific Method in Theology', *The North American Review* 70, No. 521 (April 1900), 575–84 and 'Editorial: The Scientific Method in Biblical Interpretation', *The Biblical World* 32, no. 3 (September 1908), 155–8 (1908); in the latter publication, scientific method is equated with historical method.

86 Such is the case with the treatise by Douglas M. Gane, *The Building of the Intellect. A Contribution towards Scientific Method in Education* (London: Elliot Stock, 1897) and the article by Ella Flagg Young, *The Scientific Method in Education.* (The University of Chicago, The Decennial Publications. Printed from Volume 3, 143–55. Chicago, The University of Chicago Press, 1903) but not in the case of the publication by Armstrong (1891).

87 John Dewey, *How we think* (Boston, New York, and Chicago: D.C. Heath, 1910).

88 Henry H. Bauer, *Scientific Literacy and the Myth of Scientific Method* (Urbana, IL and London: University of Illinois Press, 1992).

considered as analogous to 'teaching (and learning)' and to 'discovery', respectively.[89] Textbook science is the sum of knowledge that has been amassed to date; this is taught in textbooks (and learned by students). Frontier science, however, is that which is newly discovered; it is not considered as accepted knowledge, and it is often initially rejected or regarded with skepticism.[90] Unfortunately, Bauer observes, the term 'science' is used to refer to the former as well as to the latter, when in fact they are fundamentally distinct from one another.[91] He argues that scientific method is not able to be utilized in the realm of frontier science; it also does not pertain to those innovations concerning which we do not (yet) have a paradigm.

Numerous additional publications could be mentioned here in which the scientific method has been subjected to criticism. One important point concerning them is worthy of note. They focus on use of the scientific method by adults and university students as well as by school students at the secondary level.[92] Criticism of the scientific appears to absent, however, in publications that discuss its use at the elementary (or: primary) school level.

89 Bauer (fn. 88), 73–4.

90 'It is also a misconception that science is always seeking major new discoveries: those almost always come unexpectedly, and moreover they are almost always resisted rather than welcomed, or at least resisted before they are welcomed.' Bauer (fn. 88), 58.

91 When discussing innovation and discovery within science, Bauer distinguishes between 1. the 'known', 2. the 'known-unknown', and 3. the 'unknown unknown'. Number 1 refers to what is commonly believed and falls within prevailing paradigms. Such material is commonly taught to and learned by students. Number 2 refers to that which is known in large part, while number 3 is that for which we do not have a paradigm, that is, that which we would not even suspect to exist and/or have validity. Refer to Bauer (fn. 88), 103–4. Analagously, scientific method (mainly comprising that which is taught and learned) and discovery are not clearly connected to each other in Bellarinus's treatise from the year 1606; refer back to footnote 24.

92 Halprin and Schwab – who teach chemistry in secondary school and biology to undergraduate students, respectively – reject a set and structured approach to scientific method, arguing that '[...] there are many methods for finding solutions in science. We must help the students direct their natural curiosity toward open investigation.' Myra J. Halpin and Janice Coffey Swab, 'It's the Real Thing – The Scientific Method', *Science and Children* 27, no. 7 (April 1990), 30–1. Also refer, for example, to the following: Darrel Patrick Rowbottom and Sarah Jane Aiston, 'The

The scientific method is often utilized in instructional plans and suggestions intended for elementary school classrooms. In those instructional settings, the scientific method is usually considered to consist of a number of steps that are followed when investigating a given problem and/or completing a given lesson or task.[93] For example, Lynne Kepler lists six steps

Myth of the 'Scientific Method' in Contemporary Educational Research', *Journal of Philosophy of Education* 40, no. 2 (May 2006)' 137–56; Xiaowei Tang, Janet E. Coffey, Andy Elby, and Daniel M. Levin, 'The Scientific Method and Scientific Inquiry: Tensions in Teaching and Learning', *Science Education* 94, Issue 1 (January 2010), 29–47 (this study focuses on ninth-graders); Clyde Freeman Herreid, 'The Scientific Method Ain't What It Used to Be', *Journal of College Science Teaching* 39, Issue 6 (July-August 2010), 68–72; Mark Windschitl, Jessica Thompson, and Melissa Braaten, 'Beyond the Scientific Method: Model-based inquiry as a new paradigm for preference for school science investigations.' *Science Education* 92, Issue 5 (September 2008), 941–67. In other publications, criticism of the scientific method is qualified; for example, refer to the following: 'The Scientific Method, as presented in textbooks, is indispensable for designing and executing certain types of investigations. Yet, it fails utterly for others. Indeed, I have seen grant applications turned down because the proposed experiments followed the Scientific Method.' J. José Bonner, 'Which Scientific Method Should We Teach and When?', *The American Biology Teacher* 62, no. 5 (May 2005), 262–4 (262); in this same article (264) Bonner also – like Zabarella (1578) – distinguishes between two distinct scientific methods. The scientific method is presented favourably in Hugh G. Gauch, *The Scientific Method in Practice* (Cambridge: Cambridge University Press, 2003); the following article advocates the use of the scientific method as a model for successful mentoring of university-level students: Saundra Yancy McGuire, 'Using the Scientific Method to Improve Mentoring', *Learning Assistance Review* 12, no. 2 (Fall 2007), 33–45.

93 Six steps are listed for teaching art to elementary students in Pam Stephens and Nancy Walkup, 'The Scientific Method and Art Criticism', *School Arts* 106, Issue 5 (January 2007), 37; six steps are also listed for teaching science to elementary school students in Gilbert Proulx, 'Integrating Scientific Method and Critical Thinking', *The American Biology Teacher* 66, no. 1 (January 2004), 26–33. Five steps of the scientific method for sixth-graders are presented in John McBride and Roy Villanueva, 'Salt Crystals: Exploring the Scientific Method', *Science Scope* 20, no. 4 (January 1997): 20–3. 'These five steps are called the scientific method: 1. Ask a question. 2. Gather information about the question. 3. Form a hypothesis. 4. Test the hypothesis. 5. Tell others what you found.' Stephen P. Kramer, *How to Think Like a Scientist. Answering Questions by the Scientific Method.* Illustrated by Felicia Bond (New York: HarperCollins, 1987),

that she has used when teaching science to third graders: 1. Observation; 2. Question; 3. Hypothesis; 4. Experiment; 5. Results; 6. Conclusion.[94] And a recent review of an audio-visual resource on the scientific method intended for students in the third, fourth, and fifth grades can be quoted here in full.[95]

> Gr. 3–5. This film clearly explains the purpose of scientific method, the steps scientists take from defining a question to reaching a conclusion, and how the scientific method influences daily life. Real-life problems are explored, such as what type of paint is best to use in a particular climate and which athletic shoes will be most suitable for playing basketball on a blacktop court. Various examples of discoveries in medicine, household electronics, and crop cultivation are shown to be the result of the scientific method. The scientific method is presented via a scenario involving the observation of the freezing temperatures of pond water and ocean water. The guide contains pre- and post-tests, the script, vocabulary, and student activities. A valuable resource for teaching this topic and an extremely useful tool to help prepare students for science fair projects.

Cogent arguments for the utilization of the scientific method in elementary and middle school instruction are made by Scott Watson and Linda James.[96] The following pertinent points can be quoted here.[97]

20. At Amazon <http://www.amazon.com> – retrieved on September 10, 2012, this book has been designated as appropriate for Grade Levels 3 through 5; also refer to the customer reviews available there. John Cowens, a sixth-grade teacher, notes that he uses five steps (1. Problem/Observation; 2. Hypothesis; 3. Test Hypothesis; 4. Record Observations; 5. Conclusion): John Cowens, 'The Scientific Method', *Teaching Pre K-8* 37, Issue 1 (August–September 2006), 42, 44, 46.

94 Lynne Kepler, 'Fun with the Scientific Method', *Instructor-Primary* 108, Issue 2 (September 1998), 78–9. Also refer to the publications cited in footnote 93 above.

95 *Scientific Method.* Video or DVD. 14 min[utes] with t[ea]cher's guide. Visual Learning Co. 2008. 2009 release. Video: ISBN 978-1-5923-4237-7; DVD: 978-1-5923-4233-4; reviewed by Nancy Bowman (Indian Paintbrush Elementary School, Laramie, NY) in *School Library Journal* 55, Issue 12 (December 2009), 62.

96 Scott B. Watson and Linda James, 'The Scientific Method: Is it still useful?', *Science Scope* 28, no. 3 (November–December 2004), 37–9.

97 Watson and James (fn. 96), 37 (left and right columns), 39 (left column). The article by Soroka referred to here in this quotation is Leonard G. Soroka, 'The Scientific Method at Face Value', *The Science Teacher* 57, no. 8 (November 1990), 45–8; the

Some might argue that the structured approach of the scientific method is too rigid to use with students. However, while older students may not need such a structured approach to solving scientific problems, middle school and elementary school students may benefit from a structured, step-by-step approach (Soroka 1990). [...] Students who have used the scientific method in the early grades have learned a logical way to solve problems, and by third and fourth grades can begin designing their own investigations to find answers to their problems/questions while using the scientific method as a model. The scientific method is also an excellent way to develop critical thinking skills in students (McBride and Villanueva 1997). [...] Once students gain confidence in using the scientific method, they can apply it more successfully to scientific problems and to problems in their own lives, along with using it in a less structured, more realistic fashion.

Other publications that promote the use of scientific method at the elementary school level make similar points: it fosters analytical and/or critical thinking (skills) and deductive reasoning.[98] It can also teach students to follow a logical and straightforward path.[99]

One can conclude by making the following two general points. First, the scientific method can be utilized in elementary level instruction in order to teach logical ways of solving problems, analytical / critical thinking, and deductive reasoning, that is, general skills that transcend (natural) science instruction proper.[100] Analogously, late 16th-, 17th- and 18th-century

article by McBride and Villanueva is cited in footnote 93 above. Concerning the questions of the extent to which the scientific method should be used in the middle school level (or in the sixth grade), I refer to footnote 100 below.

98 Refer to the following: McBride and Villanueva (fn. 93), 20; Stephen and Walkup (fn. 93), 37; Kepler (fn. 94), 79; Cowens (fn. 93), 42. The link between scientific method and critical thinking is discussed in detail by Proulx (fn. 93), 26–32 (and especially on page 30).

99 See Cowens (fn. 93), 42.

100 Criticism of the use of the scientific method with middle-school students is presented in the following two publications: Konstantinos Alexakos, 'Teaching the practice of science, unteaching the "scientific method"', *Science Scope* 33, Issue 9 (June 2010), 74–9; Eugene L. Chiappetta and Thomas R. Koballa, Jr., *Science Instruction in the Middle and Secondary Schools. Developing Fundamental Knowledge and Skills for Teaching*, 6th edition (Upper Saddle River, New Jersey and Columbus, Ohio: Pearson, Merrill, Prentice Hall, 2006), 96–7. American Middle Schools frequently

discussions of scientific method are closely linked to the domain of logic. They also focus on 'science' [scientia] insofar as science is understood to comprise a wide range of academic disciplines beyond [natural] science.[101] One could make the case that the manner in which scientific method has often been utilized in instruction at the elementary school level over the past twenty-five years has its historical precedents dating back to the earliest known published discussions of this concept.

And second, while one might argue that logical thinking and deductive reasoning – both of which can be linked to the scientific method – do not themselves directly result in discovery, they also are not without relevance thereto.[102] Louis Pasteur's assertion, 'Chance only Favours the Prepared

serve students in the sixth, seventh, and eighth grades. Sixth grade can – depending on the school system – often be the highest grade in an elementary school or the lowest grade in a middle school. Refer to the (positive) comments pertaining to the use of the scientific method with sixth-graders – by McBride and Villanueva as well as by Cowens – presented in footnote 93. Any attempt to determine the extent to which middle-school instruction should be considered as at the 'elementary' and/ or as at the 'secondary' school level is beyond the scope of this study.

101 Bellarinus uses the term *scientia* to mean 'knowledge' as well as to mean 'science'. In the latter sense, *scientia* is not identified with what would be referred to as natural science in the United States today. During the sixteenth, seventeenth, and eighteenth centuries, *scientia* usually denotes a wider or narrower range of academic disciplines (or is understood more broadly to mean 'knowledge'); refer to the following: Freedman, 'Bellarinus' (fn. 10), 46 (fn. 8), 48, 69; Joseph S. Freedman, 'Classifications of Philosophy, the Arts, and the Sciences in Sixteenth- and Seventeenth-Century Europe', *The Modern Schoolman*, vol. 72, no. 1 (November 1994), 37–65 and reprinted in Freedman, *Philosophy and the Arts* (fn. 4), VII; Giorgio Tonelli, 'The Problem of the Classification of the Sciences in Kant's Time', *Revista critica di storia della filosofia* 30 (1975), 243–95. Concerning Francis Bacon's use of the term *scientia* refer to footnote 2 in this article.

102 For example, refer to the following well-formulated and cogent argumentation: 'We agree instead with Albert Einstein "[...]]The whole of science is nothing more than a refinement of everyday thinking." [...] Accordingly, a conception of scientific method should grow out of familiar experience. It should complement and extend ordinary discovery processes. And it should highlight how to establish reliable evidence – an aim shared, for example, by journalists and judges. A physician diagnosing an illness, a mechanic troubleshooting a car, a detective tracking a crime all use the same

Mind', summarizes this point.[103] Many of our simple, routine tasks – which we sometimes do so regularly that we are no longer conscious of them – are actions informed in great part by logic, thereby providing basic parameters for our more complex undertakings.[104] We generally utilize methods – some of which we may or may not regard (or label) as scientific – in order to increase our chances of making discoveries and/or reaching other goals.[105] In the context of research, we endeavour to employ rational strategies for what we might refer to when we use constructs such as 'the systematic search for chance finds'.[106]

 methods as scientists, although in different contexts.' Dan Wivagg and Douglas Allchin, 'The Dogma of "The" Scientific Method', *The American Biology Teacher* 64, no. 9 (November–December 2002), 645–6 (646, left col.); Albert Einstein, *Ideas and Opinions* (New York: Dell, 1954), 283. While Wivagg and Allchin do not support the use of a structured scientific method – they suggest using 'the Scientist's Toolbox' in its stead – they make good points (pertaining to 1. the importance of teaching thinking and 2. applications of science instruction to real life) that are very similar to those points made by Watson and James; see footnotes 96 and 97 as well as the corresponding passages in the text of this article.

103 This quotation has been utilized frequently; for example, see Laddie J. Bicak and Charles J. Bicak, 'The Scientific Method. Historical and Contemporary Perspectives', *The American Biology Teacher* 50, no. 6 (September 1988), 348–53 (349, right col.). The first use of this quotation – Chance only Favours the Prepared Mind [le hasard ne favorise que les esprits préparés] – is found within a lecture that was held by Louis Pasteur on 7 December 1854 and can be found in Louis Pasteur, *Oeuvres de Pasteur*, réunies par Pasteur Vallery-Radot (Paris: Masson et C.ie, 1922–1939): 7 (Mélanges scientifiques et littéraires), 129–32 (131).

104 Numerous resources could be referred to here; for example, see Joseph Murphy, *The Power of Your Subconscious Mind* (New York: Bantam Books, 2000).

105 This point is stated well in Bicak and Bicak (fn. 103), 348 (right col.): 'Scientific method, or objective thinking, or problem solving, or however we wish to address it, has been present since man has attempted to interpret observable natural phenomena.'

106 The construct 'the systematic search for chance finds' is my own. An analogous phrase is given in the title of the following article: Wendy M. Duff and Catherine A. Johnson, 'Accidentally Found on Purpose: Information-Seeking Behavior of Historians in Archives', *Library Quarterly* 72, no. 4 (October 2002), 472–96.

Appendix
Authors and Other Participants (1578-1957): Chronological and Alphabetical Concordances

Chronological Concordance

In those published writings where more than one author or participant is named, the first named person is listed first.

Willichius (1550) – Valerius (1560) – Zabarella (1578) – Zabarella, Jacobus. Opera logica ... affixa praefatio Joannis Ludovici Hawenreuteri ... editio tertia. Coloniae: Sumptibus Lazari Zetzneri, 1597/1966) – Bertius and Burgius (1603) – Bacon (1605) – Bellarinus (1606) – Timplerus (1612) – Bacon (1620) – Bacon (1623) – Bellarinus (1630) – Jungius (1638) – Dreier (1644) – Luingh and Achrelius (1651) – Jungius (1657) – Systema logicum (1659) – Bechtlin and Jordan (1662) – Jungius and Vagetus (1681) – Gervasius Briscensis (1687) – Ludovicus and Schwerdner (1694) – König and Gentilott (1694) – Reimann (1709) – Gundlerus (1716) –Schmier (1722) – Wolff (1728) – Wolff (1730) – Klingenstierna and Wallerus (1731) – Ickstatt (1731) – Schmier (1731) – Grosse and Hoffmann (1732) – Holzman and Zeitler (1733) – Wolff (1736/1962) – Carpzov (1737) – Schubert (1738) – Corvinus (1739) – Koch and Neubauer (1740) – Wolff (1740/1983) – Wolff (1741) – Carpzov (1742) – Engelhardus, Nicolaus (1742) – Engelhardus, Regnerus (1742) – Berckenkamp (1743) – Wyttenbachius (1747/1749) – Steinmeyer (1750) – Widmer (1751) – Desing (1752) – Carpzov (1753) – Desing (1754) – Stiebritzius and Mauritius (1754) – Wolff (1754/1972) – Wolff (1755/1972) – Corvinus (1756) – Wolff (1764) – Cramer (1767) – Compendium logicae (1784) – Gmeinerus (1786) – Elementa logicae (1795) – Gmeinerus (1807) – Fowler (1867) – Bain (1870) – Bain (1870) – Fowler (1870) – Jevons (1874/1996) – Jevons (1877) – Haldane (1890-1891) – Armstrong (1891) – Gane (1897) – Hoffmann (1900) – Young (1903) – Bawden (1904) – "Editorial" (1908) – Dewey (1910) – Jungius (1957) – Meyer (1957)

Alphabetical Concordance

Achrelius (1651); Armstrong (1891) – Bacon (1605, 1620, 1623) – Bawden (1904) – Bain (1870) – Bechtlin (1662) – Bellarinus (1606, 1630) – Berckenkamp (1743) – Bertius (1603) – Borelli (1803) – Burgius (1603) – Carpzov (1737, 1742, 1753) – Compendium logicae (1784) – Corvinus (1739, 1756) – Cramer (1767) – Desing (1752, 1754); Dewey (1910) –Dreier (1644) – "Editorial" (1908) – Elementa logicae (1795) – Engelhardus, Nicolaus (1742); Engelhardus, Regnerus (1742) – Fowler (1867; 1870) – Gane (1897) – Gentilott (1694) – Gervasius Briscensis (1687) – Gmeinerus (1786, 1807) – Grosse (1732) – Grosserus (1716) – Gundlerus (1713) – Halane (1890-1891) – Hoffmann, Friedrich (1732) – Hoffmann, Frank Sargent (1900) – Holzman (1733) – Ickstatt (1731); Jevons (1874, 1877) – Jordan (1662) – Jungius (1638, 1657, 1681, 1957) – Klingenstierna (1731) – Koch (1740) – König (1694) – Ludovicus (1694) – Luingh (1651) – Mauritius (1754) – Meyer (1957) – Neubauer (1740) – Reimann (1709); Schmier (1722, 1731) – Schubert (1738) – Schwerdner (1694) – Steinmeyer (1750) – Stiebritzius (1754) – Systema logicum (1659) – Timplerus (1612) – Vagetus (1681) – Valerius (1560) – Wallerius (1731) – Widmer (1751) – Willichius (1550) – Wolff (1728, 1730, 1736/1962, 1740/1983, 1741, 1754/1972, 1755/1972, 1764) – Wyttenbachius (1747/1749) – Young (1903) – Zabarella (1578, 1597/1966) – Zeitler (1732)

14 Digital Renaissance

They're tweeting from the northwest, from the southeast, from London, from Tokyo, from the university of Heidelberg, from the university of Saskatchewan, in offices, in conferences, in traffic. Topics range from the Ars Nova to the *Vita nova*, from the *De vulgari eloquentia* to the *De revolutionibus orbium coelestium*, including a quotation, an aperçu, but just as often, a web link, news of a new book or chapter, a word of praise or blame, whatever can be squeezed into 140 characters. See 'earlymodernweb.org' hope this helps, one says. What's on at the Morgan? asks another. Or, terrific Persian Manuscript collection at the British. Great restaurant near the Folger. Even an apartment in Florence for rent at 'sabbaticalhomes.com'. The hashtag is #Josquindesprez, #dante, #renaissancestudies, whatever fits the moment. It's the Renaissance world of Twitter, and microbloggers on the highly subscribed social networking service include scholars, students, and whoever has a penchant for talk about art, war, love, and anything that comes between the middle and the modern, plus fellow travellers more interested in the later or the earlier. Going back to the past is not the point here; the point is to congregate, for a minute, even a second, in a virtual community, an oasis of freedom outside of meetings, evaluations, projects, fundraising, promotion, and that perpetual motion that is the experience of the modern institution, maybe to learn something, to catch a whiff of what is fresh before it gets stale. Some tweeters are more technologically adept, some are less; often technology is the subject of the posts, and surely it is the glue that holds this somewhat ramshackle community together. Inevitably, the MLA has pronounced on the matter, now that there are guidelines about how to cite web pages, blog posts, podcasts. Tweets are to be cited thus: 'Last Name, First Name (User Name). "The tweet in its

entirety." Date. Time. Tweet.'[1] By the time we go to press this information
will be as common as the tweets themselves. And not only.

The Digital Renaissance is here; amid much murmuring, especially
among the disciplines, about where it is headed and how.[2] The debates
are not new, although ubiquitous technology surely is. Great databases
of Renaissance studies on cards, on tapes, on floppy disks, once littered
the offices of a few pioneering digital humanists regarded with a certain
bemusement by their colleagues; communications via Arpanet and Usenet
required clunky devices and much patience. Now a recent survey at Oxford
University indicated 64 per cent of researchers on campus were concerned
about data management – whatever they may have thought this to be –
of whom 38 of 77 humanities scholars considered this 'essential'. Among
315 respondents, 210, or 67 per cent, used numerical data, and among the
77 humanities respondents, 17 used numerical data, 22 used statistical, 12
used geospatial, 35 used images and 15 used audio.[3] The imagination needs
no stretching to consider that the twenty submissions to the Renaissance
society meeting in New York correspnding to keyword 'digital' are only a
few of the many which will be based on digital tools of some kind; much
more are those which casually utilize digital resources for reference. The
bulletin of the American Historical Association published an announce-
ment by William Cronon stating, 'I'm lucky to be following Anthony
Grafton as president, since we agreed to form a kind of tag team encour-

1 MLA Handbook for Writers of Research Papers, 7th edition (New York: Modern
 Language Association of America: 2009), 6.4.1. For what follows, I am inspired also
 by Michael Ullyot, 'Digital Humanities Projects', Renaissance Quarterly 66, No. 3
 (2013), pp. 937–47.
2 E.g., Joris van Zundert, 'If You Build It, Will We Come? Large Scale Digital
 Infrastructures as a Dead End for Digital Humanities', and S.H.M. Gladney, 'Long-
 Term Digital Preservation: A Digital Humanities Topic?' both in Historical Social
 Research Vol. 37 (2012), No. 3, respectively at pp. 165–86 and 201–17.
3 James A.J. Wilson, Paul Jeffreys, Meriel Patrick, Sally Rumsey, Neil Jefferies, 2012,
 University of Oxford Research Data Management Survey, posted on the project
 team's blog at <http://blogs.oucs.ox.ac.uk/damaro/2013/01/03/university-of-oxford-
 research-data-management-survey-2012-the-results/>. Thanks to James A.J. Wilson
 for supplying the raw data files.

aging the AHA and its members to think systematically about the digital transformation of our discipline.'[4]

The advantages are too obvious to require comment. No one annotating a sixteenth-century text fingers through the brittle pages of nineteenth-century concordances any more to find passages in Cicero or Quintillian. The search for a symbol, a theme or a painting very often begins on the Internet rather than in the volumes in the library's reference collection. Wikipedia, reviled in the classroom, is the researcher project organizer's secret friend, even for the debates it engages because of inaccuracies and exaggerations. Internet libraries – Google Books, Hathitrust, Archive.org – bring original sources as well as modern scholarship to places that had no Renaissance or indeed that have no library to speak of. Virtual tours of monuments jog the memory and provide a cheap and queue-free alternative to travel. The separation of means from ends, of data collection from data analysis, creates efficiencies and improves capacities. Researchers have long benefited from library cataloguing systems and electronic text delivery. The creation of multi-user databases of all kinds means that researchers do not have to collect all their own data. And digital presentation methods, in millions of colours, with audio accompaniment and in two, now three, even four dimensions (throw in 'time'), allow an unparallelled staging of Renaissance research. No wonder the Renaissance researcher has the sensation of being part hermit, part impresario.

As online research becomes the norm, so also will online publication. Already H-Net has mainstreamed as one of the most authoritative voices in Renaissance reviewing. A recent search turned up reviews of 150 publications with 'Renaissance' in the title, reviewed since the inception of the service, mostly in English and German (with some French). The usefulness is confirmed by readers' published comments: 'The book reviews are well-written and judicious. I have my undergraduate and graduate students in history use them as models for the book reviews I have them write for class assignments.' 'It is really useful to know through reviews about all the

4 William Cronon, 'The Public Practice of History in and for a Digital Age', *Perspectives on History*, January 2012 issue.

research and the areas people are exploring. It is like an ongoing literature survey through my E-mail Inbox.' 'The purchase of (English) academic books for our department now relies entirely on the reviews published at H-Net.' 'The reviews have been an excellent resource for me, in research as well as in teaching. With respect to teaching, due to the online availability of reviews, it's easy to incorporate discussions of recently published literature or recent films in class.' 'I find the book reviews that are completed for H-Net far above those that are published in journals. They are more analytically insightful and have a genuine honesty about their usefulness in the classroom.' 'The reviews of books of historical importance and the roundtable discussions are of great interest to me particularly as I am in a somewhat isolated location.'

Not just textbook writers writing for teachers, but authors of scholarly monographs as well, now customarily reference their work to outside links augmenting textual material or providing access to images and graphics. When Ann Blair published her *Too Much to Know*, an account of knowledge management in the sixteenth century, with Yale University Press, she provided accompanying information on her Harvard web page, including 'Supplement to the footnotes: foreign language quotations' linking to a seventy-seven-page Word file mostly of Latin and French, sometimes with English translations; 'Supplement to the printing history of the Polyanthea: survey of extant copies from on-line library catalogs by Morgan Sonderegger' with forty-seven pages of lists and tables; 'Supplement to the printing history of the Theatrum and Magnum Theatrum: survey of extant copies from on-line library catalogs by Morgan Sonderegger', another twenty-five pages of lists and tables. What the publisher won't print nowadays goes online.

R. Burr Litchfield's *Florence Ducal Capital*, a 'born digital' research monograph published only as an ACLS e-text, is accompanied, so says the Introduction, by the web site 'Florentine Renaissance Resources: Online Gazetteer of Sixteenth Century Florence'. Other online sources utilized in the work include the records of the *tratte* regarding Florentine Office Holders, 1282–1530, compiled by David Herlihy's group, in Brown University's 'Florentine Renaissance Resources', as well as Paolo Malanima's records of wheat prices in Florence, 1260–1660, at <http://www.iisg.nl/

hpw/malanima.php>. The understanding of Florence as a ducal city is conveyed in terms of space and place; and indeed a major argument in the book is the change in the locus of major activity in the city from north to south of the Arno, as the area around the new ducal residence at Palazzo Pitti and the associated ducal court gains importance. This shift is conveyed not only quantitatively, by reference to the numbers of families in various occupational groups, but also verbally and visually by associating the statistical data with the many maps. With some fifty maps and fifteen tables, the work exemplifies digital publication's capacity to deliver more content than print, as well as the possibility of moving around the text via links.

A major concern among friends and critics of the Digital Renaissance (often the same persons in different guises) is, as far as actual research is concerned, what is changing and what remains the same?[5] What do the new instruments offer, and what do they not offer? What insights are new, and what are simply recycled? No one disputes that the possibility of visualizing large arrays of data or objects in particular frames or from particular angles or relative positions in space and time or the bringing together and easy manipulation of words and things all stimulate the analytical and creative faculties. Such has been the function of manipulating the data and the writing, always. Is the Digital Renaissance a quantum leap or a step forward, or a passing spasm? More importantly for young academics, what can they get out of it?[6] Our purpose in this chapter is to look at a few areas where the Digital Renaissance has made significant contributions and to examine some of the theses which have emerged as a result.

Here we are not talking about bibliographies or tools and instruments for gaining access to scholarship *per se*, but instruments and tools for engaging with the original sources of the Renaissance past. Specialized lists are important here, to be sure, for locating the respective sources; and the RSA site, the Iter Renaissance portal, and many library portals such

5 Anthony Grafton, 'Digitization and its discontents', *The New Yorker*, 5 November 2007.
6 Deborah Lines Andersen, *Digital Scholarship in the Tenure, Promotion, and Review Process*, History, Humanities, and New Technology (Armonk NY: M.E. Sharpe, 2004).

as the Datenbank-Infosystem (DBIS) of the Kunsthistorisches Institut in
Florenz, or the Brandeis University Library and Technology Services, will
take you deeper still, pointing you in the direction of the UC Irvine Analytic
Bibliography of Online Neolatin Texts or the University of Houston reper-
tory on the Anglo American Legal Tradition, or even the Cusanus Portal
maintained by the Institut für Cusanus-Forschung at the University of Trier.
New initiatives are occasionally mentioned by more general services such as
HASTAC, DARIAH, CENDARI, and their respective web pages, or blogs
such as the 'Boite à outils des historiens'.[7] These are not our subject here.

To start with the new instruments themselves, they may be grouped
in the three categories of databases, visualizations, and editions, but they
generally refuse confinement to any one of these. A database may contain
visualizations and editions. A digital tool may deal predominantly with
numerical, textual or other types of data or may mix one or more of these
in different ways. Since our purpose here is not to give lists but to convey
our understanding of the contents of particular instruments, we will analyse
each of these categories from the point of view of the kinds of insights it
might supply. Occasionally we will refer to instruments currently used in
other fields which could be applied to Renaissance Studies.

A typical database might be the Medici Archive Project, located on the
premises of the State Archive in Florence but governed by a US-based
board of trustees and funded from a variety of public and private sources.
It has for years been building a fully searchable database linking synopses
and transcriptions of documents from the Medici papers to names and
places as well as context information of various kinds. Edward Goldberg's
original intention as project founder, of tracing a number of material cul-
ture categories – paintings, sculptures, jewellery, buildings – has evolved
into a more general effort to get as much document content as possible
online. The innovative production scheme called for appointing numerous
postdoctoral research fellows to work on portions of the database related
to their own scholarly interests. Thus, the database has grown along with

7 <http://www.boiteaoutils.info/2011/09/les-historiens-seront-ils-finalement.html>.

the utilization of it by the very individuals who contributed to building it. As of early 2013 the online version includes over 20,000 documents, with references to over 80,000 place names and 13,000 personages. The new 'Bia' platform developed by current director Alessio Assonitis, Lorenzo Allori and their team introduces a new method of transcription and annotation, by placing digital images of the documents online and inviting the international scholarly community to post their versions, which will be edited by the Project.[8]

New discoveries necessarily arise simply from the close inspection of the documentary material which goes into the process of database building. However, the new context and content unearthed regarding key figures of the European past, the vital statistics corrected, the previously unknown personages identified, the general interpretations modified, the topics reassessed, all due to work by researchers on the Medici Archive Project or utilizing the Project database, are inseparable from the general currents of Renaissance studies *per se*, so a particular assessment of Project impact would be hard to make. Project director Alessio Assonitis refers to 20,000 average monthly hits, which gives a partial idea of the perceived usefulness.[9] A resurgence of interest in the grand ducal period of Florence, once regarded as the 'forgotten centuries', can surely be traced to the easier availability of archival sources compared to other times and places, as well as to the interest generated by the Project's novelties, the investment in early career researchers, as well as the educational possibilities of massive document transcription into readable Italian, Latin, Spanish, French or what have you, and summarizing in English.[10]

Letter collections such as the Melanchthon project are predominantly text-based, although because they include dates and can be counted, they are susceptible to time series analysis.[11] By contrast, the Medici Archive

8 <http://medici.org/>.
9 <http://www.medici.org/about/mission>.
10 Consider the project site's publication and conference page: <http://medici.org/publications-conferences>.
11 <http://www.haw.uni-heidelberg.de/forschung/forschungsstellen/melanchthon/mbw-online.de.html>.

Project provides a sampling of the Medici material, chosen on the basis of the researchers' tastes, so time series are misleading; and the administrative protocols of the archive dictate that most of the material comes into and out of Florence, so geographic quantifying is one-sided. The Melanchthon database includes fully searchable summaries of letters as well as context-related information such as identification of persons and places mentioned in the letters. Places and persons cannot be browsed as separate linked tables, and persons who are not senders are dealt with only in the summaries.

The 'Circulation of Knowledge' project at the Huygens ING in the Netherlands proposes to combine time series with topic and concept searches to study the problem of 'how did knowledge circulate'.[12] A virtual research environment called the *ePistolarium* facilitates a variety of searches and visualizations regarding some 20,000 letters to and from seventeenth-century scholars in the Dutch Republic, to understand the breadth and development of the network, including collaboration, co-citation, etc. Comparative increases and decreases over time in the volume of discussion regarding particular topics – religion, nobility, the Scandinavian conflict – may be set within a vast countable semantic universe, as soon as the various linguistic and theoretical issues have been ironed out so that scholars can experiment with the tools and conceive of new questions to explore with them. Whether Latent Dirichlet Allocation, a topic model the project originally considered particularly promising, will unlock the secrets of Renaissance communications if applied to still earlier documents, only time will tell.[13]

Name-based databases are particularly friendly to cross-searches and correlations for producing outputs that give rise to conclusions regarding particular populations or groups. How did religious affiliation affect career prospects of educated people? What role did geographical origin play? How did student mobility change from year to year? Such questions will

12 <http://ckcc.huygens.knaw.nl/>.
13 Dirk Roorda and Charles van den Heuvel, 'Annotation as a New Paradigm in Research Archiving. Two Case studies: Republic of letters – Hebrew Text Database', ASIST 75th Anniversary Conference, Baltimore 28–30 October 2012.

eventually be put to the Repertorium Academicum Germanicum (RAG), a collaborative project of Swiss and German institutions, founded by Rainer C. Schwinges at Bern and now being coordinated by Suse Andresen, also at Bern. The project has announced processing of some 40–50,000 individuals who graduated from German institutions of higher learning between 1250 and 1550. Data will include vital statistics, attendance, family relations, careers, important accomplishments. Thus one may even ask, what were differences in life chances from generation to generation? Do doctors live longer than lawyers? Are they more likely to remain celibate? 'Qualitative and quantitative statements on the intellectual elite of the Empire, their European networks, as well as institutional and territorial comparisons will be possible', the team has announced. 'Thus the scholars' role in pre-modern society can be described on a firm empirical basis and explained within the framework of modern educational research, with special reference to social, cultural, and scientific history.'[14]

A particular challenge in name-based databases is the name ambiguity problem imposed by the existence of similar names belonging to unrelated people. The Gemeinsame Normdatei (GND) convention attempts to provide a solution within the German context, assigning a unique number to single individuals. The RAG project of which we have spoken utilizes the GND as a standard. So does the Repertorium Germanicum Online (RGO). The RGO, a project of the German Historical Institute in Rome currently run by Jörg Hörnschemeyer and Michael Matheus, joins the Repertorium Germanicum (RG) and the Repertorium Poenitentiariae Germanicum (RPG) to form a repertory of circa 160,000 German persons, churches and places from 1378 to 1492 from all the Vatican registers and files as well as the lists of supplicants to the Tribunal of the Apostolic Penitentiary.[15] The platform will support focused searches on particular names as well as name browsing among similar entries and variants. Likewise tending

14 The comments are at <http://www.rag-online.org/en.html>.

15 <http://www.romana-repertoria.net/fileadmin/user_upload/pdf-dateien/Online-Publikationen/Dresden_Histtag/Hist_Grundlagenforschung_Mittelalter_Neuzeit.pdf>.

toward the GND standard is the newly online name registry of Germania Sacra, based on the *Handbuch der Kirche des alten Reiches* begun in 1917 and now running to some sixty-three volumes.[16] Letter collections will permit massive processing of names, dates and places, as the data becomes available.[17] Inspired in part by the 'Mapping the Republic of Letters' project at Stanford, but more concerned with an earlier period, the 'Early Modern Letters Online' project at Oxford (within the 'Cultures of Knowledge' project run by Howard Hotson) has begun to look to connecting the vast quantities of metadata in its union catalogue of correspondence (not the correspondence itself) to dynamic visualizations of networks.[18] Much depends on being able to gain an adequate sampling in order to give meaningful answers to the questions being asked, and confining generalizations to those that can actually be supported. Typical pitfalls in historical network research include a careless use of the relevant terminology, misunderstanding the nature of particular nodes, attempting to accommodate bimodal networks in forms of analysis designed for single-mode networks, mixing symmetric relationships (undirected edges) among nodes with asymmetric relationships (directed edges). Another pitfall lies in misinterpreting the specific kind of 'centrality' among nodes, as detected by the software.[19]

Digital enhancements to textual analysis have received particular impetus from Shakespeare studies, where classic textual issues, arising from

16 <http://personendatenbank.germania-sacra.de/>.

17 On the topic in general, see especially James Daybell and Andrew Gordon, 'New Directions in the Study of Early Modern Correspondence', *Lives and Letters: a Journal for Early Modern Archival Research*, 4 no. 1 (2012), which is the presentation to a special issue of this journal concerning the topic. Unpaginated paper consulted online.

18 <http://emlo.bodleian.ox.ac.uk/>; and concerning the visualizations, <http://cofk. history.ox.ac.uk/visualizing-and-navigating-the-republic-of-letters/>.

19 Some examples and suggestions are in Scott Weingart, 'Demystifying Networks, Parts I and II', *Journal of Digital Humanities*, 1 no. 1 (2011). Unpaginated online version. I profited here from a presentation by Christoph Kudella entitled 'Beyond the Metaphor: Social Networks and Historical Science', at the University College Cork Digital Arts and Humanities Research Colloquium, 5 February 2013.

crucial differences between the Folio and Quarto editions, have long stimulated scholarly imaginations. Could the digital move textual studies in new directions?[20] Application of corpus linguistics techniques in the early 2000s called for readily-accessible as well as reliable texts in a format easily subjected to algorithmic searches. To this end, the WordHoard Shakespeare, a service hosted at Northwestern University, provided XML-coded texts of The Globe Shakespeare, the one-volume version of the Cambridge Shakespeare, edited by W.G. Clark, J. Glover, and W.A. Wright (1891–3). According to the website, 'the Internet Shakespeare editions of the quartos and folios have been consulted to create a modern text that observes as closely as possible the morphological and prosodic practices of the earliest editions'. Indeed, 'spellings, especially of contracted and hyphenated forms, have been standardized across the corpus'. Moreover, 'the text has been fully lemmatized and morphosyntactically tagged'.

Grammatical and lexicographical searches across the corpus may yield frequencies of specific terms or morphologies to generate hypotheses regarding concept, emphasis, tendency, style. Weighted lists permit breaking up a text and visualizing portions of it to find regularities, provoke conclusions. What words are more prevalent in which plays? How do characters speak? How is gender portrayed? A recent study 'observed that Shakespeare's female characters more often use adverbs, interjections, adjectives, personal pronouns, negations, and question words, while male characters use more determiners, articles, prepositions, subordinating conjunctions, modal verbs, adjectival particles, infinitives, and question pronouns'. Clearly such analyses say more about authorial gender projection than they do about gender *per se*, since we suppose the same playwright constructed all the utterances. Yet they may well shed some light on otherwise inaccessible corners of the creative process.[21] If such findings so far seem to have contributed more to debates about text authentication in terms of gender, time

20 Consider the comments of James O'Sullivan, 'Electronic Textual Analysis: What and Why?' in James O'Sullivan, ed., *Digital Arts & Humanities: Scholarly Reflections*, Apple IBook. Unpaginated online version.

21 Sobhan Raj Hota, Shlomo Argamon, and Rebecca Chung, 'Gender in Shakespeare: Automatic Stylistics Gender Classification Using Syntactic, Lexical, and Lemma

frame and ethnicity, going on within the espionage community, they may soon inspire more curiosity within Renaissance scholarship as the techniques become more widespread and corpora for other Renaissance authors become available for comparison.[22] A further step along the same lines has been taken by the MONK project ('Metadata Offer New Knowledge'), which includes some 500 texts from 1533 to 1625.

In 2008 Martin Mueller noted 'given the centrality of the Shakespeare corpus, it is disappointing that we still lack a robust textual infrastructure to pursue quantitative inquiries.'[23] In the meantime, significant strides have been made. The Folger Digital Texts initiative provides easily-searchable texts of twelve plays with a promise of a complete suite by the end of 2013, along with downloadable pdfs and source code.[24] These tools now accompany two online and downloadable exemplars (5 and 68) from among the Folger's eighty-two First Folios (out of 228 thought to be in existence), one of which is displayed on their site using the Luna Imaging company's innovative Insight visualization programme. With good reason, the Bodleian Library emphasized the particular characteristics of its battered First Folio, such as the notably worn pages in the *Romeo and Juliet* and notably unsullied pages in the *King John*, indicating possible hypotheses about variations in interest or popularity between the different plays, when embarking in Summer 2012 on a VIP-studded fundraising campaign to put this exemplar too online.[25] Such efforts of course are less concerned with the text *per se*, and more concerned with the typography, the context, and especially the community outreach potential of the Digital Renaissance.

features', paper presented to the Chicago colloquium on *Digital Humanities and Computer Science*, 2006. Unpaginated online version.

22 Yaakov HaCohen-Kerner, Hananya Beck, Elchai Yehudai and Dror Mughaz, 'Stylistic Feature Sets as Classifiers of Documents According to their Historical Period and Ethnic Origin', *Applied Artificial Intelligence: An International Journal* 24, Issue 9 (2010), 847–62.

23 Martin Mueller, 'Digital Shakespeare, or Towards a Literary Informatics', *Journal of the British Shakespeare Association* 4, no. 3 (2008), 295.

24 The information is from the project website at <http://www.folgerdigitaltexts.org/?chapter=0>.

25 The event is celebrated at <http://shakespeare.bodleian.ox.ac.uk/>.

The MLA committee on the Variorum Shakespeare sponsored a competition in 2012 for the 'most compelling uses of the data' in the recently published edition of *The Comedy of Errors*.[26] The announcement was preceded by the release of the XML files and schema for the edition on a Creative Commons licence. Specifying new interfaces and visualizations as well as new data-mining techniques, the committee was clearly looking to the creation of new knowledge and new tools for acquiring knowledge. The winner was a programme by Patrick Murray-John called Bill-Crit-O-Matic, designed to allow new ways of analysing the scholarly apparatus of the edition. The prize committee spoke of 'interconnecting the data as conversations between scholars'. Thus, on the site at bill-crit-o-matic.org, readers can look up a particular concept, say, in Lacanian criticism, view all the citations of that concept in the bibliography, and either click on the passages in the play to which reference is made in this connection, or click on a particular bibliographical reference and see which other scholars have referred either to it or to other works by the scholar who wrote it. The intention is to furnish, in seconds, a complete array of thoughts in relation to the text and in relation to the scholarship.

The Shakespearean International Yearbook published by Ashgate has announced a new volume for 2013, co-edited by Hugh Craig and Brett D. Hirsch and entitled 'Digital Shakespeares', which promises to take text analysis to a new level. 'If data is "the next big idea in language, history and the arts"', the editors inquire, citing Patricia Cohen, 'where are we now in Shakespeare studies? Are we being "digital" yet?' Papers are likely to stem in part from the George Washington University Digital Humanities symposium held in January 2013. Contributors to the volume are invited 'in particular' to study 'the application of digital technologies and methodologies – such as computational stylistics, data mining and visualization, 3D virtual modelling, electronic publishing, etc. – and their impact on Shakespeare research, performance, and pedagogy'.[27]

26 The announcement is at <http://www.mla.org/nvs_challenge>.
27 The announcement of the volume, to be published in 2013, is here: <http://blog.ashgate.com/2012/05/23/the-shakespearean-international-yearbook-prepares-a-special-section-on-digital-shakespeares-papers-are-invited/>.

The Digital Renaissance extends to musicology. Richard Freedman of Haverford College and Philippe Vendrix at the Centre d'Études Supérieures de la Renaissance in Tours have created a research tool for studying the *Livres de chansons nouvelles*, sixteen sets of books printed by the Parisian printer Nicholas Du Chemin between 1549 and 1568.[28] By collecting digitized versions of the scattered partbooks in a single place, the project enables research across the whole range of some 300 polyphonic songs by various authors anthologized by Du Chemin, while giving access to the performance possibilities of the corpus. As five of the Du Chemin volumes are incomplete, including only the superius and tenor parts, research will include plausible reconstructions of the missing counter-tenor and bassus parts as well as studies of the whole repertory. To this end, project directors are providing their own hypotheses, while inviting online collaborators to participate by using the links and downloads available on the site. For those inclined to making transcriptions, there is a downloadable sheet of blank music paper, and for those more mechanically oriented, a link to Scorch, a free programme for creating and playing scores in modern notation. Other links will permit comparisons with other chanson collections from the period, as these become available. To facilitate comparison and engage further collaboration, future versions of the Du Chemin project are promised to be encoded in XML according to the standards of the Music Encoding Initiative (MEI), which is emerging as the standard for combining words and notation in digital music editions.

Output from the project so far includes, among much else, reconstructions of the partially preserved chansons 'Pour l'un des baisers jolis', by Le Gendre, 'Mon Dieu, pourquoy n'est-il permis', by Morel, and 'Tu m'as, cruel, sans cause délaissée', by Gardane, all in the Twelfth Book; and, from the Thirteenth, 'Elle a voulu de moy se séparer', by Du Buisson. Some of the conclusions from the research include Freeman's hypothesis that the editor deliberately included pieces with melodic lines similar to those of chansons printed by the royal printer, Attaignant, reinforcing the notion

28 The project is located at: <http://ricercar.cesr.univ-tours.fr/3-programmes/EMN/ Duchemin/>. What follows is gleaned from this website.

that there developed in mid-sixteenth-century France a 'rich economy of musical and poetic ideas shared by composers [...] who took evident delight in the play of related pieces and poems'.[29]

The Computerized Mensural Music Editing Project (CMME) has undertaken to provide online scores of music from the age of mensural notation (circa 1300–1600), including such masters as Dufay, Josquin, Machaut, Palestrina, and Tallis, for use by students, scholars, performers, and interested amateurs. Based at Utrecht University in the Netherlands under the direction of Theodor Dumitrescu and Marnix van Berchum, the project represents a collaborative effort of specialists in musicology, information science, and music retrieval.[30] The editing tools permit transcription in early format as well as modern format, and inclusion of variant readings. So far, input is manual; but there are suggestions of collaboration with image-based projects such as the Digital Image Archive of Medieval Music (DIAMM) at Oxford University, to develop software capable of creating machine transcriptions from images, for subsequent elaboration into modern editions. To facilitate such collaborations, the CMME has made the Java source code of its tools available online.

How can masses of musical data be compared in order to understand aspects of stylistic change in music over very long periods, or, say, between the Renaissance and the Baroque, which may be missed by other methods? The Electronic Locator of Vertical Interval Succession (ELVIS) project of Michael Scott Cuthbert (MIT) and collaborators attempts to do just this. The project endeavours to utilize information about intervals, harmonies, dissonances, etc., in somewhat the same way as the text-oriented projects utilize textual elements; indeed, a project presentation asserts the affinity with the seminal work of John Sinclair, *Corpus, Concordance, and*

29 I cite from the 'Introduction' to Richard Freedman, *Du Chemin's Chansons nouvelles: The French Chanson at Mid Century*, a web publication posted on the project website. I also consulted Richard Freedman and Philippe Vendrix, 'The Chansonniers of Nicolas Du Chemin: A Digital Forum for Renaissance Music Books', *Die Tonkunst* 5 (3) (2011), 284–8.

30 <http://www.cmme.org/>.

Collocation (1991).[31] It even makes reference to the seventeenth-century work of Pedro Celone, *El melopeo* (1613), comparing letters to intervals.[32] Scores are reduced to numbers as follows: between any two voices, unison equals 1, a sixth equals 6, a downward melodic movement of a third equals minus 3, and so forth. The team has developed software called Vertical Interval Successions (VIS) to analyse the interval 'triangles' made up of a first vertical interval, a second vertical interval, and the melodical interval of the lower voice. The intention is to trace the frequencies of certain combinations from time to time and place to place and composer to composer (where known), to give profiles of the musical texture of particular pieces. The 600 years of Western music which the project examines is regarded as 'big data', and accordingly the project applied for and got an award from the 'Digging Into Data Challenge' for 2011.[33] Presumably comparison with thousands of other musical pieces will permit some conclusions regarding where the remarkable frequency of the major tenth in the Kyrie of Palestrina's 'Missa Dies sanctificatus', as well as the frequency of harmonic movement from a fifth to a sixth, fits within the entire course of Western music.

As we are not providing lists here, we do not need to mention such initiatives as the Texts on Music in English (TME) based at the University of Nebraska, the Traités français sur la musique (TFM) at Indiana University in Bloomington, the Saggi musicali italiani (SMI) at Louisiana State, the Thesaurus Musicarum Italicarum (TMI) at the University of Utrecht, or Thesaurus Musicarum Latinarum (TML) centred at Indiana University. As far as making the early books and manuscripts available by digital imaging is concerned, 'Early Music Online', a project of Stephen Rose and collaborators at the Royal Holloway College of the University of London, has begun a pilot project to digitize some 300 volumes of early printed music anthologies now held in the British Library. The imprints are from

31 <http://simssa.ca/sites/simssa.ca/files/Elvis%20presentation%20November%20 2%20SIMSSA%20lunch%202012.pdf>.
32 The citation is to *El melopeo y maestro* (Naples: Gargano, 1613), Book 9 ch. 3, 565.
33 <http://www.diggingintodata.org/Home/AwardRecipientsRound22011/ELVIS/ tabid/192/Default.aspx>.

Italy, Germany, France and England, and they contain roughly 10,000 compositions. Access to the content is freely available under the terms of the British Library users' licence. The same arrangement applies to many of the other imaging projects to which we now turn.

Massive online manuscript delivery has moved the scholar out of the physical archives and into the virtual archives.[34] The new Vatican digital library was unveiled on 31 January 2013. On the opening day, some 256 files were displayed, each containing images of all the pages of single illuminated manuscripts ranging in age from 1,000 to 500 years, with a minimum of description: author, epoch, geographical origin, contents of the volume, sometimes more detailed than the 1886 inventory, sometimes less, the manuscript descriptions forming the basis for any searches.[35] Images are of exceptionally high quality, and lend themselves to consultation, clipping, and every form of manipulation. Further developments of the Vatican's digital repository are to include an engine for searching the illuminations by a graphic pattern across the whole range of 80,000 manuscripts in the Vatican collections. I just scrolled through a particularly well-illustrated French manuscript of Boccaccio (Pal. lat. 1989), comparing the illuminations to those of the Venetian printed edition of 1492. Study in Rome will never be the same.

The thirty-two manuscripts digitized for the DanteOnLine site are not from one library, but from many, and will be many more again if the project succeeds eventually in digitizing all of the 803 extant manuscripts of the *Divina Commedia* currently listed in the bibliography.[36] Whether we consider Dante to be a precursor or a fellow-traveller of Petrarch and Boccaccio, this project of the Società Dantesca in Florence, which went online in 2009 with sponsoring from the local Cassa di Risparmio, exemplifies the benefits of joining a number of scattered codices in one place for comparison. This

34 Some of the challenges are noted in Desmond Schmidt, 'The Role of Markup in the Digital Humanities', in *Historical Social Research* Vol. 37 (2012), No. 3, 125–46.

35 I consulted the online catalogue to the new collection at <http://www.vaticanlibrary. va/home.php?pag=mss_digitalizzati&BC=11>.

36 <http://www.danteonline.it/english/home_ita.asp>.

potential is particularly interesting in studies on the *Divine Comedy*, where, as in the case of the Shakespeare corpus, there is no autograph.

The question will be, from the standpoint of the Digital Renaissance, what the increased visibility of texts might contribute in the way of new theses and new approaches. The mass of material is certainly impressive. The Digital Scriptorium based at the Bancroft Library, UC Berkeley, has collected an image-bank of Medieval and Renaissance manuscripts from some thirty institutions around the US. In most cases, the Digital Scriptorium gives a sampling from several pages of the original, rather than the entire document.[37] Among the most ambitious of the country-based manuscript initiatives is the Virtual Manuscript Library of Switzerland, which proposes 'to provide access to all medieval and selected early modern manuscripts of Switzerland via a virtual library'.[38] So far featuring 961 entire manuscripts from forty-two libraries, the initiative plans to place twenty-five more on line in 2013. To engage a broadly based collaboration among researchers in the selection of codices to digitize, the Rectors' Conference of the Swiss Universities and Swiss University Conference have put out a call for nominations of the next texts to digitize.

Beyond the level of national initiatives, the Europeana Regia associates the resources of the Bibliothèque nationale de France (BnF), the Bayerische Staatsbibliothek (BSB), the Universitat de València Biblioteca Històrica (BHUV), the Herzog August Bibliothek (HAB), the Koninklijke Bibliotheek van België-Bibliothèque royale de Belgique (KBR) to digitize 874 medieval and Renaissance manuscripts related to three great collections existing in the past: the Bibliotheca Carolina (eighth and ninth centuries), the Library of Charles V and Family (fourteenth century) and the Library of the Aragonese Kings of Naples (fifteenth and sixteenth centuries). The manuscripts themselves are located in the associated libraries as well as in a dozen or so others.[39] To sense the possibilities, I searched under 'naturalis' and turned up fully digitized copies of two finely illuminated late fifteenth-

37 <http://bancroft.berkeley.edu/digitalscriptorium/>.
38 <http://www.e-codices.unifr.ch/>.
39 <http://www.europeanaregia.eu>, a site in six languages including Catalan.

century manuscripts once belonging to the Aragonese Kings of Naples and containing extracts from Pliny's *Natural History*, one in the Universitat de València (BH Ms. 691) and another in the Fondation Martin Bodmer in Cologny (Cod. Bodmer 7).[40]

Most ambitious of all, and still very much in the planning stages, is the 'Enrich' project, aimed at 'creating a virtual research environment providing access to all existing digital documents in the sphere of historic book resources (manuscripts, incunabula, early printed books, maps, charters and other types of documents)'.[41] Building on the Czech-based 'Manuscriptorium' project which has already produced nearly 5 million digital images of manuscripts from libraries in the Czech Republic and elsewhere, it will combine a digital image library with a TEI-based information resource uniting the manuscript catalogues of libraries across Europe.[42] But with such a project we are getting out of the realm of Renaissance-specific computing and into the wider world of humanities computing in general.

Does this 'decentering of the archive', as Stephen J. Milner has called it, along with the removal of the 'touch and smell' of the papers and their repositories, fundamentally change the relation between the researcher and the document?[43] Will the demise of 'the solidity of the concept of archive' along with advancing convictions about 'the subjectivity of archival sources' contribute to further undermining the traditional 'autonomy of the historian as subject'? In other words, as we gently nudge Burckhardt out the window are we nudging ourselves out as well? Surely actual archival experience will remain an essential concomitant to historiographical training, even as libraries and archives reexamine their traditional roles

40 For an acknowledgment of the possibilities of the collections from the standpoint of the history of medicine, see Joseph Ziegler, 'Michele Savonarola: Medicina e cultura di corte (review)', *Bulletin of the History of Medicine* 86.1 (2012), 123–5.

41 I cite from <http://enrich.manuscriptorium.com/>.

42 This is from <http://www.manuscriptorium.com/apps/main/mns_direct. php?docId=rec1341954866_195>. The technical details are in the online reference manual, at <http://www.manuscriptorium.com/schema/referenceManual_en.pdf>.

43 Stephen J. Milner, 'Partial Readings: Addressing a Renaissance Archive', *History of the Human Sciences* 12 (1999), 95.

in institutional development.[44] But there is no doubt that the new avail-
ability of material encourages and facilitates forms of collaboration that
could only have been imagined in the past, creating new opportunities for
engagement in research endeavours across space and time.

What is more, the potentialities of digital media suggest new ways
of engaging public interest in Renaissance themes. Or perhaps the use of
the digital in the 2010 Stratford Shakespeare Festival production of *Two
Gentlemen from Verona* was merely a concession to the Zeitgeist. Did the
possibilities of abundant digital film accompaniment influence the eventual
choice to set the production in the world of 1920s Vaudeville? Certainly
the clever use of silent film clips mixed with audio effects could be expected
to appeal to an audience more attuned to visual than to verbal virtuosity.[45]
The Renaissance authors' own sense of showmanship in bringing classics,
or versions of classics, to the stage, supplies the legitimate precedent for
refashioning, updating, indeed remediating, if such were needed.

Can gaming stimulate new generations to peruse the themes in
and around Renaissance Studies and perhaps draw more public atten-
tion to our work? The 'Dante Digitale' videogame conceived in 2009 by
Gabriella Carlucci would have been designed to do that. Carlucci, mayor
of Margherita di Savoia in Puglia and former member of the Chamber of
Deputies, along with a group of advisors from the Università Cattolica of
Milan and the Sapienza of Roma, thought of a kind of educational tool
informing about the poet and the poem. 'More than television, more than
cinema and music, the video game represents the main form of enter-
tainment of the twenty-first century,' her site announced.[46] The resulting

44 On this topic, Donald J. Waters (Program Officer, Scholarly Communications, The
 Andrew W. Mellon Foundation), 'The Changing Role of Special Collections in
 Scholarly Communications', presented at the Fall Forum hosted by the Association
 of Research Libraries and the Coalition for Networked Information, entitled: An
 Age of Discovery: Distinctive Collections in the Digital Age, Washington, DC, 14
 October 2009.

45 M.G. Aunea, 'Destination Shakespeare: The Stratford Shakespeare Festival 2010',
 Shakespeare 8, no. 2 (2012), 264–74.

46 The announcement is on her site at <http://deputati.camera.it/gabriella.carlucci/
 doc/progetto_dante.pdf>.

product, in English and Italian, would 'reconcile the need to make known the work of the poet with the need to entertain young students'. Perhaps the two goals were less reconcilable than had originally seemed. In any case the project appears to have been shelved, also because another game soon hit the market.

If in Carlucci's idea the yearning soul perhaps might have had the chance to get to heaven, 'Dante's Inferno' released by Electronic Arts in 2010 confined the action to Hell.[47] What is more, the educational theme and commemorative intention seem to have been sacrificed in order to churn out enough 'blood and gore, intense violence, nudity and sexual content' to keep the attention of the 17+ age bracket marked on the box. Here was a rival to 'World of Warcraft', or indeed, a sequel, promising an 'epic quest of vengeance and redemption' while the gamer travels 'through the nine circles of Hell' and battles 'ever more fierce and hideous monsters'. There would be a chance to 'Face your own sins, a dark family past, and your unforgivable war crimes', but no chance to sample too many sub-tleties. The simple story line is not about self-knowledge or redemption but about saving Beatrice from the monsters. Quipped Federico Cella in *Corriere della sera*, 'lasciate ogni speranza', give up all hope, of ever finding the scholar's Dante here.[48]

Will a game based on Boccaccio be so daring? Surely it will not be long in coming. On 15 January 2013 the Decameron Web at Brown University in collaboration with the Italian Consulate General in Boston and the Ente Nazionale Giovanni Boccaccio of Certaldo, Italy, announced the Boccaccio AfterLife Prize for the 'best translation and adaptation of a *Decameron* novella into any media', including text, hypertext, theatre, YouTube movie, videogame, animation or digital visualization, as well as any representation on 'Twitter or any other social media' presumably including Facebook.[49]

47 The game is described at <http://www.ea.com/dantes-inferno>.

48 Federico Cella, 'Dante diventa interattivo. E picchia come un fabbro', *Corriere della sera*, 30 January 2010, 'I blog', consulted at <http://vitadigitale.corriere.it/2010/01/30/dante_si_ritrova_in_una/>.

49 The announcement is at: <http://www.brown.edu/Departments/Italian_Studies/dweb/Boccaccio_AfterLife_Prize.pdf >.

It was, the announcement specified, a tribute to the enduring value and appeal of Boccaccio's work, that in every age there were found new means for conveying ideas and concepts found therein. We might add, from the simple visualizations characteristic of the earliest illuminated manuscripts or printed editions to the later attempts on stage or at the cinema, some simply extending a passing tribute to the original (consider the suggestive 'Boccaccio '70' by Fellini and others), the various remediations have often joined a high level of technique to artistic value. Contemporary culture, the prize announcement implied, might appropriately choose the techniques provided by digital media for discovering new ways to join pleasure and instruction, as new generations attempt to turn the heroes of the past into heroes of the present.

The Digital Renaissance has brought far more new challenges and new ways of approaching our field than we could possibly enumerate here. To some degree it mirrors the time period which is our primary object of study. We view a past world through the eyes of the present and in the light of recent discoveries that have culminated in a communications revolution. We could be talking about the successors of Poggio Bracciolini, those who produced the *editio princeps* of the rediscovered Vitruvius and translated it into the vernacular to inspire architects all over. Giovanni Sulpitius and Cesare Cesariano are the prototypes for our pioneers in bringing techno-logical advances to bear on the cultural enrichment that can come from understanding the Renaissance past. Max Weber once named the 'his-torical disciplines' as those to whom 'eternal youth is granted' because to them the 'eternally onward flowing stream of culture perpetually brings new problems'.[50] He might have added, sometimes the very problems that the stream of culture presents to us are problems of methodology and of interdisciplinary integration; those problems upon which the Digital Renaissance has urged us ever more intensely to reflect.

50 Max Weber, *Methodology of Social Sciences*, tr. and ed. Edward Shils, Henry A. Finch (NY: Free Press, 1940), 104.

BRENDAN DOOLEY

Conclusion

'What drew you to Renaissance Europe?' The question may have occurred to many of our readers; and we the contributors to this volume hope our reflections have added a new dimension. That the question comes up in so many contexts and in so many guises we attribute to the importance of the period and of the associated concepts, some of them historical, some of them not. For a moment we put it on the lips of Belinda McKeon, interviewing the Irish novelist John Banville for the *Paris Review* in early 2012, and wondering about his choice of topics in such novels as *Kepler* and *Doctor Copernicus*. What indeed, she asks, drew Banville to Renaissance Europe? But first, let us take a look for ourselves.

In his 1992 novel *Doctor Copernicus* Banville explains his title character's predicament on reaching adulthood in a sixteenth-century culture at the edge of change:

> There were for him two selves, separate and irreconcilable, the one a mind among the stars, the other a worthless fork of flesh planted firmly in earthy excrement. In the writings of antiquity he glimpsed the blue and gold of Greece, the blood-boltered majesty of Rome, and was allowed briefly to believe that there had been times when the world had known an almost divine unity of spirit and matter, of purpose and consequence – was it this that men were searching after now, across strange seas, in the infinite silent spaces of pure thought?

The idea, for Copernicus, was far from consoling. 'If such harmony had ever indeed existed', Banville interprets, 'he feared deep down, deep beyond admitting, that it was not to be regained' (p. 27). The troubled personality in a transitional time made for an engrossing read.

Banville does not dodge McKeon's question. Apart from a writer's complusion 'to get away, to do something different', there was the peculiar affinity he felt with a world so strange and yet so familiar, historically

distant and yet reminiscent of the Ireland of the 1950s, a society (in his view) caught in a time warp. 'Looking back to Europe in the Renaissance', he said, 'I only had to think back to Wexford when I was growing up there to get a feel for what a primitive world was like.' Presumably, the persistence of traditionalism chimed with the author's reading of the premodern episteme. Although Banville's Renaissance may not be mine or yours, nonetheless, for him, as for many, the category enabled engagement with live memories within historical time. He could no more do without it than could we.

Banville's insight reminds us about the domesticated otherness of the Renaissance: a space familiar in cultural representations and remediations and at the same time different from anything we can possibly experience (to put it in Foucault's terms, 'the stark impossibility of thinking *that*'). 'The Renaissance within' may operate like a figure of speech, a concept belonging to our own vocabulary for referencing alterity, for dealing with events from which we are estranged, forming part of a succession involving us in a different time: in Banville's case, the strange territory, once a home, abandoned on the way here, and in another sense, the discarded self jettisoned between past and present, on the voyage of personal growth. Intense novelty, excitement, primitiveness: all may be part of the 'Renaissance within', obviously differing in prominence from case to case. And the 'Renaissance within' may relate to our understanding of the historical Renaissance in many different ways.

Jacob Huizinga saw the Middle Ages, not the age associated with the Renaissance, as strong and young. In researching the largest kinds of change, he and other experts on 'civilizational analysis' have often utilized organic metaphors such as growth and decay, youth and old age, birth and death, for translating physiological effects into concepts that organize the continuity of time. If these binaries all seem to go (literally) in a single direction, with a beginning and an ending, other phenomena associated with the seasons or with the planets suggest a returning cycle instead. And to just such a metahistorical structure numerous ancient thinkers added symmetry and elegance. The Renaissance theorists devoted much thought to reconciling the circularity of Aristotle and Polybius with the unidirectionality of the Providential view inherited from Christianity.

Other patterns emerging from the texts of history or the works of the imagination have furnished insights into the operating system guiding not only the mind but also all action: Apollonian, Dionysian (Nietzsche), Tragedy, Farce (Hayden White).

Circularity and unidirectionality abound in current public discourse. Are there, or might there be, beyond the business cycle and irreversible climate change, which have attracted the most attention, other long-term successive phases of human behaviour whose study may add to humanity's bulwark against future catastrophe? We have hoped that this book's account of one period's shadow on the present, and the present's shadow on the past, will stimulate further reflection concerning the conditions of development and the value of self and society that constitute yet another legacy of the period under study, without buying into any deterministic schemes.

Gathering, evaluating, storing, implementing the knowledge necessary for survival: the Renaissance preoccupation with its knowledge problem reminds us about our own. Another recent work set in the Renaissance, Philip Glass's 2009 opera *Kepler*, libretto by Martina Winkel, unrelated to Banville's novel of some thirty years before, suggests that the endless search for knowledge ennobles the seeker no matter what terrible things may be happening in the world. In Kepler's words,

> Inmitten des Zusammenbruchs
> wenn der Sturm tobt,
> können wir nichts Würdigeres tun,
> als den Anker unserer friedlichen Studien
> in den Grund der Ewigkeit senken.

> In the midst of the collapse
> When outside's a raging storm
> No worthier goal may we pursue
> Than drop the anchor of our peaceful studies
> In the depths of Evermore

Kepler in the opera appears to us as an austere dreamer holding on to the certainties he is able to muster while things change all around him. He sings:

> Ohne echtes Wissen
> ist das Leben tot

> Life is dead
> without true knowledge

The pursuit of knowledge per se is a defence against annihilation, quite apart from the use to which it may be put. No wonder there was in the period, in the words of Ann Blair, 'too much to know'.

And yet true knowledge remains elusive: not because of the crisis of the universities, the fragmentation of the disciplines, the deconstruction of the master narrative, the emergence of postcolonial discourse, or even the disappearance of public funding for the arts, but because of the mind itself. The epistemological 'paradox' at the end of the first act (indicated in the libretto as 'Augen, Optisches Paradoxon'), is given as a characteristic of Kepler's time, when the highest knowledge joined the pleasure of the imagination in the midst of careful empirical investigations. The Choir begins, over the orchestra playing Glass's repetitive pulsating sonorities:

> Was Augen sehn ist nichts
> Wenn wir die Augen schließen

> What eyes behold is naught
> When we those eyes have closed

Next comes the twist, reversing the meaning of the second line. Now the eyes may remain closed and the mind moves on. The opera, seemingly, has grasped the enigma of its hero:

> [Wenn wir die Augen schließen]
> Denn werden wir viel mehr
> Ja, alles sehn und wissen.

> [When we those eyes have closed]
> Then will we so much more
> Be apt to see and know.

Precisely this aspect – the effort to combine mind and body, reason and sense, theoretical and empirical – constitutes the epistemological challenge of the Renaissance, and perhaps also the challenge of the early twenty-first century; no doubt, it is an aspect that continues to fascinate, perhaps, also, to inspire.

Notes on Contributors

FEDERICO BARBIERATO is a social and cultural historian who has studied, in particular, religious dissent and magical practices, unbelief, censorship and the circulation of forbidden books in Venice between the sixteenth and eighteenth centuries. His books include *The Inquisitor in the Hat Shop: Inquisition, Forbidden Books and Unbelief in Early Modern Venice* (2012), '*La rovina di Venetia in materia de' libri prohibiti*'. *Il libraio Salvatore de' Negri e l'Inquisizione veneziana (1628–1661)* (2008) and *Nella stanza dei circoli. Clavicula Salomonis e libri di magia a Venezia nei secoli XVII–XVIII* (2002). He is Lecturer in Early Modern History at the University of Verona and a member of the editorial board of the history periodicals *Società & Storia* and *Giornale di Storia*, as well as of the web portal <http://www.stmoderna.it>.

SHEILA BARKER is Director of the Jane Fortune Research Program on Women Artists in the Age of the Medici at the Medici Archive Project, Florence. She graduated from Amherst College in 1993 and completed an MA, MPhil and PhD at Columbia University. Her forthcoming book on the career of Gian Lorenzo Bernini views the artist exclusively through the lens of contemporary journalistic reports found in the Medici Granducal Archive.

CHRIS BARRETT received her PhD from Harvard in 2012 and is currently Assistant Professor in the English Department at Louisiana State University, where she is also affiliated with the Women's and Gender Studies programme. Her research and teaching interests include early modern English literature (with special attention to epic poetry), humour studies, critical animal studies and geocritical approaches to literature. Winner of numerous fellowships and prizes, she is the author of articles and essays on Shakespeare, Spenser, Milton and the twinned history of ether and laughter.

Her current book project, entitled *Navigating Time: Anxiety, Maps, and the Early Modern English Epic*, explores anxieties (commercial, aesthetic and political) about cartographic materials in English Renaissance literature.

TOM CONLEY is the Abbot Lawrence Lowell Professor of Visual and Environmental Studies and of Romance Languages and Literatures at Harvard. He studies relations of space and writing in literature, cartography and cinema. Books include *Film Hieroglyphs* (1991, new edition 2006), *The Graphic Unconscious in Early Modern Writing* (1992), *The Self-Made Map: Cartographic Writing in Early Modern France* (1996, new edition 2010), *L'Inconscient graphique: Essai sur la lettre à la Renaissance* (2000), *Cartographic Cinema* (2007) and *An Errant Eye: Topography and Poetry in Early Modern France* (2010). He has also published *Su realismo* (Valencia, 1988), a critical study of *Las Hurdas* (Luis Buñuel, 1932). His translations include Michel de Certeau, *The Writing of History* (1988 and 1992) and the same author's *Capture of Speech* (1997) and *Culture in the Plural* (1997); Marc Augé, *In the Metro* (2003) and *Casablanca: Movies and Memory* (2009); Gilles Deleuze, *The Fold: Leibniz and the Baroque* (1993); Christian Jacob, *The Sovereign Map* (2006); and other authors. He has held visiting appointments at the University of California-Berkeley, UCLA, the Graduate Center of the City University of New York, L'École de Chartes, L'École des Hautes Etudes en Sciences Sociales, and other institutions. Awards include fellowships from the American Council for Learned Societies, the National Endowment for the Humanities and the Guggenheim Foundation.

BRENDAN DOOLEY (PhD Chicago 1986) is currently Professor of Renaissance Studies at University College Cork. Previously he taught at Harvard, Notre Dame and Jacobs University (Bremen); he has received fellowships from the National Endowment for the Humanities, the Institute for Advanced Study and the American Academy in Rome. He directs the Digital Humanities programme at UCC and the Birth of News programme at the Medici Archive Project in Florence. His publications include *A Mattress Maker's Daughter: The Renaissance Romance of Don Giovanni de' Medici and Livia Vernazza* (2014), *Morandi's Last Prophecy and the End of*

Renaissance Politics (2002), *Science and the Marketplace in Early Modern Italy* (2001) and, as editor, *A Companion to Renaissance Astrology* (2014).

THOMAS F. EARLE has just retired from the King John II Chair of Portuguese at Oxford University, a post which he has occupied since 1996. Before that he was a lecturer in Portuguese, also at Oxford. He has published a number of books and articles about intellectual and cultural life in Portugal during the Renaissance, and is currently working on a study of English translations of Camões's epic poem. He is a fellow of St Peter's College.

DAVID EDWARDS is Senior Lecturer in History at University College Cork and a director of the Irish Manuscripts Commission. He is also currently Principal Investigator of the Senior Collaborative Research Project, 'Colonial Landscapes of Richard Boyle, 1st Earl of Cork, c.1602–1643', funded by the Irish Research Council. He has published numerous books and articles dealing with the history of sixteenth- and early seventeenth-century Ireland.

JOSEPH S. FREEDMAN is Professor of History at Alabama State University and has been a guest professor at the Universities of Halle-Wittenberg (2004), Munich (2006) and Coimbra (2009). His principal area of research is early modern philosophy as taught at European schools and universities. Among the subjects discussed in his publications are how Aristotle, Plato, Cicero, Philipp Melanchthon and Petrus Ramus were used in early modern philosophy instruction. He is currently working on a monograph that will serve as an introduction to the study of sixteenth- and seventeenth-century philosophy as taught in schools and universities.

NICOLA GARDINI is Lecturer in Italian at Keble College, Oxford University. He received his PhD in Comparative Literature from New York University in 1995, with a thesis on the imitation of classical lyric poetry in Renaissance Italy, France and England. He is particularly interested in Renaissance poetry and poetics. He has been a lecturer at State University of Palermo (1999–2006) and Visiting Professor at Columbia University,

New York (2000 and 2002), at NYU in Florence (2000–2005), at IULM, Feltre (2003 and 2004) and at Università Cattolica, Milan (2005). A novelist and scholar, he is the author of *Rinascimento* (2010) and *Com'è fatta una poesia* (2007), and his new novel, *Le parole perdute di Amelia Lynd* (2012), won the Viareggio Prize.

HEINRICH LANG, currently a Research Associate at the University of Bamberg, studied Medieval and Modern History, Byzantine Studies and Philosophy at the Universities of Bonn and Cologne, and received his PhD from University of Bamberg in 2009 with a dissertation on *Cosimo de' Medici, die Gesandten und die Condottieri. Diplomatie und Kriege der Republik Florenz im 15. Jahrhundert* (2009). He is currently working on his Habilitationsprojekt, entitled *Elitennetzwerke und die Konstituierung von Märkten: Die Florentiner Kaufmannbankiers Salviati und die Augsburger Handelsgesellschaften der Welser in Lyon (1507–1551)*.

JOSÉ MONTERO REGUERA is Professor of Spanish Literature at the University of Vigo, where he has been a member of staff since 1995. He has also taught at the Universities of Valladolid, Münster and Carleton (Ottawa). He is the author of numerous publications on authors and texts of the Golden Age, with a special emphasis on Cervantes. Some of these have been collected in such volumes as *El Quijote durante cuatro siglos* (2005), *Materiales del Quijote. La forja de un novelista* (2006), *Páginas de historia literaria hispánica* (2007) and, most recently, *Cervantismos de ayer y de hoy. Capítulos de historia cultural hispánica* (2011). He is Honorary President of the Asociación de Cervantistas, which he headed from 2004 to 2012.

MAXIMILIAN SCHUH studied history and German philology in Munich and Edinburgh and received a PhD in Medieval History from the University of Münster (2011). He is currently a postdoctoral researcher in environmental history at the University of Heidelberg.

PAUL R. WRIGHT took his PhD in Comparative Literature at Princeton University, where he specialized in the development of political consciousness in Renaissance humanist thought. In addition to teaching at Princeton,

he has also been Visiting Professor at Osaka University in Japan, then a postdoctoral fellow at Villanova University. He is now Associate Professor of English at Cabrini College near Philadelphia. He has taught, presented and published on the political philosophy of Niccolò Machiavelli, John Milton, Jacob Burckhardt and Jürgen Habermas, as well as media studies subjects ranging from world cinema to American television. He is currently completing a book entitled *The Alloy of Identity: Machiavelli's 'Florentine Histories' Reclaimed*. He is also at work on a new project about the psychology and politics of cultural immigration in the early modern world.

Index of Persons